HOWE·LIBRARY

HANOVER
NEW HAMPSHIRE

TIME

FOR MY FATHER AND MOTHER

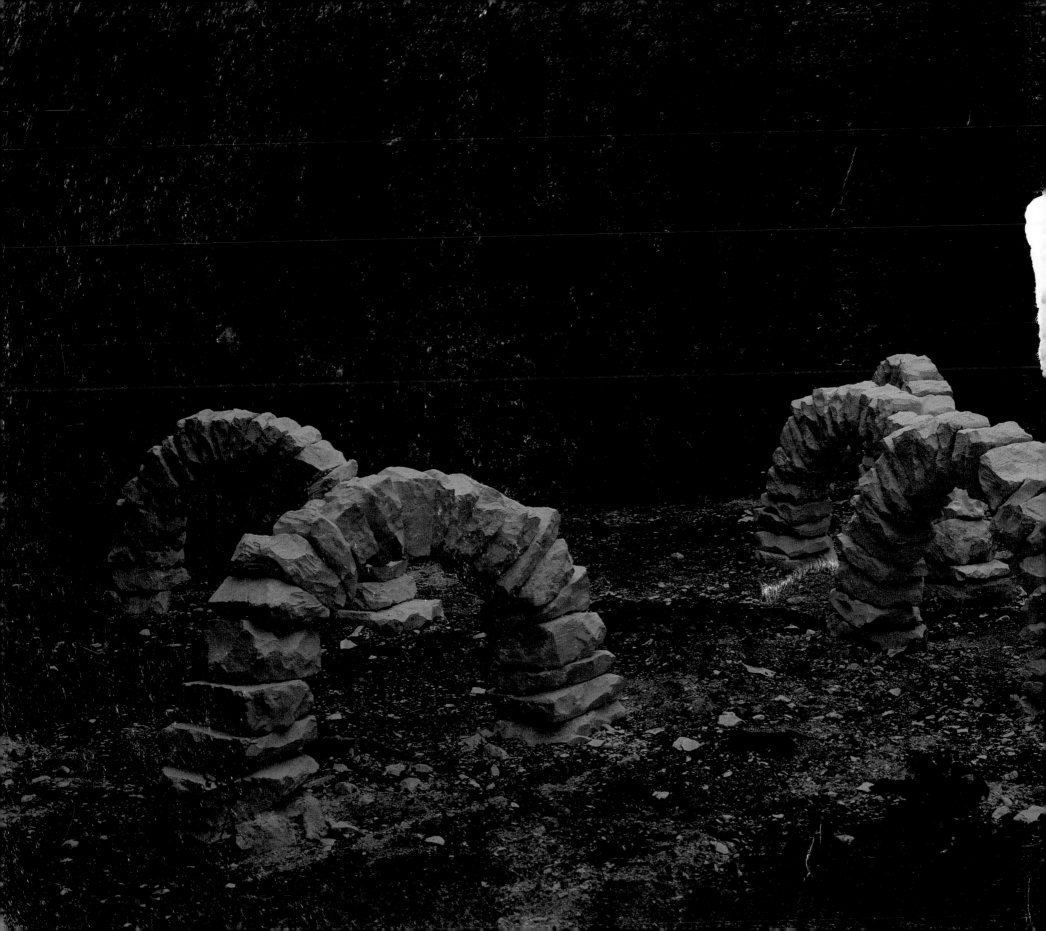

TIME

Andy Goldsworthy

Chronology by Terry Friedman

Harry N. Abrams, Inc., Publishers

Produced by Jill Hollis and Ian Cameron
Cameron Books, Moffat, Dumfriesshire, Scotland

ISBN 0–8109–4482–0

Published in 2000 by Harry N. Abrams, Incorporated, New York

Printed and bound in Italy by Artegrafica, Verona

The artist is represented by: Haines Gallery, San Francisco; Michael Hue-Williams Fine Art, London; Galerie Lelong, New York and Paris; Galerie S65, Aalst, Belgium; Springer und Winckler, Berlin

Harry N. Abrams, Inc.
100 Fifth Avenue
New York, N.Y. 10011
www.abramsbooks.com

The following photographs are reproduced by kind permission of the copyright holders: page 95, photo © Tristan Valès/Agence Enguerand, Paris; page 177, Cornell University (photo by Nicola Kountoupes); page 202 (second column, top), Storm King Art Center (photo by Jerry L. Thompson)

The artist is represented by: Haines Gallery, San Francisco; Michael Hue-Williams Fine Art, London; Galerie Lelong, New York and Paris; Galerie S65, Aalst, Belgium; Springer und Winckler, Berlin

Endpapers: River drawing on stone (details), Cornell University, Ithaca, New York, 8 October 1999 (*see* p.171)

Title page: 'A Clearing of Arches', Goodwood, Sussex, June 1995

I would like to thank all those people and organisations responsible for commissioning projects and sculpture that appear in this book. In addition, there are many people whose help with some of the larger works represented here was invaluable, in particular: in Aberdeenshire, Gordon and Jason Wilton worked on the Logie Cairn; at the Museum of Scotland in Edinburgh, Patrick Marold, Brian Dick and Ian Vernon worked on the clay wall; in Montreal, Claude Brault, Gerry Fitzpatrick, Gordon Grant, Brian Nish, George Rennie and Eric Sawden (Gordon, Brian, George and William Armstrong also worked on the Wiltshire arch); in Digne, Nadine Gomez-Passamar, Hervé Passamar and Guy Martini, Thierry Béving, Gérard Guillemenot and Jean-Simon Pagès (stone work), and Patrick Marold, Brian Dick, Ian Vernon, Jean-Paul Desideri and Roger Revol (clay work); in Nova Scotia, Norma Cassidy and Keith Graham, and Thomas Riedelsheimer, Dieter Stürmer, Mark Austin (who took the photograph of the snow throw) and Jane Porter of Mediopolis; in Holland, Marcel van Ool, Annemarie van Velzen and Robert Graat of the Staatsbosbeheer; at SITE Santa Fe, Craig Anderson, Carlos Beuth, Pam Ellison, Dennis Esquivel, Nathaniel Freeman, Louis Grachos, James Holmes, William Hutchinson, Erin Shirreff, Peter Sprunt and Colin Zaug; at Cornell University (with the kind support of Joel and Sherry Mallin) Nancy Green, George Cannon, Ken Carrier, Will Milland, Dave Ryan and 'Big Doogie'. I am also grateful to Cheryl Haines (with whom I discussed the concept of time in relation to my work some years ago), Michael Hue-Williams, Cécile Panzieri and Mary Sabbatino for their help in facilitating various projects included in the book. My thanks, too, to my assistants Ellie Hall and Andrew McKinna for their support; Andrew accompanied me to Holland and Cornell University, took several of the photographs showing me at work there and is also responsible for the photograph of the red dust throw.

Each page of this book is underwritten by the support, commitment, energy and friendship of Ian Cameron and Jill Hollis. I would like to thank Ian and Jill for the way they have risen to the challenge of what has been the most difficult and demanding publication of mine to date.
A.G.

CONTENTS

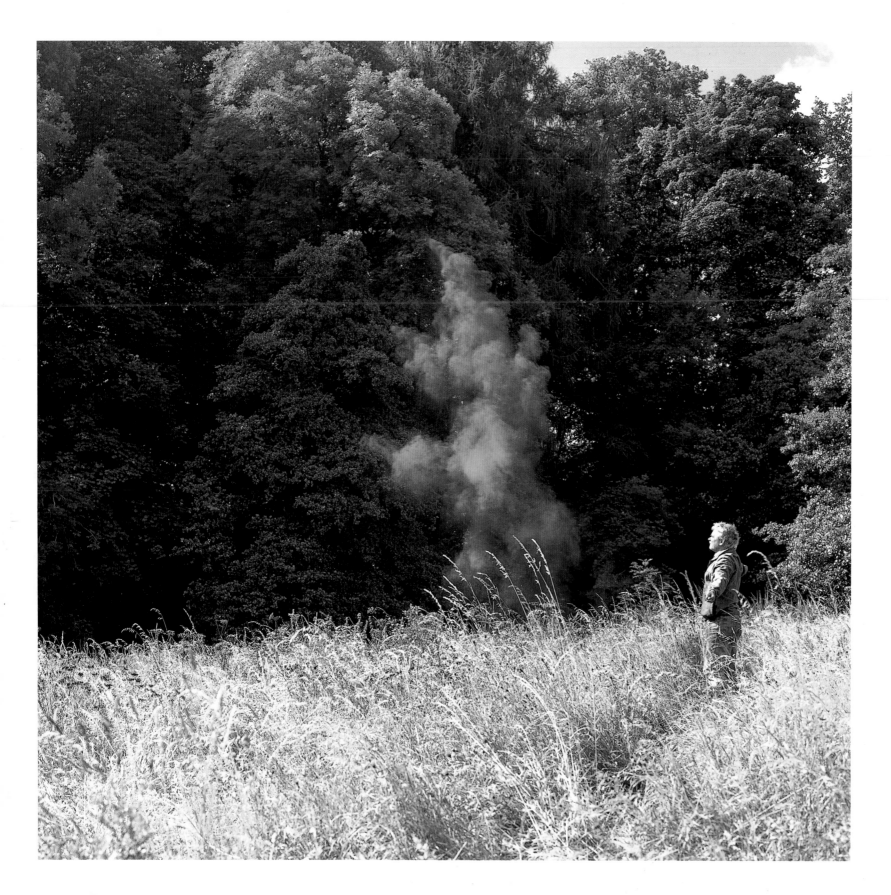

Red river stones
ground to powder
and thrown

PENPONT, DUMFRIESSHIRE

AUGUST 1999

TIME, CHANGE, PLACE

Whenever possible, I make a work every day. Each work joins the next in a line that defines the passage of my life, marking and accounting for my time and creating a momentum which gives me a strong sense of anticipation for the future. Each piece is individual, but I also see the line combined as a single work.

Time and change are connected to place. Real change is best understood by staying in one place. When I travel, I see differences rather than change. I resent travelling south in early spring in case I am away from home when I see my first tree coming into leaf. If this happens, I see the leaves, but not the growth or change. I feel similarly about the first frost or ice or snow, and the first warm day after winter. I thrive on the disruption forced by seasonal changes – a hard freeze, heavy snow, a sudden thaw, leaf fall, strong winds – which can change dramatically any working patterns that have become established in a particular season.

Not that seasons can be easily separated from one another. The smell of autumn can often be detected well before the season fully arrives, just as emerging growth can be seen in winter. For some plants, such as mosses, winter is their summer. The rocky, tidal area of the beach where I worked as a student was lush with green seaweed in winter, yet brown and dormant in summer.

In a previously unvisited, snowy place I have little idea of the landscape of stone, water and earth that lies below the surface. This gives me a strange perspective on the place which can sometimes be interesting. In the Arctic, for instance, I began to see the frozen sea as land which in turn made me think of the land as fluid. Usually, however, I am like an animal that needs to know where to find nourishment beneath the snow – the summer contained within winter. Being aware of the presence of one season within another and the tension and balance between seasons is also a way of understanding the layers of time that made the land.

I have enjoyed working in consistently cold or sunny places and the opportunities they give to pursue ideas cut short by the changeable British climate. The cracked clay, boulders, floors and walls might never have happened were it not for the dry California climate. My art, however, is rooted in the British landscape, and this is the source to which I must return.

When I began working 25 years ago at Morecambe Bay, I was interested only in the making and moment of individual works. The more I worked, the more aware I became of the powerful sense of time embedded in a place. The moment of my working a material and of my being there was bound up with what had gone before.

I was always interested in seeing work change and decay, but usually as a spectator. Lately the challenge has been not simply to wait for things to decay, but to make change an integral part of a work's purpose so that, if anything, it becomes stronger and more complete as it falls apart and disappears. I need to make works that anticipate, but do not attempt to predict or control, the future. In order to understand time, I must work with the past, present and future.

The beach was, and still is, a great teacher. This is where many of my working rhythms were first established. Work between the tides usually has to be made quickly and lasts for only a short time. Timing is critical. There is a gamble and balance between what I want to make and the time available to achieve it. Rarely is there enough time to finish a work just as I want. This lesson reaches beyond work made on the beach. I have tried to pitch my life so that I make the best use of my time and energy. Perfection in every work is not the aim. I prefer works that are fashioned by the compromises forced upon me by nature, whether it be an incoming tide, the end of a day, thawing snow, shrivelling leaves or the deadline of my own lifetime.

Visiting Heysham on Morecambe Bay some years ago, I was shocked to discover that a large stone I had worked on so often that I referred to it as my workbench had been smashed in two by a boulder falling from the cliff above. The stone had landed precisely where I used to stand while at work. I was reminded of a treeless valley in Japan, polluted by copper mining. Without trees, the steep and fragile mountains were eroding. I saw a huge boulder fall and roll down the mountain,

then bounce onto a dirt road before crashing into the river below. A few minutes later, a car drove where the stone had bounced, the people inside oblivious to the drama that had just taken place.

There is something beautiful, yet harsh, about living in the same place in a small community. When I moved to Penpont in Dumfriesshire, I got to know an old lady. She was a dour woman and had had a hard life. Her daughter had, I think, been killed in a farming accident. When I arrived in the village, I was 30 years old and full of the future. One day, talking to her, trying to be positive, I mentioned that my eldest son, now twelve years old, was the first child to be born in the street for 21 years and that since his birth, we'd had two more children and a neighbour had also had a child. I hoped that this would give some sense of optimism for the future, but she replied that I see births and she sees deaths. This made me think of the street in a totally different way. Before, I saw only those people living there at the time – after all, I'd only been in the village myself for a few years. Through her eyes, I saw the people who once lived there and who have since died. I hope that, by the end of my life, I do not go through the village aware only of deaths, but see my own life as part of the story of the continuing life of the village. I hope I will always be able to see new life and to make some sense of that continuity, even when shocked by premature death.

The older I become, the more connections I can make between times, experiences and places. I have always felt uncomfortable with the easy categorisations that people sometimes apply to my art. I remember overhearing a comment by a member of an audience waiting for me to give a lecture who was trying to explain my work to the person next to him and saying that I use only natural materials and no tools. My commitment to what are described as 'natural materials' is often misunderstood as a stance against the 'man-made'. I need the nourishment and clarity that working the land with my hands gives me, but at various times I have made use of light and heavy machinery, and I see no contradiction in using the technology of photography. Pretending I could do without such tools when I need them would be a bit like pretending I swim to America. Likewise, I live in buildings and should, on occasion, work in them.

My work with buildings is an attempt to understand and draw out their nature. Installations that engage with the building architecturally have been the most successful in trying to achieve this intention. There is a difference between a work that hangs as a rectangle on a wall and one that covers the wall completely – one is a picture, the other is the wall. At best, these works should feel as if they have risen to a building's surface as a memory of its origin, a connection between the building and its material source.

In 1992, I covered the floor of a London gallery in clay. In 1996, I made the same work at a gallery in San Francisco, but this time directly against a wall fourteen feet high by seventeen feet wide. I knew that the clay would crack, but didn't know whether it would stay attached. To my surprise it remains fixed to this day, despite the occasional earthquake. This clay wall was made in a spirit of experimentation, and I realised that by more careful preparation of the wall and application of the clay, I could make the installation stronger.

I had noticed that my clay walls and floors did not crack evenly. When making the first clay floor, I used wooden battens to maintain a consistent depth. The join where one section was added, although initially invisible when the clay had been smoothed over it, later produced a straight, cracked line; likewise, joists below the floor affected the drying out, and different hands involved in the making caused variations in the cracking.

I work in a landscape made rich by the people who have worked and farmed it. I can feel the presence of those who have gone before me. This puts my own life into context. My touch is the most recent layer of many layers that are embedded in the landscape which in turn will be covered by future layers – hidden but always present.

In 1998, I was asked to make a group of works for the new Museum of Scotland in Edinburgh, the majority of which were for the Early People section. It was intended that my work would introduce a dialogue between the ancient and the contemporary. Many of the objects in the museum's collection were found after having been buried, the discovery sometimes prompted by signs on the surface: a different colour of earth, patterns revealed by dry weather, old foundations or a particular type of plant.

I decided to make a clay wall with parts where the clay was laid deeper in a river form that would relate to the dug-out canoes placed in front of it. You cannot tell where the deeper part is until the wall begins to dry out, and then the join between the different depths of clay reveals itself as two, continuous, parallel cracks, drawing a sinuous meander across the wall. In the summer of 1999,

Clay wall

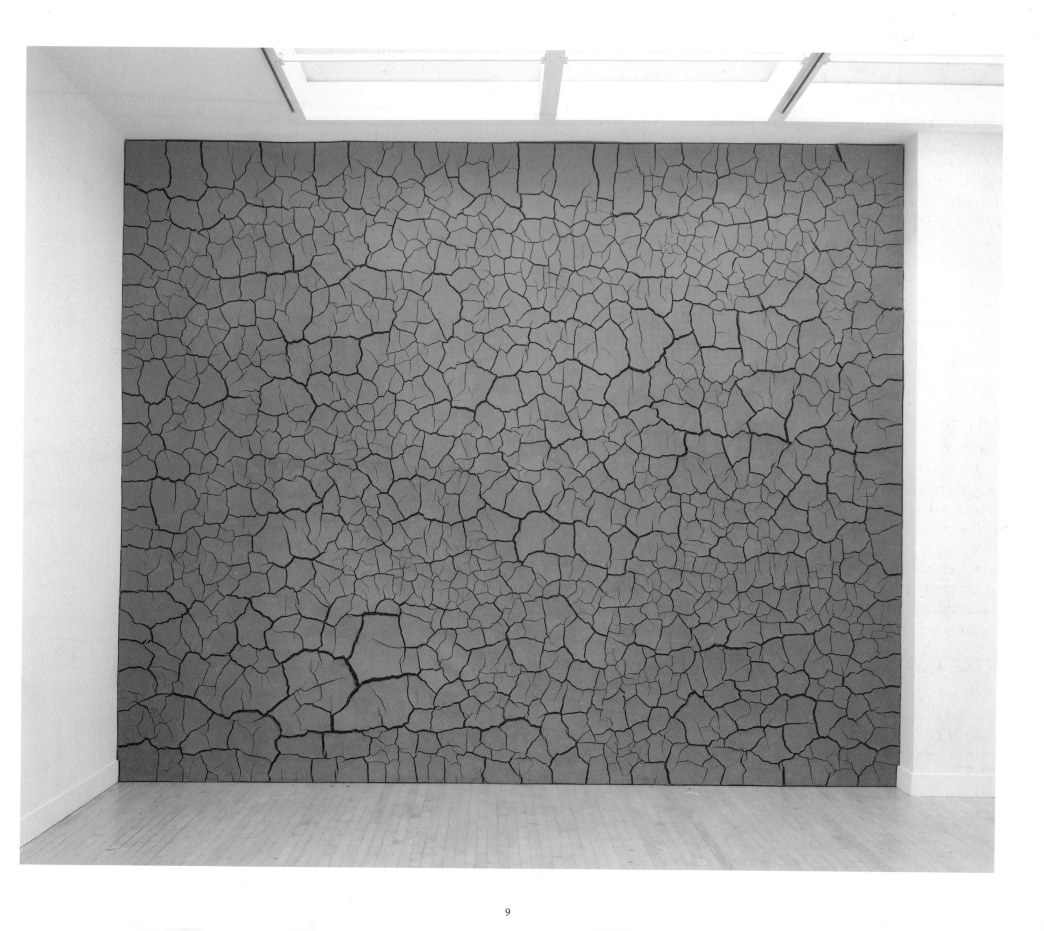

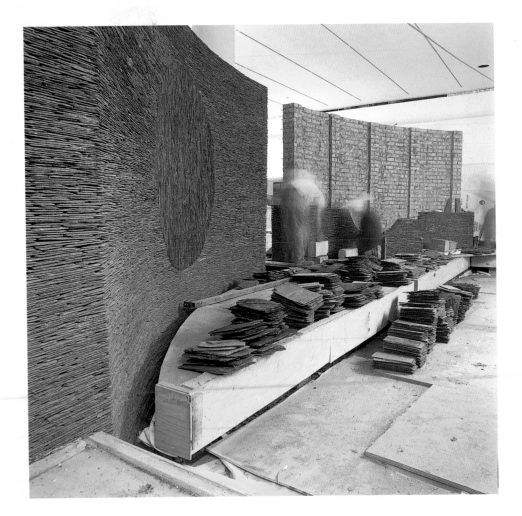

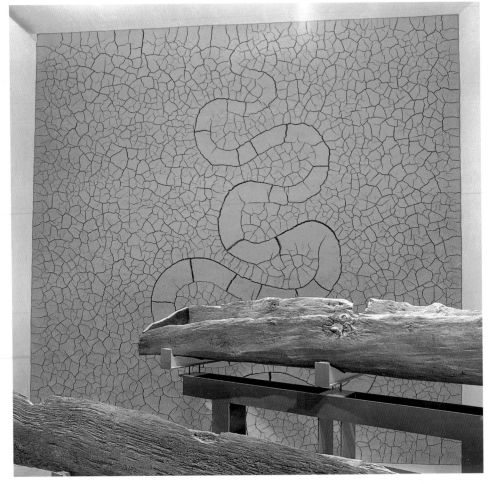

I decided to rework this river form on a larger scale at the Réserve Géologique in Digne (*see* pages 82-95). I describe this form as a river and prefer it not to be referred to as a snake. It is not a river either, but in calling it one I hope to touch on the movement associated with a river. A river for me is not bound to water. It is the flow, not the water that is important – a river of wind, animals, birds, insects, people, seasons, climate, stone, earth, colour . . . And yet when I see a snake I am fascinated by its form and movement. It draws beautifully the surface over which it travels. It is the essence of line, movement and form. I have seen snakes cross smooth, wide, fast-flowing rivers as if the current wasn't there. The effortless way in which they travel reveals an acute feel and understanding of their surroundings. The perfect sculpture.

Perhaps I do not make snakes in the same way that Brancusi didn't make birds or fish.

As river relates to boats, so the circle relates to buildings (the form of some of the earliest dwellings). At the Museum of Scotland, I pursued the idea of the circular

enclosure with four slate walls surrounding objects related to agriculture, hunting and food production. Each wall is built of horizontally laid slate, but at the centre is a circle of slate laid in different directions. Read left to right, the circles turn clockwise. The turning of time and stone is a quiet, but, I hope, powerful expression of the connection between the agricultural tools and implements on display and the practice of working the land in a cyclical process dictated by seasons and weather.

Near the centre of the enclosure is a burnt wood piece (timber taken from a skip on a building site) – an acknowledgement of the hearth traditionally at the centre of life in the home. Just before the exhibition opened, I installed a parallel group of work at the Ingleby Gallery, Edinburgh, which is located in a nineteenth-century town house that is still partly lived in. It was a good opportunity to place the ideas from the museum into a dwelling to reinforce the sense of connection and continuity between the past and the present.

Most of the work at the museum was carried out in the spring of 1998 over an eight-week period. The Early People section is in the basement and as a

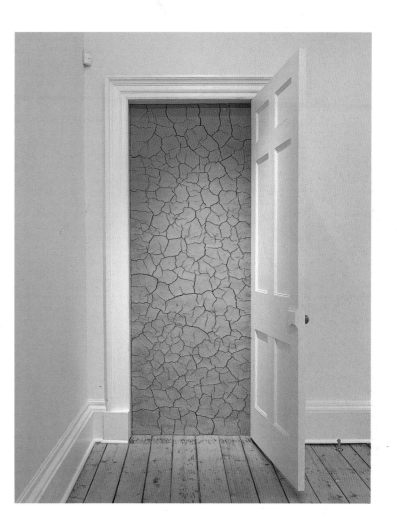

construction site it was rough, cold, damp, dark and noisy. Even the museum staff had restricted access, and my presence was at first somewhat resented by the building contractors who perceived what I was doing as disrupting the main task of completing the building, which was behind schedule. Just walking through the forest of scaffolding was hard enough, let alone getting the many tons of slate and clay on site. Materials had to be wheelbarrowed and sometimes, when there was not enough room for a barrow, manually carried long distances to where we worked. I had to keep shifting from one part of the sculpture to another in an effort to avoid being in the way of the tradesmen.

Despite all the effort and energy being expended in the building, the space felt dead when compared to the spring that was happening outside. Perhaps I just resented missing the spring, but I am not sustained by working indoors. I have too much control inside, and after a while I am drained of reasons for being there.

In the year 2,000, I will be 44; I began working as an artist 24 years ago and I may well work for about another 24 years. Thinking back to how little I knew at the beginning and how much my art has taught me makes me aware of how much there is still to learn. What I have made so far gives me a strong sense of the work yet to come.

As for most people of my generation, my life will straddle the two centuries and I will not belong to either one of them but to both. Time did not stop in 1999 and begin again in 2000. One year flows into another and whilst I am interested by the heightened awareness of time that was provoked by the changing centuries, I was not interested in the event itself. Just as my own life began in one century and will finish in another, so will those sculptures I have made for the millenium.

In 1999 I made three half-built sculptures which will be finished in the course of 2000. Near Aberdeen half a cairn awaits completion. Between the two halves will be a thin gap – the passage of time – which will be visible only if viewed from a particular angle. From everywhere else, the cairn will be perceived as being whole and solid.

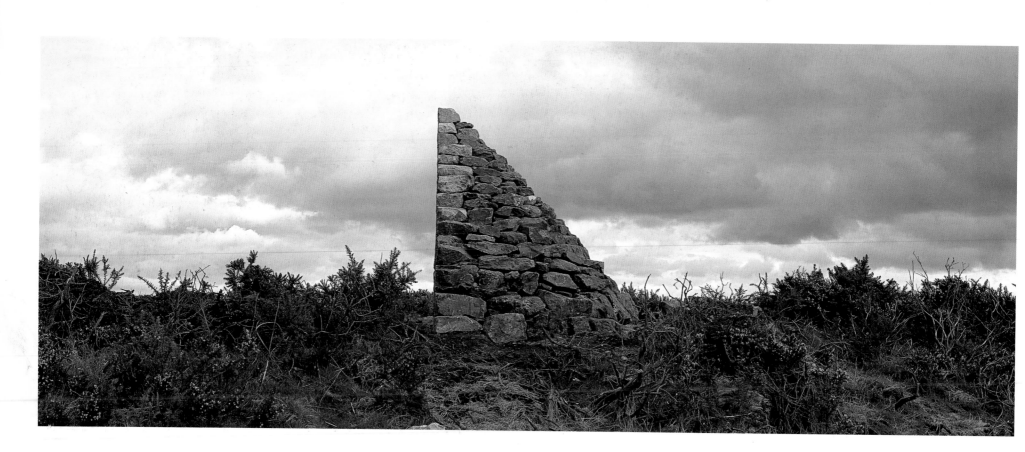

First half of Logie Cairn, awaiting completion

ELLON, ABERDEENSHIRE, MARCH-APRIL 1999

Opposite: First half of Hollister Cairn, awaiting completion

HOLLISTER, CALIFORNIA, NOVEMBER 1999

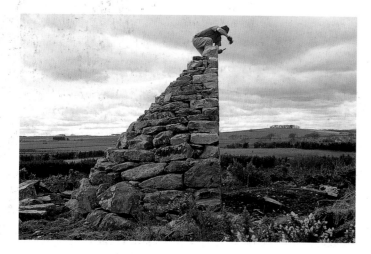

During its construction I saw the potential for making another version of this work in which there would be no gap between the two halves. Instead, one side would butt up against the other, creating what in dry-stone walling is called a running joint – something that occurs only in a badly made wall! In a properly made, seamless wall, each stone should cross the joints of the stones below, though a trained eye can, even then, often make out the join where one day's work ended and the next began.

A second cairn now stands half-built in California, made of flat-bedded, horizontally laid stone which will accentuate the vertical joint. Being made on the San Andreas Fault gives this joint additional poignancy.

One cairn is in Scotland and the other in America, emphasising their role as markers not just to time, but also to place and journeys.

These dividing lines mark time in a similar way to the growth rings of a tree. Sometimes the divisions between times and seasons are clearly recognisable, while on other occasions they form only a faint trace. Each of the three sculptures has a division: one a clear gap, another a thin line; the third is simply a concept.

In Wiltshire, half an arch, supported by scaffolding, waited several months for its other half to be built. Now completed, it bridges the two centuries, stepping

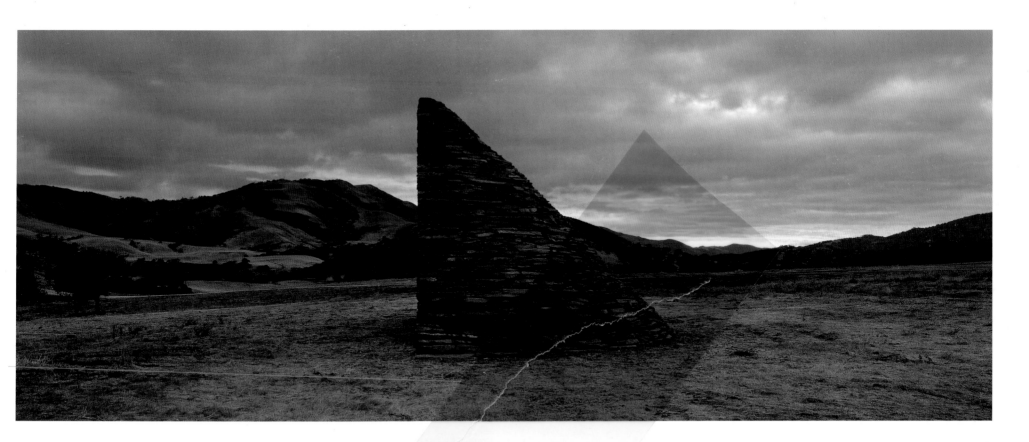

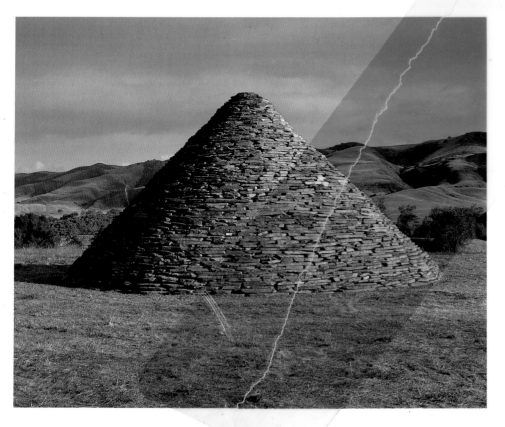

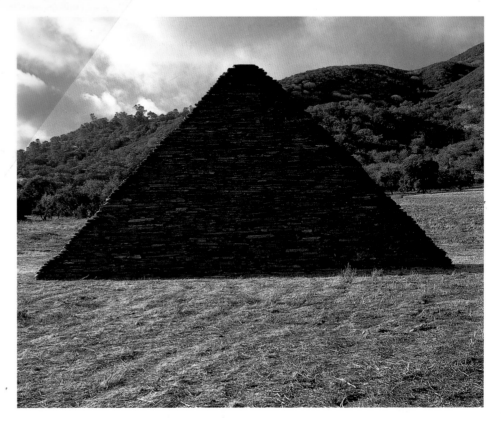

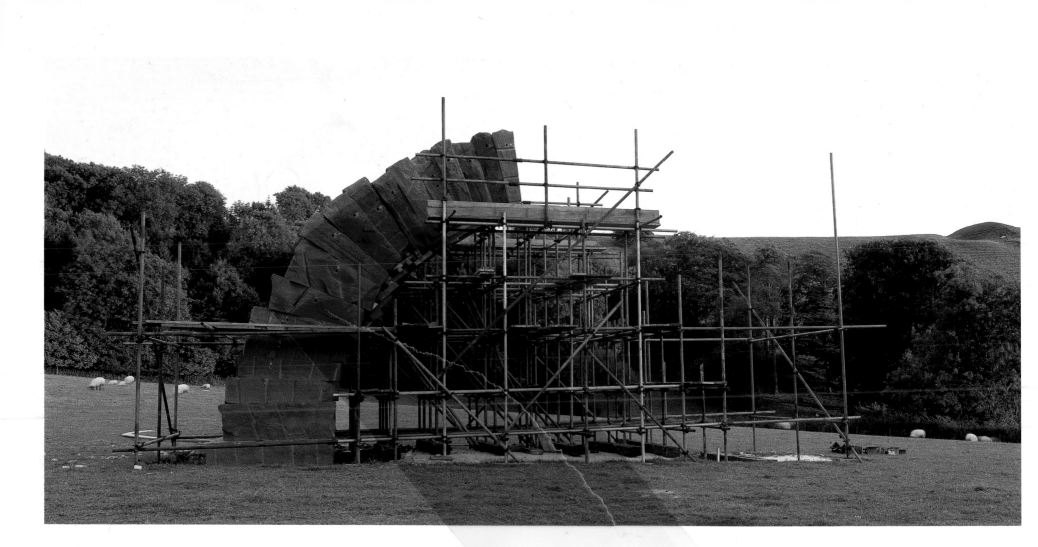

Locharbriggs sandstone arch
half-built
awaiting completion in 2000

OARE, WILTSHIRE
SEPTEMBER 1999

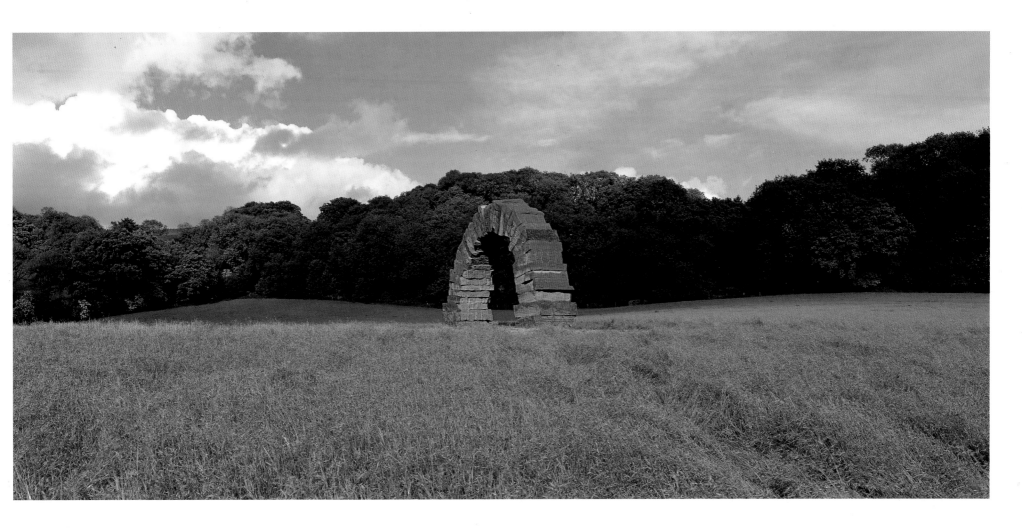

Locharbriggs sandstone arch
completed

OARE, WILTSHIRE

MAY 2000

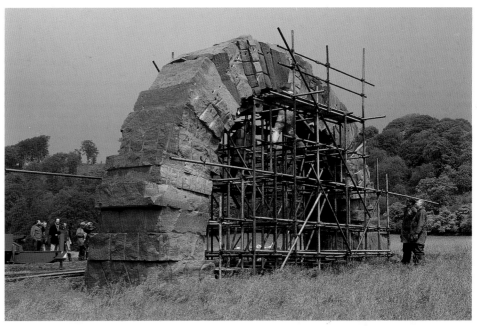

through time. The join will be understood only by those who know the arch's story. The half-built arch had become interesting in its own right, and I hope that the incomplete arch and the half-cairns will be missed once these sculptures are finished. This reaction will eventually be replaced by what has been gained, but the memory of the half-completed sculptures will remain a strong image in the minds of those who witnessed them.

On clear, sunny, cold mornings I try to find time between freeze and thaw to stand still and cast a cold shadow that will hold the frost whilst the surrounding area melts. The resulting white shadow is a balance between the cold night and warm day. If the temperature remains below freezing, I will not achieve a shadow; if it rises slowly, the process is prolonged, causing my shadow to drift to an area that has already begun to thaw. I will often lean sidewards in an effort to keep the shadow in its original position. Occasionally the sky has clouded over and the attempt failed. Autumn and spring, when the sun rises warmer, higher and more rapidly than in midwinter, are the best times.

I have never timed how long I stand for. As I stare at my dark shadow, an almost imperceptible white shadow begins to emerge, becoming stronger as the sun rises. It is interesting to contemplate the coexistence of black and white – light coming out of dark – as I wait for the contrast between the frost shadow and thawed ground to be at its strongest before I step back to reveal the white.

A figure standing still in an empty field is almost a sculpture in itself.

I once stood as a farmer did the rounds of his sheep and cows by motorbike. After doing a tour of the nearby hills he eventually came round towards me, stopping off at a turnip field on his way. When he reached the field I was in, he slowed down, said hello, and dropped off a couple of turnips.

(Today I made a shadow in the garden of my parents' home. My father is seriously ill in hospital. It was a brilliantly sunny morning and the lawn was still frosted over where it was shaded by the house. I had my cameras with me but did not come prepared for cold weather and borrowed my father's coat to keep me warm. I stood on the lawn newly exposed to the sun and watched as the frost slowly burnt off – a time to think.)

Last year I carried out a commission at Clougha Pike near Lancaster. The initial proposal was to build three, life-sized chambers in stone: the first in 1999, the second in 2000 and a third in 2001, so that again the components of the work would connect and mark the passage of time. To realise the first part in 1999 I had to work during December, which turned out to be a particularly cold and wintry month. The hilltop site was exposed and bitterly cold. The chamber became a coat of stone that I wrapped around my body to give me shelter from the elements and, although forced by a busy schedule to carry out construction in

Frost shadow in the making

CIUDAD REAL, SPAIN

JANUARY 2000

Frost shadow

PICKERING, YORKSHIRE

MARCH 2000

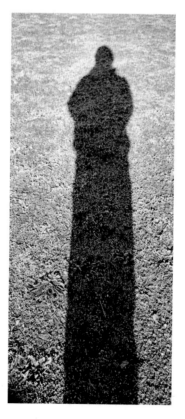

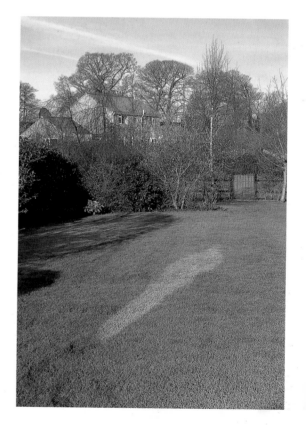

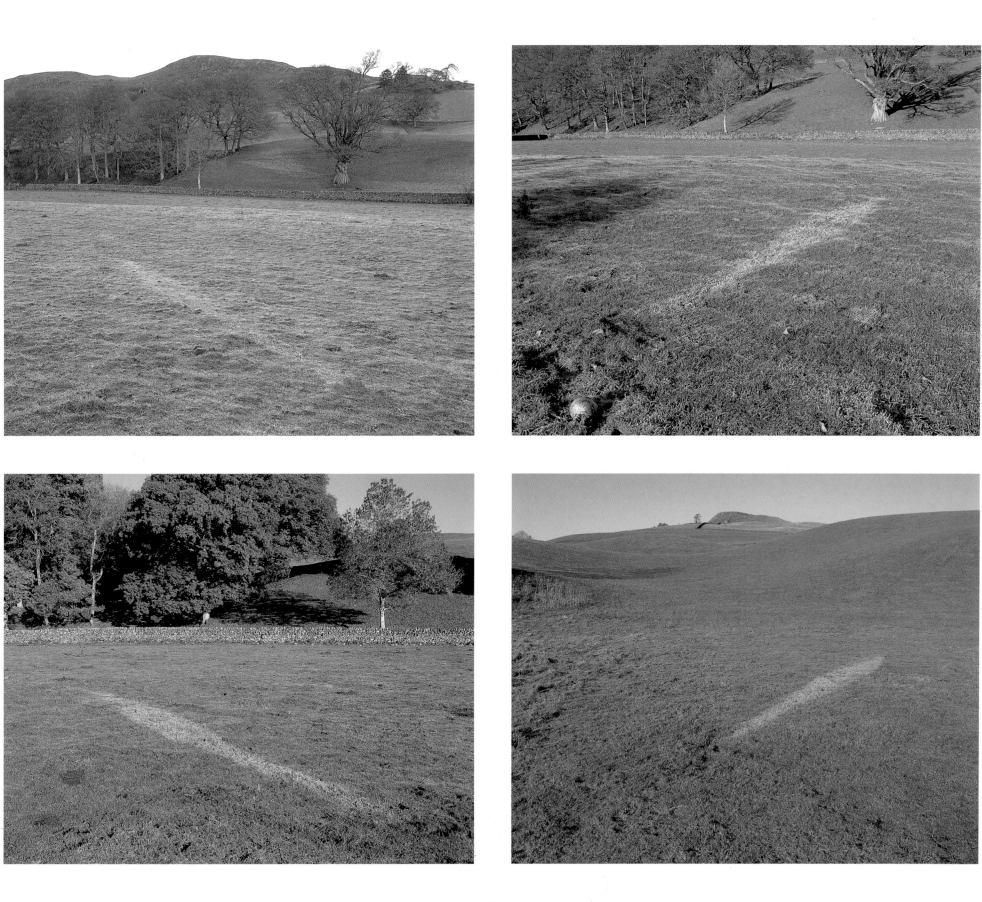

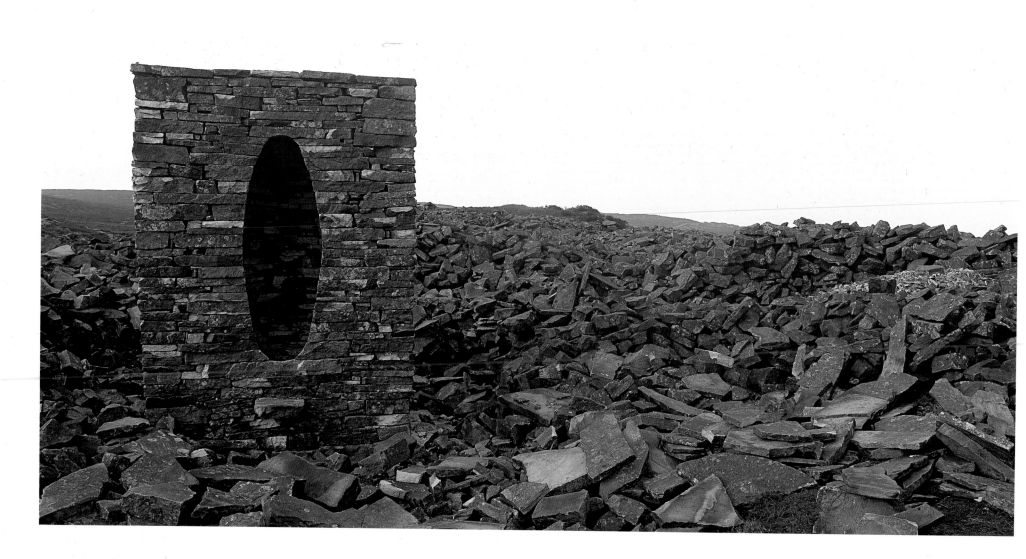

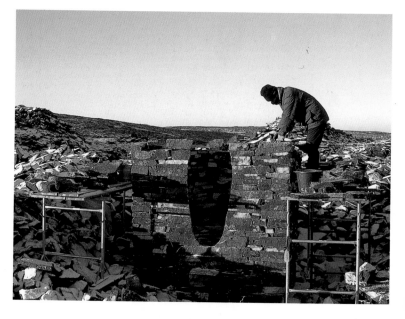

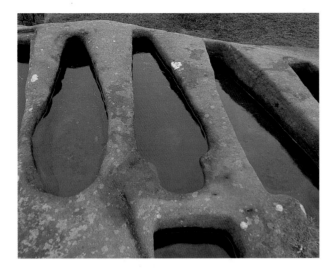

Above: Stone graves, St Patrick's Church, Heysham, Lancashire

Opposite: Stacked millstone grit

CLOUGHA PIKE, LANCASHIRE, NOVEMBER-DECEMBER 1999 (PROPOSAL DRAWING 1998)

Below: Old lime kiln
ash leaves stitched together with grass stalks

HUTTON ROOF, CUMBRIA
AUGUST 1996

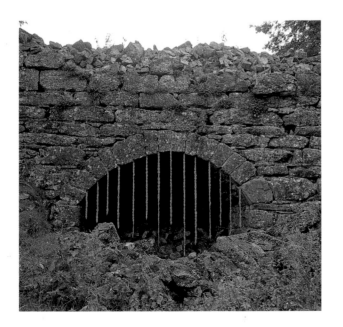

difficult conditions, I would not have wished it otherwise. The rawness of the weather imparted to the work a sense of need and protection.

Thinking of the chamber as something to wear rather than as a room helped me achieve a sense of intimacy and warmth within the enclosed space. It was conceived for people to step into and must be one of the most personal and autobiographical sculptures I have made. The site felt familiar when I was shown around before making the sculpture, and I realised that I had made works around here when I was a student at Lancaster 25 years ago.

From Clougha I can see Morecambe Bay where I made my first works. Heysham Power Station is clearly visible, and Heysham Head and Half Moon Bay, where I made the majority of my student works. On my way to work I would often pass by the remains of St Patrick's Church, where, carved in to the bedrock overlooking the beach, are six graves. They are often filled with water, and in winter I was able to lift ice out of a grave in the shape of the space where it had formed. These hollows, which feel as though they have absorbed the bodies that once lay in them, were very much in my mind when I was deciding what form the Clougha Pike sculpture should take.

The sculpture sits in a depression and is only partly visible above the skyline. The eye is drawn into the chamber and the immediate place, but at the same time makes connections and references to the surrounding landscape. There is a dialogue between intimate, internal perspective and external, distant landscape.

Below lies the Lune Valley through which the river Lune winds; I have worked many times along its banks. I can see Caton, where my wife was born and her father had his pottery. It was there that I first began experimenting with kilns. Just outside Caton is Brookhouse church where Judith and I were married. On a clear day the Lake District and the Langdale Pikes where I made my early works in Cumbria can be seen. Closer to is Hutton Roof where among other things I once worked in a lime kiln (another form that helped determine my response to Clougha). To the east there is Ingleborough and nearby Clapham Scar where in 1980, while living at Bentham, I made a precursor to the Clougha sculpture – a limestone hole. I could go on, I have so many rich associations with this area – places where I have lived and worked. In many ways these places belong to my past, but I still feel a connection and a presence. Perhaps this is what the Clougha sculpture is about: the space and memory that we leave by our absence. The chamber will collect and become rich with memories of those who stand in it.

The human element has always been present in my work. Early photographs of finished works occasionally had me in them as if to say, 'this was made by a person'. Putting me in the picture is unsatisfactory, forced and too personal, a family snapshot, falling well short of a deeper understanding of human nature.

Clockwise from top left

Rain shadows

PENPONT, DUMFRIESSHIRE, SEPTEMBER
1995; PENPONT, SEPTEMBER 1995;
PENPONT, SEPTEMBER 1992; MUSEUM OF
SCOTLAND, EDINBURGH, JUNE 1998

Clockwise from top left

Rain shadows

ANGERS, FRANCE, SEPTEMBER 1992; CORNELL UNIVERSITY, ITHACA, NEW YORK, MARCH 2000;

TICKON, DENMARK, JULY 1993; MOUNT VICTOR, AUSTRALIA, JULY 1991

The rain and frost shadows are more successful; they talk about human presence without the intrusion of a personality. It is important to me that I lie in the rain and stand in the cold – I take the memory, but the imprint left expresses a concern about the broader human condition.

I have never tried to conceal the fact that my work is made by a person and I am surprised when people suggest that I must spend hours clearing the site of all

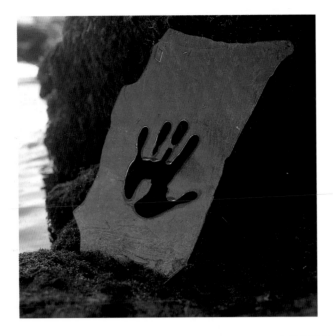

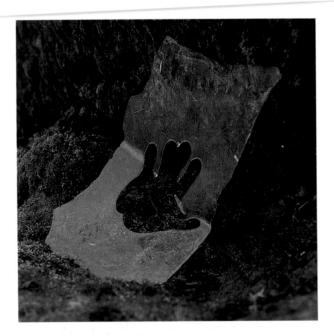

Hand held to
thin, spring ice
returned later
to find ice not broken
but buckled as it thawed

SCAUR WATER, DUMFRIESSHIRE
25 MARCH 1993

footprints. Apart from gathering up leftover materials and toning down the odd mark, I don't do anything like that. At times it is difficult to say where my touch ends and the place begins. This lack of a division can at times be disturbing. It is easier and in some ways more pleasing to make a sculpture work through its contrast to the surroundings, but the greater challenge is to make work that is completely welded to its site.

In recent years I have worked directly on trees and stones in an attempt to tap into the life and energy contained within them. That these works appear to have grown in the place is an indication that I have understood something of the internal tree and stone. They are not an attempt at mimicry. I return and photograph their disintegration to remove any mystery surrounding their construction.

Near where I live I am making the Dunesslin Cairns, one finished in 1999, another to be made in 2000 and the third to come in 2001. I had previously made a smaller version of this work at my home, but I was unsure how I would realise the same form on a larger scale. The stone came from a nearby whinstone quarry – a hard, unforgiving stone that is very difficult to cut or carve. When I rang Faulds of Glasgow, who are specialists in making chisels, to ask them for the appropriate ones, they said that there are none!

The cairns will be about ten feet high and twenty feet across the base, each with a hole in which a hawthorn tree will grow. The form is simple, but the method of construction is complex – made more difficult by the nature of the stone. Sandstone or slate would have been easier. Problems, however, are a good teacher, and it was the material I wanted to use in that place.

In the quarry I had to pick stones with something of the form that I needed. I worked them with a hammer and chisel, but only to help what is already in the stone. The process bears some resemblance to modelling in that one piece is put on another, but, apart from that, it has nothing to do with modelling and, in spite of the use of hammer and chisel, little connection to carving either. It is a way of working stone that falls outside the traditional categories of modelled or carved sculpture.

I am rarely either a carver or modeller. They are not processes that I am comfortable with. Carving relies upon the integral strength of a block of stone. Flaws and fissures are not welcomed by the carver, but these qualities talk of the way a stone has been laid in the earth and offer openings through which I can enter to work and understand stone. The laying of one stone upon another draws parallels with the building-up of strata. The stone is returned to a state of bedrock in a solid but flexible mass that will bend and settle over time. This is the strength and durability of stonework without mortar.

One of the few occasions when I have carved stone was for another commission

for the Museum of Scotland, this time for the roof terrace. The views from the terrace are extensive, showing an extraordinary mixture of city and geology. I enjoy views, but don't like the way buildings and people compete to claim them. There is something detached and arrogant about having a view. My own house looks out over a very beautiful stretch of landscape. It is the first time I have lived with such a view and I feel slightly uncomfortable about possessing it. During the renovation of the house, I dug a hole in the floor into which I worked clay in a series of concentric holes that became smaller as the hole became deeper – a view into the ground at my feet as a counterpoint to the distant ones outside. The work is still there, protected by glass.

I reworked this idea in Dumfriesshire red sandstone for the Edinburgh roof terrace. The sandstone was gradually laid down in layers, has been gradually compressed over time and is evidence of when Dumfriesshire was desert; black lines in the stone are ash deposits from erupting volcanoes. The stone has a grain that allowed me to cleave (not cut) each of four blocks into five slices; I then carved holes of descending size into the slices, so that when each stone was reconstructed the holes drew the eye into the centre of stone and back in time.

Geologists invite us to look through the surface of stone to the changes that have occurred within the earth, and the sculptures were intended as a homage to the eighteenth-century geologist James Hutton, one of the first to realise that stone is in a state of continuous movement and change. The installation is titled 'Hutton's Roof' after the geologist, but also refers to the name of a hill where I once worked near the Lancashire and Cumbria border. I like the connections between the roof terrace, a geological roof and a geologist.

Layering makes connections to geology and growth. The form emerges slowly as each stone is added in a process generated by and rooted in its internal structure. Each stone is tied into the work – not stuck to the outside as a veneer or dabbed on as clay might be.

It has taken many years for me to be able to work with clay. I experienced the same difficulty with clay that I had with paper, and, to some extent, indoor spaces generally. I need the resistance of weather, place and material. I become somewhat lost faced with the emptiness of a room, a blank sheet of paper or the easy malleability of clay.

Time is the tool with which I have been able to work clay and paper. A snowball melting on paper and a cracking clay wall give the resistance and unpredictability that I need. These works are made in the same spirit as the throws. My energy is put into the throw, but I cannot control the outcome.

Even with works made in stone, such as the Dunesslin Cairns in which my hand retains some control, there is a feeling of nurturing the sculpture into fruition

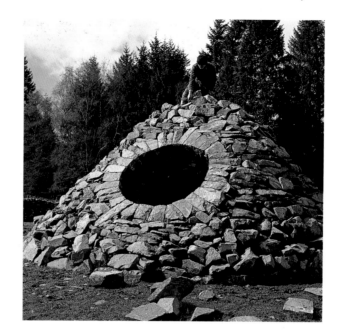

Dunesslin Cairn
made of whinstone
planted with hawthorn sapling

JANUARY 1999

APRIL 2000

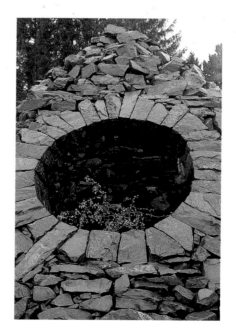

rather than forcing the form into being. There is a difference between placing and making a work on a site. A work made in a place grows there and becomes part of it in a way that a sited object has difficulty in achieving. This is not a criticism of other sculptures, just an observation that in my own work I can see the way different approaches affect the way a sculpture welds to a place.

I resisted planting a large tree to achieve an immediate completion of the Dunesslin sculpture. I want there to be little evidence of growth at the beginning. The tree will slowly grow out of the hole and into the space outside the cairn. The cairn will shelter the tree from the prevailing westerly winds. This relationship between stone and wood lies at the core of the sculpture. Stone is in some ways the least likely place for growth to occur, but in a landscape where sheep eat most plants, trees have had to find protection in stone by growing in difficult, inaccessible, often stony places.

I spent a whole day finishing the last part of the circular arch that surrounds the hole, about six or seven stones in all. The last stone is always difficult to get right. After a bit of work, I found one that fitted tightly and needed to be hammered home for the last few inches. This made the circle of stones taut and it lifted itself off its supports, a wonderful moment. Then came the time to take away the wooden former and I could see the hole for the first time. When I finish a work, I see all the faults – qualities that I often grow to like most later on. The hole looked well in the grey overcast light. The stones were dry and light, which intensified the dark, contained space.

I didn't know at the beginning whether I would construct the internal hole by laying stones on top of each other or by building arches. During the making of the work, I decided to layer the stones. This gives the stonework at the back of the hole a strange, wall-like quality, which dramatically affects the perception of the black. There is a visual tension between the exterior stone and the interior stone, in that the stone of the hole looks as if it is in the far distance or is hovering somewhere behind the hole. It looks disconnected. If I had made it as arches, the structure would have been evident and connected to the exterior. I like this dislocation of the senses. It is like looking at a river of stones behind the hole, flowing in the black.

Each tree will grow differently. I like the unpredictability of growth. There is a possibility that the tree will not grow at all and, if so, the hole will be enough. I don't think this will happen and I look forward to seeing the relationship between tree and cairn develop. The tree will inevitably obscure the hole, which could possibly appear like a negative moon through the branches, and the leaves and blossom like passing clouds.

Most of my permanent sculptures have been made elsewhere as private commissions which I see during and just after construction. Occasionally I make return visits to see how they have changed, but this is nothing compared to the relationship with the sculpture that is possible for someone who lives with it. I have enjoyed the different lights and qualities that have played on the hole of the cairn outside my house – it was beautiful under moonlight with a light covering

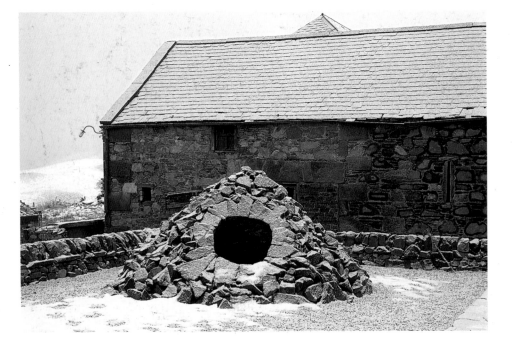

Whinstone cairn

PENPONT, DUMFRIESSHIRE

CONSTRUCTED 1996

Opposite

Three rocks

red maple leaves

held with water

KOSHIN-GAWA, ASHIO, JAPAN

NOVEMBER 1990

of snow. I have been surprised that something made solid in stone can be so changing, an aspect that at Dunesslin will become increasingly apparent as the tree grows and spreads over the hole.

Plants can be as difficult as stone to work with, sometimes even more so. Working with the dandelion is working with time and weather. In Scotland it has to be dry, bright and not too cold before they will open. Once picked, they retain the memory of when to close again, usually around late afternoon. There is a sense of urgency when working the dandelion. On one unusually (for Scotland) hot day the flowers began to close early to escape the heat, and it was difficult to finish the piece that I was working on. In the south of France I have seen them open consistently, even when it rains – though they look somewhat shocked as if they almost don't know what to do. In generally easier and more predictable climates, they seem less alert and responsive to the weather. I feel that sometimes the most significant differences between places and countries can be found in their similarities.

In Japan the red of the maple is one of the strongest I have found – not just for its colour but in its context. I have worked with red leaves in the American fall, but there the colour is part of a wide variety of colours, including many different reds. The isolated Japanese red maple set amongst green trees on a mountainside is so violent that it appears as an open wound. I would climb up to such a tree in an attempt to work the red, but it faded away like a rainbow as I approached. The colour gained its strength from its place and the way the mass of leaves caught the light when seen from a distance. By working the leaves in the river I was able to bring the red alive.

Small red stones can be found in one particular place along the river near where I live. When rubbed together in water these stones turn the river red. There is little indication that red is present and I worked there many times before finding it. It has to be prised from the place and is a shock when first discovered. That such an intense colour can be so hidden is a reminder to look beyond the surface of things.

I have found and worked with red in many countries and talked of it as the earth's vein – a description confirmed by the realisation that the earth and stone are red because of their iron content which is also why our blood is red.

The beauty of the red is its connection to life – underwritten by fragility, pain and violence – words that I would have to use in describing beauty itself. This sense of life draws me to nature, but with it also comes an equally strong sense of death. I cannot walk far before seeing something dead and decaying. Uprooted trees, fallen rocks, landslides, flood damage . . . A grip on beauty is necessary for me to feel and make sense of its underlying precariousness. So many of my sculptures are within a hair's breadth of failure. I often see works – a balanced column of rocks, stacked icicles – looking stronger with each piece that is added, but also know that each addition takes it closer to the edge of collapse. Some of my most memorable works have been made in this way, and some of my worst failures could have produced some great pieces. Beauty does not avoid difficulty but hovers dangerously above it – like walking on thin ice.

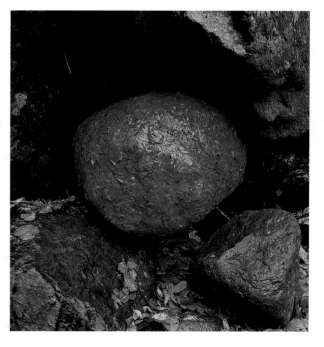

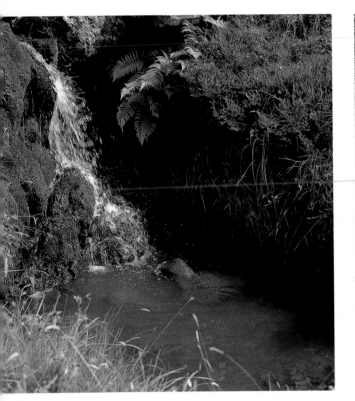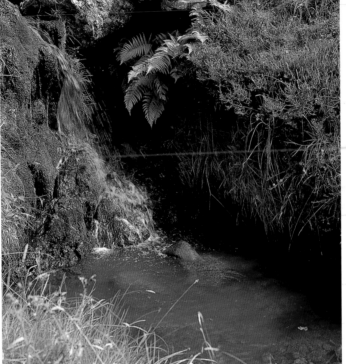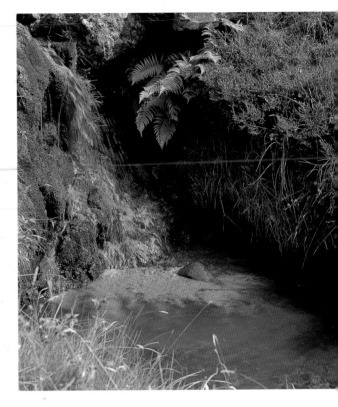

Red river rocks
ground to a powder
slowly released
upstream of a waterfall

BOTANY BAY, SCAUR GLEN, DUMFRIESSHIRE

JULY 1997

26

SCOTLAND

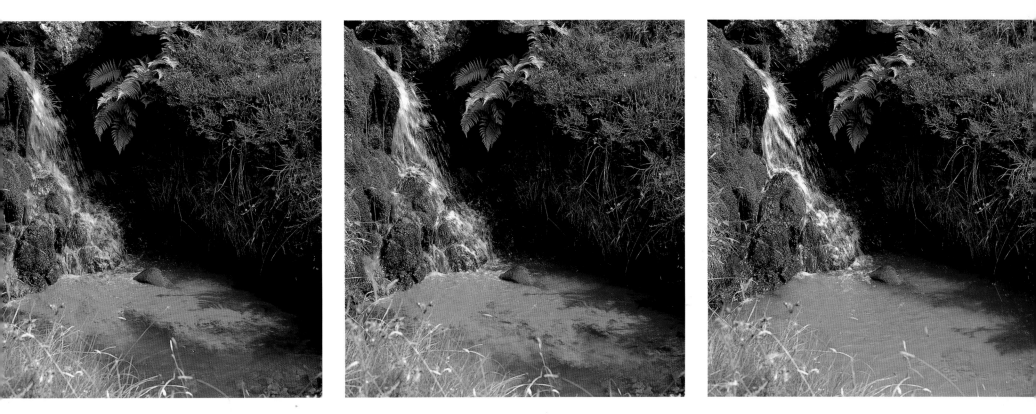

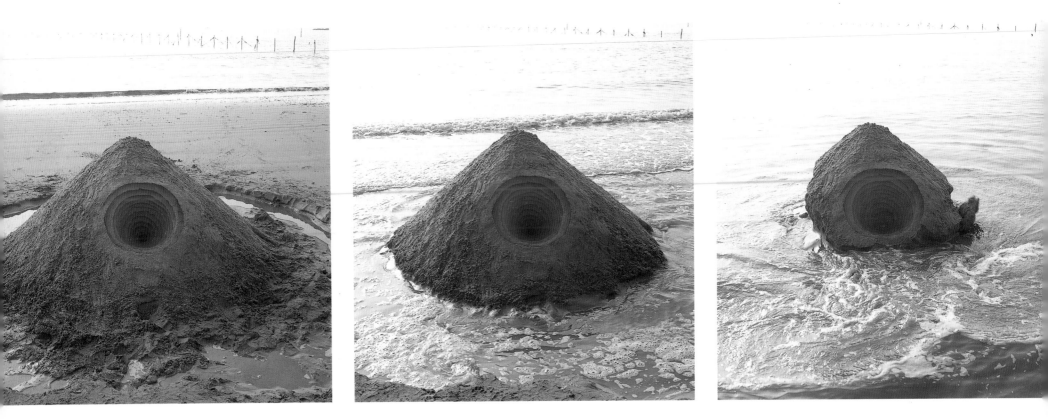

Sand holes

for the incoming tide

ROCKCLIFFE, DUMFRIESSHIRE

MARCH 1997

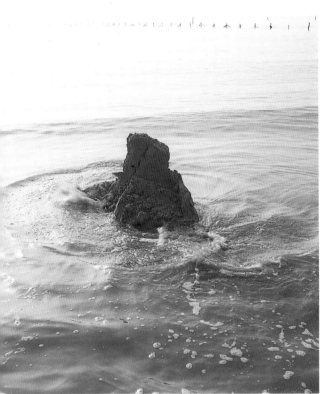

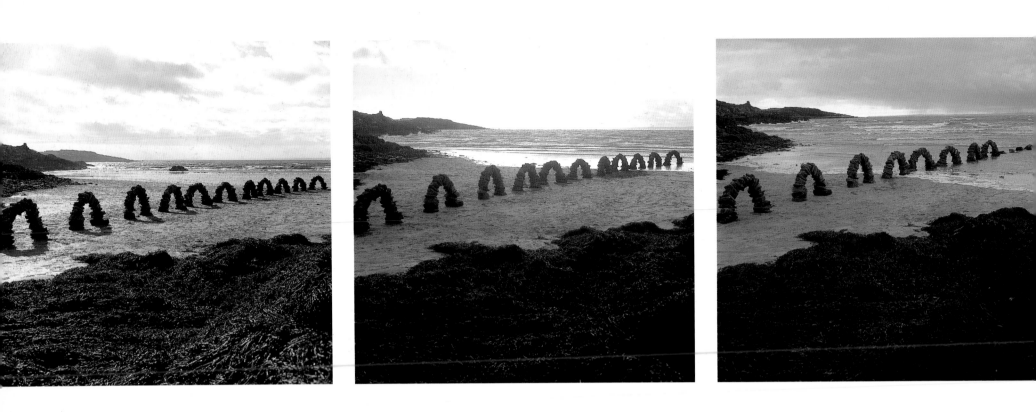

Eleven arches
made between tides
followed the sea out
working quickly
waited for its return
sun, wind, clouds, rain

CARRICK BAY, DUMFRIESSHIRE
17 OCTOBER 1995

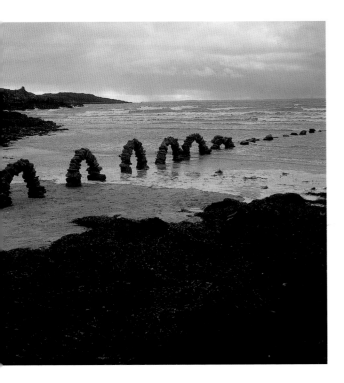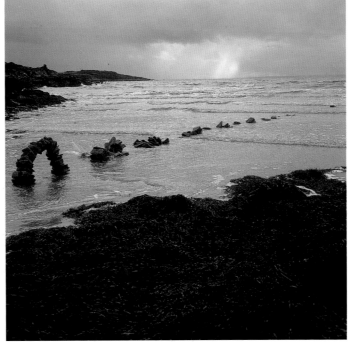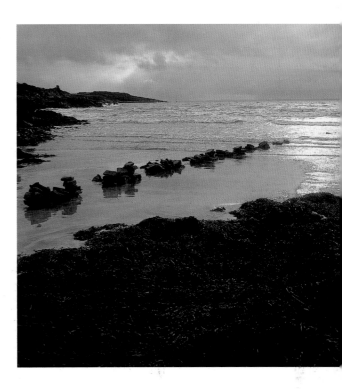

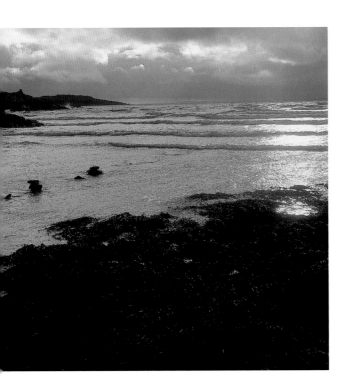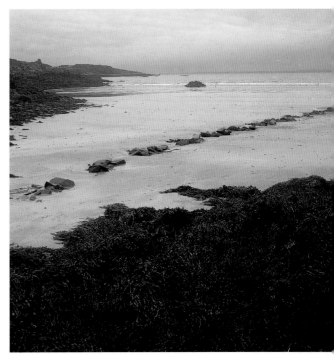

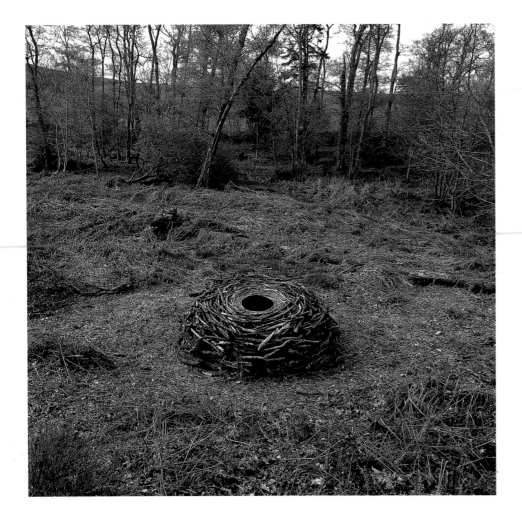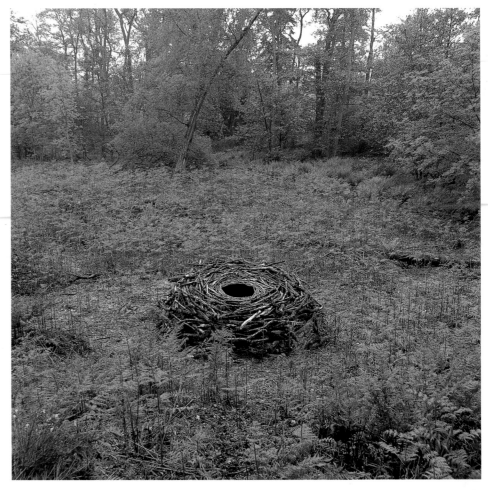

Stick hole

spring into summer

SCAUR GLEN, DUMFRIESSHIRE

APRIL-AUGUST 1999

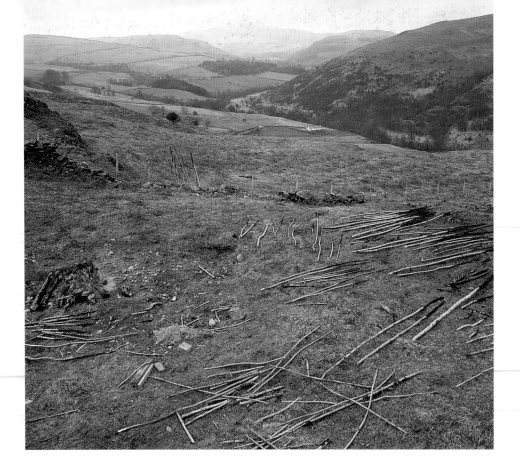

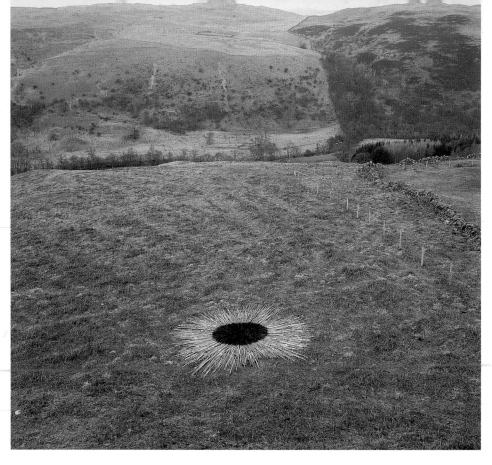

Dead hazel sticks

collected from nearby wood

partly burnt

laid on old bracken

in anticipation of the new

revisited from late winter through to summer

SCAUR GLEN, DUMFRIESSHIRE

MADE 11 MARCH 1997

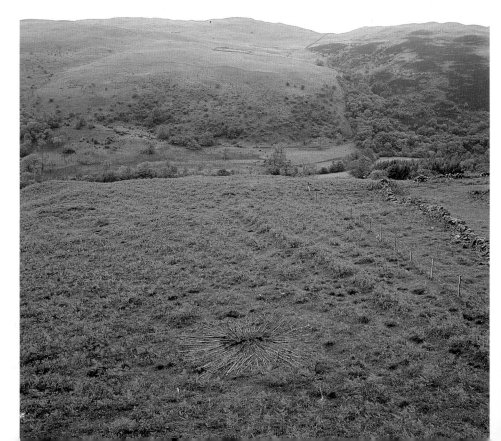

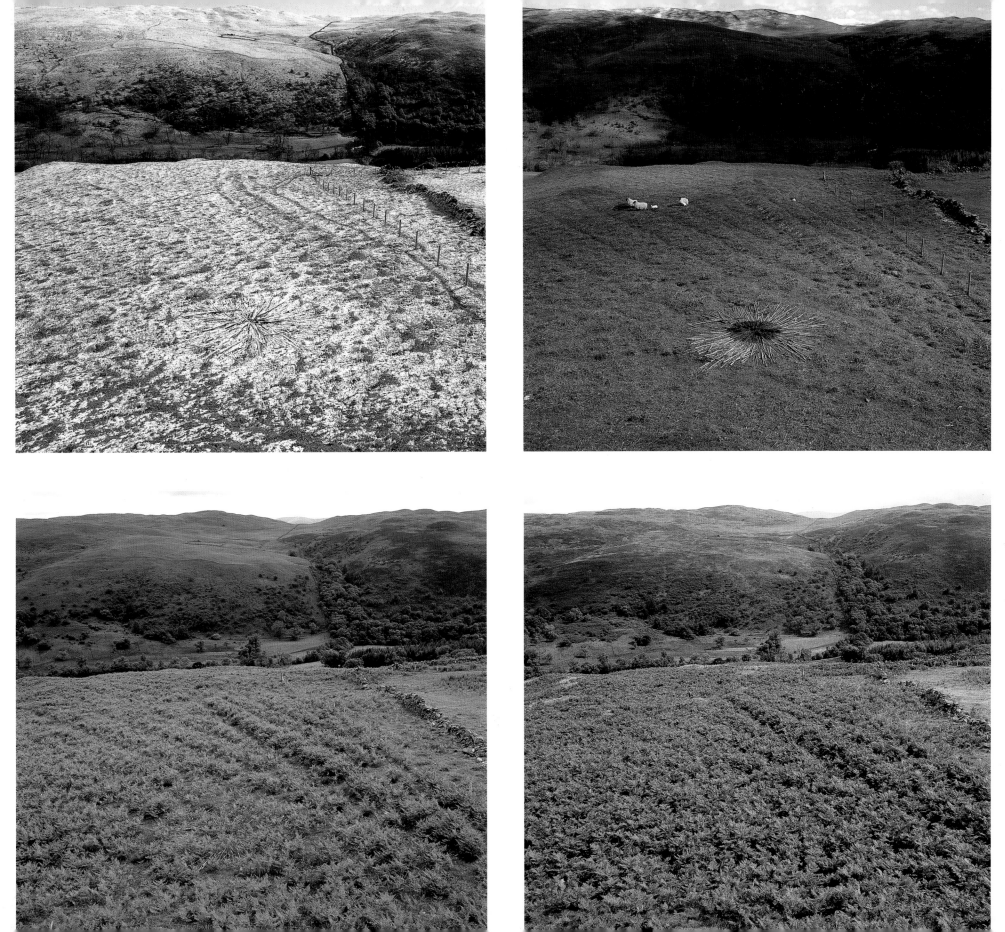

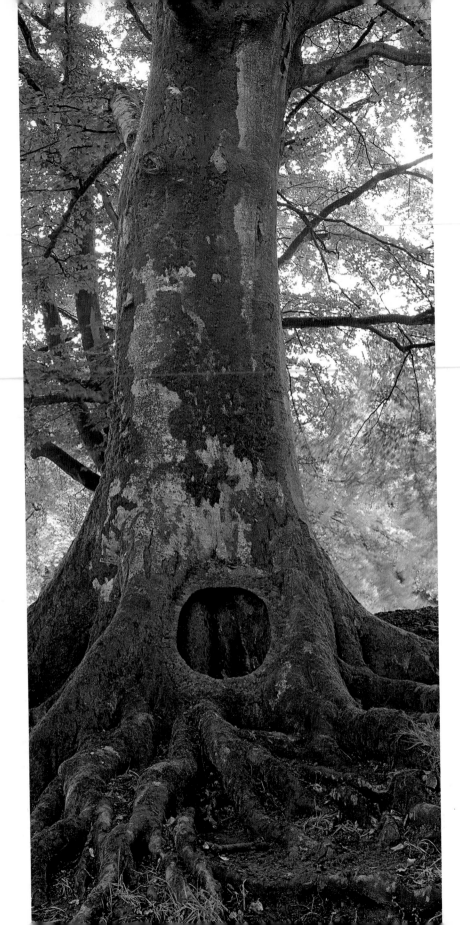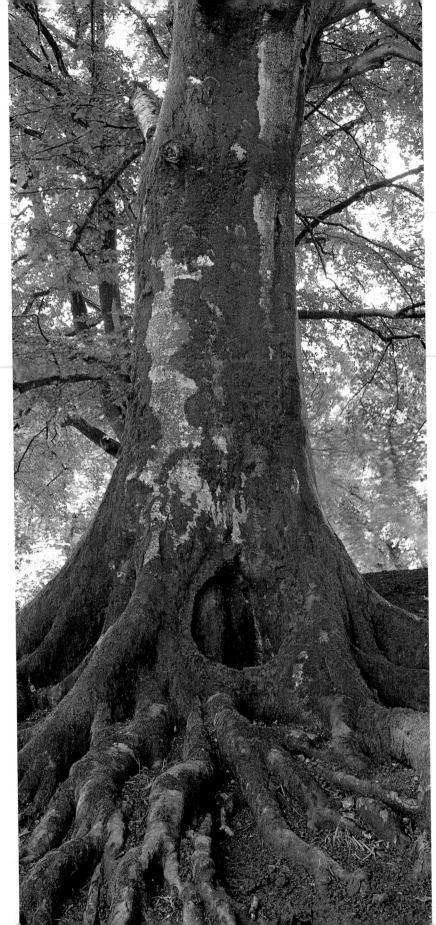

Wet summer
ground
churned up
by cows
sheltering
under trees
good,
malleable mud
worked to
moss-covered
edge
enclosing
space at base
of a beech tree
overcast

DRUMLANRIG,
DUMFRIESSHIRE
4 AUGUST 1998

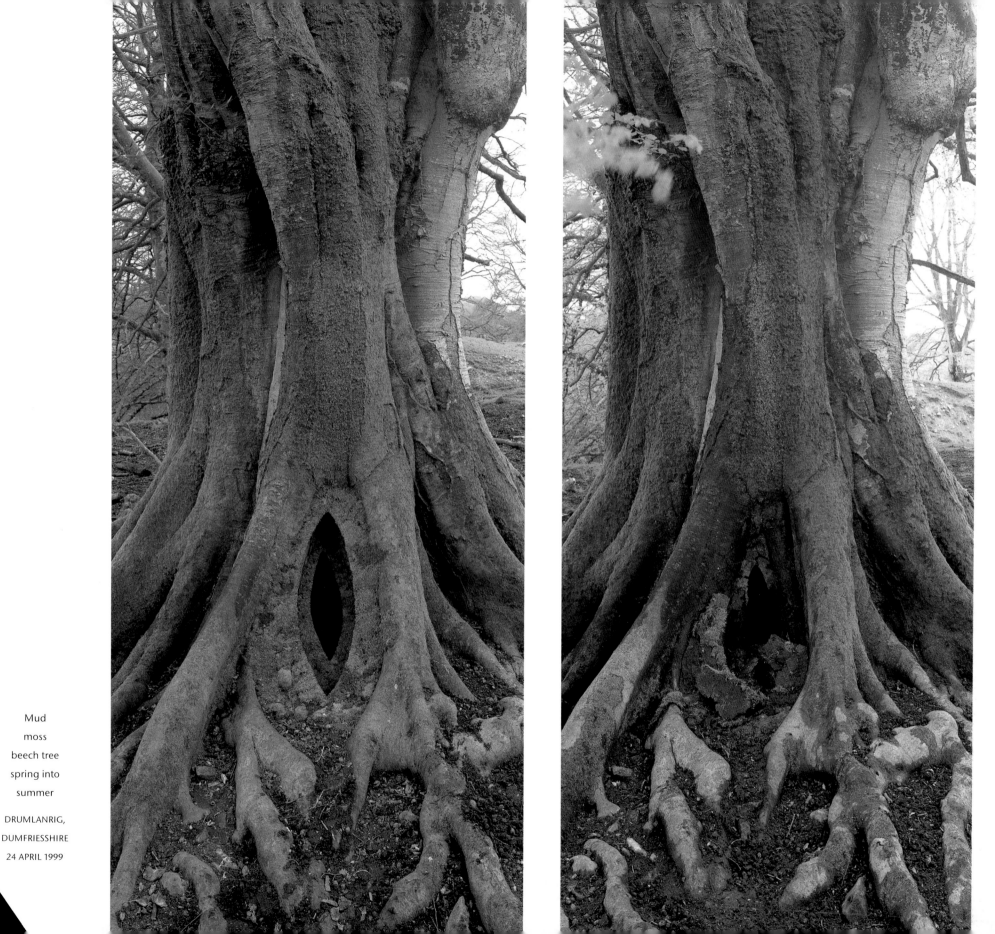

Mud
moss
beech tree
spring into
summer

DRUMLANRIG,
DUMFRIESSHIRE
24 APRIL 1999

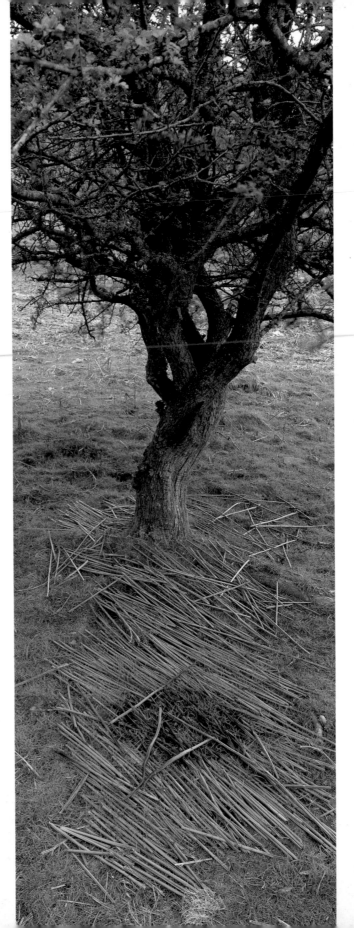

Bracken stalks
black from beneath the ground
laid around a hawthorn tree
raining

SCAUR GLEN, DUMFRIESSHIRE

20 APRIL 1999

Opposite
Chestnut leaves
creased and folded
held with thorns

DRUMLANRIG, DUMFRIESSHIRE

8 NOVEMBER 1998

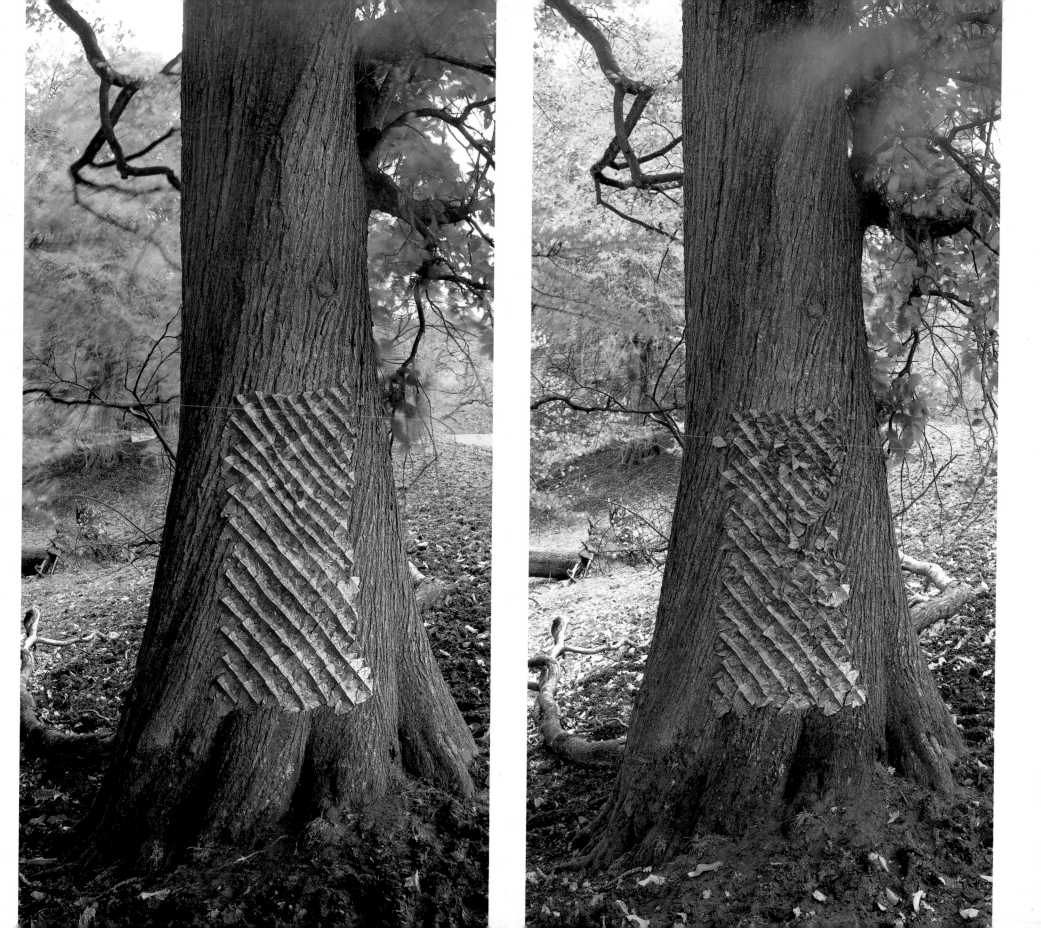

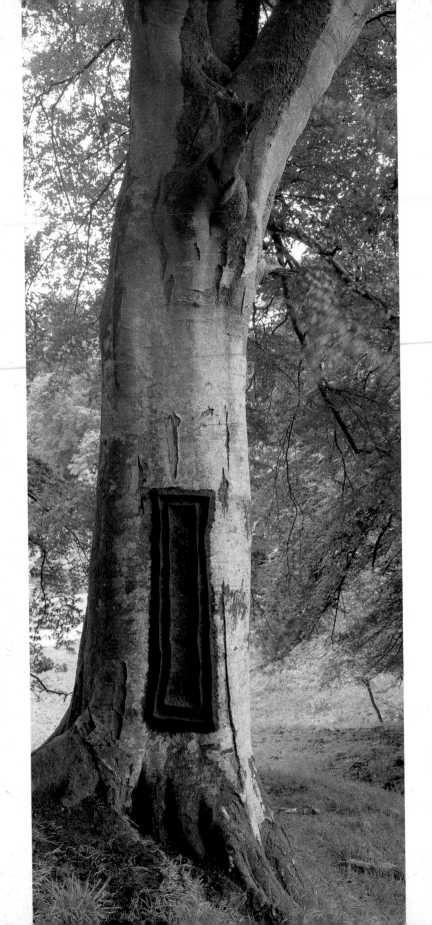
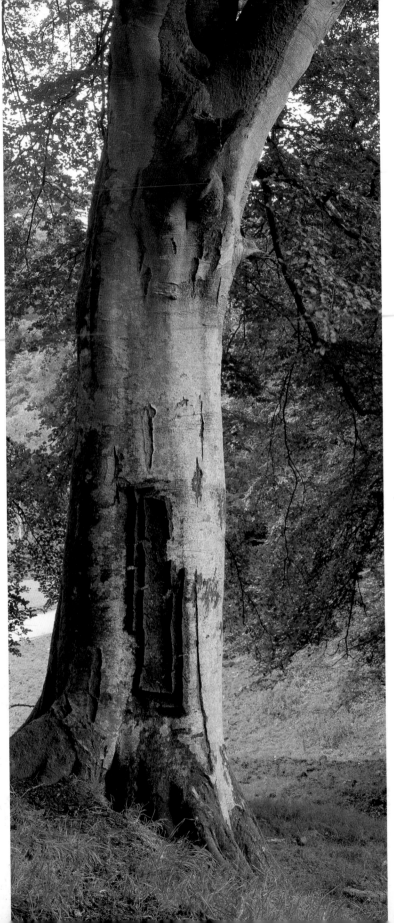

Dark, well composted mud
enriched by the tree
made workable
pressed onto bark
an edge
to cut the overcast light

DRUMLANRIG, DUMFRIESSHIRE

9 AUGUST 1998

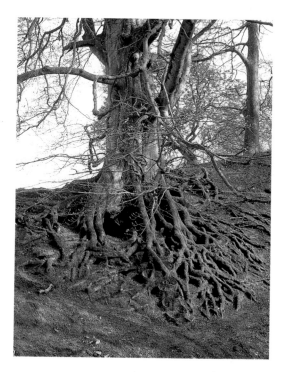

Spring
mud and moss
worked into the roots
of a beech tree
returned in summer

DRUMLANRIG, DUMFRIESSHIRE
25 APRIL 1999

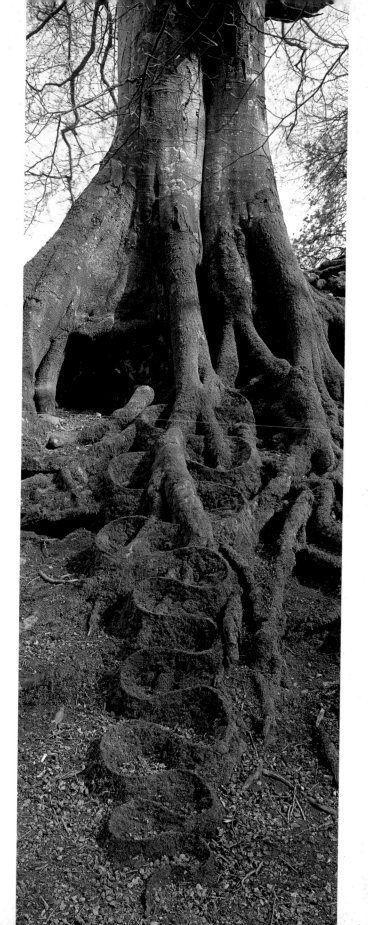

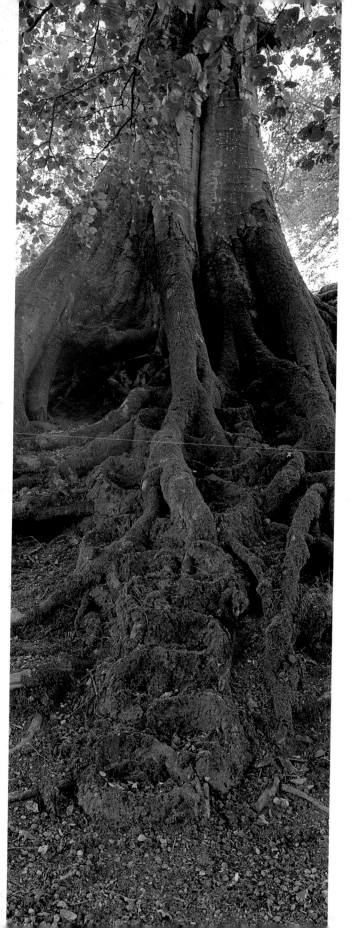

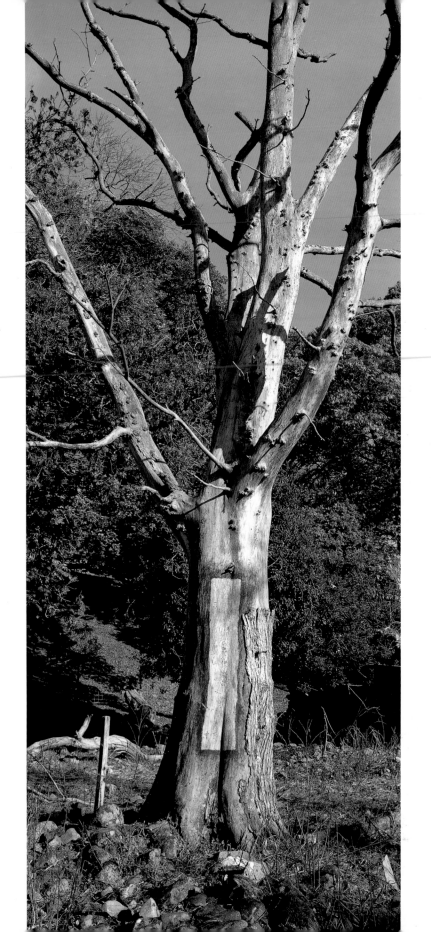
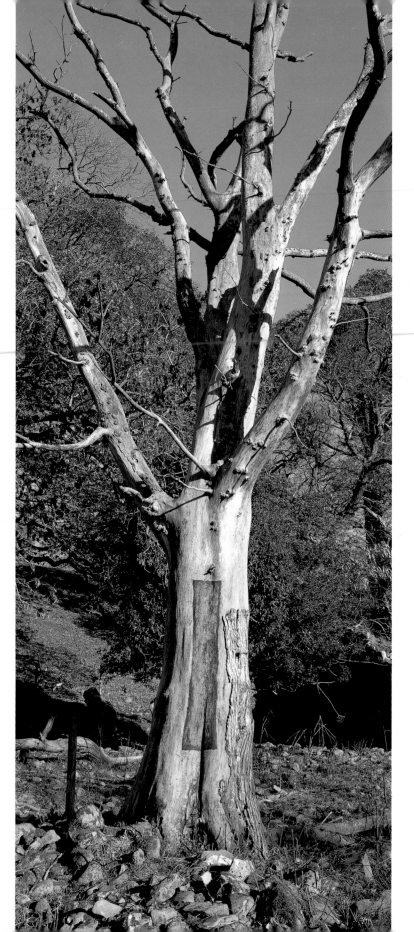

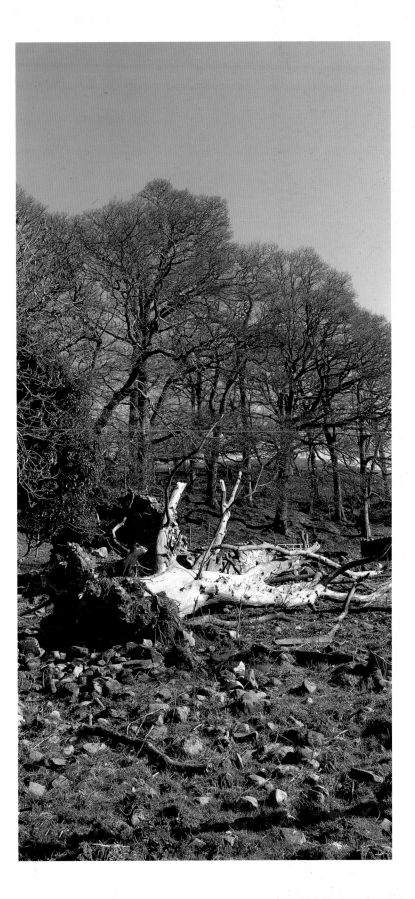

Elderberries
rubbed onto dead elm
tree fell down the following March

SCAUR GLEN, DUMFRIESSHIRE

31 OCTOBER 1998

16 NOVEMBER 1998

Overleaf

Snow
heaped into a line
to thaw slowly

PENPONT, DUMFRIESSHIRE

MARCH 1998

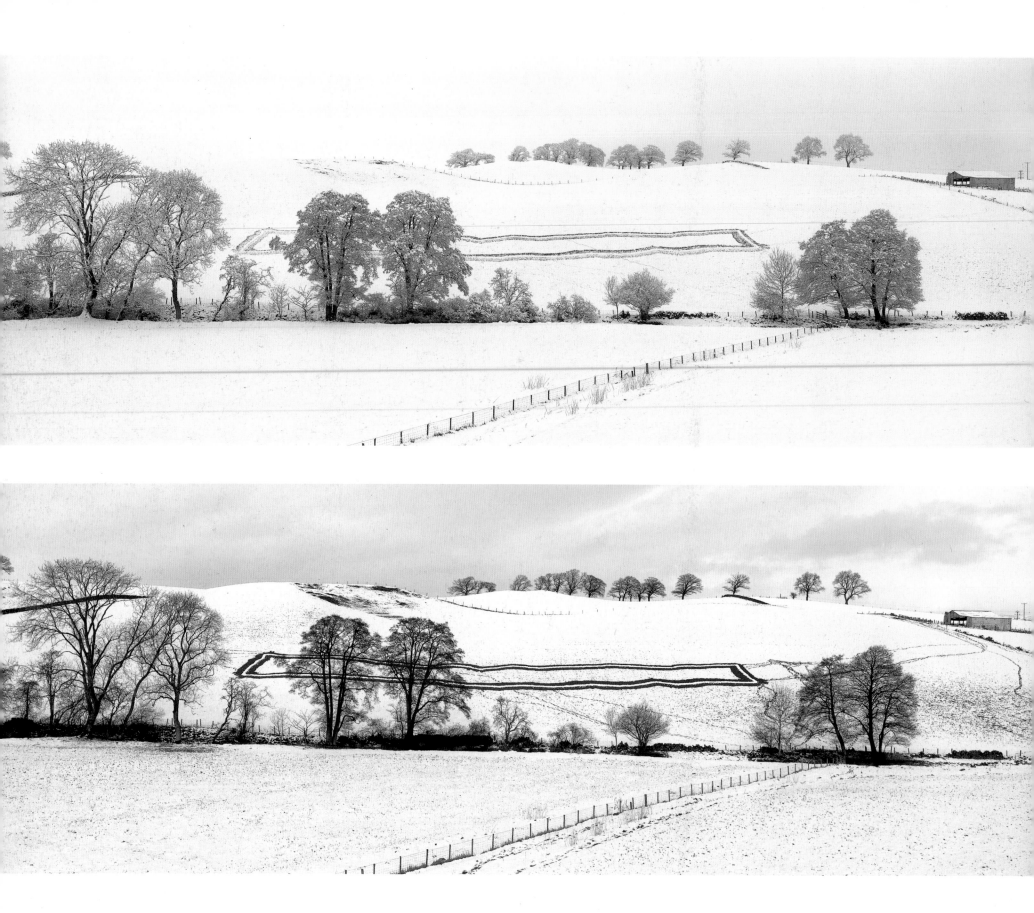

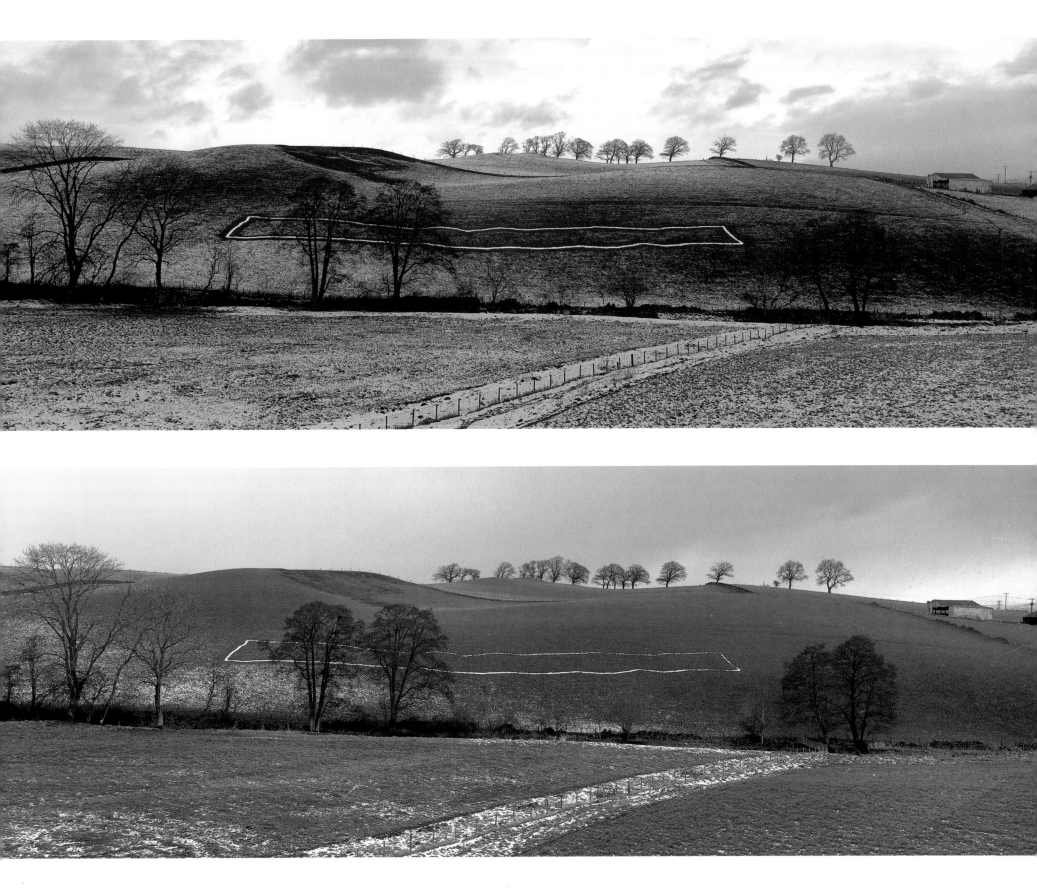

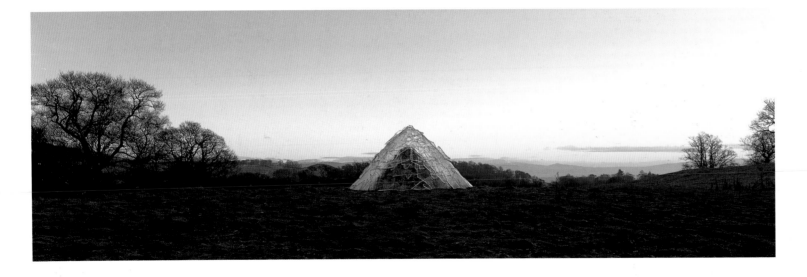

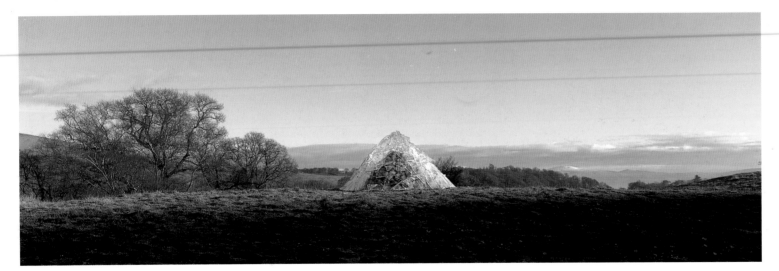

Stone pile
made during the day
enclosed with ice during the night
the first night
only just cold enough
clouds drifting over making it warmer
many collapses
large collapse just before dawn
failed
returned the following night
colder
finished just before dawn
bright sunny morning
soon turning overcast
revisited the cairn over the following days

CAMLING, DUMFRIESSHIRE
23-25 DECEMBER 1996

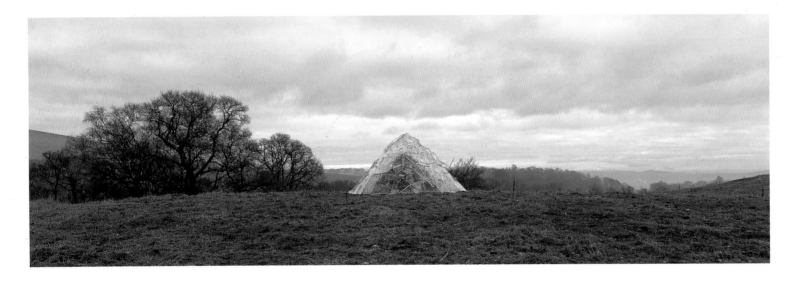

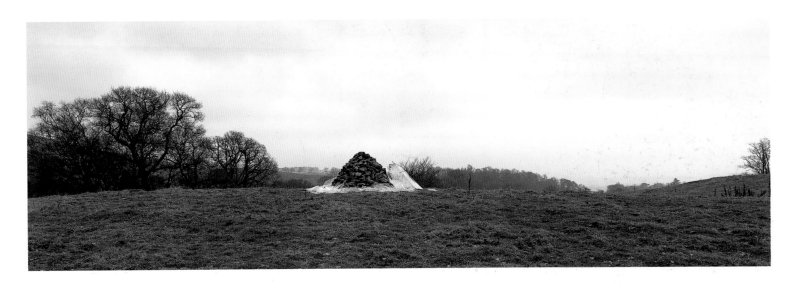

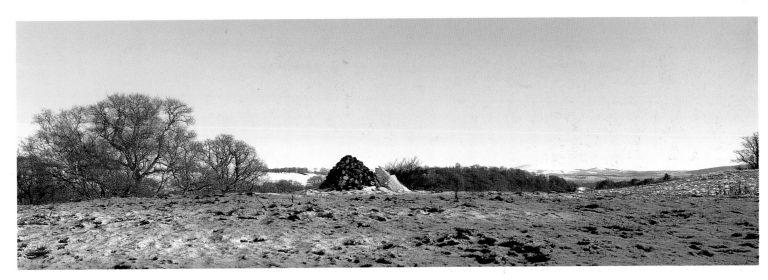

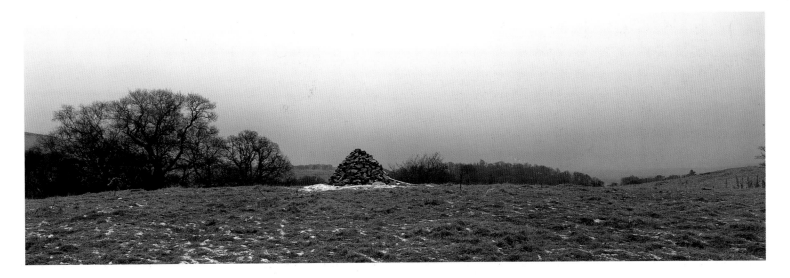

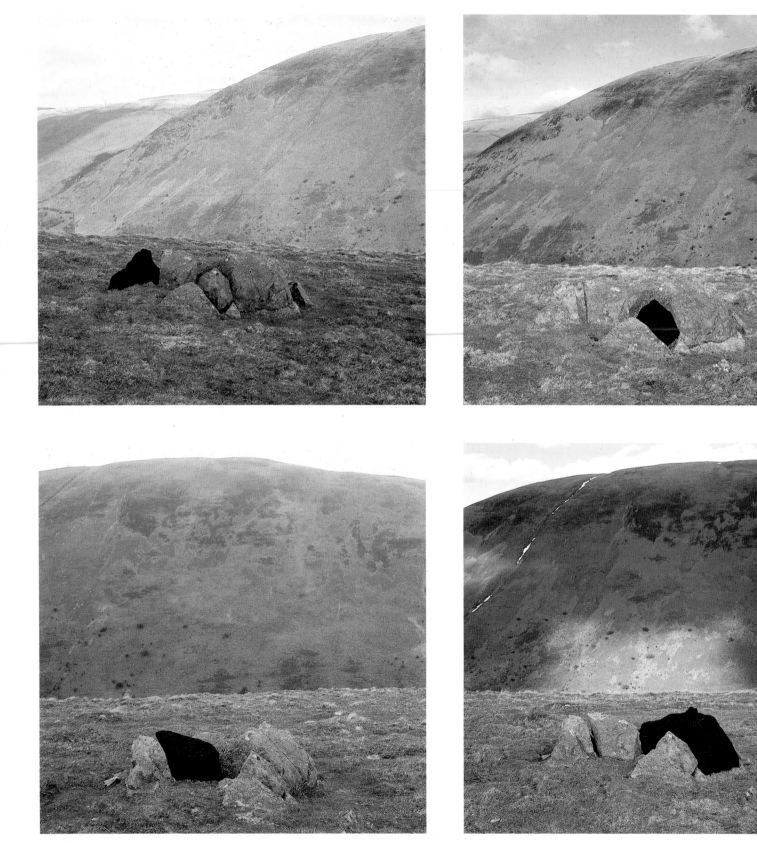

Four peat-covered rocks

SCAUR GLEN, DUMFRIESSHIRE

1994-1997

Four pools
stained with red river stone
waited for river to rise
then fall
the old washed away
before the new was made

SCAUR GLEN, DUMFRIESSHIRE

AUGUST 1997

Stone wood
red stones
ground together in water to make red cloud
a patch of sweet chestnut leaves

PENPONT, DUMFRIESSHIRE

19 JULY 1996

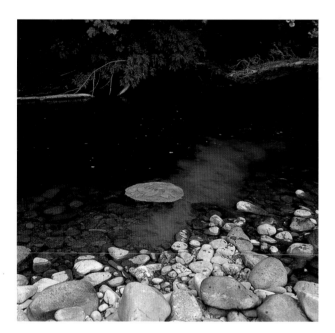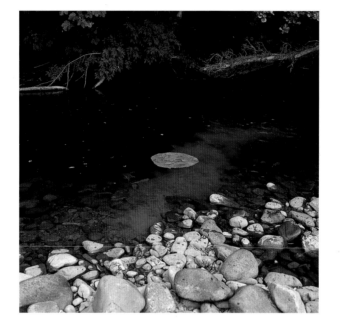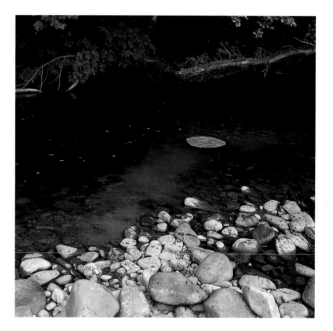

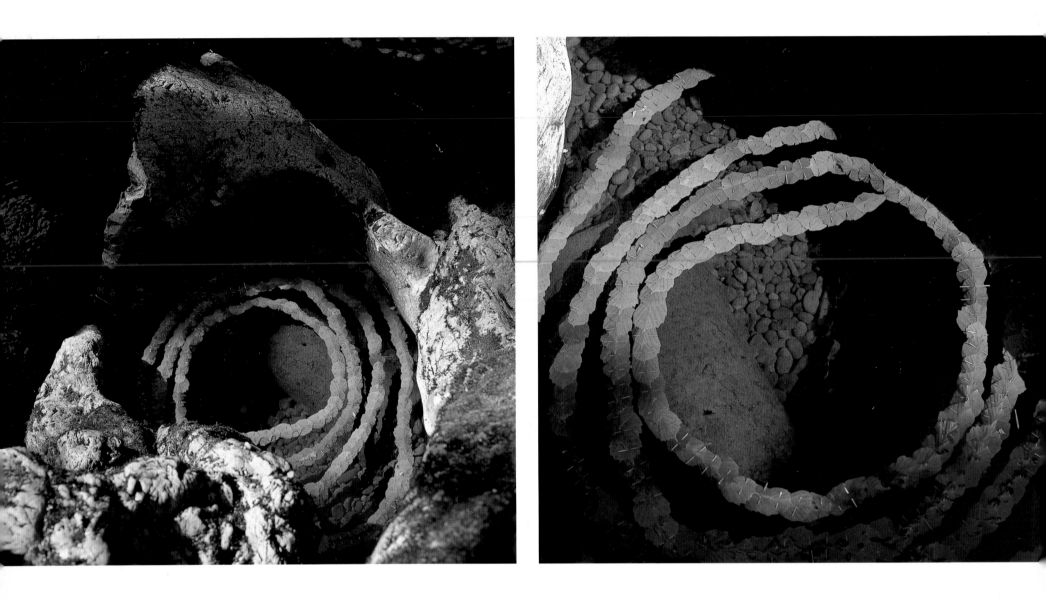

Hazel leaves
each stitched to the next with grass stalks
gently pulled by the river
out of a rock pool
floating downstream
low water

SCAUR WATER, DUMFRIESSHIRE
5 JUNE 1991

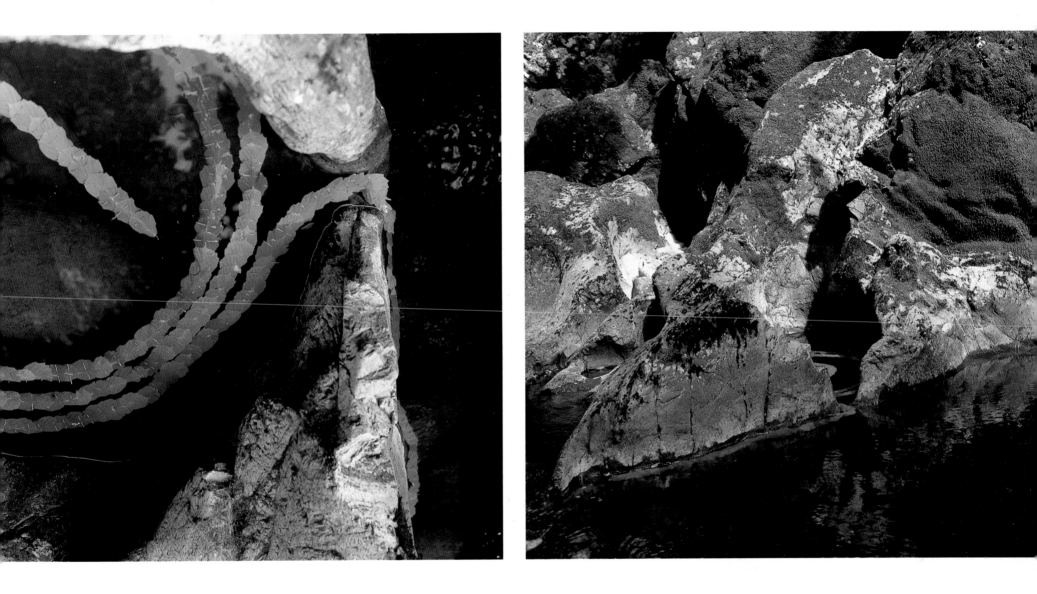

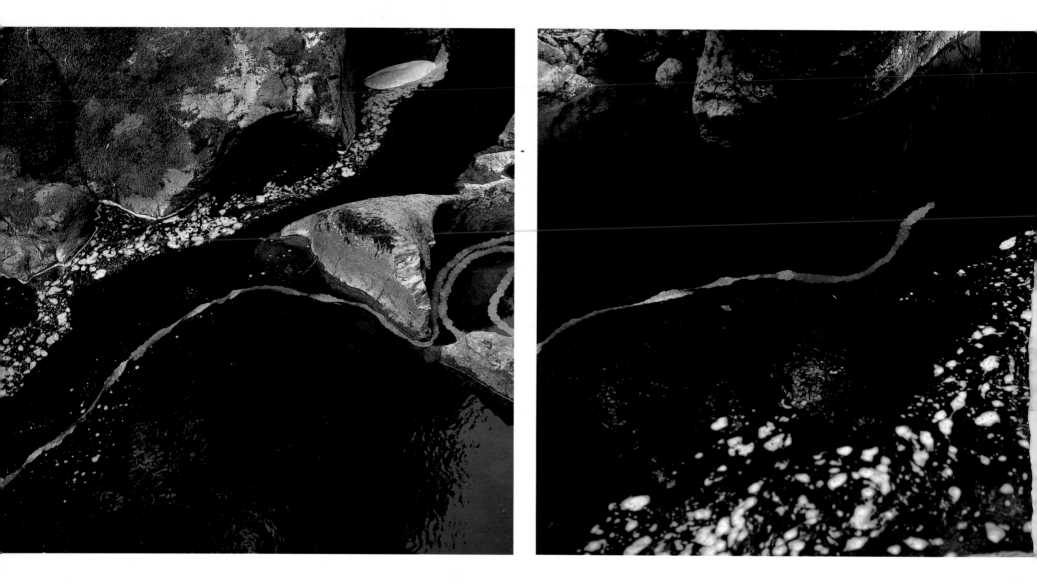

Wet feathers

wrapped around a stone

before the incoming tide

CARRICK BAY, DUMFRIESSHIRE

OCTOBER 1999

 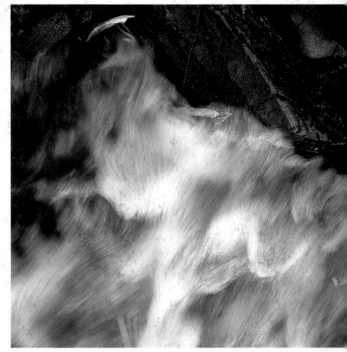

DIARIES

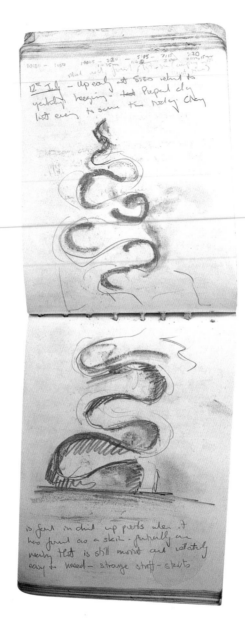

MONTREAL

In September 1996 I travelled to Montreal and was met at the airport by Claude Brault, art consultant for the Cirque du Soleil. On the journey from the airport, Claude mentioned that there were buildings in the city made from a pink stone that originated in Scotland. It had come across to Canada as ballast on ships that returned to Europe with timber.

I asked to be taken to one of the buildings in Montreal that Claude had talked of and there, sure enough, was a building made from red sandstone not just from Scotland but from near where I live. It is difficult to explain the experience of travelling across the Atlantic to be met by my home stone – a powerful moment.

Stone and people making the same journey is for me a powerful expression of movement and of the great upheavals and displacements that have occurred to both.

The arch has recurred in my work for several years. A free-standing arch released from the quarry, unconfined by a building, has for me a sense of energy and movement – 'here stone leapt up from the plain earth'.

My arches are raw, roughly hewn, fresh from the quarry, not yet dressed or tamed. Between a building and its source. The transporting of an arch gives it a new and even more vigorous sense of life and movement.

I proposed to take to Montreal an arch from Locharbriggs Quarry in Dumfriesshire of a scale that would reflect the monumental journeys and social upheavals that drove people to leave their homeland and emigrate.

The arch is heavy and strong, expressing permanence, but it is in fact about change, movement and journey.

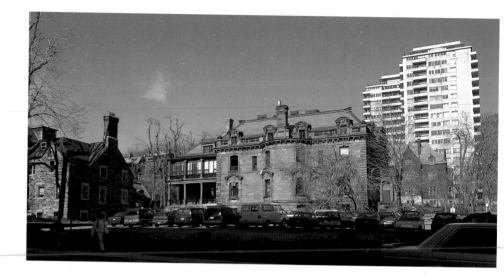

Early 20th-century house in upper Drummond Street, Montreal, built from Dumfriesshire red sandstone, now part of McGill University.

Locharbriggs Quarry, Dumfriesshire *Thursday, 27 November 1997*

The foundations are laid.

After a year or so of talking, we finally began looking for base stones – the largest that will be in the arch. It was a dark, grey morning, just turning light as I got to the quarry. Eric Sawden, the quarry manager, looked tired. The atmosphere was bad and uncertain. The stones were more difficult to find than anticipated and it was decided to blast new stone from the quarry face. As the morning progressed it became brighter and warmer. Eric began to work with more vigour, and some potential stones were found but none were put in place. I will return tomorrow when the base stones have been extracted and, maybe, placed at either side of the arch.

This is going to be a difficult piece. What until today has been just an idea now has to find form. I feel unsure, but hope that the energy released by the idea will guide me – I do not want to have too much control at this stage.

I am dependent on so many external factors – the engineer, quarry workers, stone, etc. But it is the stone that will determine the character of the arch. The unknowns can be worked through only in the making of the arch and, although this is unnerving now, it will ultimately give life to the work.

Friday, 28 November

Returned to the quarry. Hoped to see the base stones in place, but there were problems in extracting the blocks, and the stones we selected yesterday remain in the quarry face. I am worried that although they are large, the stones we have chosen do not give the surface area of 1.8 square metres that we need. I am beginning to think that we are working beyond the capabilities of the machinery. We may have to reduce the size of the arch to a proportion that can be more easily handled – we will see. Looked around for better stones. As I left, George Rennie, the assistant quarry manager, began to clear and drill the face ready for blasting. I telephoned later, but apparently the drill had broken down and the stone had still not been extracted.

Thursday, 4 December

It has taken this long for me to return because of the problems that the quarry has been experiencing with machinery. The mood there is much better, although I was disappointed that there were still no stones on the foundations. Suitable base stones have (I hope) been found. One – of about 12 tons – is next to the big crane and will need the crane to lift it.

I have to go to France for a few days and will return to the quarry next week.

Wednesday, 11 February 1998

Back in the quarry after a long break because the large crane had to be serviced, repaired and passed by safty inspectors. The quarry closed over the Christmas break, after which I was in America for a while, returning yesterday.

It rained heavily. There is one stone in place – 1.5 metres square, not the 1.8 metres that we need to achieve the size of arch we are aiming for. It seems impossible for bigger stones to be found. The machines have difficulty in lifting them without breaking bits off and making the stones smaller in the process. We do not have the necessary control. I will reduce the arch to a size that the machinery can manage with reasonable ease, with base stones about 1.5 metres across.

Locharbriggs
Quarry,
Dumfriesshire

28 NOVEMBER
1997

4 DECEMBER
1997

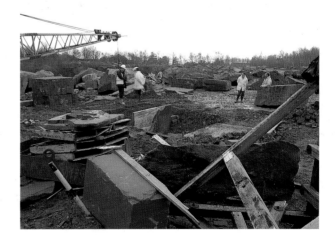

11 FEBRUARY
1998

Thursday, 12 February

There is a sense of relief at the quarry that the arch will be smaller. George and the shot firer and crane operator, Brian Nish, who are working on the arch, have been struggling. The difficulties have burdened the project.

Although a hard decision to make, I can now see that there wasn't any choice. We now have the ability to realise the arch but still don't know what quality it will take on. To some extent it will make itself. I quite like the drill marks, which I can leave or cut out. They are evidence of extraction, but could prove visually intrusive.

It was a beautiful, overcast, warm winter's day – no rain.

The base stones were put in place – beginning the arch on one side. Finally it feels as if things are moving. What a relief! I hardly dare say this in case something else goes wrong.

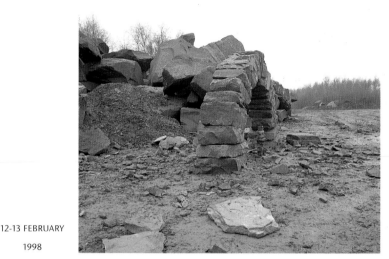

12-13 FEBRUARY
1998

Friday, 13 February

Over the last two days I have made a small arch to be exhibited at Montreal. This has kept me out of the way of the quarry workers who need time by themselves to get a feel for the large arch and its construction. I need to see what is going on. Making another sculpture in the quarry allows me to be involved but at a distance. It's also a way to explain what I want. There is a confidence that was absent in the earlier stages of the project.

The two stones that were placed yesterday have been taken away to be cut with a saw to achieve good contact between stones. Until now we had anticipated hand working each surface. But I want to have the strongest possible arch and if this is achieved by saw rather than chisel, then so be it.

The way each stone sits in the arch is determined by the way they sat as bedrock.

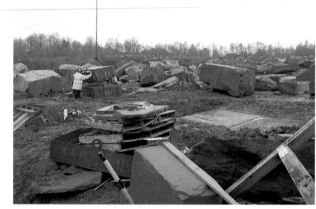

12-13 FEBRUARY
1998

Tuesday, 17 February

There are now two stones on each base. I can see the arch taking shape. Although I have anxieties I cannot help but feel a sense of excitement about what kind of arch will emerge. Work is going smoothly.

The weather has remained kind and unusually warm for this time of year. The bluebells are beginning to show, and the catkins are on the hazel trees. There is a feeling of early spring. The days are getting longer. All these things give a sense of optimism that was absent in the quarry before Christmas, when it was cold, dark and wet. I know the weather will not remain like this, but this dry spell has come at a good time. It gives a calmness to the process – time to think and consider.

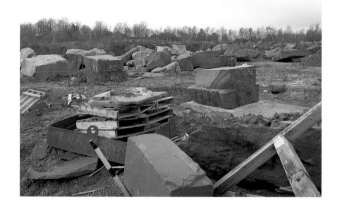

17 FEBRUARY
1998

Thursday, 19 February

There are now three stones on each side of the arch, one of the stones will have to come off as it is slightly undersized. I am pleased to see that one of the previous stones which had a flaw has also been replaced.

The scaffolding has not arrived, but hopefully this will come on Monday.

There has been such a difference since we reduced the size. The stones are large but now feel managable after the struggles with the even bigger blocks before. The balance between the material and ability to realise the idea has been found.

19 FEBRUARY
1998

Monday, 23 February

The scaffolding is finally up. It looks strong and will do the job, but it is difficult to believe that it has cost as much as it has. At least it gives an idea of the volume of space underneath the arch. It is going to be much taller than the arch in my mind, which is a good thing. The base stones now look less bulky when I envisage the completed arch.

One side of the arch is now completed to three stones high. The other side has to be taken down again and reworked. This is all part of the process of getting to know the stones, the arch and the method of construction. Complications may arise when we draw the arch inwards and I have concerns about how the scaffolding can be made to support the vertically placed stones.

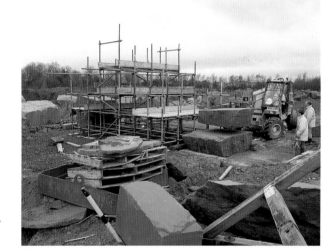

23 FEBRUARY
1998

Wednesday, 25 February

We need something as a guide to show the eventual shape. George is having difficulty knowing where each stone should go and what angle. A small arch can be more easily visualised in its completed state. I have always made the first few stones much wider that the rest to increase stability. Looking upwards at a large arch is very different to looking down at a small arch. I am concerned that the arch will appear thin in relationship to its base. The larger base stones of a small arch are less prominent than in a large arch where the base stones are almost at eye level and seem even more massive by their proximity to the viewer. I contacted Gerry Fitzpatrick, the engineering consultant , and he sees no problem if the top stones are thicker than planned. This should even out the difference between top and base.

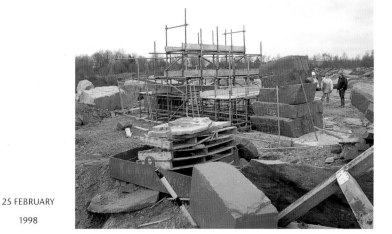

25 FEBRUARY
1998

Tuesday, 3 March

A wooden arc has been made to help us visualise the completed arch. It has also revealed problems in the way the stones are angled.

A stone on one side looks out of proportion and I have asked for its removal. It is always difficult to ask for stones to be redone as I know how much work has gone into their cutting, making and placement.

We are now at the critical point where the arch turns inwards. The scaffolding is proving inadequate and has to be revised. A fence has been put around the construction. It reminds me of a stone Gulliver held down by pins and lines.

The lines of the scaffolding draw and explore the space around the arch – revealing the energy it exerts. I am reminded of a small circular arch supported by hazel sticks that I made many years ago. Nonetheless, I look forward to the day when the supports are removed and the arch released from its binding.

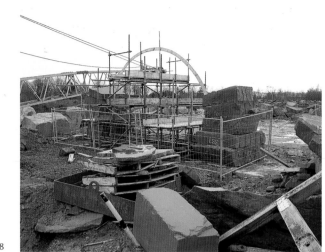

3 MARCH 1998

Thursday, 5 March

The arch is back down to two stones on one side. It is as if it is attempting a difficult leap – stretching out but failing – waiting to regain strength to try again. Eventually the arch will be strong enough to complete the leap, but at the moment failure, trial and error are a necessary part of the making.

I have to go to London tomorrow for a week. I may call in at the quarry on my way south. I hope to be able to resolve any problems so that work can continue whilst I am away.

5 MARCH 1998

Friday, 13 March and Monday, 16 March

There has been good progress. I am concerned that the stones are getting smaller too quickly even though the upper stones are now larger than originally planned. We will take the smaller stones off and use them later on when the arch is higher.

I am becoming more interested in the marks caused by the stones' extraction – especially the drill holes into which explosive charges were inserted; these appear as lines on the outside of the arch. I like the way they follow the curvature of the arch, giving a quality similar to the effect if I were drawing the arch on paper.

A couple of the stones have rather severe saw cuts which I do not like. They feel too manufactured. I will leave the two small holes that are cut into each stone so that it can be lifted by hooks and manoeuvred into place. I like the way these become higher up on each stone as the arch progresses, depending upon what

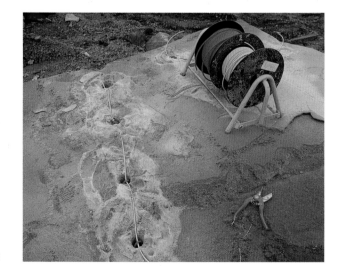

Drill holes

angle a stone needs to be suspended at as it is being offered to the arch. All marks can be cut away as well as any structurally unnecessary stone that protrudes too much. I will wait until the arch is complete before making decisions.

The arch is gaining in presence as it rises above the quarry. Communication between myself, George and Eric is becoming clearer now that we understand better what kind of arch we are trying to achieve. I am anxious about the support. I have difficulty understanding how it will work, especially when we try to reproduce exactly the same shape in Montreal.

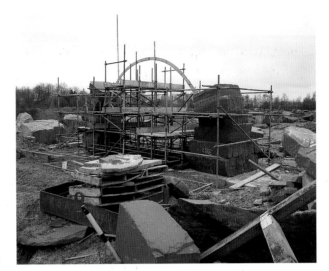

16 MARCH 1998

Friday, 20 March

The hooks used to lift the stones seem to work effectively – although a huge stone gripped between two small claws seems precarious.

Yesterday I was in Edinburgh organising work for the Museum of Scotland, so I arrived at the quarry today knowing that several stones would have been put on in my absence and was somewhat anxious. I can see, however, that George and Brian understand the needs of the arch and are working well.

It is extraordinary to see a form become so large that until now I have always made small. It is as if I have shrunk. The upper stones are thinner than I had anticipated. I am delighted with this. They give the arch movement. Thicker stones seem difficult to find: it all depends upon the depth of the beds being quarried.

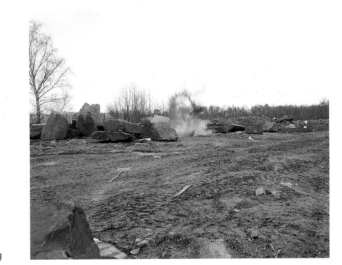

Blasting

It is a very large arch. I cannot imagine making it the size we had originally intended. This is big enough! The scale is both challenging and threatening. The tension I felt at the start of this project has returned – a fear that I may have taken on something too large. I keep thinking of the tests the arch will be put through before going to Montreal.

The engineers who worked on the specifications for the arch could not say whether the arch would be able to meet the stringent earthquake building codes that apply in Montreal. On its completion the arch will be load tested. Its construction is an act of faith – an expression of our belief that it will be strong enough.

We tried chiselling away some excess stone. The resulting marks have confirmed my feeling that the raw, extracted stone with its drilled and cleaved sides is the more honest and effective surface – telling the story of the arch. The chiselling seems decorative and unnecessary.

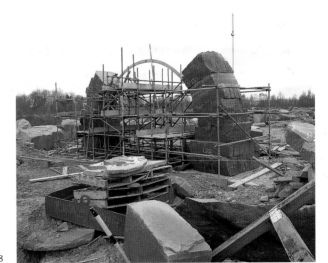

20 MARCH 1998

Saturday, 28 March

After being away for a week I felt excited but nervous about how the arch would appear. It has taken so long to make it that I am now having to work around other commitments, which has meant leaving the arch in the hands of the quarry more than I would like. But seeing it today has reassured me. My wife Judith says you can definitely tell that it is one of my arches. The many smaller arches I have made in the quarry act as a guide, but the stone is the real director of the arch.

The arch looks visually strong at the apex and does not taper excessively. It takes a good, strong stride. There are only three or four stones to come – most crucially the keystone. This is an important stone, not because it is the key to the arch, but because I do not want it to become too prominent. The arch should feel as if it starts at one side and strides to the other in a single step.

We are nearing completion. I really believe the next two days will see the arch finished.

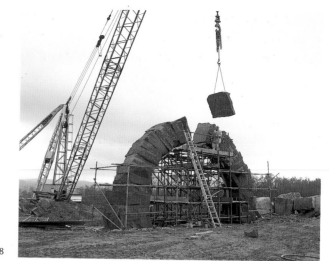

28 MARCH 1998

Tuesday, 31 March

I arrived at the quarry to find the arch complete. The men had worked late to get the last stone in place. I have been impressed by the commitment they have given to the arch.

It has an incredible presence from a distance as it rises above the piles of stone debris littering the quarry. I now have to get to know the arch, some elements of which I did not anticipate. It feels well balanced and there is a good sense of movement. The first few stones on either side were stacked vertically before turning in to form the arch – this gives height and makes the arch stand more upright than it would have done as half a circle.

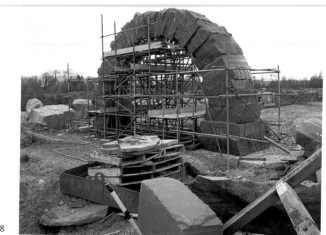

31 MARCH 1998

The arch had to be large. The stuggle of working on this scale becomes part of the work. In Montreal the sheer size will provoke questions about how it was made, where it came from and how it got there. The journey of its making and the journey to Montreal are integral parts of the sculpture.

Thursday, 23 April

Today the arch was tested. Wire cables were attached to it and it was put under tension via a pulley and winch to measure the load being applied. Inevitably there was a sense of apprehension. This was a big moment. I didn't know whether to stand watching the arch or looking at the pulley to see how much load was being applied. It looked great as the wire ropes became taut.

It survived without any problem, much to everybody's relief and delight. It was a great triumph for the arch and for the people at the quarry. Its making has spanned a very traumatic period there, with a take-over by another company and several employees, including Eric, being made redundant. I am hopeful that Eric will be re-employed. He is a good man.

When the arch was being tested and put under strain, part of me was curious to see how much it could take. It felt close to my ephemeral work which is so often taken to the edge of collapse. My larger permanent works are taking on qualities and tensions that were previously present only in the ephemeral works. When compared to the Grizedale sculptures that were pinned together with metal rods, the arch has much more structural integrity and thereby, I hope, a stronger scuptural presence.

23 APRIL 1998

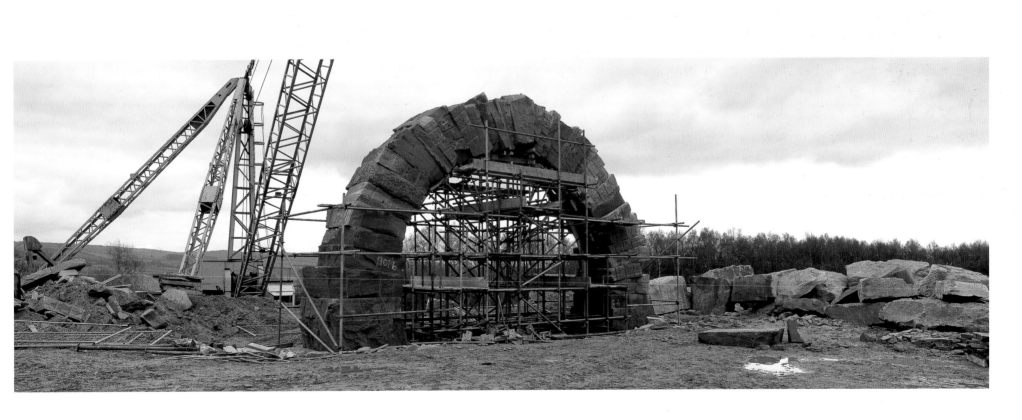

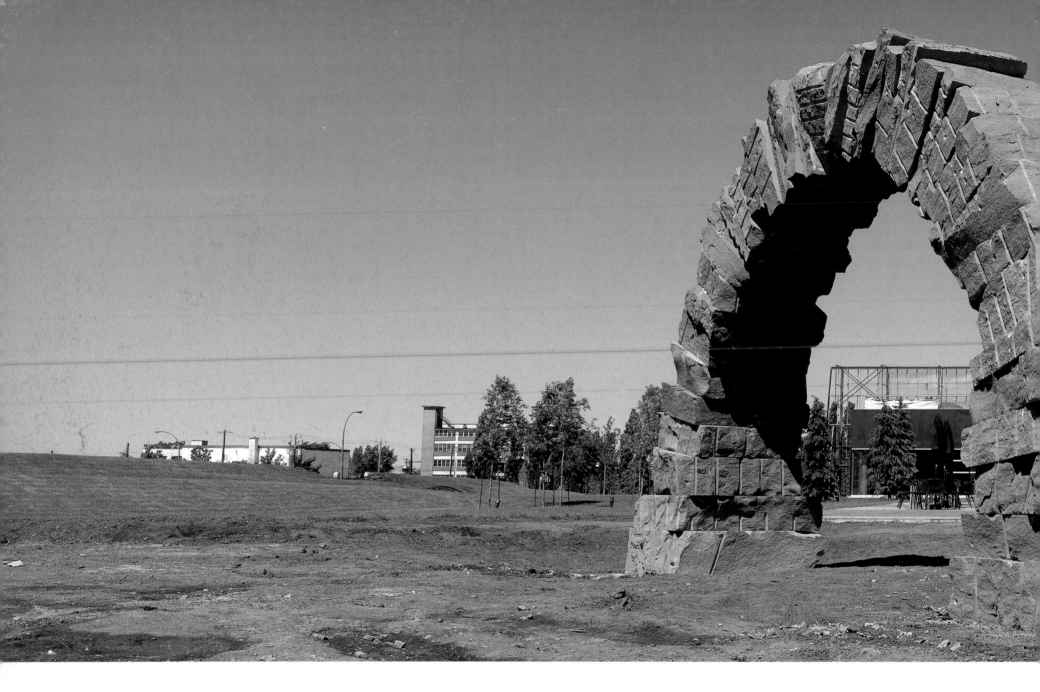

Thursday, 28 May, Montreal

The arch is now in Montreal. It was taken down at Locharbriggs and shipped over here a couple of weeks ago. Gordon Grant (general manager of the quarry), Eric and George came ahead of me and began reconstructing the arch on Monday. It is now Thursday. It was with a great sense of joy that I found that the arch completed. I had not expected the work to progress so quickly. Claude Brault met me at the airport and I could see that he could hardly contain his excitement. He did not know that I had seen the arch from the 'plane – what a moment that was! The colour, light and form.

It is difficult to know exactly how a sculpture made so far away from a site will work and it was with great anticipation that I went to the Cirque du Soleil headquarters to see the arch. I am very happy with the way it looks. The scale is perfect. Standing underneath it reveals the full impact of the arch. This is a perspective that up till now I have not had – scaffolding has always been in the way. This is the first arch tall enough that I can stand beneath it and look upwards. I can almost hear the clattering of stones as the arch strides above me. The feeling of standing underneath stone supported only by stone vindicates my

insistence that there should be no metal rods or mortar holding the stones together.

It was good to have Gordon, Eric and George in Montreal. They have given tremendous commitment to this work. The arch has all the qualities that I wanted. It has tension, energy and movement. I am very proud of what they have done and that they have become ambassadors for the stone here in Montreal. Someone described their installation of the arch as being almost balletic, it appeared so easy.

It is my arch, but it is also Eric's, and I am sure in Montreal it has been called Claude's arch. For all those people who have been closely involved with its making, it has become their arch. I couldn't ask for more.

We had a small opening ceremony attended by people from the Cirque and a champagne bottle was smashed on the sculpture which is unusual but somehow appropriate, as it makes a connection between the arch and the method of its transportation. I liked the idea of 'launching' the arch.

DIGNE

Monday, 6 July 1998

Arrived yesterday to find a very different river to the one I worked with several years ago. The place appears the same, but the river has changed colour and direction, leaving dried-up hollows and channels where it once flowed and formed pools. I don't remember the water ever running clear – at its clearest it's milky, and at its murkiest, thick black. There has been no rain for several weeks.

Made small touches in the river and I feel great potential in them. Unfortunately couldn't see them to fruition, because today I start on a permanent work for the Centre at the Réserve Géologique – Five Water Cairns. The stonework for the cairns will be done by three wallers from Britain. Water from a nearby stream will be diverted through the cairns.

I hope it remains sunny, so that I can continue the work in the river, which needs to be done under a clear sky.

Tuesday, 7 July

Unable to finish the work begun yesterday. Woke up last night thinking my son Jamie was shining a torch in my face, but it was the most intensely bright lightning I have ever seen. Heavy rain.

Last time I was here when this happened, the river ran black with mud the following day. Yesterday was so clear with a strong light – no suggestion of an oncoming storm. It didn't become heavy or humid, the opposite in fact. By this morning, the rain had stopped, the sky, although cloudless, was slightly hazy and the light less intense. Strangely, the atmosphere today was more storm-like.

The river had not risen, but the weather had changed and clouds gathered. The work needed bright sunlight and a clear sky to reflect blue on to the river. Clouds made the river grey, obscuring the riverbed and reducing the colour of the stones I was trying to work with. Grey stones disappeared completely.

As the morning progressed, the clouds thickened and although I finished the work, I had lost it. Thunderstorms seemed imminent, and I lifted the stones to a safer place so I could remake the work if the right conditions returned. It is a pity. I have a glimpse of something that I would like to see more clearly.

Saw a pale, brown-green snake swimming out of the pebbles into pools and under a rock. What movement! Most of the rain fell in another valley, and the river where I am working remained clear. The river Bléone that joins the Bès not far downstream looked as if it had turned to chocolate.

I went to the Centre Géologique to see how the wallers were progressing.

In the late afternoon thunderstorms came once again, but did not last long. It is difficult to judge. A slight thunderstorm here can be a huge downpour a mile or so away. We will see tomorrow. Clear tonight. Full moon.

Wednesday, 8 July

A brilliant, sunny day. River low and clear. Finally able to continue working on a line to follow the colour changes in stones. I have made this work before, but never in water. It is probably no coincidence that the work at the Centre also uses stone and water, but it is only now that I can make such connections.

Thursday, 9 July

Finished the colour change line. It has taken several days to find all the stones. It is a great place for a coloured line. The predominantly grey beaches make it difficult to believe these stones are from here.

Returned to the river in the afternoon.

Worked the sun, river and yellow stones. Tried stones at various depths. The deeper the stone, the less vibrant the colour; too shallow and the stones are too evident. I wanted pure liquid colour.

Worked in a fast-flowing riffle that distorted the stones and visually welded one to another. Tried lines, but individual stones too strong. Grouped stones together in a patch. Better when one patch was made in the wake of another.

Tried a black patch of stones next to the yellow. The stones are flatter and lie more easily. The dark spaces, which had interfered between yellow stones, actually intensified and helped the black. The black merged with the dark spaces making the patch more unified and shadow-like, more abstract – the stones' energy released and made fluid.

Placed the black upstream of the yellow so that its flow distorted the yellow. The black was still much stronger. The yellow needed the black more than the black needed the yellow. The black became a shadow to the yellow. Took the yellow away, leaving the black on its own.

Remade the black in another place – the move from one place to another was interesting. Perhaps I will come back tomorrow and make a series: a dark stone shadow travelling downstream.

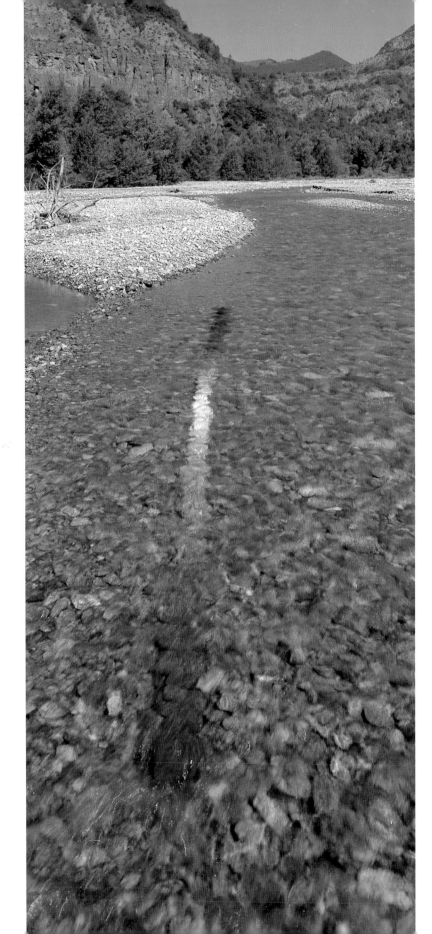

Clear water

sunny

line to follow colour in stone

DIGNE-LES-BAINS, HAUTE PROVENCE, FRANCE

8 JULY 1998

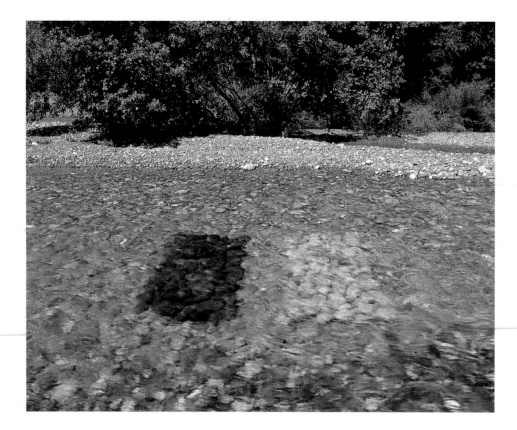
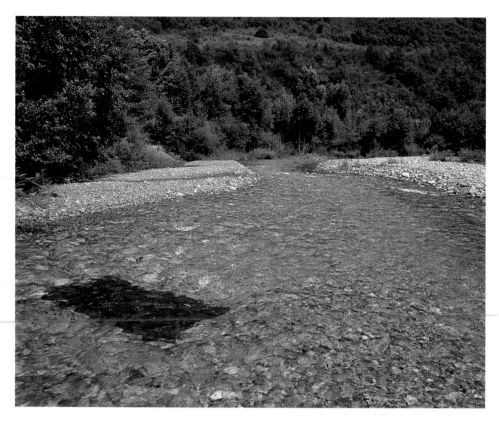

Dark stone patch
lifted and remade five times
moving downstream

11 JULY 1998

Friday, 10 July

Waited most of the day until 3pm before beginning work. Wanted to work with the light on the river at this particular time of day.

Intended to remake yesterday's work several times, moving it downstream. After I'd completed the first one, the water turned murky. There had been no rain so I thought excavation work or amateur dam builders must be upstream. Went to find out and saw three men energetically building a large pebble dam. I waited, but after a while the right moment for the work had passed. So frustrating. Tomorrow it could rain. There were a few clouds around today.

Saturday, 11 July

Returned to yesterday's work. Sun not so bright, with broken cloud, but the river was clear. Made the black shadow six times. Would have liked to have done perhaps two more, but sun obscured by large bank of clouds. Still, it was enough to give the feeling of movement that I wanted. The black is so liquid. A good work.

I could not have worked like this in Scotland where, even in summer, the river is too cold to sit in for several hours. The Scaur is dark, and it is difficult to see the riverbed, which is furry with growth. Each river has its own character, and there are different ways to understand and work with it.

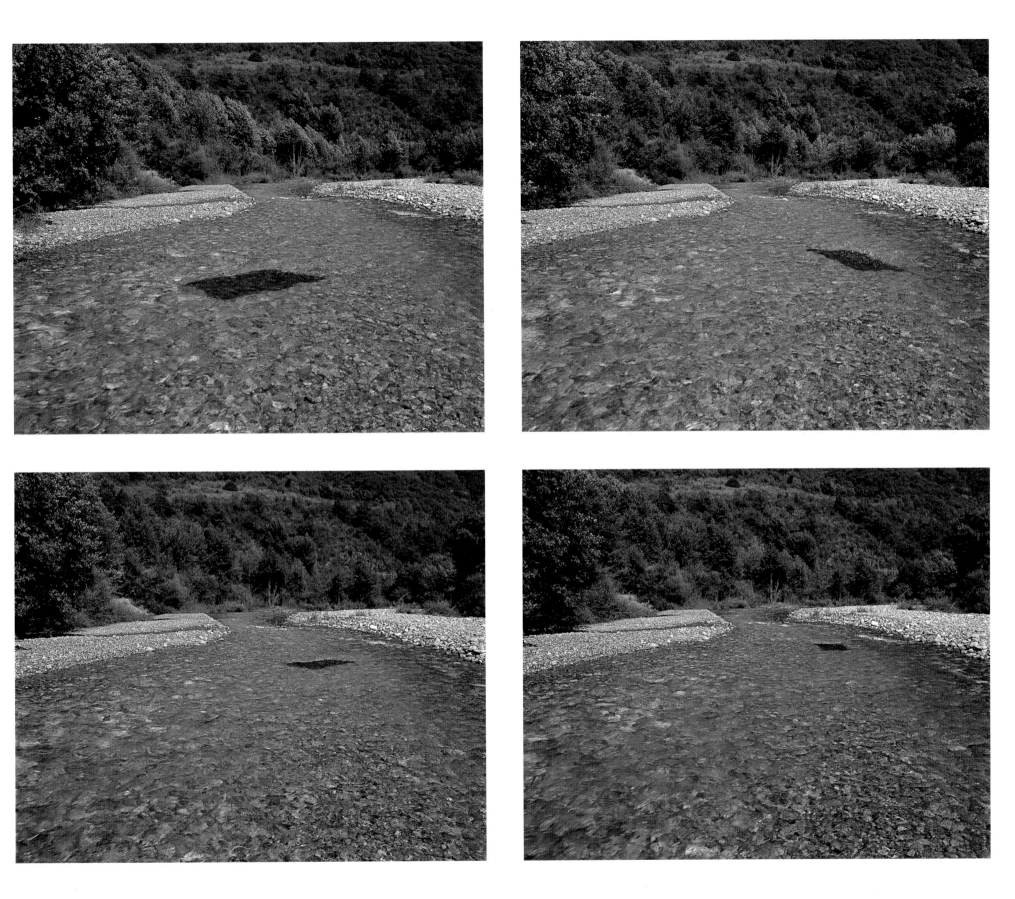

Earlier on in the day I began to work against a vertical rock face that drops into the river. Used nearby clay-mud and made an edged serpentine form stuck to the rock, descending to the water. I have always thought of this form as a river, so it is appropriate to make it next to one.

The sun caught the edges so beautifully that I decided to wait until tomorrow before making the work. I will start work very early in the morning, hoping to finish so that I will see the sun's first touches bring it to life, then watch it dry, crack and change colour.

All the work I have made so far has needed a prolonged time for its making. The weather here is more predictable than in Scotland and allows me to work for more than one day at a time on a piece. This always involves risk, but here there is more chance of success. Most recently my ephemeral work has explored change over extended periods of time. Choosing the right moment to release the work and initiate these changes is critical if the process is to come to fruition.

Sunday, 12 July

Up early at 5.30am. I prepared clay last evening to save time today. Lifted the clay from dried-up pools where it has formed a skin. Fortunately, there is one nearby that is still moist and relatively easy to knead. Strange. Starts quite stiff, then becomes very sloppy as it is worked. Water must be trapped in between the layers of clay. Sloppy clay has little body and is difficult to work, so I laid the wet clay on dry sand, which soon drew out its moisture.

It was cold early on; difficult to stand on the rock face which became more slippery with water and clay as work progressed. I had until 10.30am, when the sun would first reach the work, and managed to finish at 10.

The sun slowly rose above the cliff top to shine directly down upon the work. So beautiful to see the light picking out the rounded edges of the clay. The place and weather are perfect, the light so intense. The cliff is shale, compressed mud, similar to the mud I have worked into it and in an area known for its fossils.

Throughout the day, I returned to the work, to see how it changed, cracked and dried. So hot and windy. The clay dried quickly.

I have gained on this visit a much better understanding of Digne. I previously found the sun difficult to work with and worked early in the morning before it became hot – not to catch the light as I did today, which is a far more appropriate response to a country where the sun shines so often.

Photographed the work every one and a half hours or so during the day, following changes of light, drying and cracking. It has been hot enough to dry out most of the clay in one day.

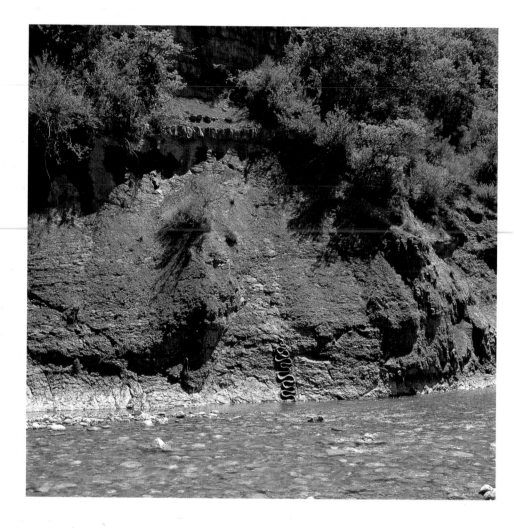

River clay
worked into cliff face
brought to an edge
to catch, cut and turn the light
up early
finished just before the sun touched the clay
hot and windy
clay drying and cracking
fully dry the following day

12 JULY 1998

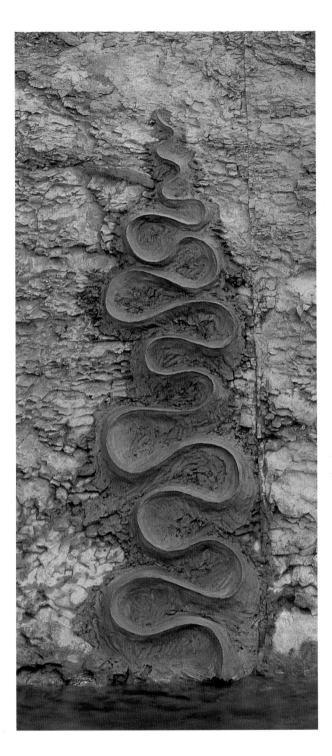
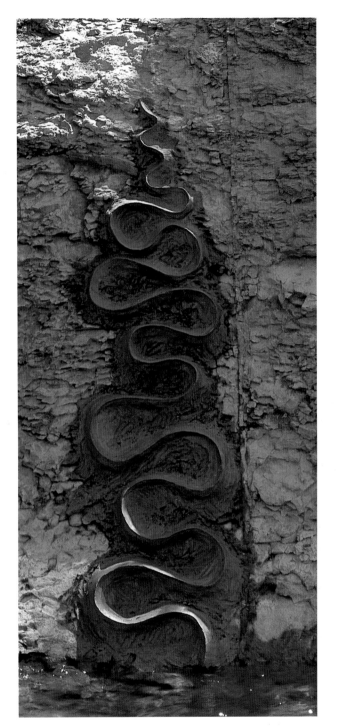
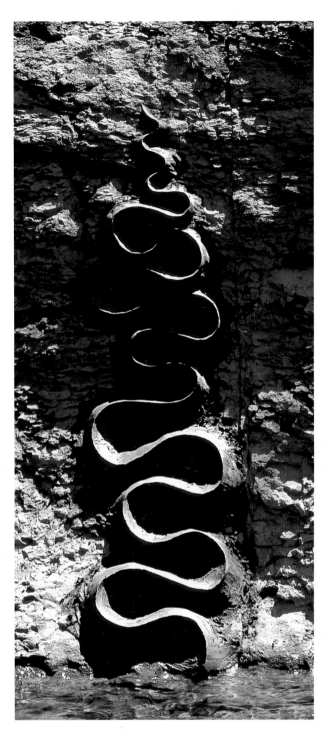

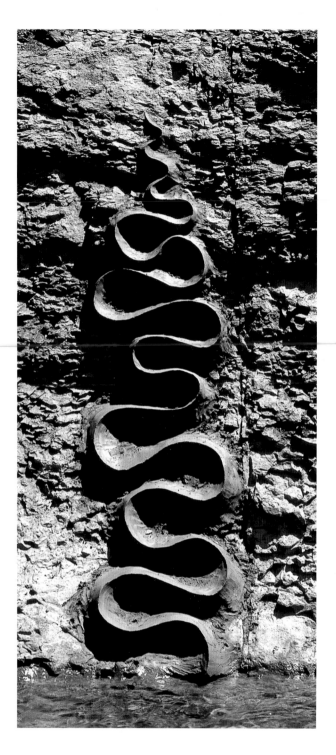
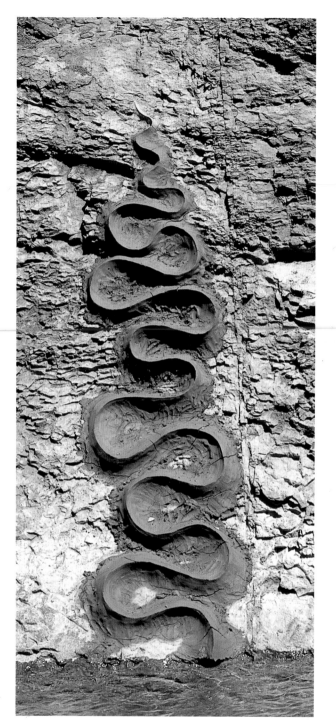
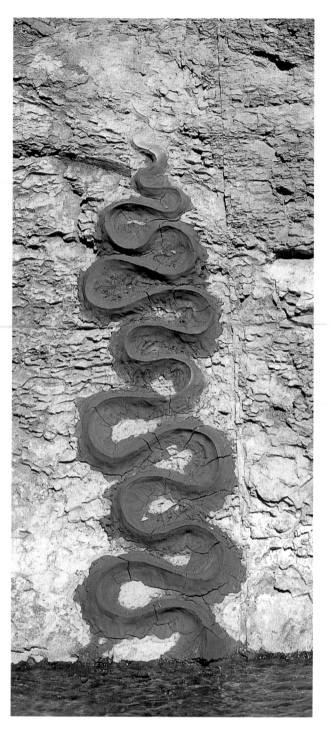

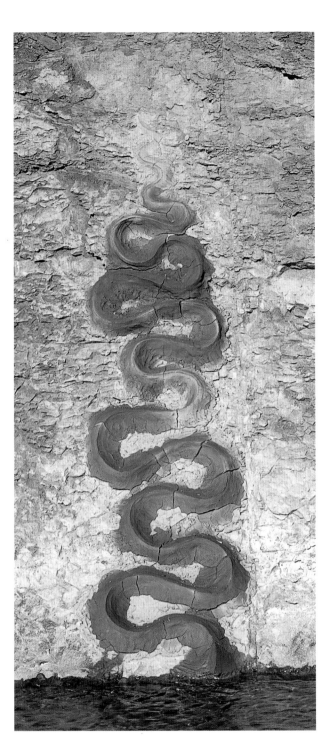
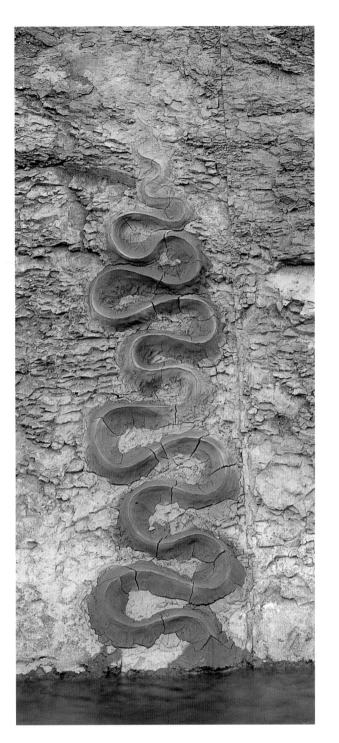
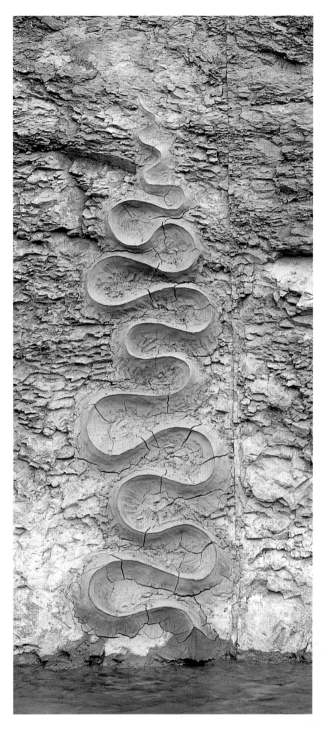

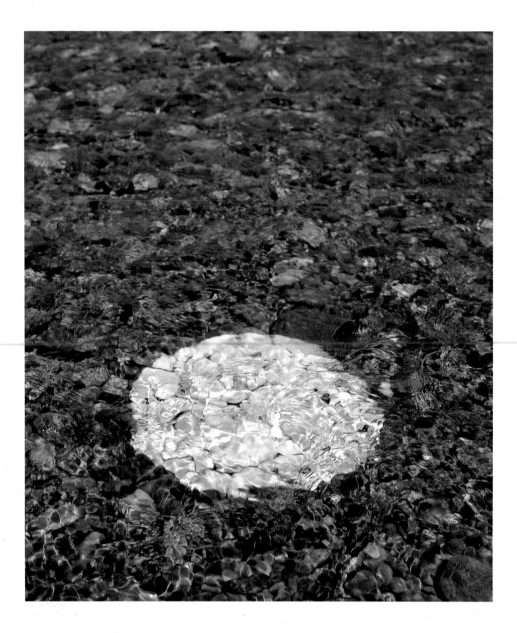

Found part white, part dark pebbles
to make edge of white patch
laid in shallow, rippled water

14 JULY 1998

Opposite
Leaf sheet and shadow
drifting round and round
before floating off downriver

17 JULY 1998

Monday, 13 July

Today the clay dried out completely, apart from the end that touches the river. Much cloudier and, as evening fell, it began to rain. Perfect timing! No new work today. Just watched and photographed yesterday's. I have a strained foot from clinging on to the slippery cliff yesterday. Visited the cairns. It was enough.

Tuesday, 14 July

An old work, I feel old myself today. My foot is still painful, particularly when walking on the pebbles. Collected stones that were half-quartz, half-grey, to form an edge around a patch in the river.

Wednesday, 15 July

Still hobbling around. Went to the Centre to organise the cairns. One of them is unstable and has to be partly taken down. I hate these moments – not just because of the failure, but because I know it upsets the wallers. However that's my job in these situations: to make sure the work is right.

Went to the river and found a good place to make a work with yellow stones. Made part of it and will wait for tomorrow's midday light to complete.

Thursday, 16 July

Continued yesterday's start. Brilliantly sunny at first. Needed the sun to penetrate the deep water and bring the colour out of the stones. As I worked, a massive bank of clouds drifted over and the sun went in. Continued work, although it looked as if the sun had gone for the day. However, an hour later, it returned.

Friday, 17 July

Up early. Collected hazel leaves, picking those of the most vivid green. Went to a river pool found whilst fishing where the water is deep and slow-moving. Within an hour the sun shone on the pool. The sun rises so quickly here.

Stitched the leaves together with grass stalks to make a sheet, then let it float away leaving a shadow on the river bottom. Difficult to make it float where the shadow was strongest. The work was more about the shadow than the leaves. In very deep water the shadow faded, and as the leaves travelled over rocks the shadow became distorted. The leaves slowly floated around the pool. Occasional undercurrents sucked them under the surface, weakening the relationship between leaves and shadow.

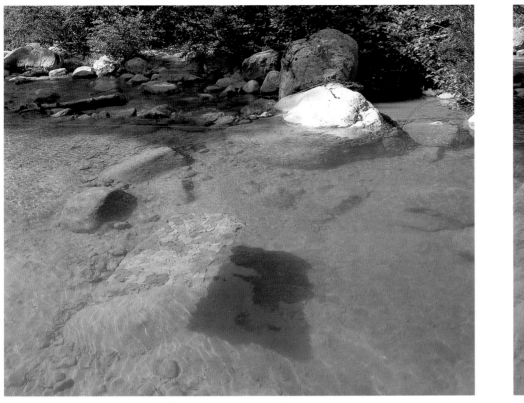
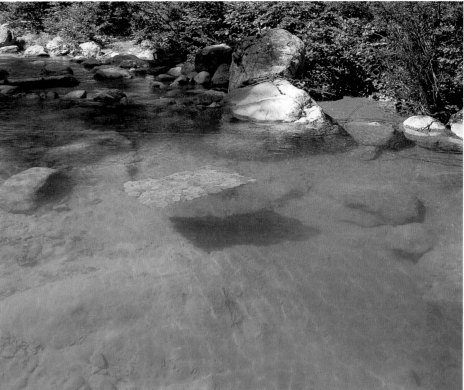
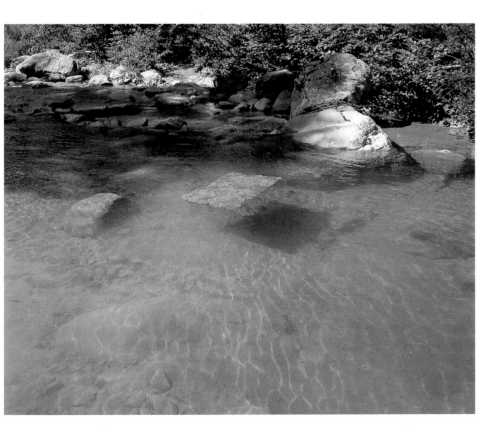
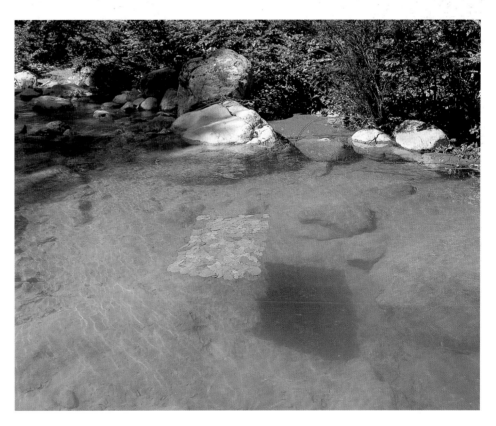

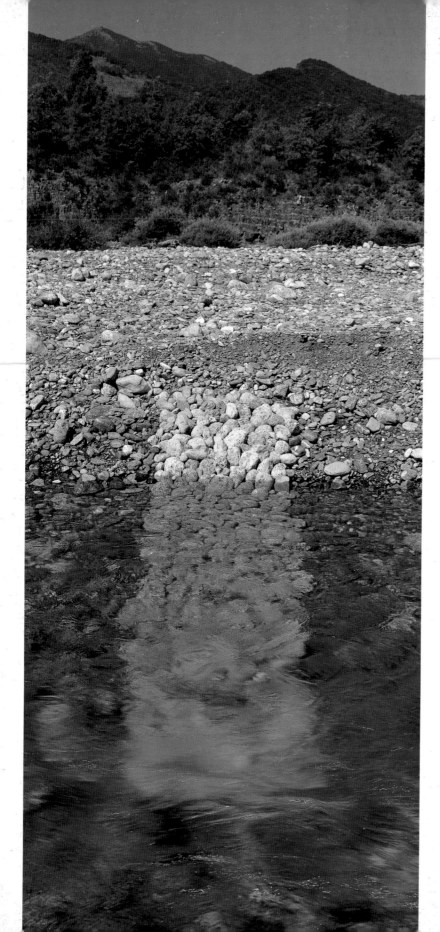

I tried this work several years ago at home on the Scaur, but the river was too dark and it didn't work. Here it was much better. A leaf cloud.

Made two lines, one of leaves and another its shadow. Foot still hurts, even after doing nothing yesterday.

Saturday, 18 July

Went out this morning, but didn't make anything. My foot is better, but I am still cautious when walking. Went back to the house, where there is a large walnut tree. Collected some leaves and attempted to make a work.

Found blackthorns nearby. If possible, I would like to make a leaf horn for the slab of ammonites that the Réserve is so famous for. The problem is that these leaves lose their freshness very quickly. Perhaps I will make it in the early morning. Where to place it in relation to the wall and in what light? The work will be at its best when just finished. Will have to work with that particular time in mind.

Returned to the river in the afternoon. I tried not to – wanted to give my foot a rest – but couldn't resist. I have so enjoyed working during what was, on previous visits, the most difficult part of the day. The early afternoon, when the day is at its hottest, is now the time when I work best. The river, although warm, keeps me cool, and the light at its highest gives a good, strong, flat light for the work that I am making – intense, but without too much shadow.

The Five Water Cairns are complete, placed at intervals along a path from a car park to the Centre.

I do not particularly like sculptural fountains. The stream flowing through the five water cairns is heard, but not seen, until the fifth cairn. By making the water invisible, I hope its flow and movement through stone is more strongly felt. It is like showing heat without flame. The sound becomes a heartbeat within the stone – an expression of the living rock which I hope in the context of the Réserve Géologique takes on a broader connection to the geological movement, flows and energies within the landscape itself.

Yellow stones
laid into deep, fast-flowing water

16 JULY 1998

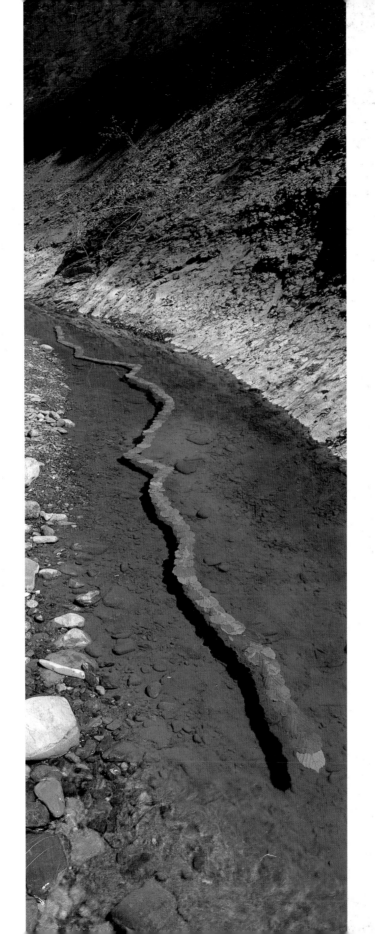

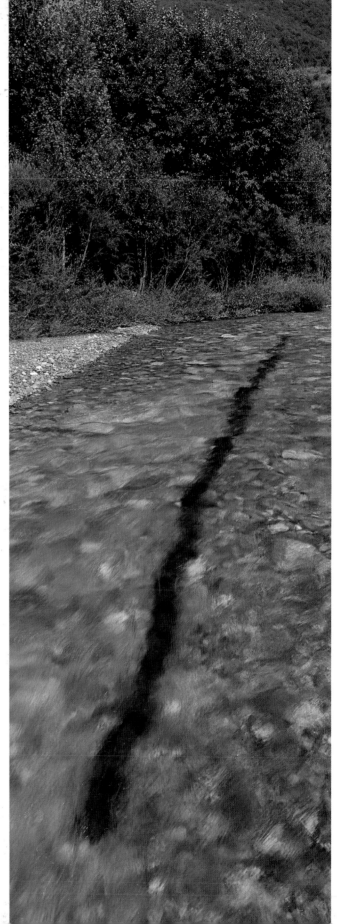

Left
Hazel leaves
stitched together with grass stalks
for a short time held in place by a stick

17 JULY 1998

Right
Black stones
laid deep
in fast-flowing water

18 JULY 1998

Clay Wall installation, July 1999

In the summer of 1998, I met with the French choreographer Régine Chopinot in Scotland to discuss a new project. Régine wanted to make a film about my work on the river in Scaur Glen to which she would choreograph a dance. I suggested that, instead, I should make a clay wall to be filmed as it dried and cracked using time-lapse photography, the whole process taking about two weeks. The wall would need to be constructed indoors under controlled light conditions. Régine agreed.

We talked about where the piece should be made and discussed various possibilities. But strangely enough it was only when I arrived in Digne later that year and was actually working in the river that I realised this was the place. Sometimes the obvious is the most difficult to see. Now I cannot understand why I did not think of it immediately: this has become one of the most important places to me away from my own home landscape in Scotland.

The problem was finding the right building. I thought this might be a barn or similar agricultural structure, somewhere that we could borrow for the duration of the filming. I hoped that the wall might remain afterwards, but knew that to insist on this would restrict possible locations and jeopardise the project.

When I discussed the matter with Nadine Gomez-Passamar, director of the museum at the Réserve, her response was enthusiastic. She suggested a wall in a room on the upper floor, which was about to be renovated. I went to see it, and it was perfect. Régine visited shortly afterwards, and it was agreed that the wall would

be realised in the summer of the following year. Drawing on the experience of the cracked walls in San Francisco in 1996 and Edinburgh in 1998, I decided for the clay wall at Digne to rework the river form to a larger scale (*see* page 10).

The origin of the clay was important. My feeling was that it should come either from Digne or from where I live in Scotland. We decided to use clay from my home. One of the reasons for this, apart from my love of the material, was that the difference in this particular clay between wet and dry is enormous, to the extent that people often think I have used two different clays. As the clay dries, the deeper area of clay remains damp and dark, as the surrounding area becomes pale and dry, and the river form slowly reveals itself

In making the wall, I was assisted by tradesmen from the village in Scotland where I live and who have also worked on my house. Ian Vernon, a local joiner, made the frame for the wall, and the plasterer, Brian Dick, along with several others, helped me to apply the clay.

The day after the wall was finished, Régine, along with the whole company of Ballet Atlantique, came to Digne to watch it change and crack. They stayed for several days, during which time we worked together on the river. It was good to have a dialogue between the river of clay in the museum and the river of water outside. The dancers helped me collect and lay sticks for a work made to change from dark to light, depending on the time of day and where it was viewed from.

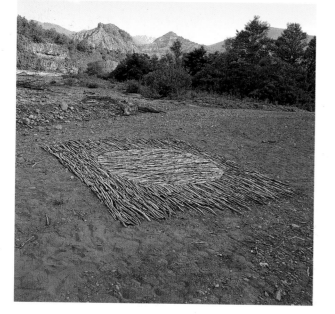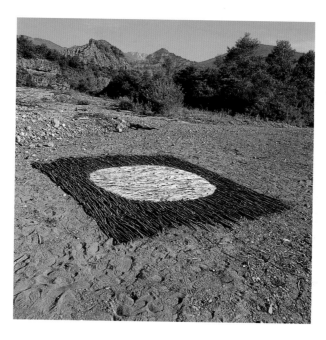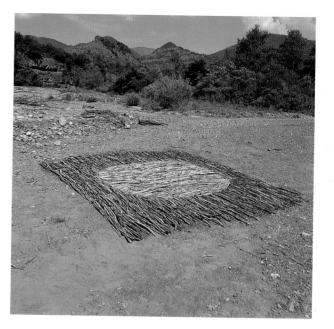

Sticks

laid one way and another

to turn dark to light

and light to dark

as the sun rose and set

Assisted by Ballet Atlantique-Régine Chopinot

JUNE 1999

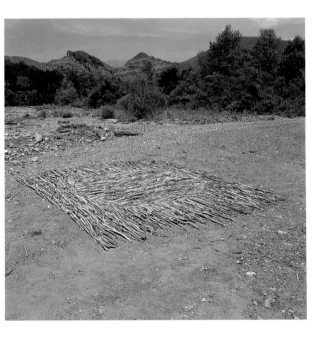

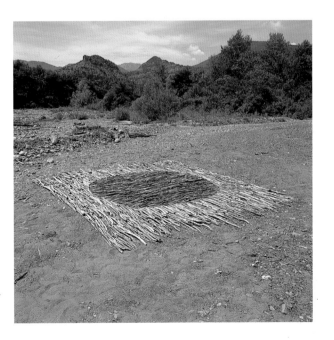

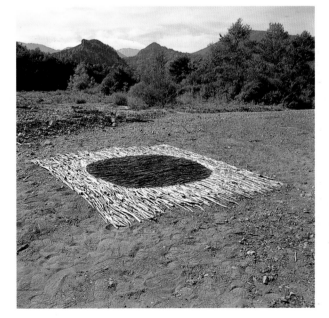

The filming of the wall was a very simple idea, but its realisation proved enormously complex. The resulting film has many irregularities and characteristics that I had not expected. Shooting the same but slightly changing image for ten days, then reducing the footage to an hour and ten minutes accentuates any changes in light levels and film colour.

I found the flicker and movement of the image as it goes through the projector more disturbing than I had anticipated. Originally I had intended that the film should also be seen without the dance. Now I am not so sure. Viewed by itself, the physical nature of the film and its projection makes the medium more present that I would like it to be. It needs the movement of the dancers to conteract the movement of the image.

Dumfriesshire clay wall
made and filmed for 'La Danse du temps'

JUNE 1999

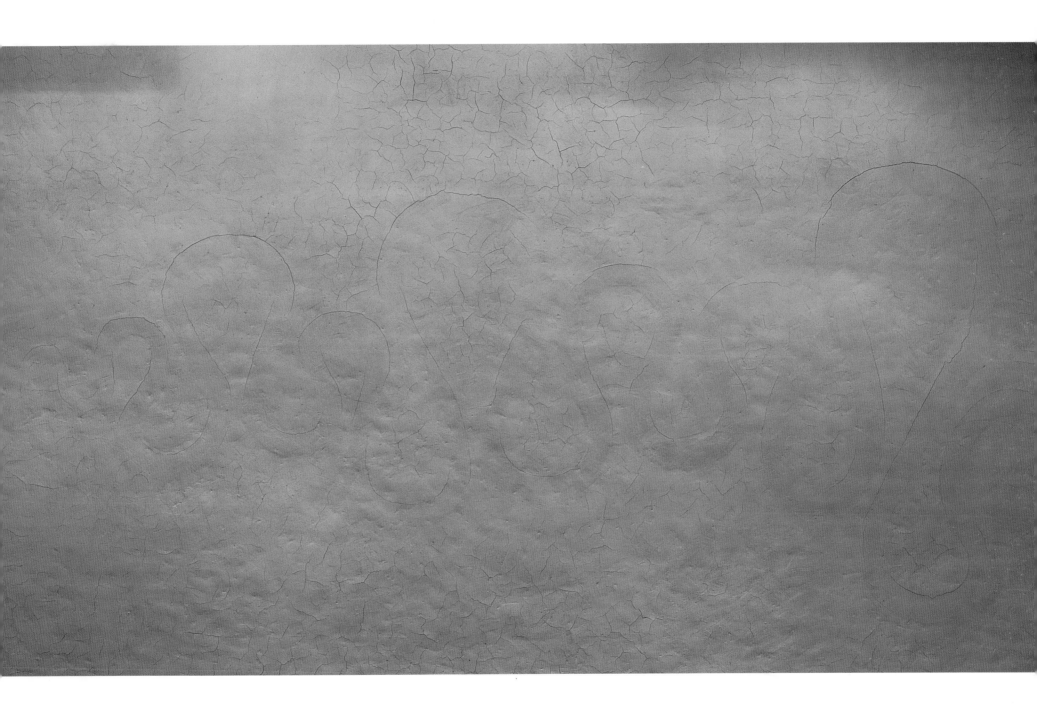

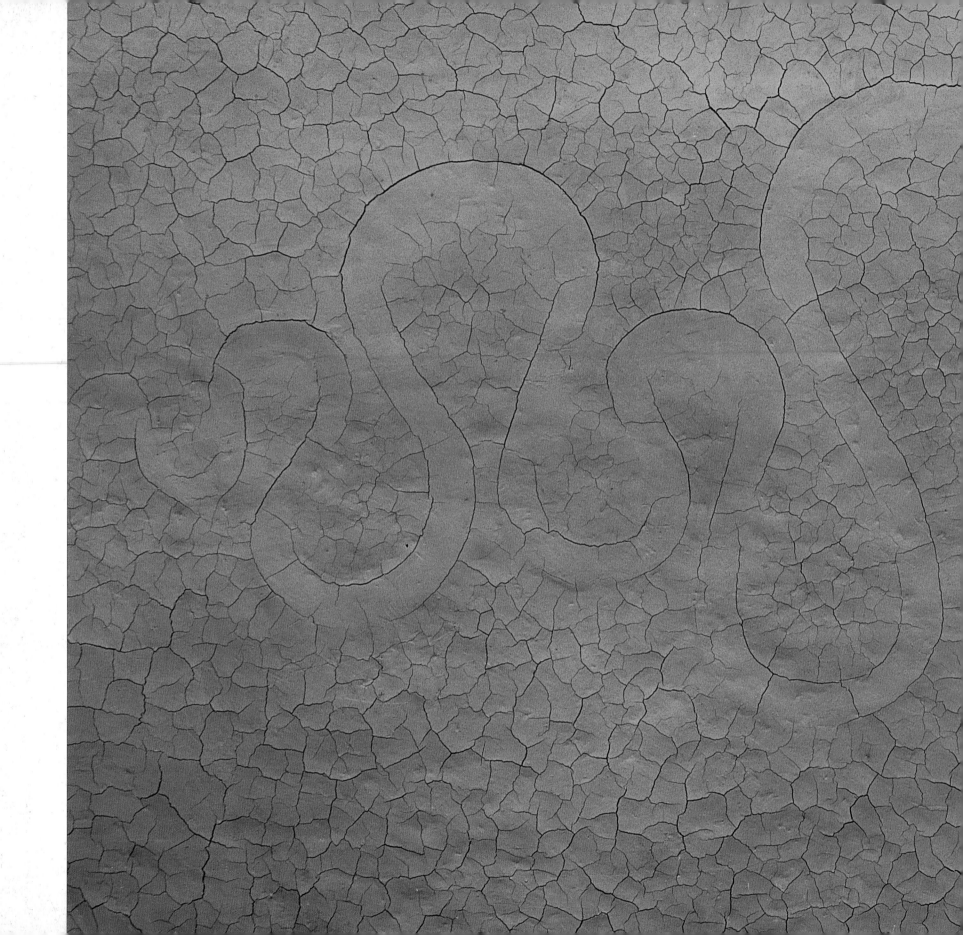

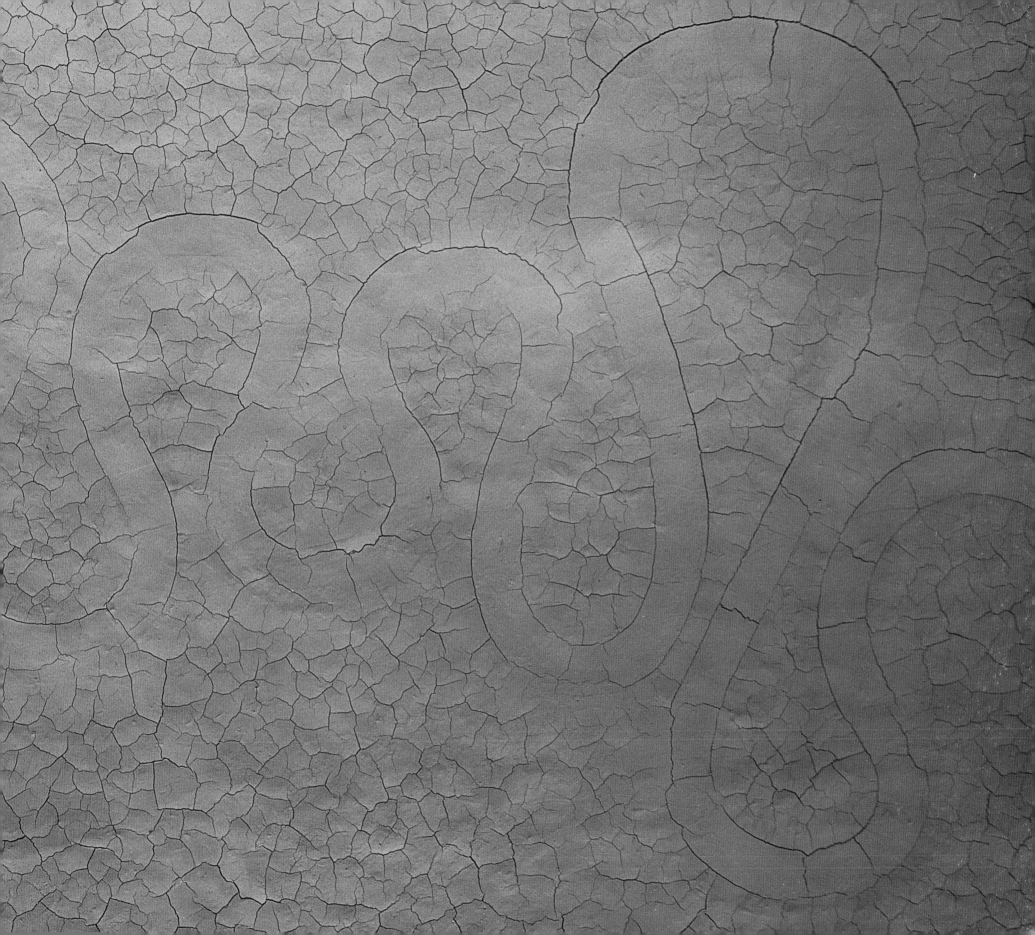

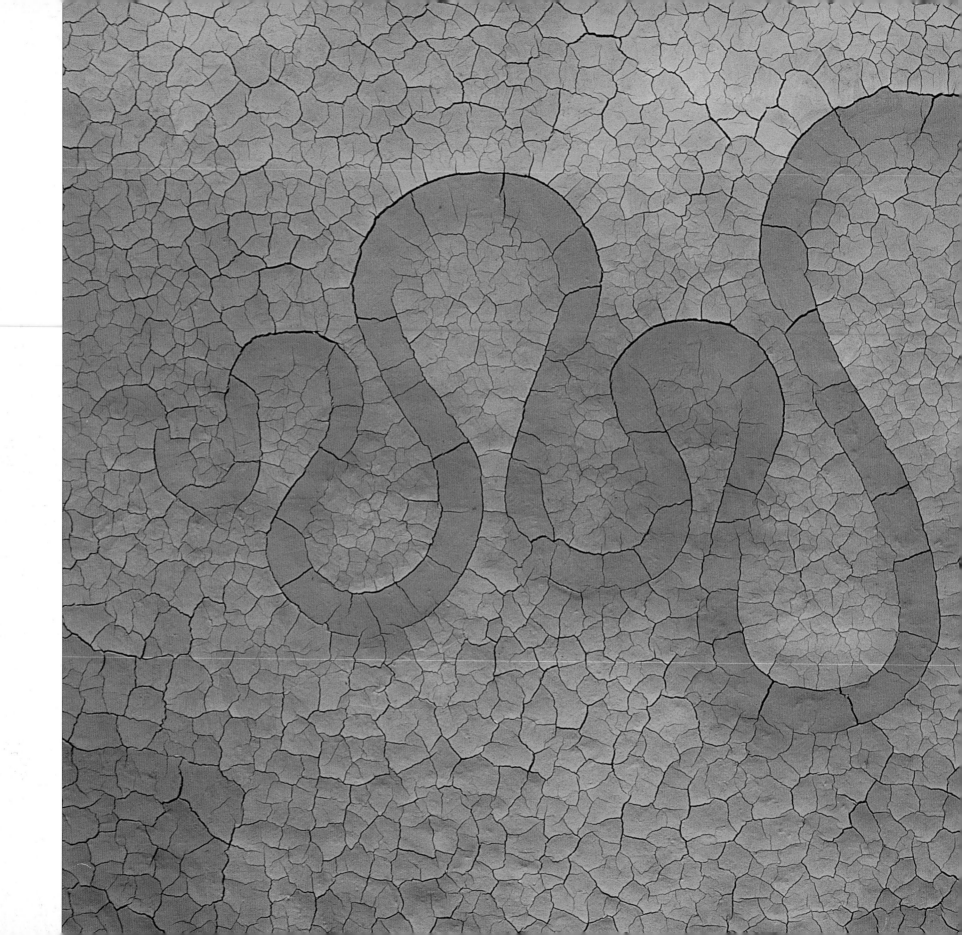

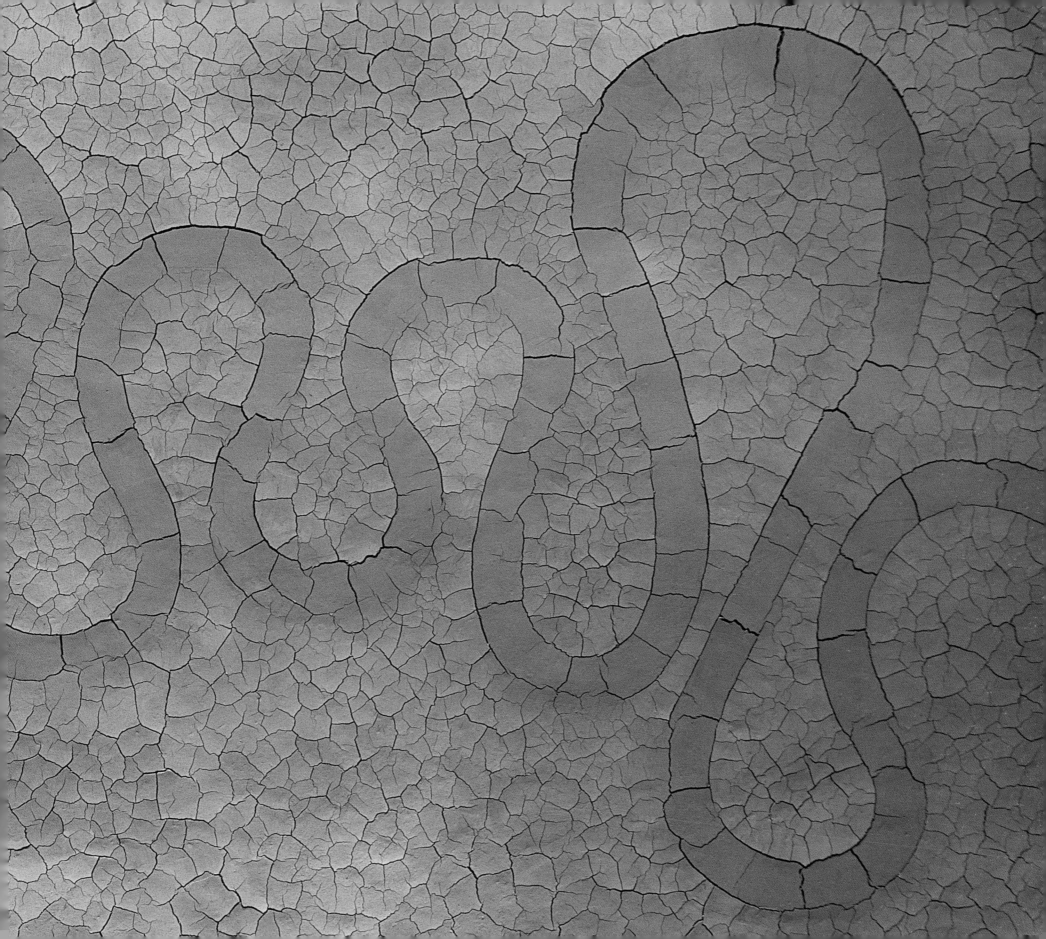

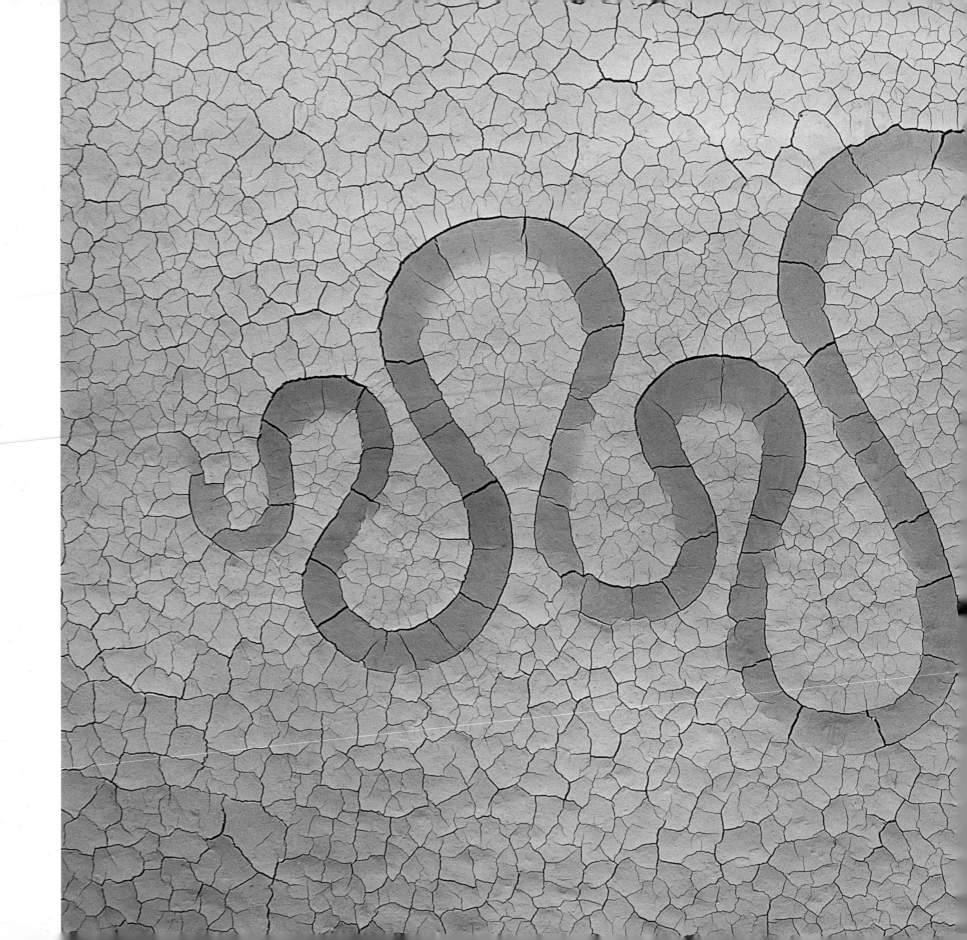

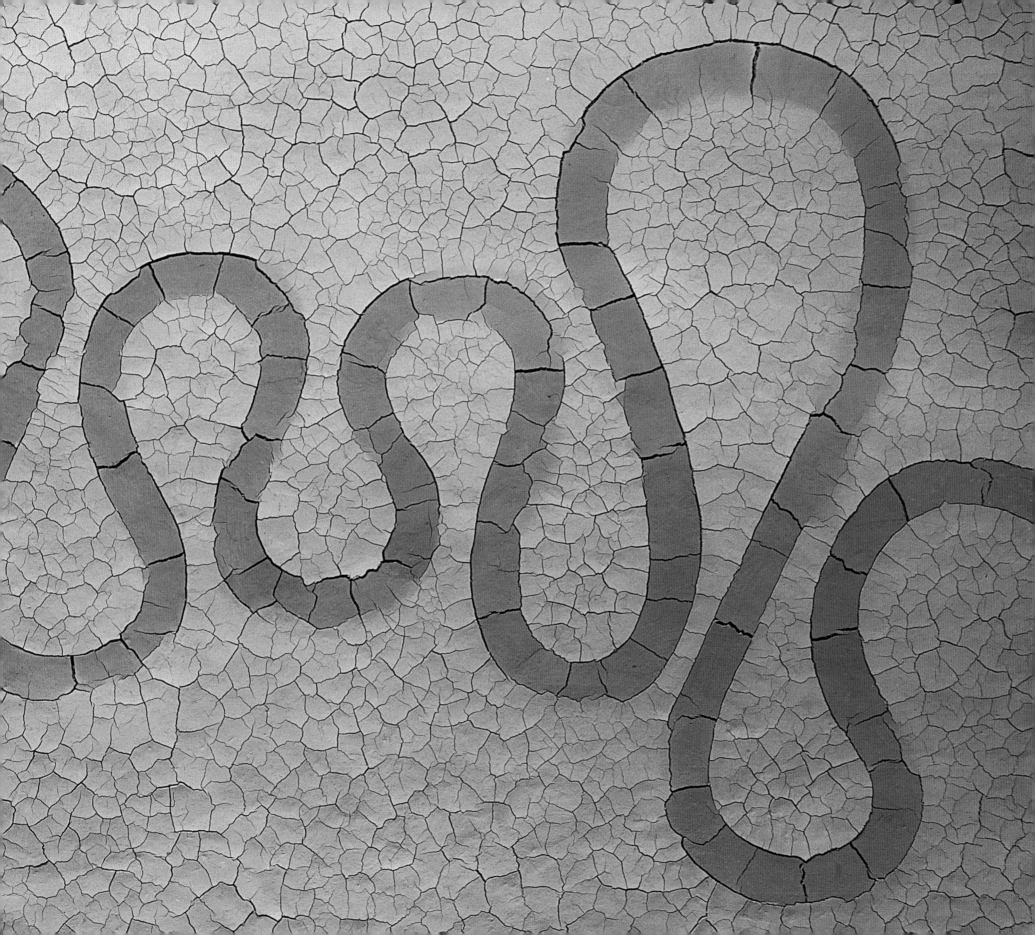

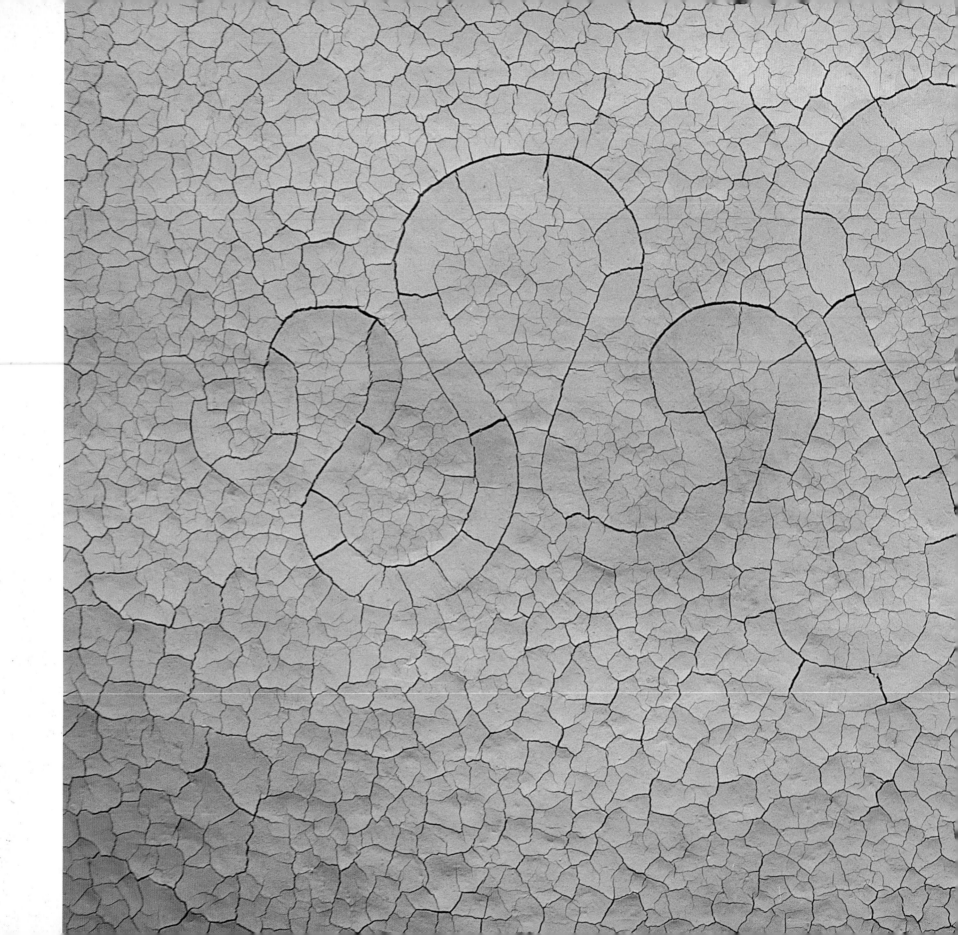

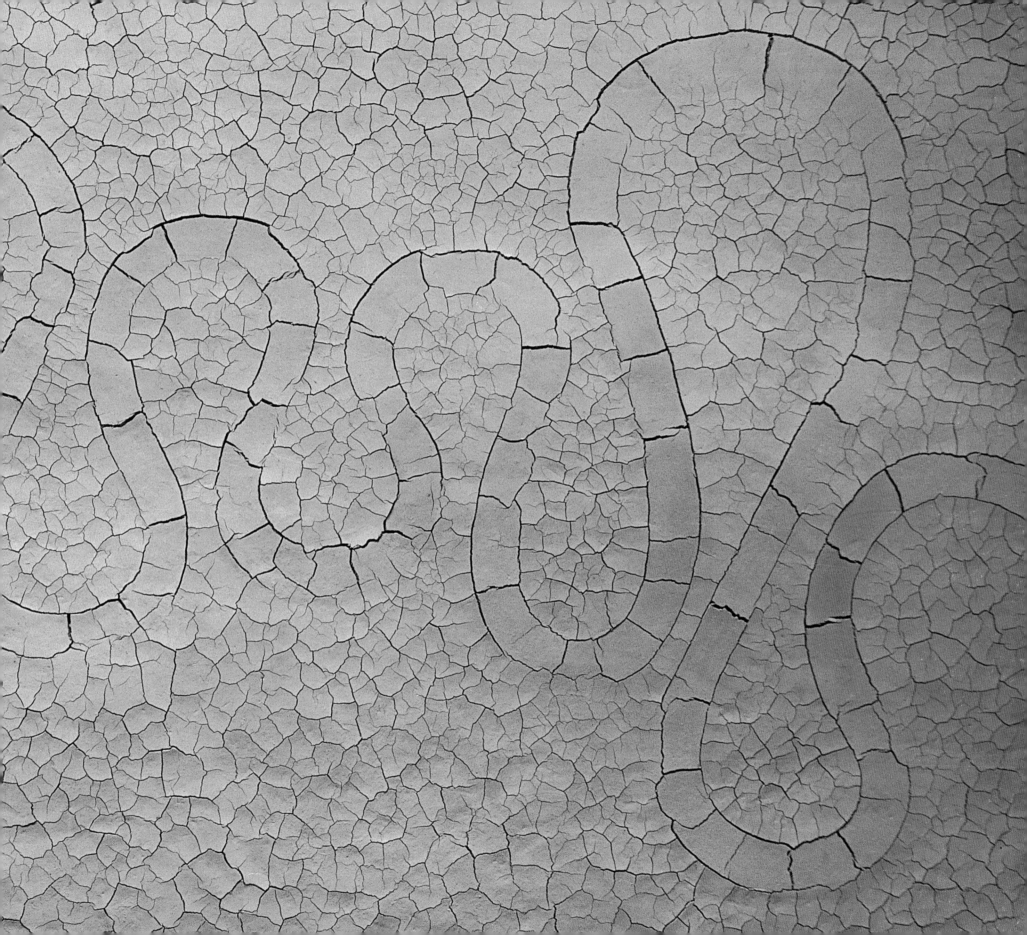

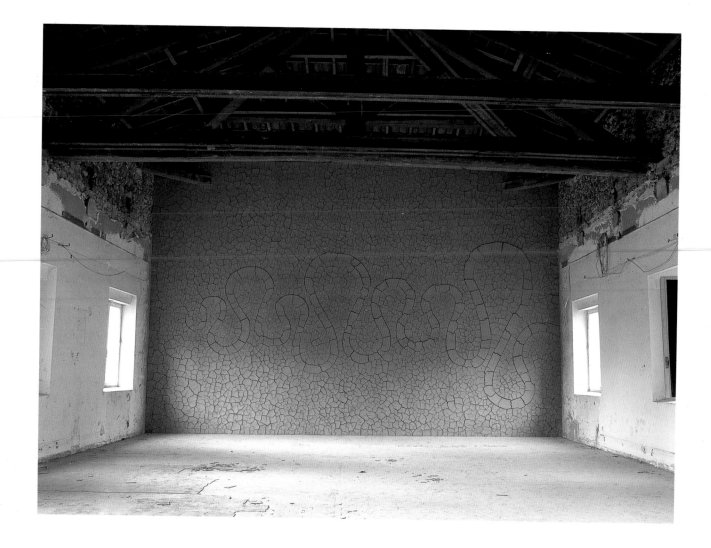

Clay wall

dried

MUSÉE DÉPARTEMENTAL DE DIGNE, DIGNE-LES-BAINS, HAUTE PROVENCE, FRANCE

JUNE 1999

'La Danse du temps'
performed by Ballet Atlantique-Régine Chopinot

THÉÂTRE DE LA VILLE, PARIS, FRANCE

11-15 JANUARY 2000

NOVA SCOTIA

Saturday, 30 January 1999

I arrived at Halifax yesterday evening with Thomas Riedelsheimer, who is making a film about my work, and Dieter Sturmer, his assistant. I am here to make snow and ice works for the film. Our luggage did not arrive with us, which always makes for a difficult start. Stayed at a hotel near the airport. Luggage arrived this morning.

It took most of the morning to get the film equipment through customs and into the vehicles. Left Halifax around 1pm. Stopped off at Truro on the way, arriving at Fox Point just as it was getting dark. We are staying at the home of Keith Graham (who is an architect) and Norma Cassidy in an interesting group of farm buildings, one of which was built by Keith.

It was cold, but no snow. I could feel Thomas's unhappiness. This portion of the film was intended to show winter. For me the snow is not necessary. Cold is more important. In a new place there are advantages to there being no snow, at least to begin with, so that I know something of the landscape before it is hidden.

The drive from Halifax to Fox Point was interesting but not extraordinary. I sensed Thomas's disappointment in the landscape. It is a long way to come to find something that looks so apparently ordinary. I have been in this situation many times before and have often found that apparently ordinary places yield extraordinary things. It's a good lesson.

Sunday, 31 January

Cold, bright morning. Walked from the house to the beach. I enjoy being within walking distance of where I work. A very difficult day – being followed around by a film crew in a place that I don't know.

Slabs of ice were stranded on the beach, left by the sea. These could be interesting, but I wanted to work with the cold itself, not just its result. As the sun rose I retreated into the shadow of a rock where it was coldest. Attempted several touches. Eventually began to freeze a circular arch around the tip of a large boulder. Felt better once I had begun working; warmth began to flow and I was able to work without gloves. Art generates its own energy and warmth – different from the heat produced by physical work – something I cannot explain.

After a few hours, the work collapsed. A wave of cold went through me and I had to put my gloves back on. I tried to rebuild the work, but its life had gone. The sun now shone directly on the place, which made it impossible to continue.

The temperature was still below freezing in the shade, and I went into a nearby wood. Began to drip icicles from branches. This could lead to something interesting. Perhaps, after completion, I could take the branches out onto the beach and stick them in the ground, so that the icicles 'hang' horizontally.

Tomorrow I will get up early to work with the ice. I was too ambitious today. I need to set my sights lower and just make something before I can go deeper.

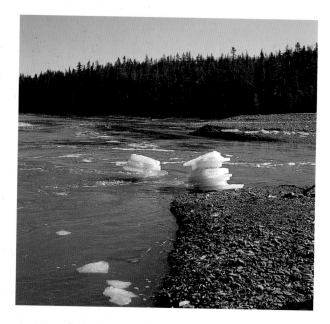
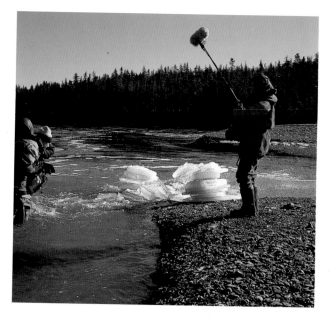

Monday, 1 February

Up early and out for 5.30am to take advantage of the night cold. Wanted to make an ice arch on the beach for the sea to wash away. The moon was out and I could see that the ice had gone! Decided instead to make the arch next to a river where ice could still be found.

Worked on a shingle bank. As dawn broke I realised that the ice we had been choosing was opaque and didn't work the light as well as I would have liked. Managed to find enough clear ice to complete the arch. Finished after the sun had risen, the arch melting and freezing at the same time. Water was dripping from it and yet these drips were making icicles. The arch was formed over a support of logs, which were pulled out once it was completed, with the hope that it was frozen enough to hold.

I have never worked at the mouth of an estuary before. It was a powerful moment when the sea came up the river – a meeting of two flows and energies. I had no idea when and how the work would be affected by the tide. I am a stranger here, and this work is my introduction to the place. It opens up new ideas. Unfortunately, this was the highest tide that I will see.

In the afternoon I made an earth drawing on a large sheet of ice. The warmth of my hands melted the ice so that the earth stained it. The form was fluid, not unlike a trapped air bubble seen through ice.

Opposite

Up early
working in the dark
before the day became too warm
to complete the arch
ahead of the incoming tide
a meeting of two waters –
river and sea

FOX POINT, NOVA SCOTIA
1 FEBRUARY 1999

Dark earth
collected from nearby wood
rubbed into ice

1 FEBRUARY 1999

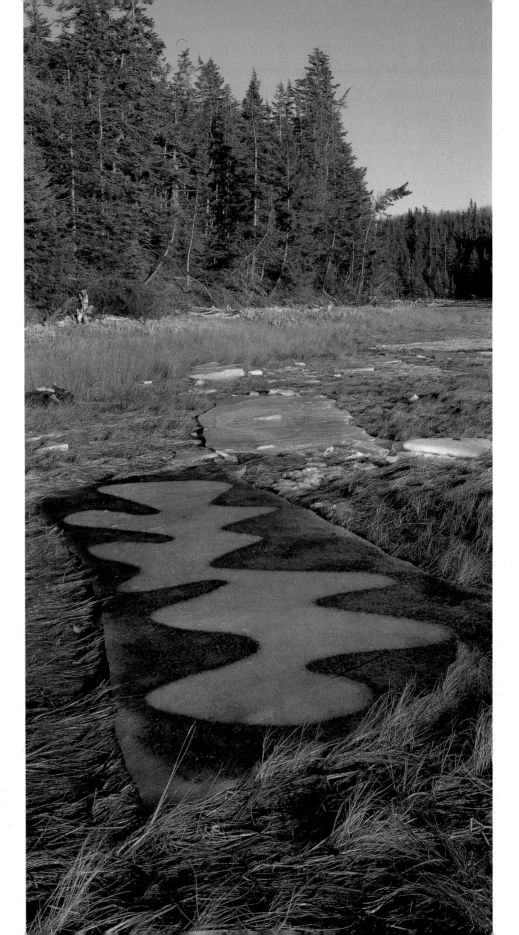

I am so tired. It has been a long day. There are many feelings that I would like to pursue, but I have been taken unawares by the daily changes in temperature. This is not a place of constant cold.

Tuesday, 2 February

Thomas and I got up early and were out just after 6am. Went down to the beach and found very little ice where we had worked yesterday. Decided to go upriver. Came to a plateau with a small valley along which the creek twisted and turned. A lot of ice scattered around. The valley was enclosed except for the distant opening through which the sea would come up the creek. It felt inland. Had the idea of making a work connected to the sea – waiting for its arrival.

Began to make an ice cairn. Difficult to find clear ice, and decided to work with whatever I could find. This was an ambitious work to make in one day, and there was no time to be too selective. In the end, it was the white ice that reflected the sun and looked better than the clear, which showed the darkness inside the cairn.

Worked quickly to do as much as possible before the sun rose. The ice froze very well, almost immediately. I wanted to finish the cairn before the tide came up the valley. I had more or less completed it when the first creaks, indicating rising water, were heard.

Ice left by the tide

stacked and frozen

worked quickly before the tide returned

stack shifted and settled at high tide

one sudden drop but no collapse

2 FEBRUARY 1999

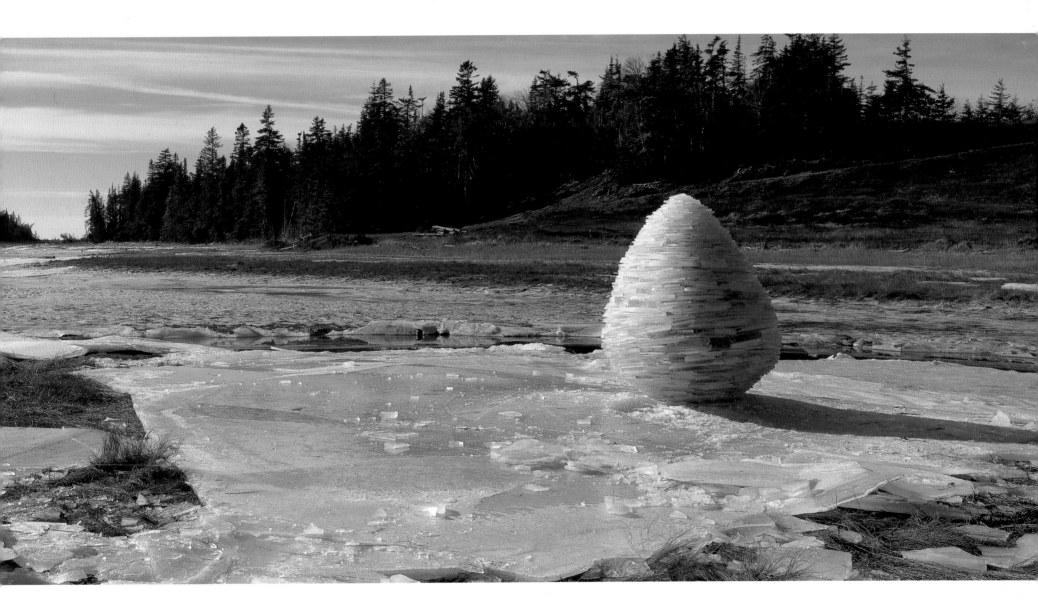

The cairn settled, crushing the ice upon which it was made, and leaning forward towards the valley entrance. The light was extraordinary and the sense of anticipation great as the tide began to come in. It was so beautiful to watch ice being lifted, broken, scraped and carried along by the sea river.

The sea reached and went beyond the cairn. Fortunately we had boots on, although one of mine leaked, which gave me an extremely cold foot, but that was not enough to spoil my enthusiasm for the incoming tide. The cairn survived, but as the sea receded, it collapsed slightly and tilted even further forward, causing a ring to form in the water around it. A few small bits came off the cairn, but it remained largely intact.

Although I had intended it to be broken by the tide, this gentle touch of the sea was more interesting; the cairn appeared to have been washed up and left stranded by the departing tide. Like the arch yesterday, this is something that I have made before and have rediscovered in a different context.

Towards the end of the day, I stood five large sheets of ice upright and threw water at their base, hoping that they will freeze for me to work on tomorrow. I have finally found a way of working with the white ice, by orienting it to catch the sun. The forecast, however, is for drizzle and rain.

Wednesday, 3 February

Woke up to overcast skies, hail and snow that soon turned to rain. Went to the cairn, which was standing just as we had left it last night. The ice sheets that were frozen in position were also intact, despite the strong wind, but soon fell down when I removed the supports – a great shame. I can now think of so many things that I could have made on that first day when it was cold and sunny. The energy has left with the cold. In the mild and wet it is difficult to be motivated, and I

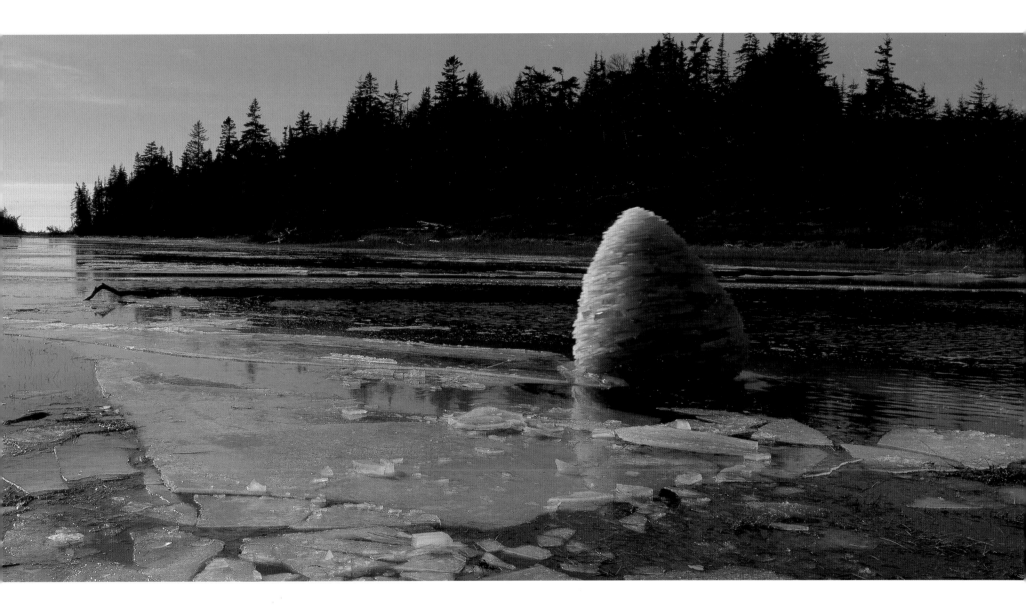

managed to make a piece with ice only after much struggling. It could have been better, though its relationship to the streaky, dark and white surroundings was interesting. We finished early. It has rained on and off all day.

Thursday, 4 February

Much warmer today. Decided to make a cairn on the beach. Up early to collect stones. Very difficult. Several collapses. Under pressure from the incoming tide. Eventually gave up when there was not enough time to complete before high tide. I will return tomorrow. Each failure has taught me a little more about the stone.

There was something strange about the collapses. I have worked with worse stone with more success. This cairn was made on sand with the intention that it would collapse into the sea once the tide had reached it. Perhaps the soft base was not giving enough support.

It was a beautiful, warm, calm, sunny day. The sand had thawed and I made an edge to catch the light. Until now, I could not have worked with sand above the tide line because it was frozen solid. I realised that I might be able to work wet sand from below the tide line and freeze it to forms not achievable by compression.

I have never been in a place other than my home where I have had to abandon so many ideas because of changes in the weather.

On the way back, I worked on a patch of snow left in the shadow of a wood. Sprinkled a line of soil on the snow, which became a line of snow on the bare ground. A difficult day for work, but one that was too pleasant, calm and warm to complain about.

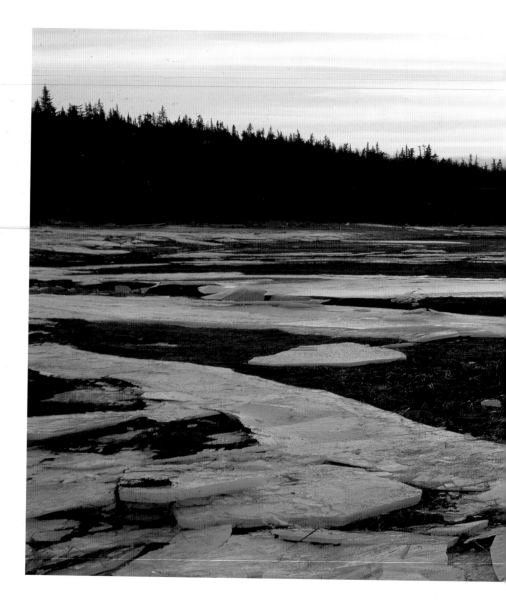

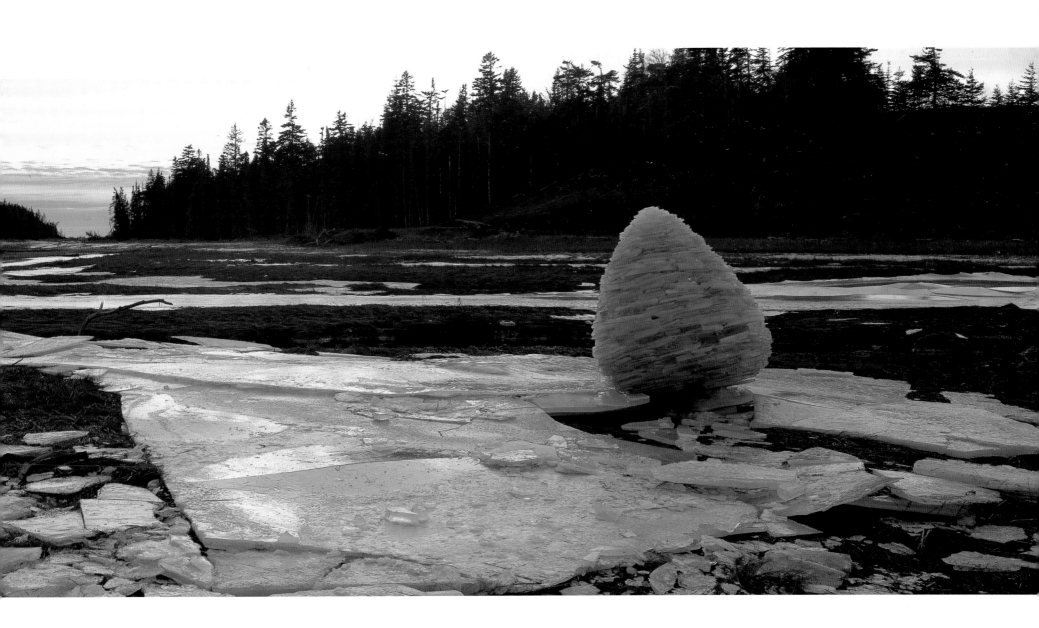

Friday, 5 February

Up and out before dawn. Returned to the failed cairn of yesterday, accompanied by a local called Jim, who helped with the collecting of stone, which allowed me to put all of my energy into the making. A grey, calm, warm morning, just around freezing. Worked carefully, but after about two hours and reaching about a foot and a half the cairn collapsed – for the fifth time.

These failures are unnerving, especially when I am working with a form and a method of construction that I know well. My decision to make something that I know could be a reaction to the pressures of being watched and filmed. Finding instability in something so familiar has given me a sense of insecurity, which has provoked me into thinking about the work afresh. This is reason enough to repeat a work.

I am still uncertain as to why the cairn was unstable. It could have been the sand or the weak stone or perhaps a combination of the two. I would get so far in the construction, then feel a softness different from anything I have experienced before when working with stone.

The stones were telling me that the cairn would fall, which eventually happened again around ten o'clock. With a high tide at about 3.00pm I did not have much time left. Working in front of a tide that had turned gave renewed purpose to the making. The connection between the stone and the sea was made stronger because of this tension.

This time I built the cairn on a partly submerged stone, which I hoped would make it more stable and this seemed to be the case. It took away the soft feel in the making of the cairn. It did not, however, take away the settling and breaking of some of the internal stones, and about a quarter of the way up, it came quite close to a collapse. Once I had laid in long throughs [stones passing from one side to the other and projecting], the cairn became stronger and eventually I got above the critical widest point and began to work inwards. It is a good feeling when I can accelerate and lay stones on with a rhythm and fluidity, making the cairn grow fast, my energy working in tandem with the energy of the tide – both flowing quickly. Only a few more cracks and movements and none too severe.

I managed to finish the cairn with the tide still out. Distance between stone and water was necessary to create a sense of anticipation.

The ice and stone cairns were not made in front of the incoming sea just to be seen collapsing. They are gifts for the sea. The changes brought upon them by the sea are creative, not destructive . . . changes from which I can learn a great deal.

The tide came in. It was a powerful moment when the sea first met the cairn. Quickly it began to engulf the base. I felt that the initial flow would soon undermine the sand and break the cairn. The more it rose, the more unpredictable the collapse became. The sea rose higher and higher. There were no waves so the rise was fairly uniform, but with a tremendous current in which the cairn left a wake. Slowly I realised that the cairn might survive the tide.

Watching it was beautiful and strange. It was difficult to connect the cairn above water with what stood unseen below. I began to see the part above as the complete work – so the cairn became a floating pile.

The sea finally engulfed the whole cairn. I have never before watched a work becoming invisible while remaining intact and staying exactly where it was made. This has profoundly altered the way I see things. My art has shown me so many things that were hidden to me. To have a sculpture removed from sight, but to know it is still there affects my perception of things that have gone. It was as if the cairn had gone off to another world and time.

An hour or so later, the cairn began to show itself again. It looked like a fish coming up for food, occasionally kissing the surface. Slowly the sea drained away, revealing an only slightly changed (at the tip) cairn. Just as the outgoing tide reached the base, the sun set and the horizon turned red. The incoming tide had been like a river; outgoing, it looked like a lake draining.

There was no collapse, but what a journey this work has taken me on! I am back at the house where we are staying and the cairn is out on the beach in the dark, now engulfed by the night just as it was by the sea earlier in the day. I feel just as connected to the cairn as it stands in the dark as I did when it stood in water.

Saturday, 6 February

A smattering of windswept snow. The blueberry fields on the way to the beach were almost bare of snow, but the beach itself, sheltered by cliffs, had an even covering. Part of the shore was black where the tide had melted the snow. I made a line, black on white and white on black. Snow and sand alternating. It began snowing again, and the shore became white, defeating the purpose of the work. Went to the cairn, which is still standing!

Gathered bits of snow that I smeared on a rock then etched with a stick. As I worked, it began to snow heavily and soon the beach and yesterday's cairn had become white. A work that had begun on a warm sunny day was now covered in snow, in a cold biting wind – marking time and change.

I felt tired today, perhaps because of not sleeping so well last night as a result of a strained shoulder muscle. It was also frustrating not being able to concentrate on the snow, having promised Thomas that we would do overall general shots of me walking in the landscape, etc.

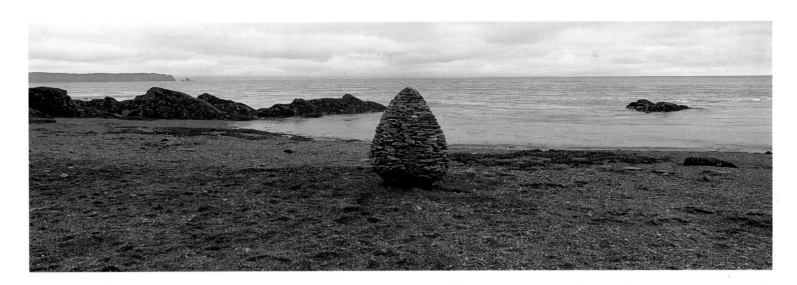

Cairn
built on sand
between tides
several collapses
ran out of time
returned the following day
one more collapse before I succeeded
cairn survived several tides

5 FEBRUARY 1999

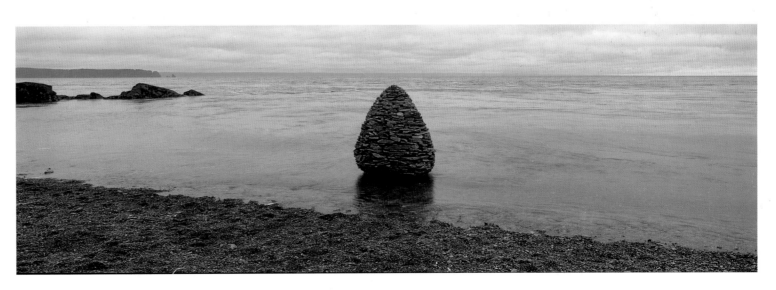

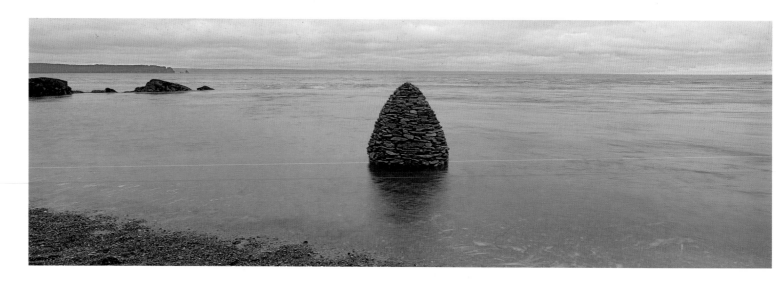

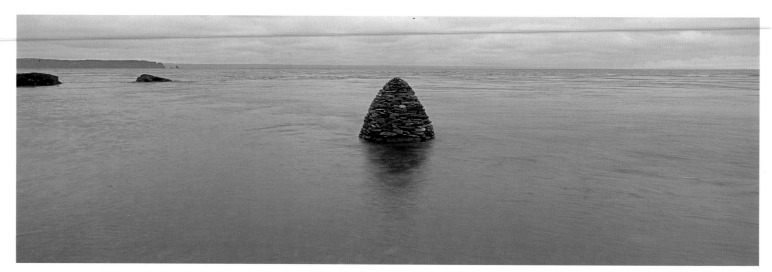

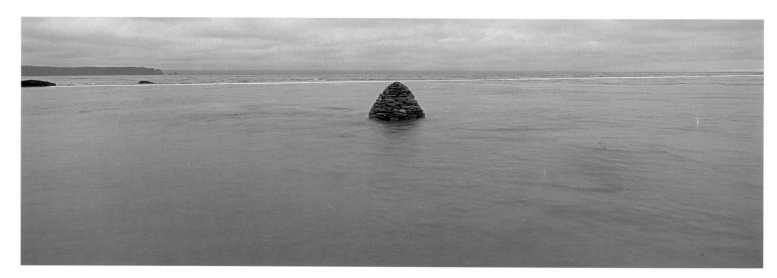

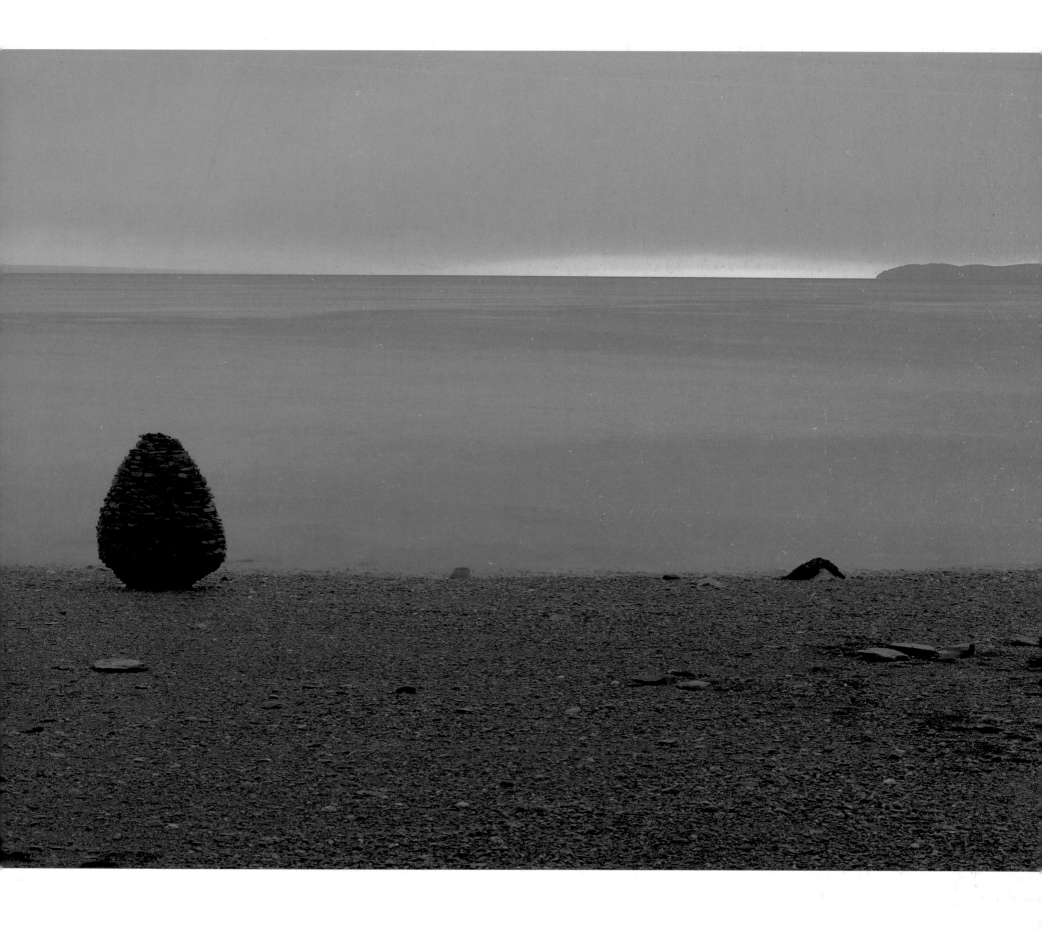

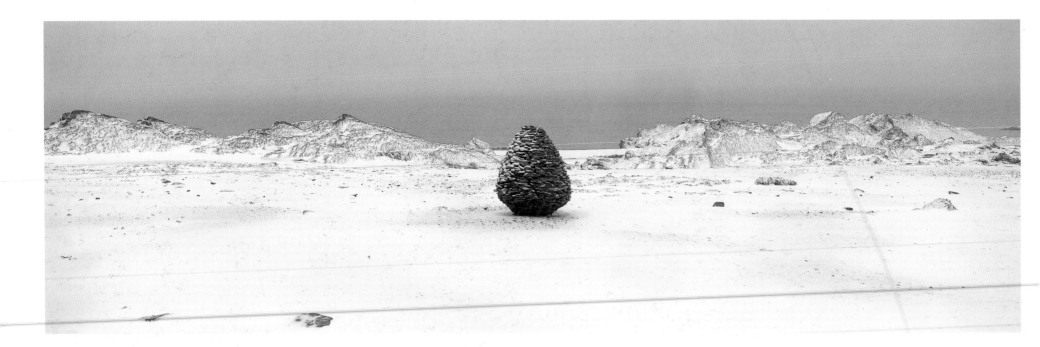

The texture of the blueberry fields is interesting. Made a couple of small sketches with blueberry twigs that didn't amount to much; I may continue them tomorrow. Gave up for the day, but on my way home placed sticks on the ground to be covered by snow. I am surprised that I have never thought of making a work like this before. Of course I have seen snow drifts around things that I have finished, but I've never made that part of my intention.

I laid the sticks zigzagging in the direction of the house. It was almost impossible to photograph before snow drifted against the sticks. I am looking forward to seeing it tomorrow and the changes brought to it by the wind.

Sunday, 7 February

A beautiful sunny morning, the brilliant light reflecting off the white snow and creating an incredible contrast between the white fields and the dark forest edge. The snow was cold and powdery. I had intended to go down to the beach, but decided to make snow throws instead. Spent some time looking for a space divided between light and shadow into which I could throw handfuls of snow.

My first attempts were caught by the wind and taken into the shadow instead of travelling in front of it. I thought of the wind as a problem until I realised that if I found the right place, the wind would take the snow on a journey. The snow travelled much further than I expected. It felt as though I was releasing the spirit from the snow. The powder separated like chaff from grain as the larger lumps of snow fell around me. Something of the day's essence had been touched upon in

Opposite

Snow

sun

wind

throws

7 FEBRUARY 1999

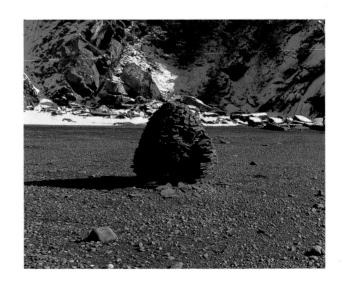

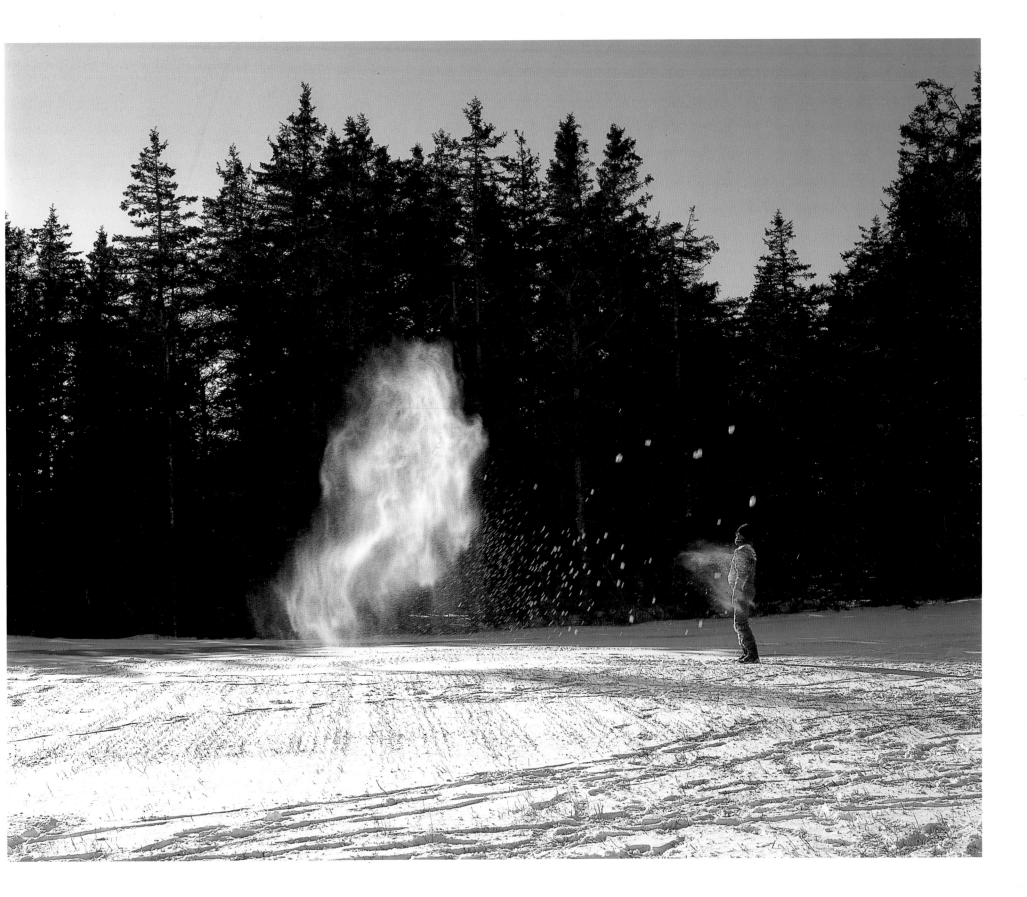

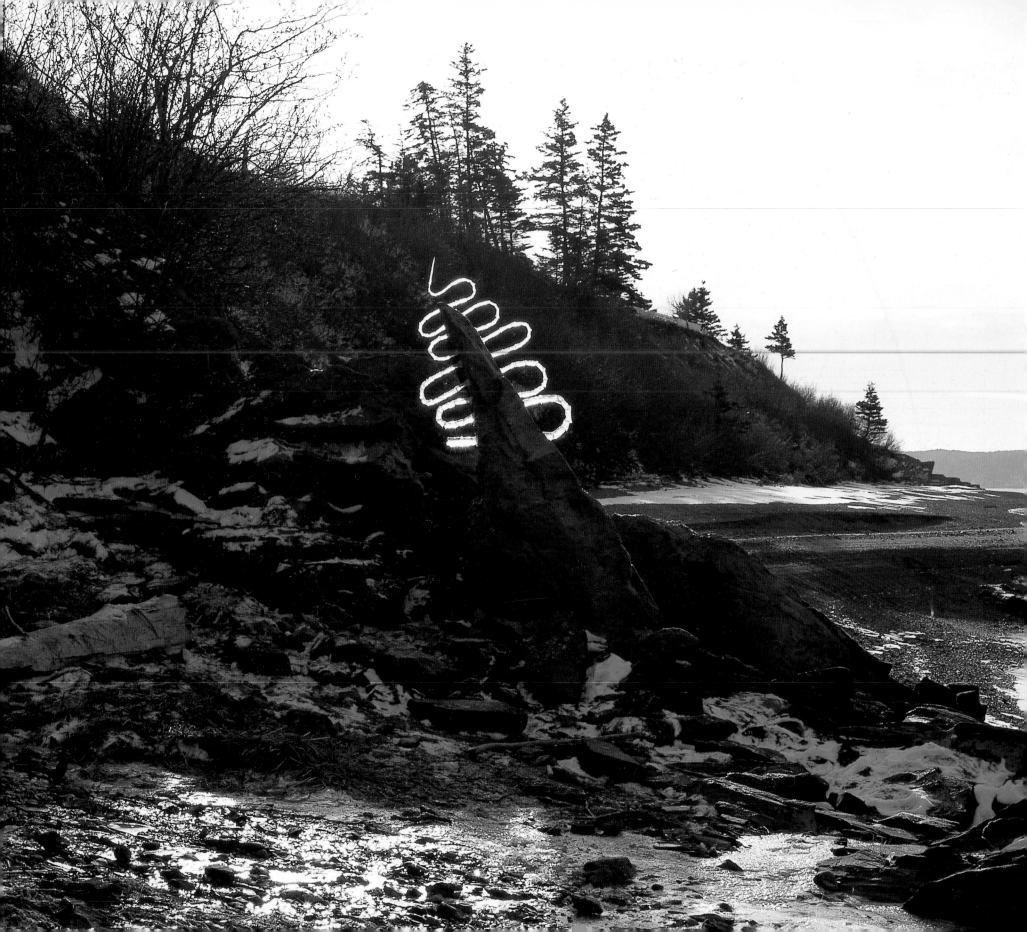

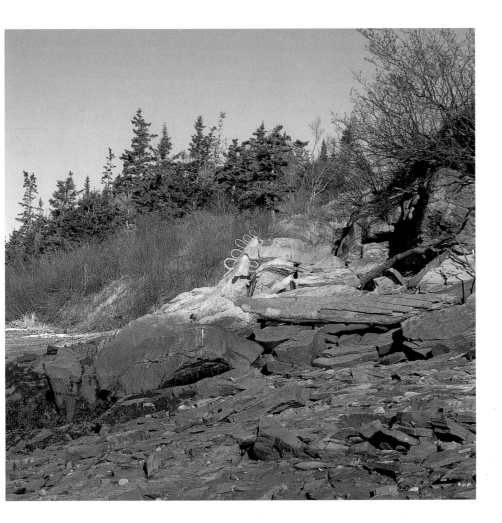

Reconstructed refrozen icicles
second attempt (first try thawed)
worked through the cold dark night into day

9 FEBRUARY 1999

this combination of light, wind, shadow and snow. Good to be making random, less controlled and constructed works.

Later on, I went down to the beach. A white and black shore. I attempted to do something, but the snow melted too quickly on the warm, dark pebbles. There were a few deep drifts of snow where I began working, but it was difficult. Good to see the waves crashing against the rocks, flinging white foam throws of their own into the air.

The cone was nearby, still standing, but almost collapsed, torn by last night's heavy waves. The guts of the cairn had been taken away, leaving it riven and very precarious. I began to anticipate the next tide, which would certainly cause its collapse. While I was working with the snow, I turned round and realised that the cone had fallen. I did not hear it because of the wind. It went so quietly – unnoticed. Impossible to be disappointed at its collapse after it had had such an extraordinary, long life. Even as a heap on the beach, it had presence.

I continued working with the snow, moved it onto the beach and worked in front of the incoming tide. Not good work, but an attempt to use the pressure of the tide to force me to work quickly in the hope that something new may be provoked. It was an awkward-looking piece. It is going to be a cold night, so who knows what will be waiting for me tomorrow.

Yesterday's sticks lay in wait for the drifting snow but nothing happened. The winds dropped last night and there was very little drifting after I left yesterday evening. It seems that another idea is to be thwarted. I will find the right place and time somewhere else. At least I have been made aware of the possibility.

Monday, 8 February

Returned to where I saw icicles yesterday evening. Becoming light as I arrived. Clear and cold – able to freeze icicles quickly to a rock. Broke icicles into sections then worked them into curves so that they wove in and out of a stone. It had the potential to be a great piece. The sun rose much earlier than I thought and between 8 and 9am it shone on the work.

I had no idea about the alignment of icicle, rock, place and sun before working. I was astonished that the sun rose directly behind the stone and illuminated the icicles perfectly on both sides while a shadow was cast by the cliff behind. It was a great moment. However, the work was unfinished and needed two additional curves to give more movement and connection to the rock. There wasn't the right balance between icicle and stone.

Today I entered the cold. To be able to freeze ice to stone and ice to ice in a matter of a few seconds is exhilarating, giving energy to the piece. I could have

continued working once the sun rose, but the moment had passed.

I collected icicles in a basket and placed them in the shadow behind the work in preparation for tomorrow. I will have to get up at 4.30am in an attempt to make this work again before sunrise. It will be difficult working in the dark, but I have to try. There are not so many icicles around and I had to look among eroded and exposed tree roots to find them. It had the feel of collecting food – wherever I removed an icicle, another would grow in its place. In the end I took old, thick columns from good, icicle-forming places in the hope that by tomorrow, new and more workable icicles will have formed.

A day with some success and great failure.

Tuesday, 9 February

Up at 4.30am and out in the dark to rework yesterday's piece. It was very cold. Some said minus eighteen degrees, although it didn't feel quite that cold to me. A quarter moon gave some light but the place where I was working was in shadow. Difficult to find icicles and freeze them to the rock. It was a very slow process, not helped by getting up so far in advance of dawn. The more slowly I worked, the colder I became. My hands were as cold as I have ever felt them. I have to work without gloves at times, both for sensitivity and to prevent my gloves from freezing to the icicles. I was able to pick the icicles and the pieces up not by gripping or holding, but just by touching them – they froze to my hands.

It was very difficult to see. I was intensely tired when dawn broke and came very close to giving up. I had not finished by the time the sun touched the work, but managed to shield the icicle from the first warmth of the sun and extended its working life for another hour, by which time it was complete.

The light on the icicles was intense. An extraordinary place. I am particularly interested by the way the ice combines with the stone, piercing yet knitting it together, as if the icicle were emerging from within the stone.

About two hours later, pieces began to fall off and when I left only two curves remained.

In the afternoon I went to Parrsboro, which is about fifteen minutes' drive away. This is the first time I have left the area around the house and it was interesting to see the white wooden buildings that make up the town and surrounding farms. In the middle of the town there is a brick-built former post office, the foundations of which look to have been built from Dumfriesshire sandstone. It is so similar to the stone at home that it could be some of the stone that crossed the Atlantic as ballast on ships. I would like to find out. It is always a very poignant moment to find stone from Scotland in another country.

Keith Graham's family has been here for 200 years and although he has worked in other places, this is where he now lives. As a child, he played among the rocks and fields where I am now making sculptures. This gives an additional richness to my stay here, made even stronger by the fact that Keith's family originally came from Scotland.

Wednesday, 10 February

When I arrived over a week ago, the first thing I saw when I stood on the cliff looking down towards the beach was a pool of water turned in a circular motion by the river. The pool was too deep to wade into and touch directly. A few days later I tried throwing sticks into the pool to see if they would rotate in the water, trying to work the movement from a distance. It was unsuccessful.

Today I returned to make a work to echo the movement of the turning pool. I laid sticks in a circle, adding more until they were brought to a dome, leaving a hole at the centre. The rhythm of laying the sticks was like the turning of the water. I had collected the branches from an embankment on the opposite side of the river where they had been washed up by the sea and left for a considerable time, becoming grey and bleached.

The work fitted perfectly into an almost concave area in the rocks about twelve feet wide. I was able to work within the dome by way of a small opening through which I crawled in and out.

Around five o'clock, the sea began to touch the sticks. Very slowly, the work rose. A few branches floated off here and there. Sometimes a branch popped up. There were interesting reflections within the hole. As the dome separated from the land, it lifted up with sticks shooting out from underneath and I expected the hole to collapse. Instead, it floated ever so gently out into the river, where it began to turn.

Made as an echo of the pool's movement, the work was now turning in the pool itself. This was one of the most beautiful moments I have had with any work. The hole remained completely intact. The sea meeting the river gave such a gentle motion to the sticks. Slowly, it drifted upstream, then as it picked up momentum, I had to run to keep up.

It was extraordinary to see a work lifted up and carried intact by the river – something I have never experienced before. I could not have predicted what would happen. That the hole was lifted and turned was confirmation that my response to this place was a correct one. I followed the sticks upstream – darkness was falling – eventually leaving it to drift off into the night towards the town.

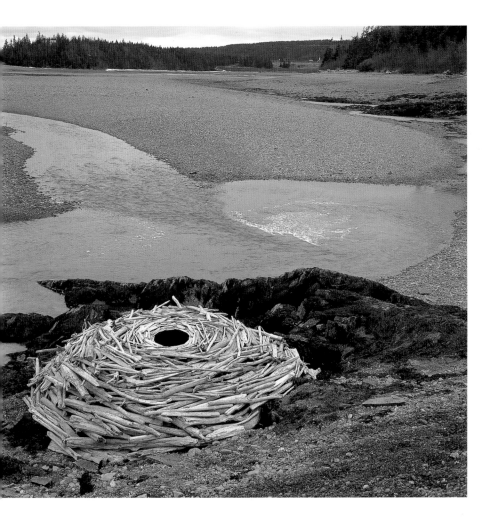
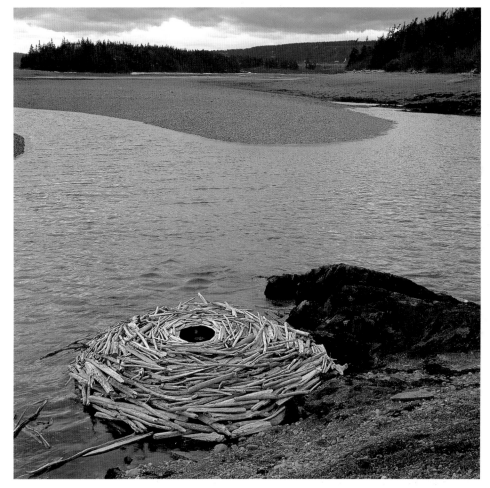

Stick dome hole
made next to a turning pool
a meeting between river and sea
sticks lifted up by the tide
carried upstream
turning

10 FEBRUARY 1999

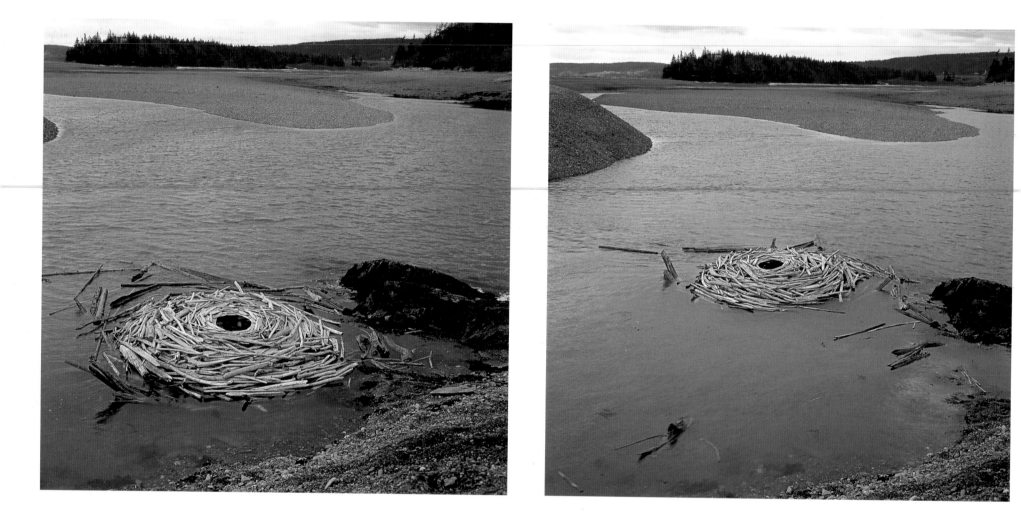

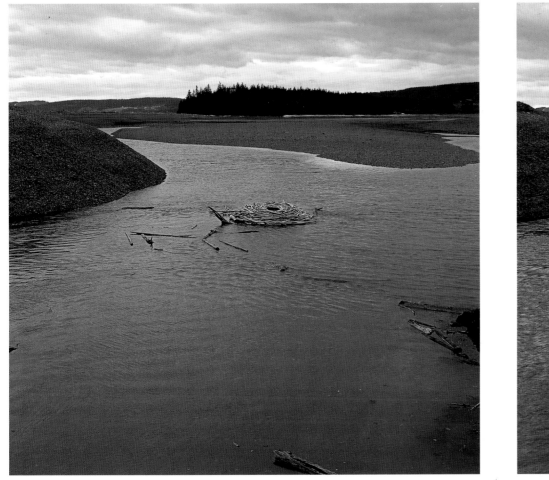

I live for days like this. A hard morning collecting when I didn't think there would even be enough time to get all the branches, but fortunately I was helped by Jane and Dieter, part of the film crew. This crew is so enthusiastic and willing to get involved in the work, which I very much appreciate. I am very happy that I lost a bet with Dieter about when the sticks would be gone, which I got wrong by about fifteen minutes. I now owe him an eighteen-year-old bottle of Macallan whisky.

During the day, Keith visited. He told me of swimming in the pool where I had worked and of the many salmon that used to gather there.

Thursday, 11 February

Out on the beach an hour or so before dawn. Wanted to make an inverted frozen cairn. Went to a rock I had found several days before. Tried, but failed. I didn't have enough fresh water with me to wet the rock. Came back along the beach and tried another rock . . . didn't feel right . . . too vertical and I wanted something more horizontal for the cairn to hang down from. Began on a stone that I dismissed earlier for being too small, but with time running out it seemed a good choice now. Felt warm to begin with, but as dawn broke, it became intensely cold and I was able to freeze stone upon stone very easily. The contact was almost immediate. Some stones fell off, but generally the work was made very quickly.

Thomas decided to start filming the cairn – making it appear upright, then rotating the camera to show its true orientation. As he began filming, the cairn fell off. He had the presence of mind to carry on with the shot even though the cairn had gone. This will be interesting to see. Unfortunately I was not able to take a photograph myself, but I was delighted that Thomas had filmed it.

On the way back, I looked at the creek, which had frozen over with beautiful, clear, thick ice. It must have been very cold last night, which I hadn't realised. A whole new world opened up – ice I could walk on and scratch into, making lines. I threw some white snow on to the ice, then etched them. This was potentially good work that could lead in all sorts of directions if only the ice would stay for another day.

I now understand much better the cycle of ice and tide that explains the ice slabs found on the first day. I presume this creek will stay frozen until the high tides return to lift off the ice, carry it out to sea and wash it back onto the beach.

A good day. I enjoyed not knowing what would happen next and must have made four or five pieces. I particularly liked the lines that crossed the river connecting the two banks. It's an extraordinary feeling to be able to cross easily something that has, until now, been a barrier.

Friday, 12 February

Returned to the river, which was still iced over and workable. Although cloudy, the weather remained cold. Dusted the ice with powdery snow into which I drew a line that crossed from one bank to the other. It was a development from yesterday's touches and resulted in a much stronger work with rhythms and irregularities that gave it a tension I liked. It was beautiful to watch throughout the day as it began to thaw. The edge, being of thicker snow, remained for longest, seemingly etching itself into the ice, so that even when the snow had gone, you could still see where it had been. I would have liked to have seen it completely gone, so that just its shadow in the ice was left, but the ice melted rapidly and water began to cover the work.

I made one or two other drawings on the ice with the snow until the temperature rose and it began to rain slightly. The snow became too sticky and I couldn't make a fine dusting over the ice.

Made a snowball in the pine trees with the now-sticky snow. There was dynamism in the way the pine trees shot upwards, which made for a very different feel to the snowball in the trees that I made in Bentham in 1980.

A very good day, beautifully calm at times and always overcast and grey. It was very warm as I finished and walked home in the dark. This is the last day the crew will be filming me. They have been tremendous in the way they have involved themselves in what I have made, not just as film makers, but also physically helping me at times. Compared with the very difficult first day, when I felt unsettled by having them around, I now feel very comfortable with them. So much so that for one shot I actually rode the dolly that was placed on tracks so that I could etch snow on ice at exactly the same time as the camera moved over it.

Saturday, 13 February

My last working day and what a change in the weather – warm, overcast and raining heavily. It was beautifully grey and foggy, with an incoming tide. I worked at the junction of river and sea where I had made the ice arch. The ice in the river is melting and very clear – invisible in the water. I found a very large piece and made a small pile of stones on top, which I then set afloat. You couldn't see the ice, and the small stone cairn floated around on the water but wasn't quite as I wanted. The shape was not good.

The idea stuck with me and in the afternoon I returned to make another. Much better form. The tide was now going out and the cairn floated towards the sea. This would have been a great work except that the stone pile tilted the ice causing a small part of it to stick out, which ruined the idea completely.

It turned extremely cold as I was working.

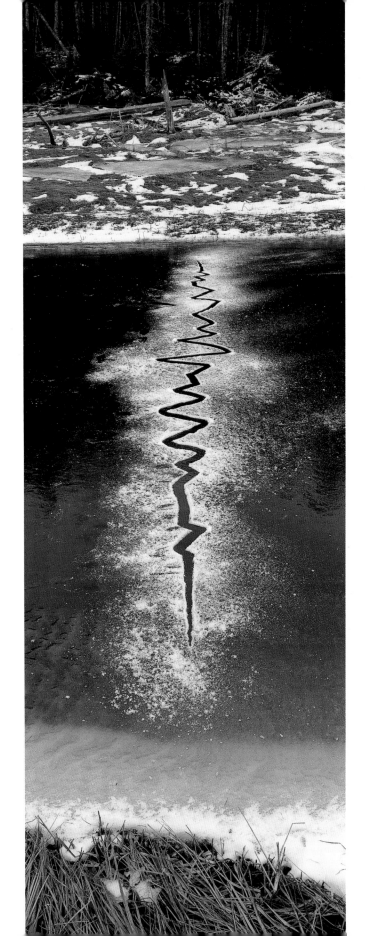

Scattered snow on ice
drawn through with my hand
leaving a line

12 FEBRUARY 1999

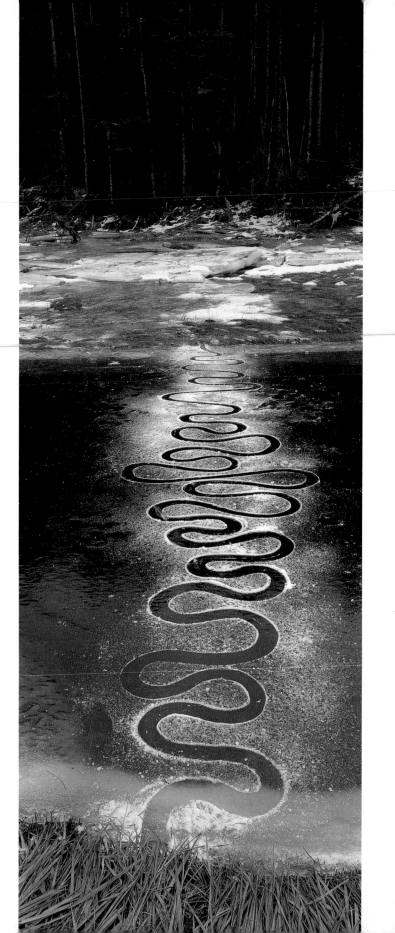
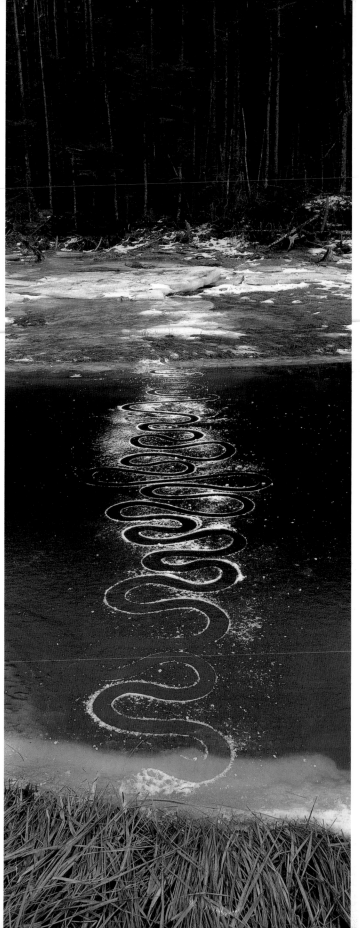

Frozen river
strong enough to walk on
spread with snow
cleared back to ice with hand
to make a line
began to thaw

12 FEBRUARY 1999

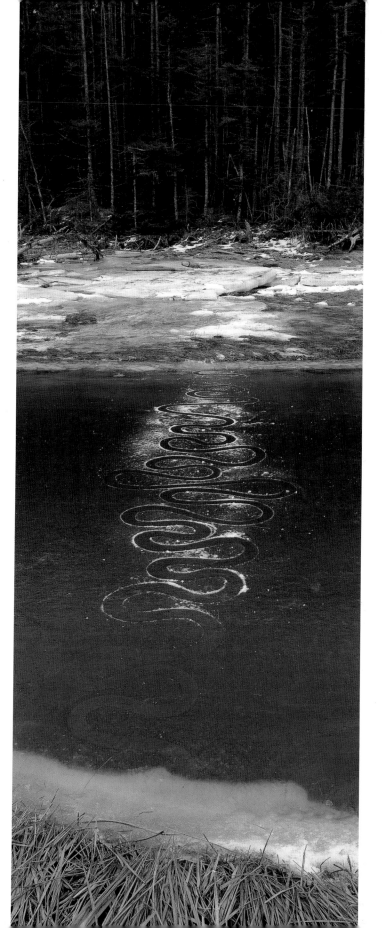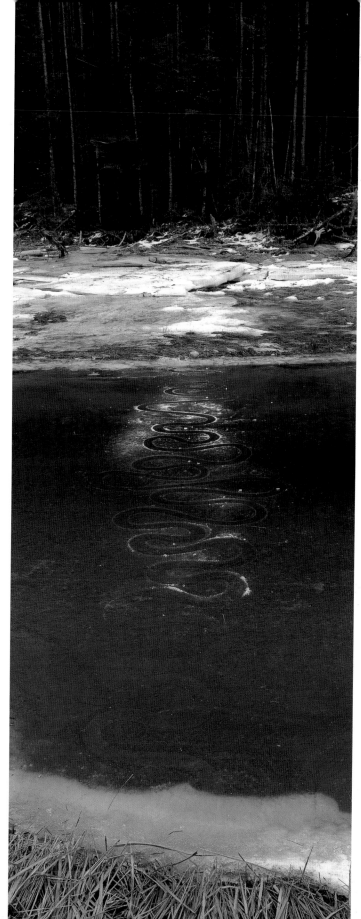

HOLLAND

Monday, 15 March 1999

I have been invited here by the Staatsbosbheer (Dutch forestry commission) to make work as part of its 100th anniversary celebrations. Beautiful, sunny, calm, cold morning, becoming warm as the day progressed. For a first day it was very relaxed. Travelled by bicycle and covered a lot of ground, which is unusual for me. When on foot, I start work sooner. On the bicycle it was difficult to stop.

It was difficult to decide where to go. Initially, the woods, which are planted with firs, appear uniform, but as I travelled about, each area took on a different quality. The dunes without trees contrast dramatically with the woods: the openness, colour and bleached white grass.

I began to work at a place where I had stopped on my previous visit. I was curious to see if sand would stick to the rough-barked, large pine trees nearby and began to make a serpentine form against the trunk. Difficult at first – sand dropped off. Tried wet sand, but the water drained out, ran down the tree and weakened the sand below. Then I used drier, firmer sand, throwing it against the tree to gain a hold. Eventually I was more successful. The work was made for the light catching the tree from one side. The tree and its orientation were equally important. I am trying to understand the internal tree – the tree below and above ground and the process of it drawing nourishment through its roots – discovering the tree of earth that is within the tree of wood.

There was no sign of the sand dropping off as we left; in fact, it became firmer as it dried. I wonder if it will still be there tomorrow.

I also tried several things with branches which didn't quite work, so decided to leave. On departing, I noticed a dark shadow cast by the wood edge, so similar to the place in Nova Scotia where I made snow throws. That memory, the sun and white sand, made me decide to make throws. The light was good, but the sand dull, so again I set off back, thinking to make them another day if I could find whiter sand. Within about two minutes I found beautiful, smooth, white sand uncovered by horses' hooves. The needs of a sculpture allow me to find what is there.

Not a bad day. It was enjoyable and Andrew's first day as my assistant went well.

Tuesday, 16 March

Beautiful, calm, sunny day again. Returned to the same area as yesterday. Tried to wrap a sand edge around a tree. Had to anticipate how the light would fall on the tree in several hours' time. A very difficult piece to make. The sand fell off, and I spent more time replacing it than putting it on. Incredibly hard and frustrating at

Opposite, left
Damp sand
compacted to the tree
brought to an edge
to cut the light
drying hard
parts still fixed after one week

SCHOORL, PROVINCIE NOORD-HOLLAND
15 MARCH 1999

Below and opposite, right
Damp sand
pressed into tree trunk
difficult to stick
several collapses
took all day

SCHOORL, PROVINCIE NOORD-HOLLAND
16 MARCH 1999

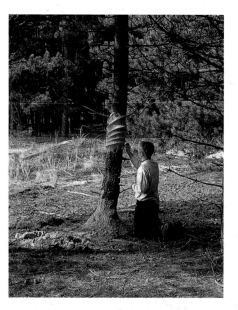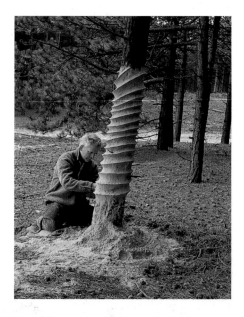

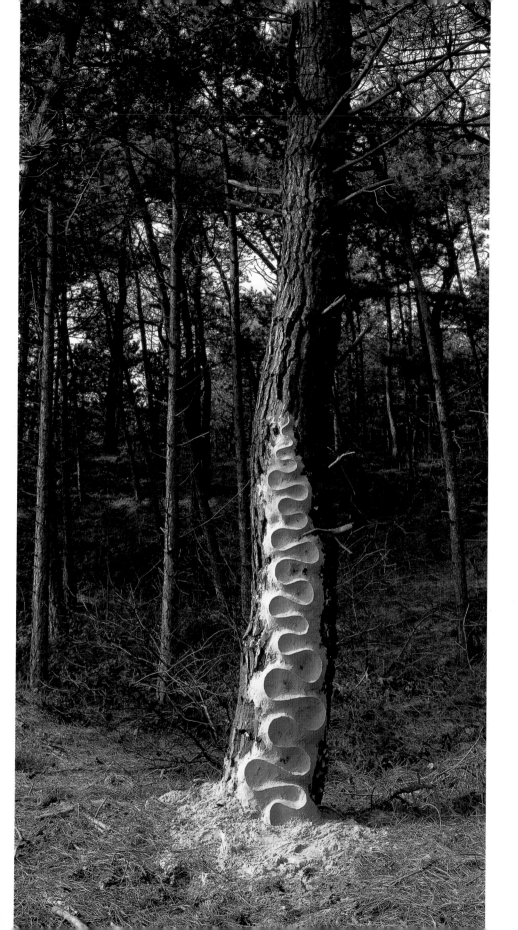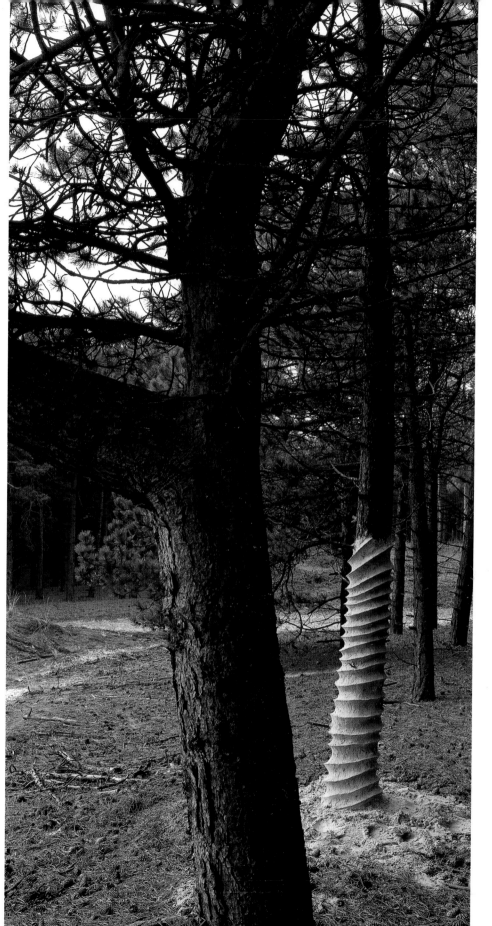

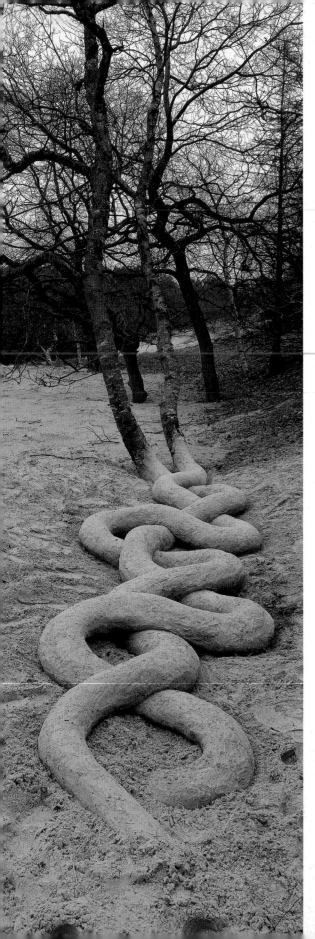

times. It took me from about 9.00am until 4.00pm to finish. When I stood up, I could hardly walk – I had strained a muscle in my side after having worked so long in an awkward position.

I have no idea if this is a good work or not. I became numb to it after several hours of trying to get the sand to stick. I found ways to do this, but it demanded a lot of concentration. At one point I asked Andrew to put sand on, but he couldn't get any to stick, and more fell off through his attempts. By the time I finished it had become cloudy – a good light for the work, softer and more interesting than harsh sunlight. The work gave the tree the appearance of screwing itself out of the ground. I have noticed before the spiralling growth of some trees, especially sweet chestnut.

There is so much in this place that I can't see. Trees that I cannot find and places that I do not know. I cannot explain what I am looking for, but feel there is something here. Seven days may not be enough to get anywhere close to it.

There seems to be a change in the weather. I don't know what tomorrow will bring. Yesterday's work was intact, whitening in the process of drying. As the day went on, small parts fell off.

Wednesday, 17 March

Rained most of the night, but by morning it had stopped. A beautiful, grey, calm day. My shoulder and sides were aching after the contortions of yesterday.

Worked among the dunes in the woods: white holes in the dark woods. Entering them was like walking onto a stage. On my first visit, I had thought that this would be a good place for the making of the stick house in 'Végétal' to be performed. Sand has drifted around some of the trees, giving me the opportunity to carve near to the trunk where the roots would normally be. I found two large birch trees growing together. The trunks may even join below ground and be the

Two trunks

extended into sand

carved and compacted

SCHOORL

PROVINCIE NOORD-HOLLAND

17 MARCH 1999

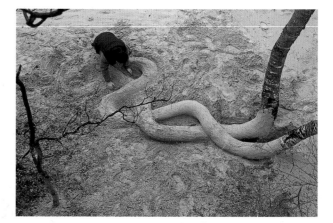

same tree. I extended the forms of the trunks into, then along, the surface of the sand. I enjoyed making this piece and have never worked sand so connected to trees, taking form, energy and movement from the trunks.

I remember from Haarlem this kind of ground with no stone. Today I have been given a glimpse of the wood that I have not seen before. This work could not have been on any other two trees – it belonged to this place and these trees.

Thursday, 18 March

Worked on a tree near yesterday's piece. Made sand 'stones' into which I carved holes, the holes and stones aligning so that they led to the tree. I enjoyed making this work and was pleased with it. The weather was perfect: calm, dry, overcast. At one point, it looked as if the sun might come out, which worried me a bit. The dark holes were made for an overcast light, not the harsh shadows created by bright sunlight. The damp, workable sand dried white. Just as I finished it began to rain heavily and, unfortunately, I had not photographed the work when it was completely dry and at its lightest.

This is the second time that I have missed the white. Even so, the work today looked well. I particularly enjoyed the way it drew the eye both to the tree and into the ground. As the day went on, the rain continued. I returned in the late afternoon to see its effect. The rain stopped just before I reached the site. The sand stones were mostly intact, apart from one hole which had caved in. The major change is the texture left by the heavy rain drops that dripped from the tree.

Went looking for a tree. I don't entirely know what it is that I want to do. There is one tree that I keep noticing but I cannot think how to work with it.

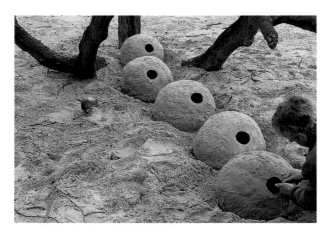

Sand stones
compacted sand
hollowed out
calm and overcast
began to rain just as I finished
returned later that day

SCHOORL
PROVINCIE NOORD-HOLLAND
18 MARCH 1999

125

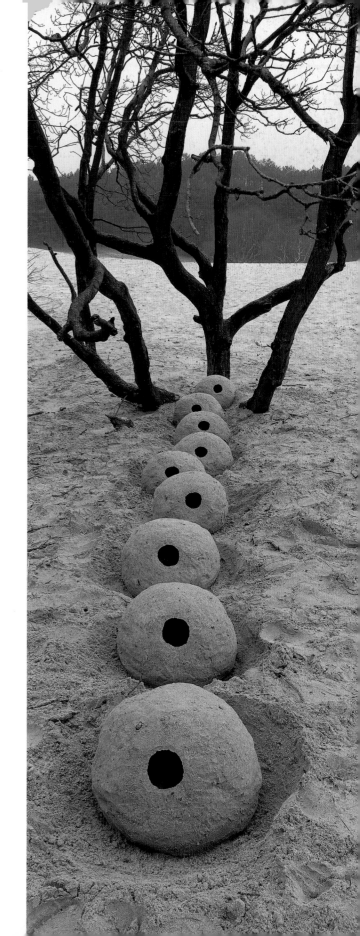

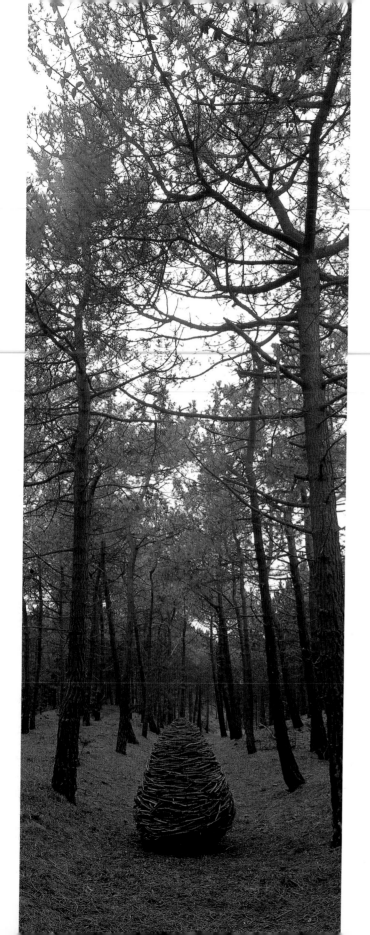

Stacked, windfallen
pine branches
one failure
and one partial
collapse
after completion

SCHOORL
PROVINCIE NOORD-
HOLLAND
19 MARCH 1999

Friday, 19 March

Went to the tree that I saw yesterday, but it still didn't feel the right place to work. Cannot really explain why. Returned to the dune where I had worked yesterday. Experimented with the curved branches that litter the pine forest floor. Realised I could stack these branches into a cairn and tried to find a good partner tree. Difficult to find one that would visually claim the cairn. The forest is too densely planted for the cairn to belong to any single tree. Space is necessary to isolate tree and cairn from their surroundings for the relationship to work. There should be no doubt about which tree the cairn belongs to.

I had to rethink the relationship. Perhaps the cairn could be made on a dune, giving it a feel of having been cast off by surrounding trees in their attempt to colonise the sand? Then I saw an avenue of trees along a path and decided to make the work there – not attached to an individual tree, but to a path. The form of the cairn is related to a seed, and it is in the nature of a seed to travel. The path gave a sense of movement and journey.

Difficult piece to make, and my first attempt failed. The branches are very springy and the more I placed in position, the softer the work became, spreading out and becoming formless. I had to rework it using stronger branches at the start. It was hard to find curved pieces and Andrew did well to collect the right branches.

This is the first time I have made a cairn of this shape from wood outside. I made one in my studio some time ago, but it did not really draw out the form of the sticks and I was not pleased with it. These curved branches gave me great control over the form and lent themselves to the shape, producing a tremendous sense of movement.

Just after I finished, there was a crack and the cairn settled, leaning to one side – so reminiscent of the ice cairn that I made in Nova Scotia.

Only one person came along the path today and, amazingly, he had also seen the sand works that I made on the tree. This is a vast place, and the pieces were so hidden that I'm most surprised someone found them, let alone coming upon me making another. Marcel and Robert came out and I enjoyed showing them the other works I had made.

At the end of the day, I laid a line of sticks on the dry sand. If it rains tonight or tomorrow I will remove the sticks, hoping they will leave a dry white line in the wet, yellow sand.

Although today's work is reminiscent of weaving, its closeness to that process only makes me aware of how different it is. In the 1980s I made woven ash balls in Grizedale Forest and on Hampstead Heath. Now I no longer bend the branches, but layer them. Between the works of those early years and today's were the windfallen oak balls that used thick, inflexible branches. Their

construction, like that of today's piece, was closer to laying stone on a dry-stone wall than to weaving. The process has strong parallels with growth.

Paths and the presence of people are important to this place both because of its current use (as a recreational area) and because of the reasons why the wood was planted in the first place. There are stories of how the dunes, before they were stabilised by the trees, drifted into towns and houses.

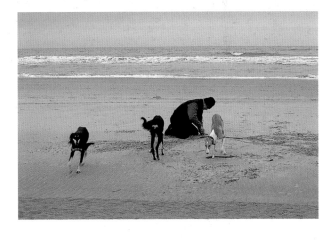

Saturday, 20 March

Intended to have a slower time after the intensity of the past few days. Decided to go to the beach, which is only a few hundred yards from where we have been working, but it is concealed by a ridge of high dunes. It was important to touch the beach and sea at least once before I leave. After all, the sea is the driving force in the making of the dunes, although today I learnt that the pocket of white sand where I have been working is glacially deposited. That white sand has been left by the force of snow and ice pleases me enormously.

On arriving at the sea, I rather confidently said to my assistant Andrew that the tide was coming in. The sand immediately in front of the sea was dry, and I began to make works in anticipation of what I thought was the incoming tide. Andrew predicted I had about ten to fifteen minutes.

Decided to make eight holes leading to the sea as partners to the eight holes I had made leading to the tree. The tide did not seem to move in either direction. It was difficult to decide where it was going. A man came by with a horse and cart. The tyre on the carriage had come off and he wanted a knife to cut away the rubber that was preventing the wheel from turning. He didn't speak much English and when we asked him if the tide was coming in, he said yes. He left and in doing so drove over the work that I had made so far! Saturday is a busy day on the beach and problematical for anything I make in the sand.

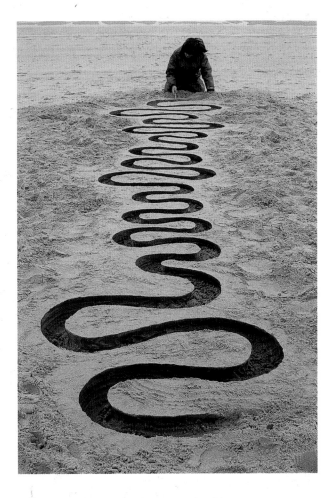

I started again, changing from the holes to a line – something that I had tried but failed at in the dunes, where it did not work because the surface was not flat. This form worked so well in Nova Scotia because it was made on the flat plane of ice, which is critical to achieving a flowing edge. One edge has to be aligned with the other, otherwise the tension and energy are lost. The sand was flat and hard, a superb surface to work on. Water made the flat, icy surface of the river in Nova Scotia and now it has had the same effect on the sand of Holland.

After digging the channel, I worked back to the original surface of the beach from which I tried to cut or add as little as possible. Eventually I realised that the tide was going out. During the day it receded much further, and I did not think that I would see it return in daylight. I had intended the work to be watched as the tide washed it away, but even if darkness had made it impossible for the event to be

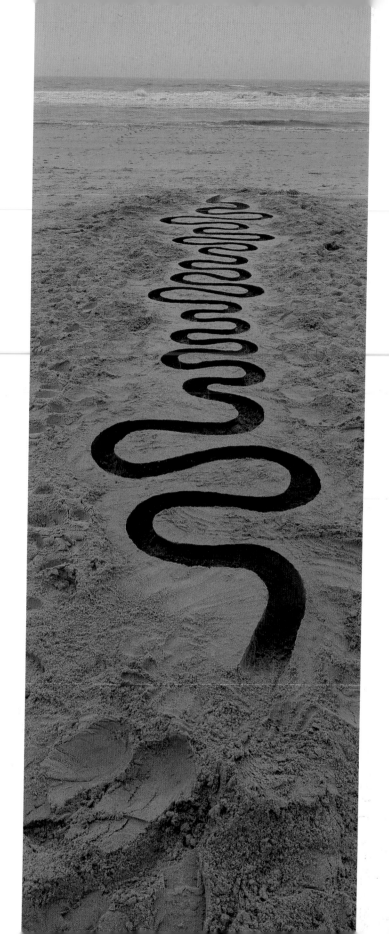
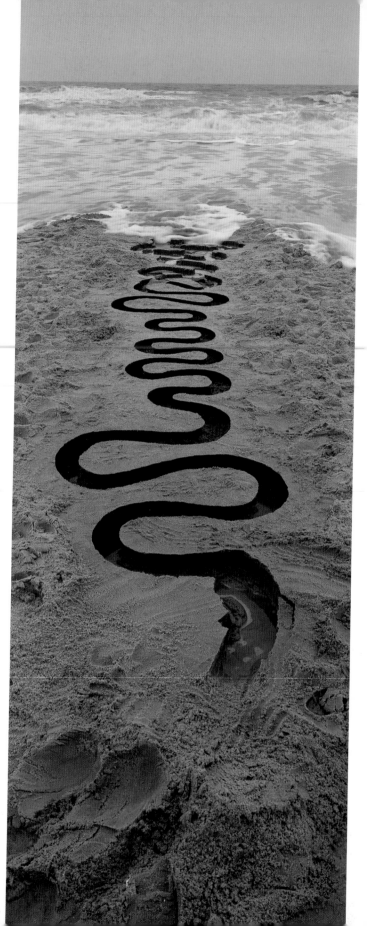

Saturday on the beach

so many people and dogs

hard wet sand

carved with knife

worked all day

tide coming in

late afternoon

windy, overcast, no rain

SCHOORL

PROVINCIE NOORD-HOLLAND

20 MARCH 1999

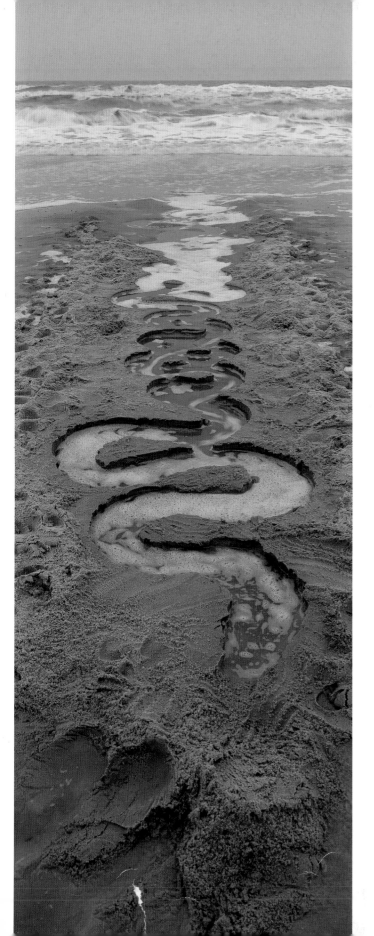

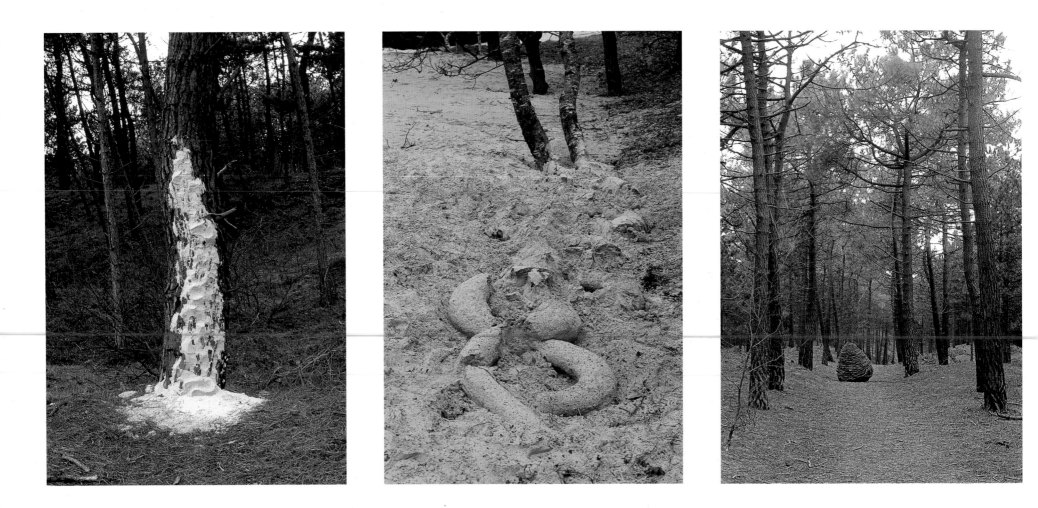

witnessed, it would still have been worth making. The ebbing tide meant that I had plenty of time to make it just as I wanted, allowing me to extract as much tautness and as many curves as I thought necessary.

There were so many people on the beach. They were drawn to what I was making. From a distance, the black within the channel appeared fluid. Dogs were the biggest danger, and I was always looking out for them. We talked to many people. Everyone spoke English, but no-one knew the tides, even people who looked as if they should know, like the man with the horse, or, later on, a man with a tractor, who thought he knew the tide times for June, but had no idea about today.

I finished very late in the afternoon, and the tide began to turn, eventually touching the work around 5.30pm. The piece was made on a slight rise, so when the tide reached it, water immediately flowed around and in front of it. In the end, it all happened extremely quickly. As the work was on a slope, water ran rapidly down the channel, which caved in as the water flowed through. It looked very beautiful, but I wished it had been a little slower, so that I could have enjoyed it more. These moments are always fraught, because I am trying to photograph at the

same time. It just so happened that the most interesting moments came when the tripod began to sink and I had to re-align the camera. However, it was still a great piece to finish on and must be dedicated to my assistant, Andrew, who is 30 today.

Sunday, 21 March

Last morning here. We will go to Groeneveld this afternoon. Revisited the old works rather than making a new one. The sand works in the dune next to the tree have been more or less completely trampled by people. There are still remains of the sand that I compacted against the two trees, and this is unexpected. The stick cairn has settled even more to one side and looks well, as if it belongs there.

Tuesday, 23 March

I have been unable to keep a diary for the last two days because things became very hectic in the transition from one place to another. Before we left the dunes on the 21st, it began to rain, and I returned to the stick line. I had hoped that the

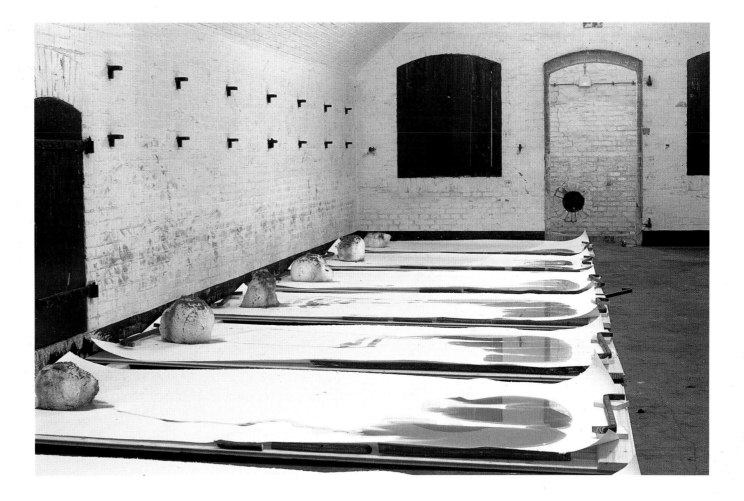

Snowballs
stained with dye from beech nuts
thawed on paper
dried

FORT VECHTEN, BUNNIK, PROVINCIE UTRECHT
23 MARCH 1999

sticks would leave a dry, white line in the wet sand. It didn't work. The rain had run underneath the sticks and broken the white line.

When I departed for Groeneveld, I hoped to make snowball drawings the same day, but due to a misunderstanding this was not possible. Instead, I walked in the woods around the castle. Some of the trees are extremely beautiful, and I found a narrow avenue of beech trees which would be a perfect place for a partner cairn to the one that I made at Schoorl.

Got up early on the 22nd in an attempt to make a work before doing the snowballs and going on to Amsterdam to give a lecture in the evening. The pressure became too much, and I didn't make anything other than a few touches with peaty mud on trees.

A frustrating day because the distance between Groeneveld and where I am making the snowballs is much greater than I anticipated. I will not be able to do the two in tandem, dropping in to see how the snowballs are going in between the works. Not only do I lose time travelling to the fortress, but the long and complicated journey along motorways breaks any thought processes that may be establishing themselves at Groeneveld.

I laid out all the snowballs on paper to melt. The place was originally a fortress – one of several that were built on raised ground so that the surrounding area could be flooded by a breach in the dykes, making an attack impossible. Then aeroplanes were invented.

Each snowball is stained with dye extracted from the seed of the beech tree. It's the first time I have made a group of snowballs all using the same seed, all roughly the same size and all melted in the same room at the same time. They will relate to the beech trees at Groeneveld that grow just outside the gallery. These all grow in the same place, from the same kind of seed, but each tree is different from the next. The snowball drawings will, I hope, have a similar quality.

Today, I returned to assess the progress of the snowball drawings and was delighted to see they had melted sufficiently to leave interesting traces on the paper. It has been cold and I thought they might not have melted at all. I took off

Beech nuts
steeped in water to extract dye for snowballs

the remaining snow so that I would not have to return that day and could finally begin work at Groeneveld.

There is a beautiful, black, peaty soil that I did not see when here last. I worked the peat into a vividly green tree and began to make yet another curving form. I made the form more open, so that the tree was a more integral part of the line. The line was defined by two parallel edges. I sometimes worked ahead of myself – marking out the route of the line. I liked the fragmented quality this gave and eventually left it broken in parts, even taking some of the work off. This was very difficult. It is one thing to leave a work unfinished and another to try to create the feeling of it being unfinished. One happens by chance, and the other is forced.

I decided to complete the work, which confirmed my view that it was a much stronger piece when fragmented. When complete it took on a designed quality. It did not integrate with the tree and lost its energy and movement. The fragmentation I introduced to the piece is something that would have come about in the end as pieces dropped off: allowing this process to happen over time would have been the strongest option. But I wouldn't have been here to see that. The peat will cling to the tree for a very long time, unless we have extremely heavy rain.

Wednesday, 24 March

This has been my first full day at Groeneveld. The last few days – with the change of locations, travelling between here and the snowballs, and the talk in Amsterdam – have been very unsettling. I have little remaining time here to make work.

It was dry, which was a relief after the last few days of cold rain. The tree trunks had dried out, but I remembered how dark they had been when wet. Yesterday the beech trees were streaked dark and light. I began to experiment with water on the trees. I first touched on this a year ago in Montreal with maple trees, but although it was winter, the weather was so dry and sunny that the water evaporated very quickly. There was more chance of succeeding here, especially after the heavy rain. Even though the trees were dry on the surface, the damp atmosphere helped the water stain last longer. I made line drawings, but found it hard to get the right line and, inevitably, squiggles appeared. I am beginning to be almost irritated by this form and decided to make a damp patch on the tree, which was a relief after the linear works I have been doing.

Once again, I was drawn back to the serpentine line. It is difficult to explain these obsessive forms. Today I found that the more controlled and the thicker the line, the less it appeared to be a stain of water, and that is what made it strong. It is difficult to believe that the dark areas are achieved only by water: it looks painted or varnished. Enormous variations exist within the same material. A tree can be perceived in many different ways, which add up to an understanding of the tree

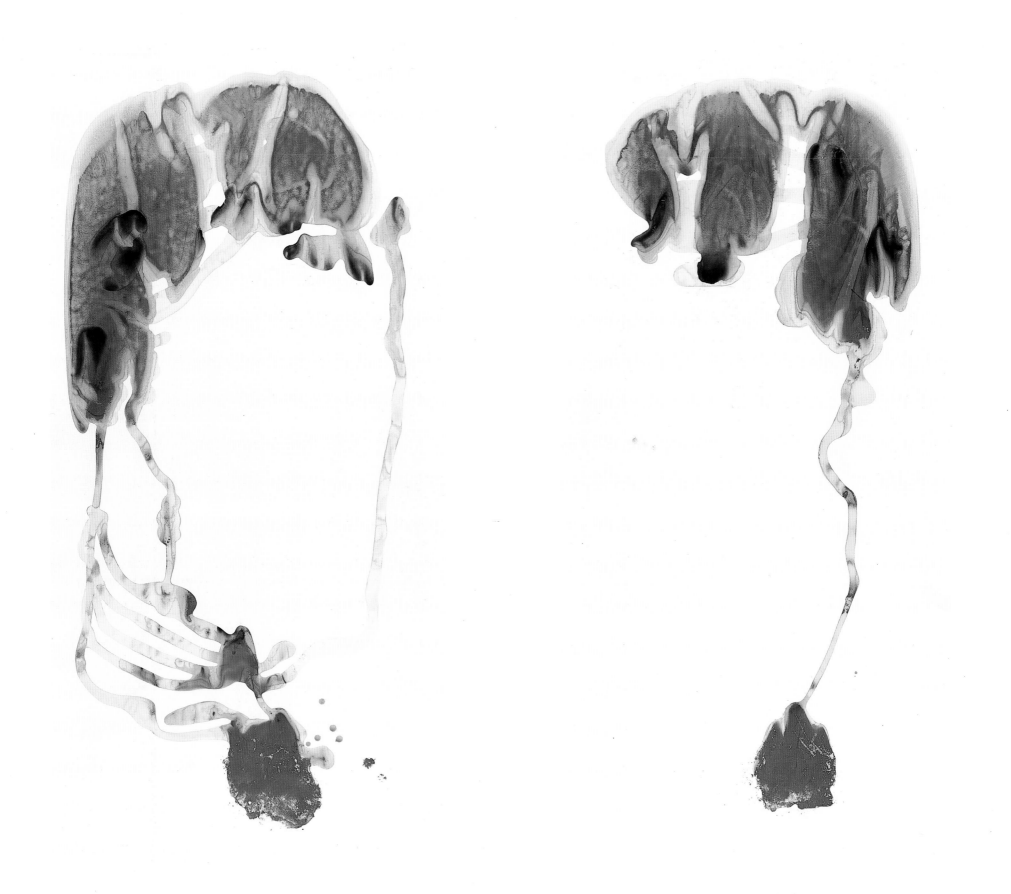

as a whole. To discover and show side by side wet and dry, dark and light, is to reveal just two of the many trees that exist within a single tree.

My difficulty today was that I was finding something new, yet was at first unable to draw it out into form. The best work that I made was a long, wide, curving form, as long as I could possibly make it. By the time I had worked from top to bottom, the top had begun to dry. It was impossible to finish. It would always be an unfinished piece. I liked it for that. The line then dried out. Photographed it as it disappeared. As the black line faded, a white shape appeared as evidence of where the black had been. The rubbing on of water with a damp cloth had left a white shadow. The whole process was a joy to watch.

After that, I returned to the patch on the tree which had now dried, though its position was evident from the marks left by applying the water. I was able to rework a negative of the patch, so that now the inside of the hole was light.

In the afternoon I checked on the snowball drawings, which were drying very slowly. I have put fan heaters in the room to speed up the process, but they keep going off while I am away, which is frustrating. The drawings work best when they dry up by evaporation. I can, if need be, lift water through suction, but this inevitably brings off pigment too and loses some of the drying patterns. This is especially important for the drawings made with vegetable stains – colour extracted from earth and stone adheres to the paper better and is less disturbed when the water is taken off. If I leave the water too long, the work will go mouldy. This is something that I may at some point encourage, but not for this particular group.

The drawings are so vulnerable while they are lying in the fortress, and I cannot protect them. They can be so affected by the way that they are handled from now on – how they are picked up, touched, transported. All this can add interesting qualities that may become a legitimate part of the process. However, having seen the drawings pristine, I will feel disappointed if, by the time they get to the exhibition, they have been smeared. At the moment, they have something of the quality of freshly fallen snow.

Thursday, 25 March

Beautiful, calm, sunny, very warm day. Such a contrast to the last few cold, wet days. The settled feeling to the weather helped me to settle into a better working rhythm, which is probably also connected to my having been here for a few days.

I decided to make a beech cairn in the beech avenue that I came across on Sunday. We had already collected some branches, and today Andrew was assisted by Marcel van Ool (art consultant to the project) and Annemarie van Velzen in bringing branches from much further afield, this time in a small truck. I worked carefully and slowly with only two collapses at the beginning. A cairn is a more

Water
drawn on a dry beech tree
soon drying and fading
leaving evidence
of how water was laid
on the trunk with a cloth

GROENEVELD, PROVINCIE UTRECHT
24 MARCH 1999

134

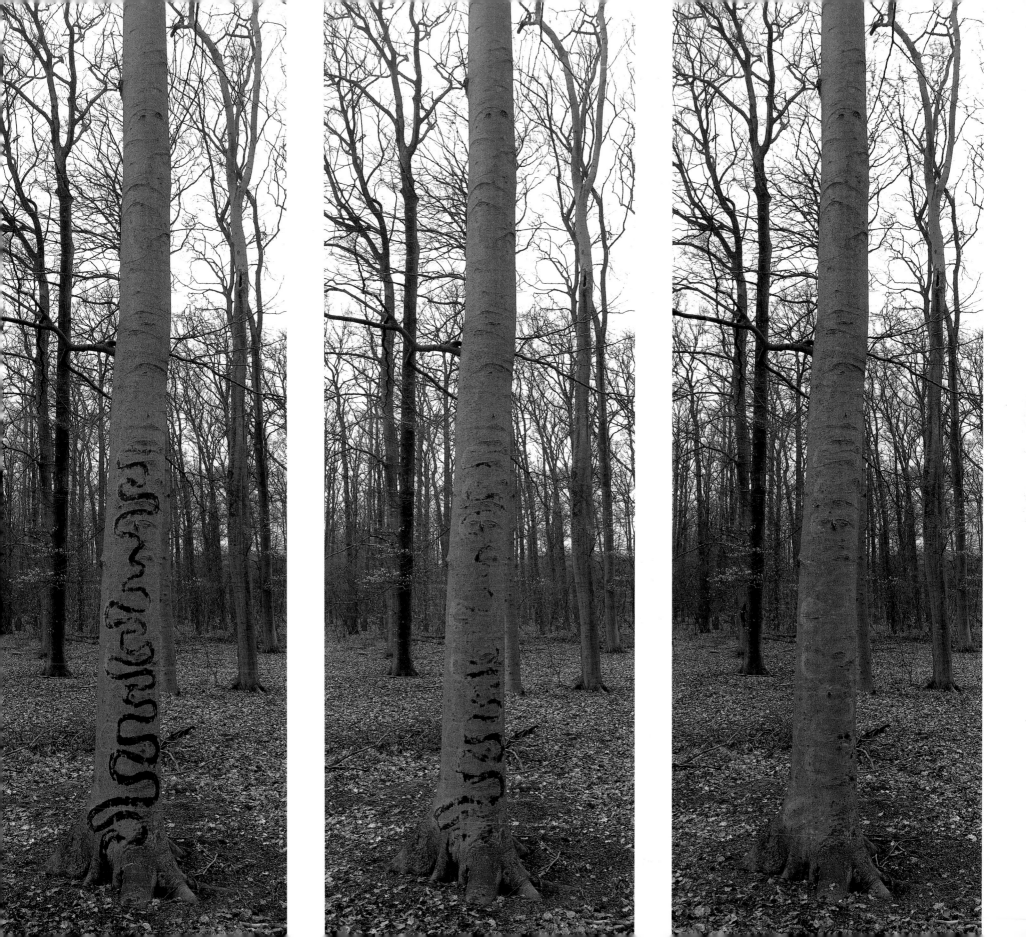

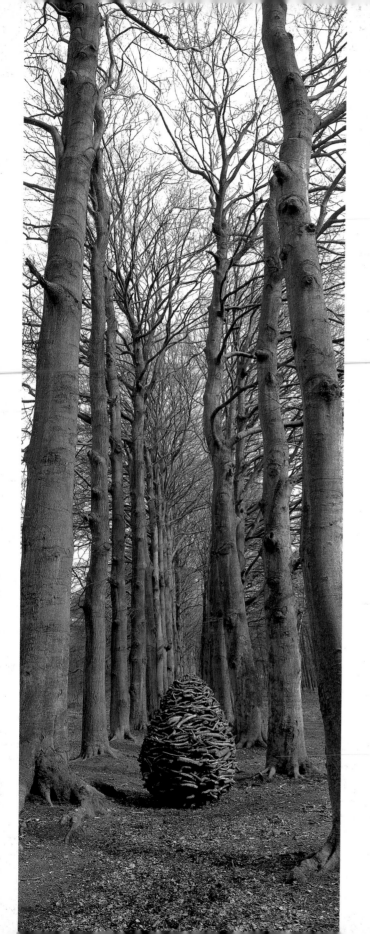

demanding form than a ball. There is far more danger of the shape losing itself in ways that do not matter in a ball. It is a major step for me to work with wood as I do stone, layering piece by piece and working from the outside in. I am pleased that a form which until now was so rooted in stone has finally found expression in wood.

The cairn took on such a strong presence as it grew in the avenue. I could not have thought of a better piece for that place, with its sense of line, space and distance. Placed within the perspective of the avenue, it took on a tremendous energy. People first see the work from some way off, then, as they are drawn towards it, they slowly discover what it is and eventually, how it is made. Those who saw it during and immediately after construction were intrigued, but finding it after I have left, with no explanation, is the best way to see this piece.

It was about three o'clock when I finished. Because the day was so beautiful and calm, I decided to make another piece – a stick dome hole against a large bulbous beech tree that I had seen the first day I arrived. It became overcast as I began and rained at one point, which worried me slightly, because I was using dry, light wood to form the hole, giving an increased sense of energy around the black. Fortunately, the rain didn't amount to much. The piece was very difficult to make, even though I have made a similar one before. I was tired, and it is always hard to form the hole on a vertical face. There were many collapses. It was also difficult to get the right intensity of black space within the hole. The tree itself is quite dark, which didn't help. When forced by the fading light to finish, I stepped back, walked some distance away, turned around and only then realised how strong the black was and how good a piece it had become.

Windfallen branches
stacked
to mark a pathway between trees
going on an unexpected journey
a few days later

GROENEVELD, PROVINCIE UTRECHT
25 MARCH 1999

Opposite
Began late in the day
tired after previous work
hole difficult to form
end of the day forced me to finish

GROENEVELD, PROVINCIE UTRECHT
25 MARCH 1999

When working, I see the work close up, then step back with the memory of knowing what is inside the hole, which is different from looking at the hole after approaching it from afar. It had such a strong presence from a distance, which was sustained even when you had walked right up to it. The black was piercingly intense, drawing you to the centre of the sticks and into the tree.

Darkness was falling as we finished. This has been a great way to end my time in Holland. Earlier, as we were leaving the cairn, a farmer on a tractor came up and asked what were doing. Marcel explained. We saw him going to see the work as we left. Some time later when I was working on the tree, he came to see us, said how much he had enjoyed the work, and took his grandchildren to be photographed in front of it. A week or so later I received a letter from Marcel telling me that the same farmer had taken the cairn and placed it in his garden! This had been reported by one of the foresters who felt it should have remained to decay where it had been made. Many unusual things have happened to my ephemeral work. I don't see them as being under my control and I often enjoy the unpredictable journeys they take.

In some ways it was appropriate for a work related to the seed to be gathered up by a farmer. Movement could also be seen as part of the nature of a work made on a path. However, on my return to Groeneveld several weeks later to install the exhibition, I felt a sense of loss at not being able to see the cairn, even as a collapsed heap of sticks along the avenue of trees, now so changed by spring. The new leaves might have given the cairn a sense that from within it came growth, turning what at first appeared as the death of a work into a continuation of its life.

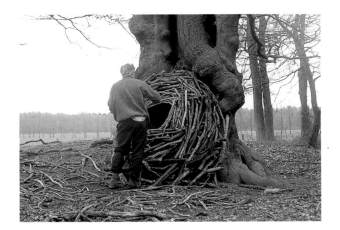

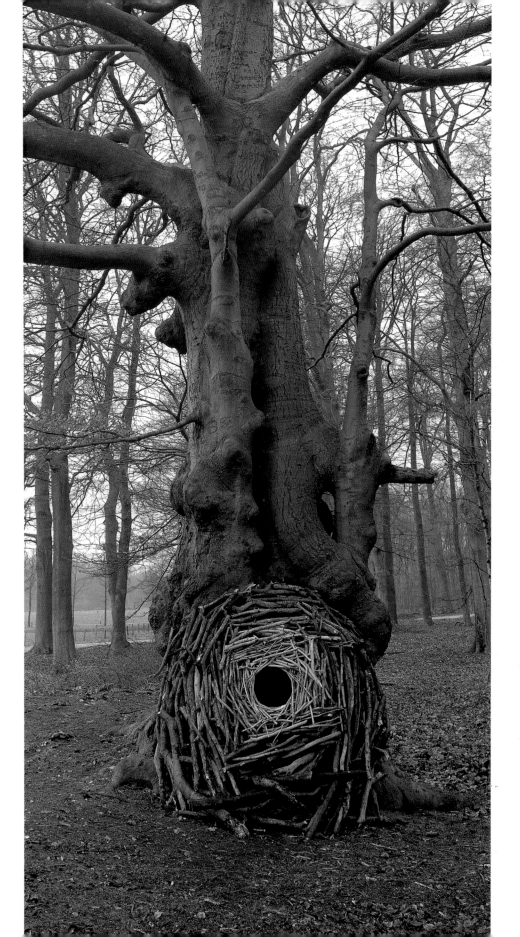

NEW MEXICO

Monday, 12 July

The last time I came to Santa Fe, I visited the home of Chuck and Bobbie Miller at Galisteo, and, while there, found a dried-up riverbed. I have now returned to this place, my interest in it even stronger after making the clay wall in Digne. There is no water, but still a strong sense of flow and movement – a river of earth. Last time the sand in the riverbed was soft and difficult to walk upon. Now it is firm. There is clay in the sand, which gives a hard surface – good to carve into. I walked only three or four yards along the river before beginning work, making a channel similar to one done recently in Holland and also connected to the Digne clay wall.

It was difficult to get a sharp edge. The sand varied between fine and gritty; the gritty was the most difficult to work. Once cut, there was no putting the sand back. It is not easy to put damp sand on dry or to make sand hard again once it has become friable and loose. Having little room for error gives tension to the making that I quite enjoy. I was pleased with the form, which had an irregular flow and movement. The morning was overcast, a good light for making this work, but around midday the sun came out. What had been a soft, enclosed, dark space became harsh shadow. I left and returned in the late afternoon. The setting sun made an interesting stripe of light that contrasted with the shadow within the channel, but once the sun had gone, the work glowed with a quiet energy. Not as dramatic as in bright sunlight, but much more powerful.

This is a good start.

I have been told to be careful about the danger of flash flooding. I like the feeling that at any moment the river could be flowing again. Today's work is an attempt to touch on the flow that is always present, with or without water.

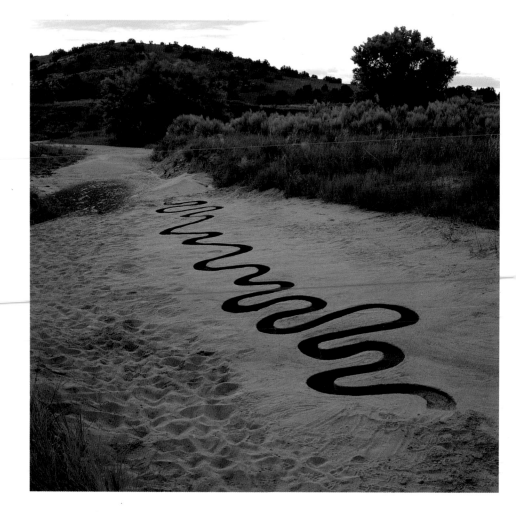

Hard sand
carved
going dark as I finished

GALISTEO, NEW MEXICO
12 JULY 1999

Tuesday, 13 July

Sunny, clear morning. Returned to the riverbed. Yesterday's work is still intact. Thunderstorms are forecast. I was hoping that I might be able to see the work under a cloudy sky. There was a strong colour in the light of yesterday evening which I quite liked, but I may prefer the more neutral colour of the day. I had more energy yesterday when it was cooler. Today was very warm, which I found difficult. Probably I was tired after yesterday's work.

Tried various touches, nothing substantial. The best attempts of the day were sand throws, made so that the sand appeared white against the shadow cast by the banking as well as casting its own black shadow on the ground. A long time ago, in San Diego, I made stick throws with shadows. I think today's were

stronger. They remind me of the clouds you see from an aeroplane and their dark shadows on the land, apart yet connected, the presence and absence of sun.

In the afternoon, I went looking for other places to work. I am finding the driving tiresome, but it is difficult to work in the immediate vicinity of where I am staying, as it is predominately houses and private property. At one point it started raining and I managed to pull over, lie down and make a shadow. Not enough rain to make a strong shadow – just a faint trace.

Wednesday, 14 July

Returned to the riverbed a bit earlier in the day than before. It was already warm. Drifted around making drawings, touches on sand and rock. Dusted the rock with fine, powdered clay and made a line with my finger – similar to work I have been doing this week at Storm King and, a few weeks ago, in France.

I began to find the heat difficult, so worked in the shadow of a tree. I carved shallow holes into the hard crust, not really knowing what I would make, curious to see what lay below. The riverbed, like bedrock, has been laid down in layers of different deposits – sand, clay and stone – which have turned hard as the river dried. The work I made on the first day is beginning to be eroded by the wind, revealing layers within the channel.

The holes in today's work have become windows into which I laid sticks all pointing in the same direction – a flow of wood beneath the sand. The piece took quite a long time. I know these temperatures are not extreme, but I find the heat difficult, unlike cold, which makes me work to keep warm.

Thursday, 15 July

Much windier today. The circulation of air gives a new dimension to the place – a river of air. The moving sand interests me. I drew in soft sand, catching the morning light, and then watched the drawing erode. I laid down a line of sticks, hoping that the drifting sand would cover the line. I'll wait and see. The works themselves were mediocre, but the changes that might happen to them could make them more interesting. I need to touch the flow of the river – dry or wet – and to make works that follow and explore its movement and are not just objects waiting to decay.

Yesterday's work was done with a knife, which today I decided not to use. Although this seems like inviting difficulty, it may actually force me to be more sensitive to the place and to find ways in without having to make a cut.

In the afternoon, I went a little way up from where we are staying in the mountains. I found a trail that ran alongside a stream, so lush, green and cool. Butterflies. There were many plants with red, foxglove-type flowers – much

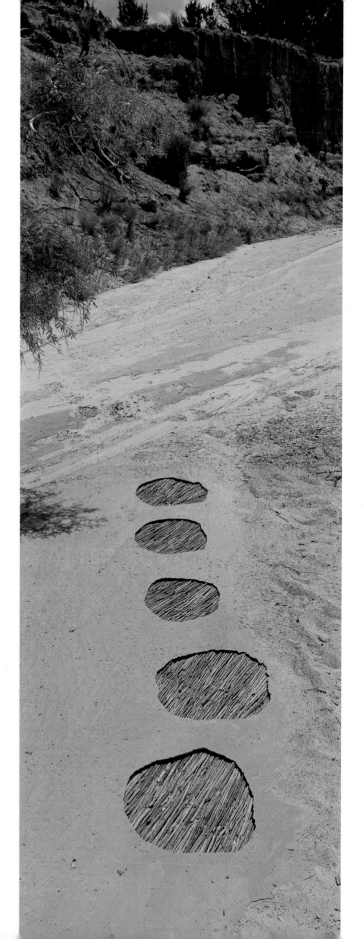

Cut holes
into river crust
carefully laid sticks
in holes

GALISTEO, NEW MEXICO
14 JULY 1999

smaller and thinner, but similar feel. It reminded me of the foxglove line that I threaded on to rushes and wound across a wheat field in Scotland and prompted me to do a variation here.

I threaded flowers on to thin, supple grass stalks which I then suspended in the green grass to make a red line. The contrast between the red and green animated the line. It began to rain, as so often here in the afternoon, and I was worried that it might become a downpour and knock the line apart. Fortunately, the rain fell as sparse, heavy drops, which actually kept the work fresh. It was a perfect atmosphere – damp and calm. The red was made even more intense by the overcast light.

After I'd finished, the sun came out and the colour drained from the line. The change was dramatic, and I photographed the work both in and out of the sun. Although a small line, it really held its own from a distance before the sun came out. The path above gave a view directly down onto the work.

I needed to make this work and have been nourished by it. It is good to have found this cooler place. Nevertheless I feel that working in the riverbed where there is no water has come at a time when I can appreciate its significance. Although a harsher environment, it is the one that I can learn most from here, and I will return to it tomorrow.

Friday, 16 July

After seeing the effects of the wind eroding the first day's work, I decided to remake it in another place more in sympathy with the wind. I would very much like to make this as a partner work to the one I made in Holland, where the channel filled with sea water. Now the channel will erode and fill with sand. The two works would connect the fluidity in both earth and water.

I am here for only for two more weeks, and it may not be time enough for the work to erode. Also, if the river flash floods, then it will be gone, which would be

interesting if I were present at the time, but that is unlikely to be the case. Today's weather was perfect for making the work – overcast to begin with, becoming sunny and warm, but most importantly, remaining calm until towards the end of the afternoon. This meant that the edge to the channel was not eroded. The sandbank was much better than the previous one, less gritty. This sand was consistent and hard with a flatter surface, resulting in a far better work. My only difficulty was the afternoon heat. I started to have cold shivers, which I suspect may be a sign of sunstroke. I went to a nearby house for water. I must have looked a bit hot and was revived with iced tea and sandwiches!

The riverbed is hotter than its surroundings. Just walking away from it made me cooler. The light reflects back off the white sand. It is a very intense place to work. When I returned, clouds gathered for the almost ritual afternoon thunderstorm. I had anticipated that this would happen, that it would become cloudy as I finished. I was making the work for an overcast sky and kept this in mind as I led the channel through the brighter parts of the day.

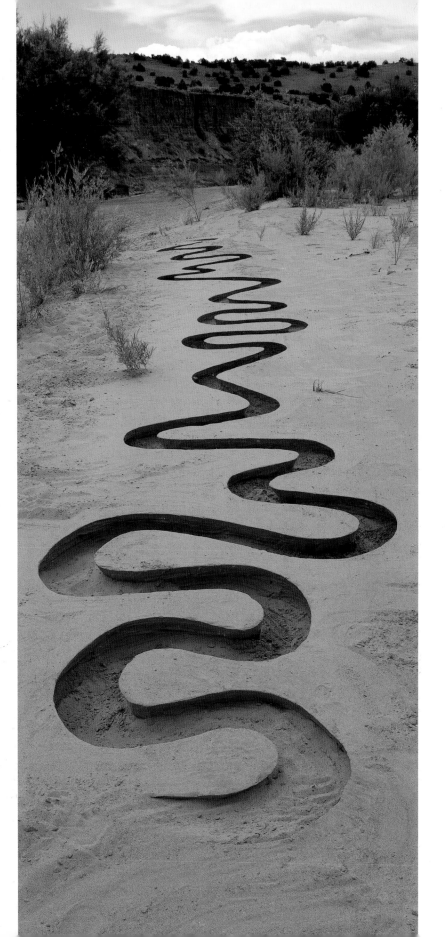

Black river
hard sand
carved and dug
long hot day
becoming cloudy

GALISTEO, NEW MEXICO
16 JULY 1999

Opposite
Red flowers
threaded onto rushes
laid in grass
calm, raining, overcast
sun coming out after I finished

SANTA FE, NEW MEXICO
15 JULY 1999

I am pleased with this work. It is very different to the one made on the beach in Holland, but at the same time a partner to it. I now have to wait and see what happens to it.

Saturday, 17 July

It rained last night, not much, but enough to make the riverbed wet. What a difference the moisture has made. The ground is now sticky and soft. None of the previous day's works has been too much affected. I felt a bit tired after the long day yesterday and made a brief touch on the soil bank. The moisture allowed the sand to be worked and I brought it to an edge to make a line. Had some interesting qualities but was not a great work.

Sunday, 18 July

Very heavy rain last night. On the way to the river, there were places where the road was washed out. A car had been swept off the road while attempting to cross the river, but by the time I arrived, the water had gone. Everything that I have made has been taken away – it is as if I was never there. The riverbed has been made new. Wet with clay and soft sand.

The work that I had hoped would be eroded by the wind is also gone, which is obviously a disappointment. I don't really know what to do. The distance from where I am staying to where I am working prevents me from seeing the river's rapid changes. I could make this work again in the same place. Even if it doesn't erode as I would like, the idea of two works in the same place, of the same form, is interesting – the similarities would throw the differences into sharp focus. But I don't know if I have the energy. Today the sand was too soft, and tomorrow I intend to go off with the family elsewhere. Perhaps when I return I will be able to take it on again.

Everything was wet. I was able to pursue ideas touched on yesterday, when it was only possible to work for a couple of hours before the sand dried out. This time, I was able to make a much more interesting drawing with the earth. The sky was overcast, which gave a good light to work in. I made an edge with mud on each of four promontories along the riverbank. Responding to light and shadow, the line took on a horizontal quality, connecting each drawing to the next and giving a collective sense of movement in the same direction as the river.

This could be a great piece, but some of its intensity was lost as the light changed during the day. When the sun came out I continued working with an overcast sky in mind, knowing that the clouds would probably return in the afternoon. When this happened, the orientation of the edge to the light had changed. In fact, it

had looked much stronger with the sun on it. I still think it was a good piece and suspect that the cause of my disappointment lies in my feeling tired after working all day.

The first drawing I did was the best, with the most energy and sensitivity: it seemed almost to float on the surface. The last was the harshest, done in full sunlight, when I didn't know what I was doing. I may return tomorrow, if it doesn't rain too much tonight.

There were times when I stepped back to view the piece as a whole and lost all sense of its scale: it appeared huge, as if I was looking at tall cliffs in the distance.

Monday, 19 July

It had rained again overnight. I returned to yesterday's work, hoping to see it under an early-morning, overcast light. The light was much stronger on the piece, but the overnight rain had washed parts of it away, which in itself was quite interesting. I was uncertain about whether to repair it or not. I decided to repair, the light was so good. I filled gaps that had appeared and redid the edge on the existing line before it dried out. Finished just before the sun came out. I made another work nearby – another edge but this time curved.

Later on, the first work dried and became a more integral part of the cliff. The sun went in behind heavy clouds. The timing was perfect. This piece has a feel of things that I have been making in the trees in Scotland, and of stones in France and at Storm King, but it is also new work.

I left early, because I am going with the family to Bandelier National Park. The forms of the cliff dwellings are not unlike the holes that have appeared in my work for so long. In fact there is so much here in this landscape that strikes a chord because of things that I have made, I am pleased to be coming here now and not earlier on in my life. To have come here earlier would have been too soon.

In the evening, we went to Jemez Springs where we stayed overnight.

Tuesday, 20 July

Set off from Jemez Springs. Took a dirt road through woodland and pasture. What a contrast to the places that I have worked so far. I stopped along the route to make something, but I find it difficult to drive and work. There isn't the same feel, sensitivity and commitment to the place when you just drive, stop, get out and make a work, then get back in the car and go again. I don't like working in this way. But it was good to get a general feel for the different landscapes and I enjoyed seeing them with my family.

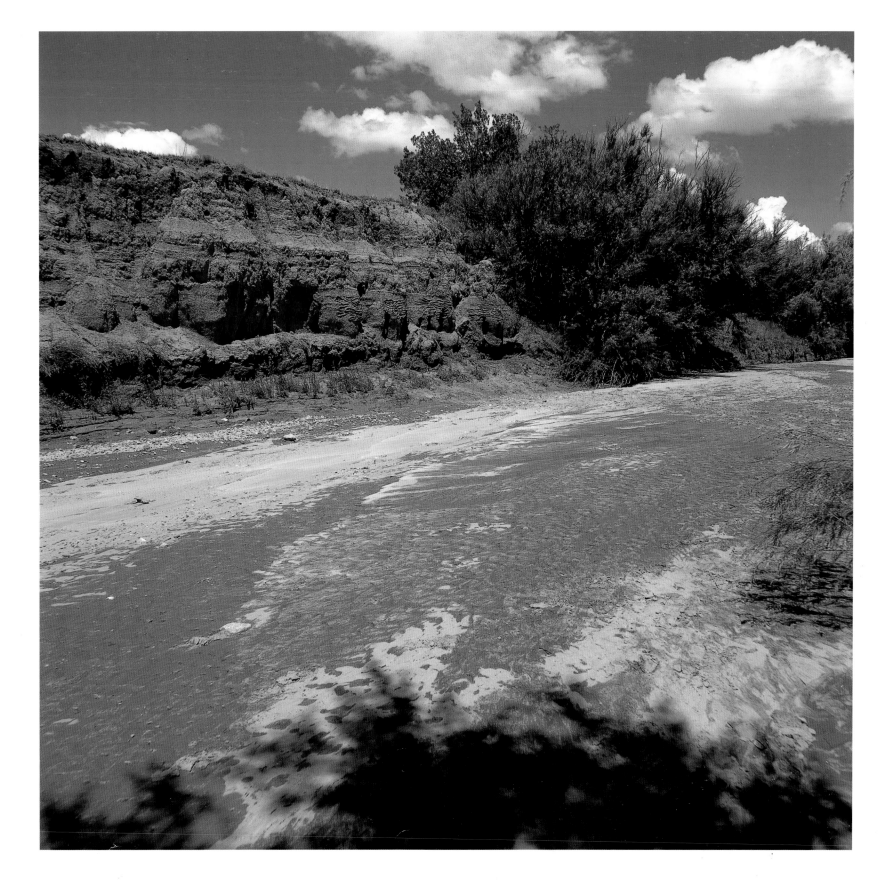

River in flood
the previous night
wet mud and sand
worked into
four, edged drawings
catching the light
made over two days

GALISTEO, NEW MEXICO
18-19 JULY 1999

143

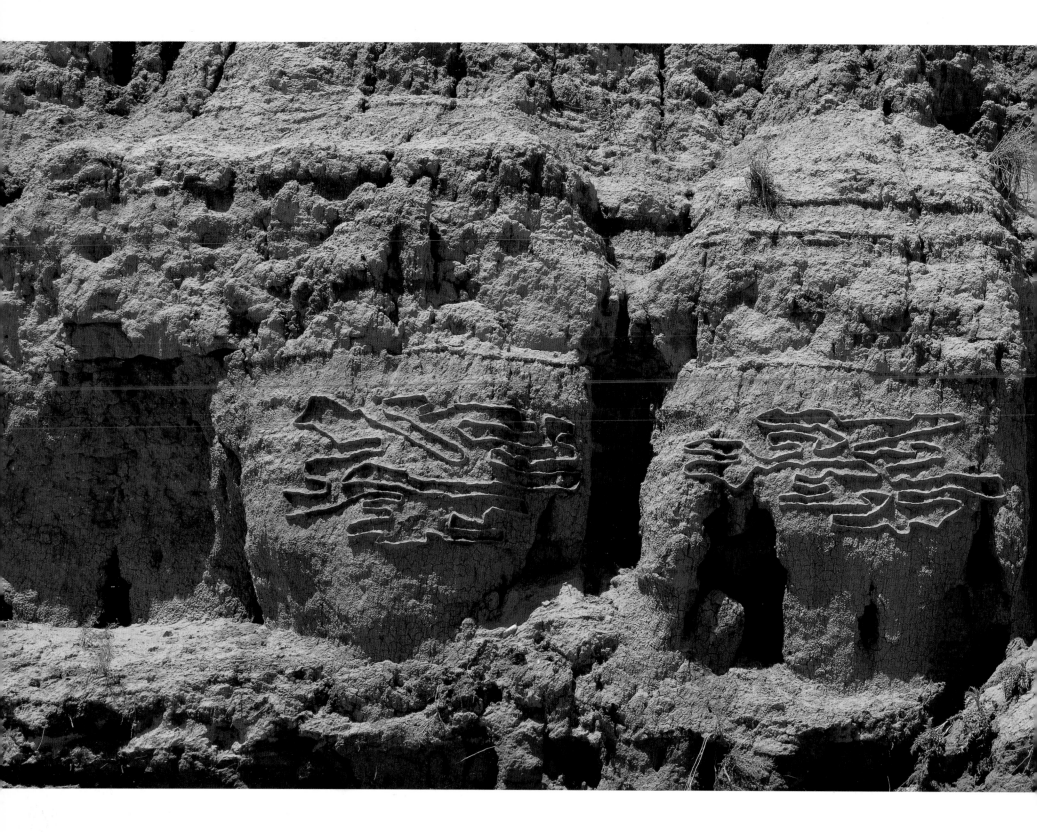

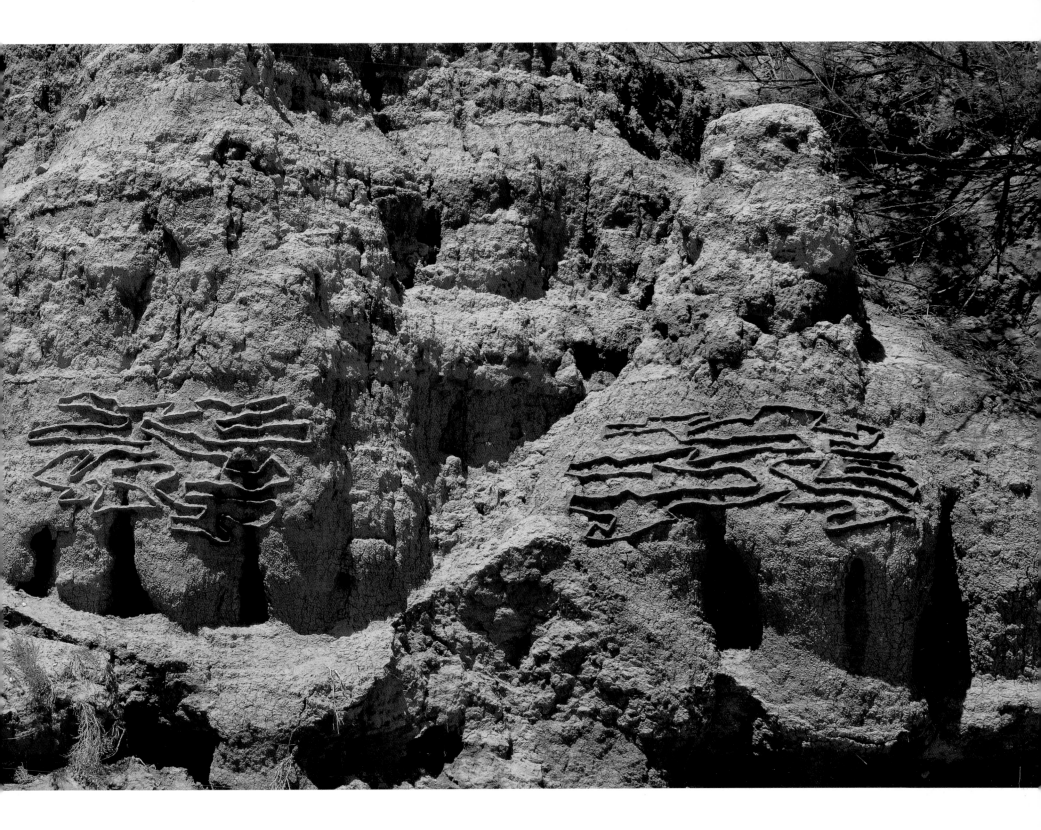

Coming down the mountain to Jemez, there were the most extraordinary red sandstone cliffs. It must be the strongest red that I have seen in sandstone. I crossed the river, leaving the family swimming, and climbed up towards the cliffs. Another intense place. The colour is vibrant, the stone fragile, and freshly fallen red boulders are littered about. A precarious place.

On the way up I followed dried-up streams that have run down from the cliffs, carrying earth with them, leaving veins of red. Although I have never seen the red as exposed as this, it makes a strong alliance with all the work that I have made involving red stone and earth. I feel very much at home in a strange place.

The work that I made was something intended for a red sandstone quarry near where I live. I worked sand into the stone, as I have worked earth into trees in Scotland, exploring forms and cavities within the stone or tree.

The compressed sand becomes as stone. The sand was originally stone and could eventually become stone again. To work sand into stone in this way is very much in keeping with the nature of stone. Achieving these forms through sand and not by carving touches the fleeting nature and movement of stone – a link between the solid and fluid states of stone.

Although it is a long drive from Santa Fe, between one and two hours, I have to come back to this place, perhaps tomorrow. After recent rain, the sand is damp beneath the surface. I could not make these works with totally dry sand. There is, however, a river relatively nearby, so I can always moisten the sand if necessary.

Wednesday, 21 July

Went back to Jemez and the red cliffs. A long drive. I will probably not work here again this trip. But what a place! The things I could make here! The orientation of the cliff is perfect. When I arrived in the morning, just after nine o'clock, the whole cliff face and the rocks at the bottom were in shadow. They stayed in shadow until around ten. If I were nearby, this would have given me three hours

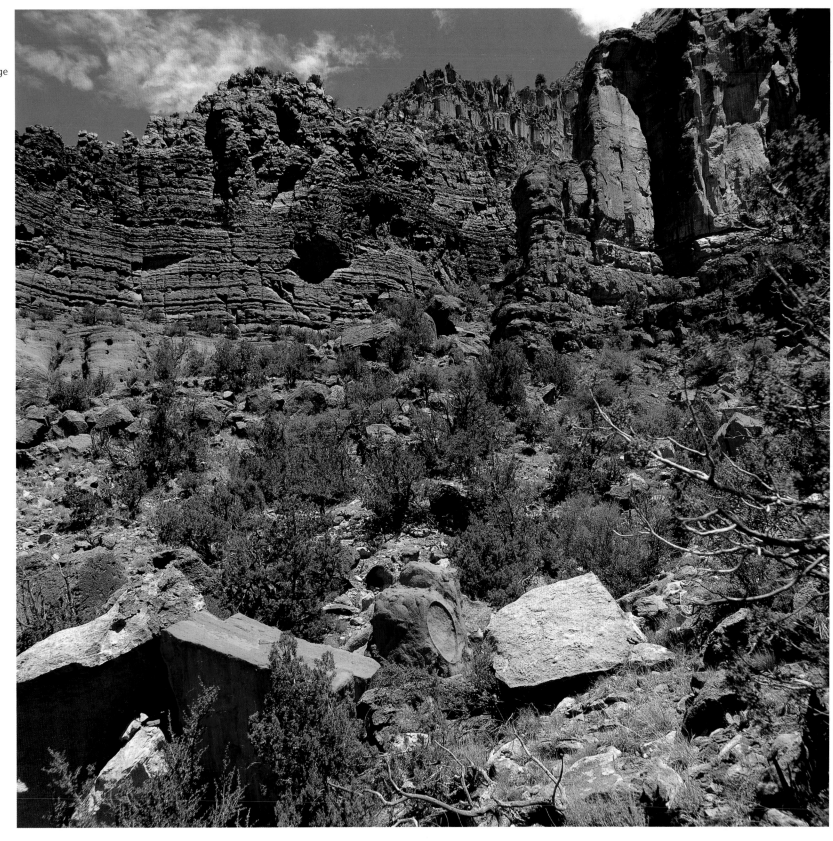

This page and page 148
Found a form
within the boulder
worked damp sand into an edge
returned several days later
after rain

JEMEZ, NEW MEXICO
21 JULY 1999

page 149
Dug down
for damp sand
worked sand to an edge
in and out of the boulder

JEMEZ, NEW MEXICO
21 JULY 1999

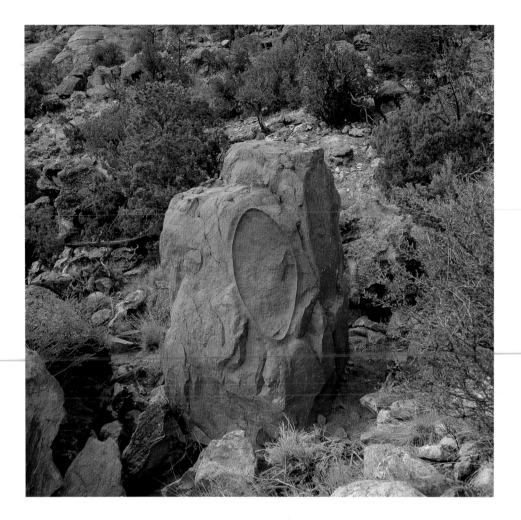

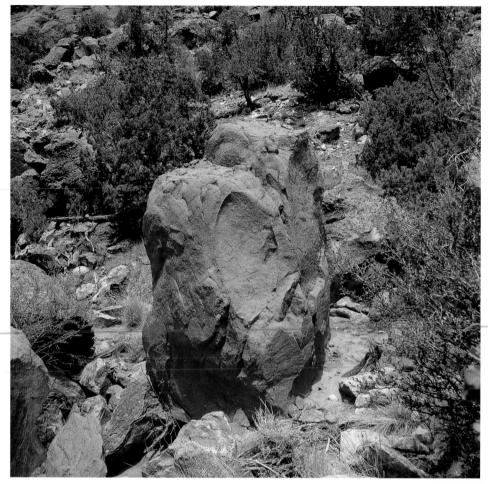

of work in the cool. More than that, I could prepare works to be touched and activated by the sun. Today, I could only attempt to understand the relationship between the rocks and the light.

Again, I worked into the shape of a rock with sand, making a simple oval form. These rocks have such a strength. They are like no rocks that I have come across before except in the quarry in Scotland. They are so fresh, vibrant and red. The contrast between the red of the stone and the occasional green growth is quite violent.

I made a second piece, but by this time the heat was getting harder for me to deal with and the sand was drying as I put it on to the rock. I brought some water from the river and wet the sand before putting it onto the stone, which made the work a lot easier. A curving, serpentine form emerged, in and out of the stone, using the facets and hollows within the stone. I cannot help thinking of the works made on trees in Scotland. These are such strong partners to them, although very different.

There were a lot of lizards, but I saw no snakes, although this must be a place they frequent. Again in the afternoon, rain clouds came over and rolls of thunder, but no actual rain. There is great drama to these days that build up to the event of a storm.

Thursday, 22 July

Went to Pecos, a wilderness area, trying to find somewhere to work nearer to where we are staying. As with most things here, distances on the map are deceptive and it was further than I thought. I took my sons Thomas and Jamie with me, so it was more of a day off and a day out. I only managed to make a very small, bad piece of work.

Friday, 23 July

There have been two nights when, in the early hours of the morning, the most pungent smell has started to arise around where we are staying. The first time it

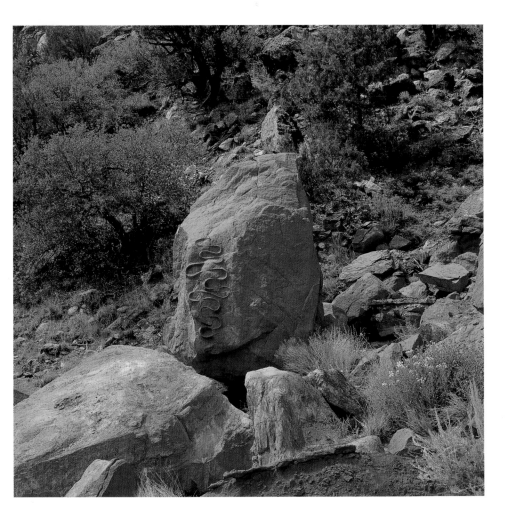

was so strong it made me almost ill. I have no idea whether it is the drains or a skunk. We did see a skunk one night, but I don't know what it smells like. Last night the smell started again and I did not sleep so well.

Being tired, I decided to try and make a work in a place where we had stopped off on one of our tours of the area with the family. It was an entrance to a cave that I had seen, with a floor of white sand. The sun cast a very strong shadow over the entrance, so it was black and white. I attempted a throw, similar to the one in the riverbed last week, where the white was in the shadow and the shadow of the white was on the white sand. After a long drive, walk and climb, I arrived at the place. It is very popular with visitors, which makes it difficult to do a piece of work. What made it impossible, however, was that the orientation of the light was not as I had hoped. I had really wanted the sun to be directly above, as it is around twelve o'clock, but at that time, the sun didn't cast a shadow between the light and dark – everything was in shadow.

I would have had to wait until later on and, by then, the alignment between the

sand and the shadow it cast would not have been what I wanted. I decided instead to gather up some of the dust from the floor, which I carried back with me and might take to the riverbed to make throws there. There is something interesting about carrying away the dust. No longer a stone, it is closer to air. It is as though I have breathed in a lung-full of the place that I will exhale elsewhere. That this material was once volcanic ash gives it an energy which will add to the energy I give to it when it is thrown. There is also a sense of spreading ashes.

Although the day was a total failure in terms of making work, it threw up some interesting ideas.

As we drove back from Albuquerque, a dark, heavy thunderstorm hung over Santa Fe, throwing out bolts of lightning at random intervals. Seeing the lightning – each strike a variation of the same energy – gave a new perspective to the idea of reworking forms in the same place. Repetition can be very powerful.

The storm was dense and solid in appearance, almost like a stone from which drawings of lightning were being generated. I have never seen anything quite as

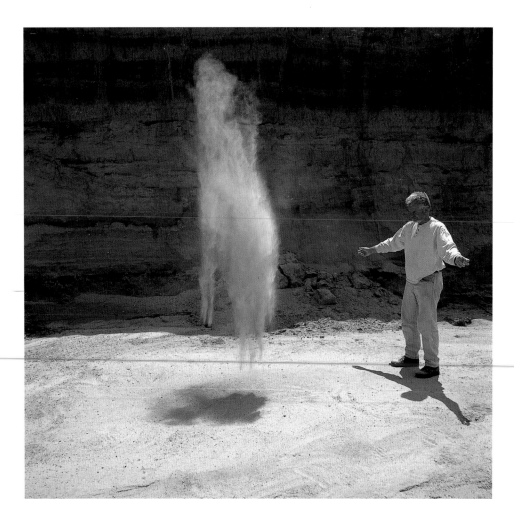
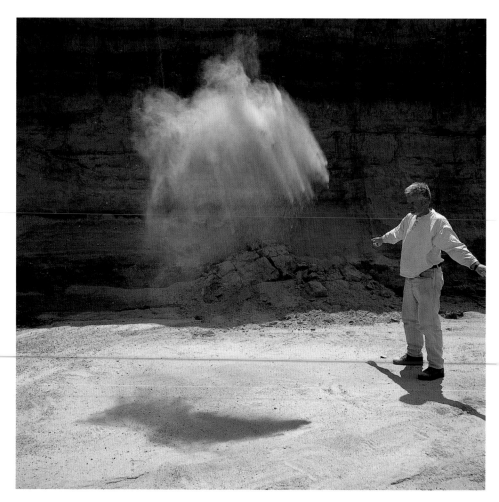

concentrated as this storm. Elsewhere it was reasonably sunny, bright and dry, in stark contrast to the sky-to-ground wall of blackness which was too solid in appearance to be described as cloud.

Tomorrow, I will probably return to the riverbed to see what has happened, what has changed and will possibly remake the black river. I certainly feel more energy for that idea after seeing the storm.

Saturday, 24 July

Bright, sunny morning. Took the ash to the river to make the throws. Waited for midday, when the sun is at its highest and the shadow is as directly beneath the throw as possible.

Whilst waiting, I collected sticks to make two patches, laid in different directions, so that they catch and turn the light as it changes during the day, similar to a work I made in Digne.

At midday, clouds began to accumulate and it looked as if I would be unable to make the throws. Fortunately, the sun hung on the edge of the clouds for just long enough. As I finished, the clouds thickened and it began to rain. I lay down on the patch of sand I had just thrown, hoping to make another shadow, this time with my own body. This is the third time I have lain down here in the rain to make a shadow. The previous two attempts left only a faint trace, as it did not rain enough. But this time the rain gathered momentum and fell with tremendous force. I don't remember ever having been so wet. There was the added problem of being in a dried-up riverbed prone to flash flooding. The ground became so wet that I began to sink slightly and the river began to run. I was forced to get up before it stopped raining, and the shadow was quickly lost.

In the evening I returned to the stick piece, and I finished it just as the sun began to go. It worked well, turning the sticks dark and light. With luck it will be sunny tomorrow morning, and the reverse will occur.

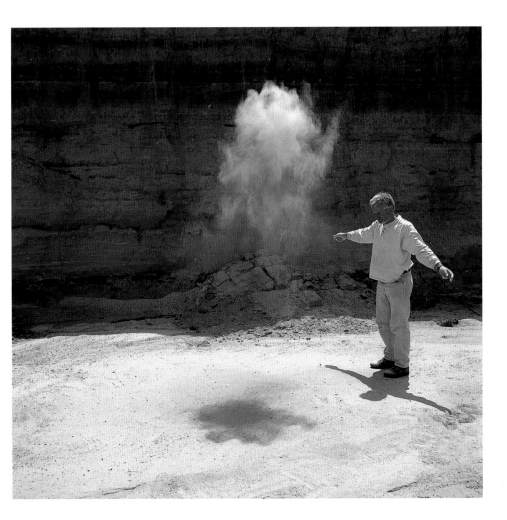

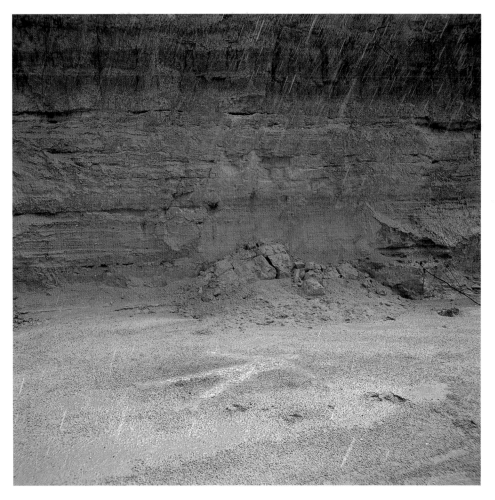

Ash throw

and shadow

midday sun

on the edge of storm clouds

began to rain heavily

lay down

leaving a shadow

GALISTEO, NEW MEXICO

24 JULY 1999

Photographs by Jamie Goldsworthy

Sunday, 25 July

Returned to the stick piece. Perfect! A complete opposite of yesterday.

Made a work using green leaves. Strangely, there seems to be wider range of green here than I have in Scotland. I made a line to follow the different colours of greens. Not a great work, but interesting to do. I then made a hole with the green radiating out from the centre. Again, although it was good to see the range of greens, it is not a form that I am particularly interested in pursuing at present. It didn't work as well as I wanted. There was too much texture in the plants. I would have had to spend a lot more time quietening down the texture, leaving just the colour.

I then carved into a shallow bank of sand, making a round stone form out of the bank. This was much more interesting and has potential for other ideas. A day of various successes and failures.

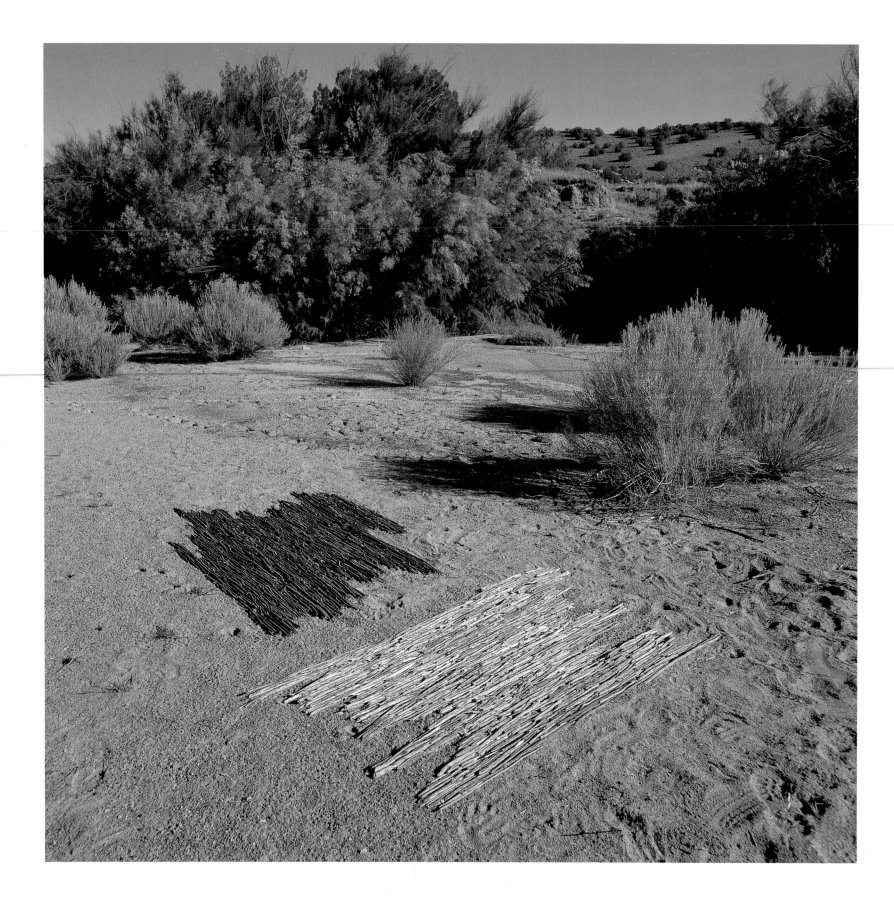

Sticks
laid in different directions
to change with the light
late afternoon
early morning

GALISTEO, NEW MEXICO
24, 25 JULY 1999

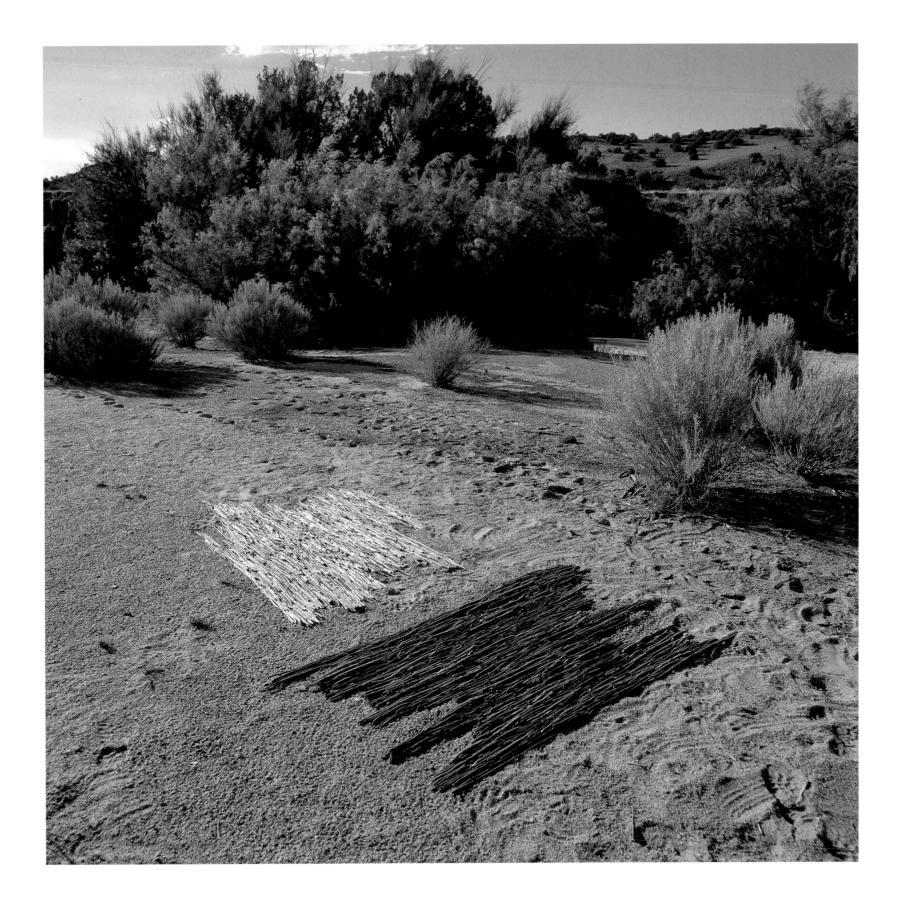

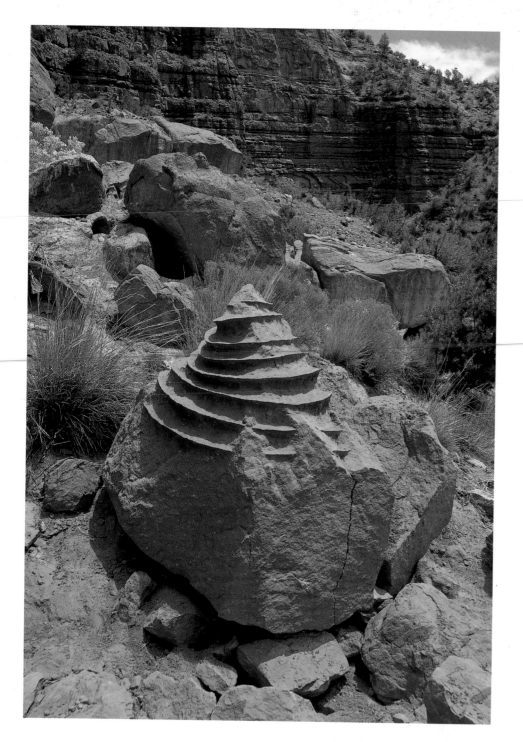

Sand worked around the top of a rock
cutting the light

JEMEZ, NEW MEXICO
26 JULY 1999

Monday, 26 July

Returned to Jemez. It is a ridiculously long journey, and I had to go back to the SITE Santa Fe museum this afternoon. But I do so want to work here. I also wanted to see how the other pieces that I have made have fared in the rain and to photograph their disintegration. They had in fact been partially destroyed, but there was enough left to show where they had been.

Began working on another rock, taking an edge from the tip and spiralling it down. Reminiscent of the icicle wrapped around the tree that I made at Penpont.

When I arrived, the cliff was in shade and there was little colour visible from the road. If I had come across it at this time of the day, I might have passed it by. Many things are visible only at a particular time of the day, under a particular light. When the sun is shining directly onto the cliff it becomes intensely red. Difficult to believe it is the same place.

I love walking into the cliff's cool shadow. I am able to walk around with more energy, looking at rocks and spaces. That energy drains out of me as the sun begins to creep over to where I am working. 97° Fahrenheit today – it was so hot. My work rate slows down the hotter it gets. I look forward to fording the river on the way back and to the cool water on my legs.

Tuesday, 27 July

Returned to Jemez. Tried to work in the same place as before, but the river was too high to cross. It must have rained heavily overnight upstream, so I went instead to a smaller outcrop of red rocks by the side of the river. These rocks seem to have been there for a lot longer and have worn rounded. One, however, standing upright and pointed, had an edge on it that cut light into sun and shadow. I worked on this edge, making it sharper with the sand, following the line and introducing some gentle curves. A very subtle piece and I don't really know if I will like it. Each work teaches me a little more about the stone.

I forgot to get water from the river to wet the sand and make it workable and had to use my drinking water instead. Fortunately, I finished reasonably early, forced on by the sun rising higher and the shadow becoming less intense. I would have dearly loved to return to this stone to remake the piece earlier in the morning, which would have given me time to meet the sun and to work with it rather than against it.

Wednesday, 28 July

Didn't know where to go – to the dried-up river or the red rocks. Eventually decided to go to the red rocks. When I arrived, it had been raining. The ground was wet, and I was afraid that the river might be high again, preventing me from

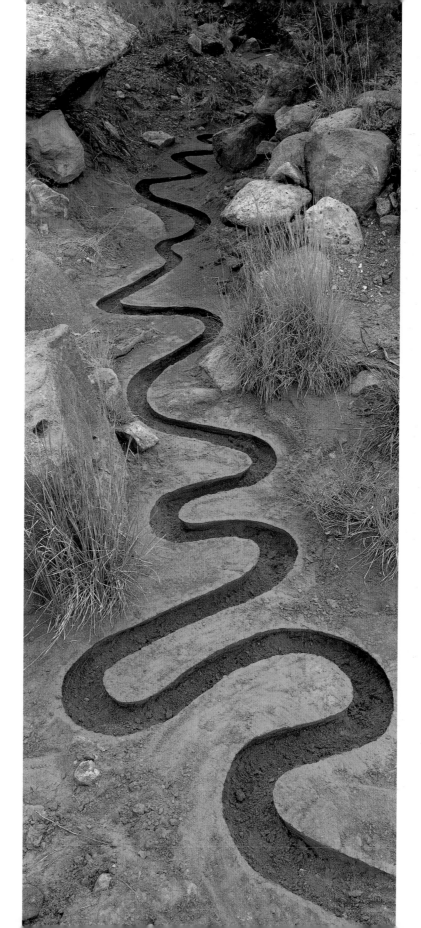

Red river

JEMEZ, NEW MEXICO

28 JULY 1999

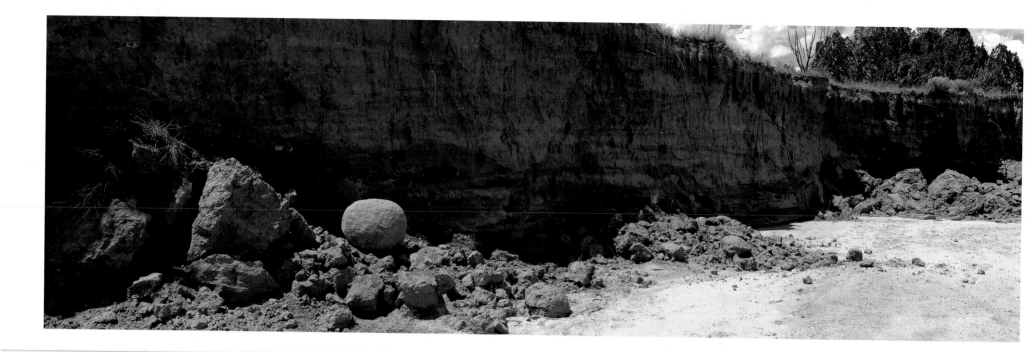

Boulder
carved and smoothed
from a rough block of collapsed river bank earth
left after recent flooding

GALISTEO, NEW MEXICO
29 JULY 1999

crossing over to the cliffs. The river was down. This is the first time I have been here when the ground has been wet, and it allowed me to work on the red streams of sand that led to the cliff.

This sand is between stone and water – evidence of a deeper movement, energy and change. These feelings are made stronger by the red, which has a flow and life of its own. The red streams running from the cliff were once the cliff itself.

I have worked with many rivers here in New Mexico, two of which, while dry, have obviously had water flowing along them at some time. There are also rivers of sand, of stone, and the river of red. When I worked with red sand on red stone I was dipping my hand into the red river that runs through all nature. My idea of the river is much more than just the water.

What I have made here in Santa Fe has finally made some sense. I have learnt a lot by working with the absence of water.

This will be the last time I work here. It is a wrench leaving this place. I have only worked here for a few days. This may be why I feel so torn. There was almost a

tear in my eye as I left, but then I know that I will touch this place again when I work with the red of Scotland, Australia, France . . . I am very grateful for this opportunity to have deepened my understanding of red.

Thursday, 29 July

My last day here. Went to the riverbed. Judith and the children came with me. Didn't really intend to do any more than a touch. It was a sunny morning. After revisiting the pieces that I had made previously, I worked black holes in the shadow of a sandbank – black in black.

I almost left, but then began carving and smoothing a rough block of soil lying amongst the avalanche debris caused by river erosion. The piece turned out to be more interesting than I expected and was reminiscent of the grinding down and smoothing of a rough stone that has collapsed into water, whether river or sea.

I had seen many times the strong contrast between the sunlit riverbed and the intense shadow cast by the bank and hoped to make something that used the

illuminated foreground and the deep shadow beyond. The now-smooth block of soil was directly lit by the sun and had great presence from quite a distance. There was a large tree just above it, growing at the very edge of the banking, and the earth boulder felt connected to it, as if it were its seed.

I felt happy to leave the river after a work like this. In the afternoon it began to rain heavily. On my way to Albuquerque, I saw that some of the rivers were beginning to flood. This was the first time I had seen the arroyas in flow. The water is not like a river, it is full of earth, a river of earth. An extraordinary sight, after seeing completely dry riverbeds for three weeks.

'Two Rivers' installation, SITE Santa Fe, New Mexico Friday, 24 March 2000

I have returned to install an exhibition at SITE Santa Fe which sponsored my visit here last year. Photographs of work made then will be presented alongside the installations. The gallery is housed in a huge former coldstore building. Although some of the walls are fixed, others are reconfigured for each exhibition, so I have been able both to respond to the structure and to rework it. I don't have much time to carry out what is an ambitious installation. I had hoped that the sand would be here when I arrived, but Craig, the Exhibitions Adminstrator, was worried that he had got the wrong kind and wanted me to see more samples.

Today I began the construction of a yucca blade screen – Craig collected the materials yesterday. The blades are held together with a fantastic thorn from the Russian olive tree, which is found here. The sand for the floor is damp and compacted in layers, so with luck it will keep its shape when I carve into it. I have made myself a very difficult environment to work in. The sand is being brought in by a diesel-driven bobcat, which kicks out a lot of fumes. We found that the best way to achieve the compacting was to put a board between the whacker and the sand, which caused even more noise than when the sand was hit directly. The team helping me with the installation is working hard and well in difficult conditions. The attitude and enthusiasm amongst the staff here is fantastic.

I have got over halfway down the screen and the hole is almost fully formed.

Saturday, 25 March

Returned to the museum and was shocked to find that the screen had collapsed overnight. I have only once before had an indoor screen collapse and in that case I knew why and was able to solve the problem at the second attempt. With this screen, however, it feels more complex. There is something I don't quite understand about this material. It appears that some of the thorn holes have opened in the drying and the thorns have fallen out. Some of the thorns that I

used were very short, which obviously hasn't helped. But it is the drying out of the plant that is the problem. This surprises me in that it comes from the desert. I had thought that the moisture content would have been minimal, but perhaps the whole point of the blade is that it conserves water. The screen had collapsed almost to the top, but it had not fallen off where it was attached to the wall itself. Ironically, when I arrived and saw the scale of the opening and the ease with which I was able to get thorns into the wall, I remember thinking, this is going to be quite simple. I have made this work and form in spaces ten times bigger than this and felt extremely confident about doing the piece. How the making of art can prove me wrong! In some ways, this takes the work closer to the experience of making something outside. Were it not for the deadline of the exhibition opening, I think I would quite enjoy the remaking of this piece because of the challenge of understanding the nature of the material and the space in which I am constructing it.

By the end of the day, I had managed to get as far, if not further, than I did yesterday. I have made the screen denser and used shorter blades and longer thorns. I hope that this will make it stronger. I don't want it to become, as one of the installers put it, 'a Groundhog Day'.

The sand floor is now complete. What a noisy, smelly day it has been. The installers have worked so well in such difficult circumstances. I hope the piece that I make will justify all the effort that has gone into preparing it.

The collapsing of the screen, a form and method of construction I know so well and have succeeded in so many times, has undermined my confidence and this makes me nervous when I look at the sand floor. This is a work that I have never attempted inside before, so perhaps my anxiety is a good thing.

Sunday, 26 March

Woke up this morning with a bad headache, feeling sick. Had intended to get to the museum early to work on the sand floor, but decided instead on the easier task of collecting more yucca blades to complete the screen. Afterwards I went to the museum, but didn't go in, as I felt much worse. Went to bed for the rest of the day.

Monday, 27 March

Up early, felt a bit groggy, but after sleeping so much over the past 24 hours, I felt I must have some reserves of energy to take on the piece at the museum. It was good being there by myself to begin with and I was able to work out the best way to make the piece. The sand has a sharpness about it that has cut my hands, which consequently are sore. I managed to work from six o'clock until eight in the

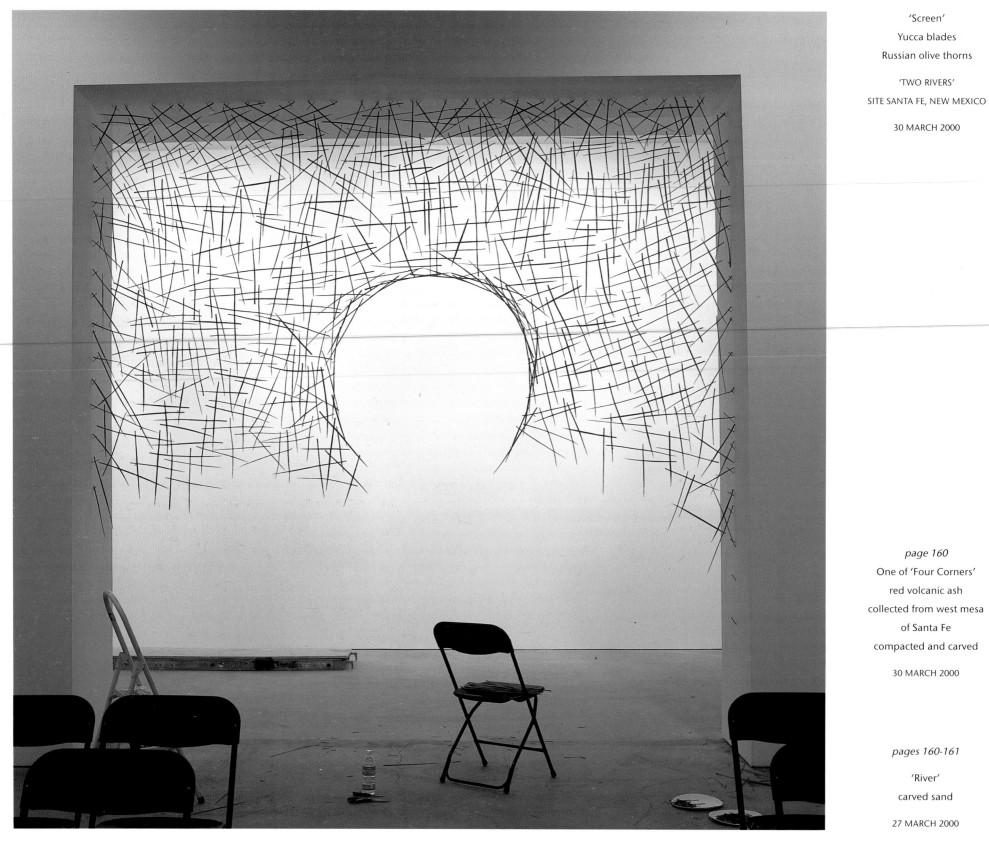

'Screen'
Yucca blades
Russian olive thorns

'TWO RIVERS'
SITE SANTA FE, NEW MEXICO

30 MARCH 2000

page 160
One of 'Four Corners'
red volcanic ash
collected from west mesa
of Santa Fe
compacted and carved

30 MARCH 2000

pages 160-161
'River'
carved sand

27 MARCH 2000

evening and finish it in one day, which feels great and has pulled back some of the time lost through the screen collapsing and my being ill.

Carlos, one of the people helping me, did a good job smoothing down the surface of the sand. It fitted the space well. The work would have been better dug into the floor of the gallery, but this was impractical. Instead, I built a room which can be looked into through narrow openings in the wall at either end, but has no entrance so that people are prevented from stepping on the floor. This gives a sympathetic, architectural feel, and I preferred it to cordoning off the floor with a continuous low wall, which would have turned the sculpture into some sort of animal in a zoo. I feel exhausted, but happy.

I don't know if I have the time or energy to realise the screen, but I would so like to have it in this space. If I don't manage it, the balance and feel of the installation I had in mind will be thrown off. I don't know if I dare attempt another version with the yucca. I feel that after maybe two more attempts I might succeed. If I do try again, I will lie the stalks out in the sun to dry before using them. I think this would make it work, but I cannot be sure. I will look at other possible materials; something stiffer and longer would make the screen both stronger and quicker to construct. I would very much like to have achieved this in yucca and to bring to fruition the dialogue inititated by the failures between myself and the material. Failure is so important to my work. It is less common in an indoor situation where there are no changes in the weather, and having it sitting there on my shoulder gives a certain edge and energy that is often missing from work indoors.

Tuesday, 28 March

Collected more yucca blades, hoping that they will dry before I have to work on the screen later in the week. Yesterday I had a box made into which sand from the river could be compacted – this took most of the morning. I hoped to make a single large sand stone, resonant of the way water works on stone, making it round. I like the idea of the relationship between the negative space of the serpentine channel and the round form of the boulder. Unfortunately, when we took the box off, much of the sand collapsed. I spent a long time working the form, trying to recover something, but if felt like a no-win situation. The more I worked . . . the more I wanted to work, the more the piece became fragile, and eventually it collapsed completely. I have never come so close to abandoning an indoor work. Gradually, I managed to make the boulder whole. It was not as I had intended or hoped. I felt uncomfortable about it sitting in its own debris, but this is a consquence of the real difficulties and problems I faced in the work's making. The fact that there are similarities between the sand stone and the image in the next room of an earth boulder in the landscape carved in the same way

should, I hope, strengthen rather than weaken the connections between the two. I have to respect the resulting work as something in its own right. If it creates an uncomfortable dialogue with another work in the exhibition, I have to live with that as somehow testing my own perception of how things should be.

Red sand has arrived for the four corner pieces. It is a very gritty, clinker-like material, and I am told it is a kind of volcanic ash called scoria. Initially I thought it would be impossible to compact, but when water is added it goes quite hard and I am very hopeful that it will form a firm base into which I can carve.

I am pleased with the way the room has contracted with the filling in of the corners. I had been anxious that they might get lost in the fairly large space.

Wednesday, 29 March

Finished off the corner I started yesterday and began carving. The material is good to carve and it felt strong. I aimed for as large a series of openings as possible. I had got to about three holes when it collapsed. I was somewhat surprised and not a little disappointed. It seems as if most things that I make for this installation have to go through some sort of test. I know that I did not compact this corner as much as the helpers did the others. I also didn't use as much water. On the next corner I made the hole smaller. There is something that I don't know quite well enough about working in a corner in this way. I think with the first attempt I reduced the shoulders of the opening to such a narrow width that it could not support the weight of the material above. With a certain amount of anxiety, I managed to complete the second attempt and later in the day, a second and third. Not finished, but still a good day's work after all the problems.

Going into the gallery each morning is a traumatic experience. I almost daren't look to see if anything has collapsed overnight. The sand stone was still here today and I feel that the longer something stands, the more chance it has of standing in the future. In the drying process, it becomes more solid, setting hard with a cement-like quality.

Tomorrow I hope to finish the four corners, and will begin my final attempt to make the yucca screen before the opening.

Thursday, 30 March

Started on the screen, carefully, using blades that have had time to dry out. This way, I hope there will be less strain on the screen, as most of the collapses seem to have been caused by the fresh yucca blades contracting. When the sand in the fourth corner had been compacted, I broke off from the screen to work on it, carving out the final holes. It was a great relief to get this piece finished.

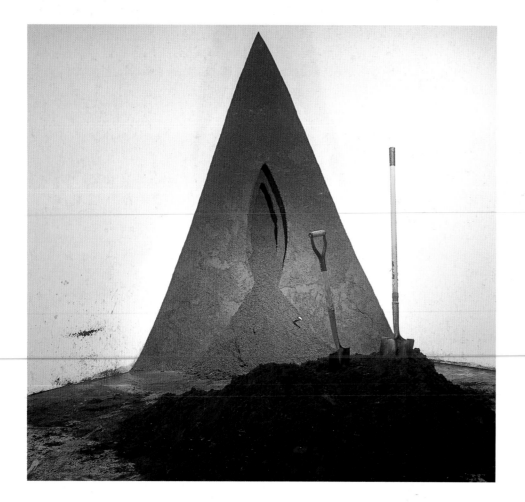

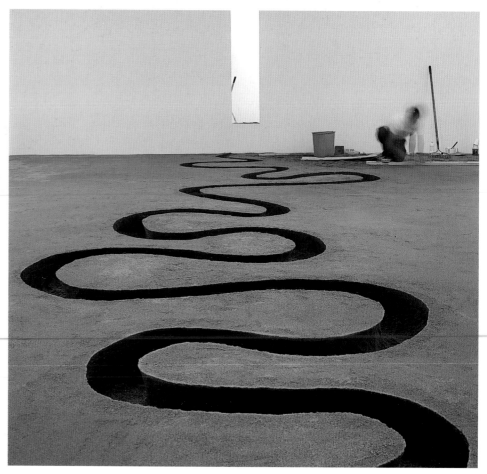

I gathered up all the debris that had come out of the holes and compacted them into a boulder at the centre of the room. In both this and the other sand installation, I have used the excess material to make another work. With the four corners there is a sense of the seed having come out of the holes.

After finishing this room, I returned to the screen, which I left more or less half done.

Friday, 31 March

Worked on the screen all day. Needed more thorns and was distracted by having to give a talk this evening, which prevented me from finishing. I would not like to say if it is going to hold or not, because the previous collapses have happened well after the initial construction and were connected with the drying process which I don't fully understand. The yucca blades hold water and seem to resist drying out quickly. After three days' drying, there is more moisture in them than I'd anticipated. The screen is looking well, its beauty heighted by an equal sense of fragility and the possibility that it will not be here tomorrow.

Saturday, 1 April

This morning I went back to the arroya at Galisteo. It was snowing – what a difference to when I was here last time! A very delicate, dry snow . . . fleeting; it was only there for an hour. I made a few brief touches, not particularly interesting, but it was good to be back.

Returned to the gallery to continue with the screen. It is still standing and I managed to finish half an hour before the exhibition opened. There were enormous queues for the opening, which was a bit overwhelming. I am very tired, but I feel that in this installation I have brought the division between the outside and the inside much closer. I have never made an installation so close to failure as this one. It is very clear to me that each work, except perhaps for the river, could quite easily have failed. I have to be pleased that these difficult works finally succeeded. That gives them an energy that I can feed off.

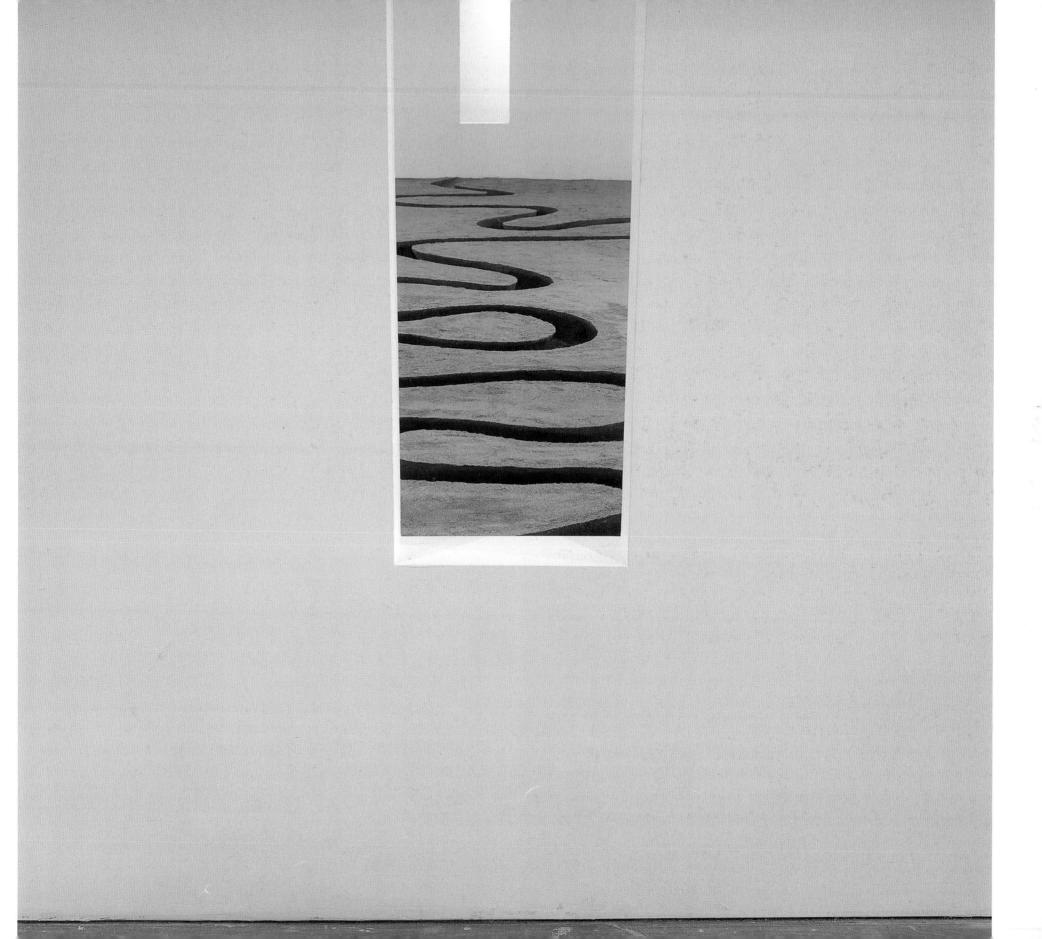

Raining
yellow leaves
stripped away
from central vein
lying flat
following contours of rock

CORNELL UNIVERSITY,
ITHACA, NEW YORK
3 OCTOBER 1999

CORNELL

Sunday, 3 October

After a traumatic journey I needed to get to work.

It was a damp, grey, windy morning. By the time I got to the bottom of Fall Creek, one of the two river gorges that run through the campus at Cornell, it had begun to rain. A good time to do a rain shadow, but couldn't find a rock dry enough to give the kind of surface that I needed. By the time I had looked around, it was too late. Everything had become wet.

The leaves are beginning to turn colour. One tree has dropped many red leaves, but it was the yellow that I was drawn to. Yellow is a very difficult colour to find. It appears so strong from a distance, but close up it is often not as intense as it first seemed.

The leaves are quite thin and translucent – what lies behind shows through, reducing the colour. I made a work on stones, wetting then placing leaves, tearing the central vein out of each leaf so it would lie flat. What made this work different to previous leafworks was that it followed the rock contours – a landscape of leaves on a landscape of rock.

I tried various other works with leaves. Wandered downstream. One work that didn't come to fruition, but that could have potential, was made by sticking leaves to the rock behind a waterfall. It was a very odd sensation – putting my hand through the waterfall, expecting the leaves to be washed away, but finding they stuck to the rock quite easily. The light wasn't very good and the leaf colour was lost so I didn't pursue it.

Nearby was a large, beautiful slab of stone upon which I did a water drawing – a sinuous line typical of the kind I have been obsessed with recently. I wanted to make this work as a connection to those I have made in other places and will return to this stone to make other drawings.

Quite a good day. It is a beautiful place to work. It has everything that I could ask for. I hope that I find something of significance from it.

Monday, 4 October

Dark, overcast, raining, much cooler. Walked to the gorge and down to the place where I'd been yesterday, returning to the same stone. Because it was wet, cold and calm I decided to work with leaves on the rock, taking advantage of the many yellow leaves that are around.

Reworked a piece similar in form to yesterday's drawing, but now in leaves. It is one of the most labour-intensive pieces I have done for a long time. My assistant,

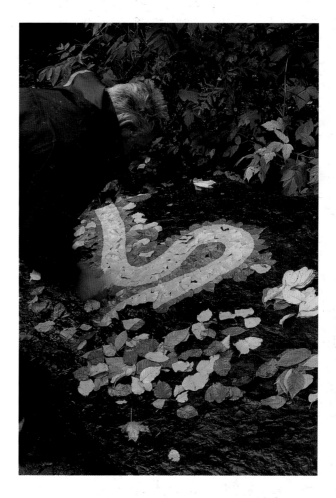

Leaf
river
stone

4 OCTOBER 1999

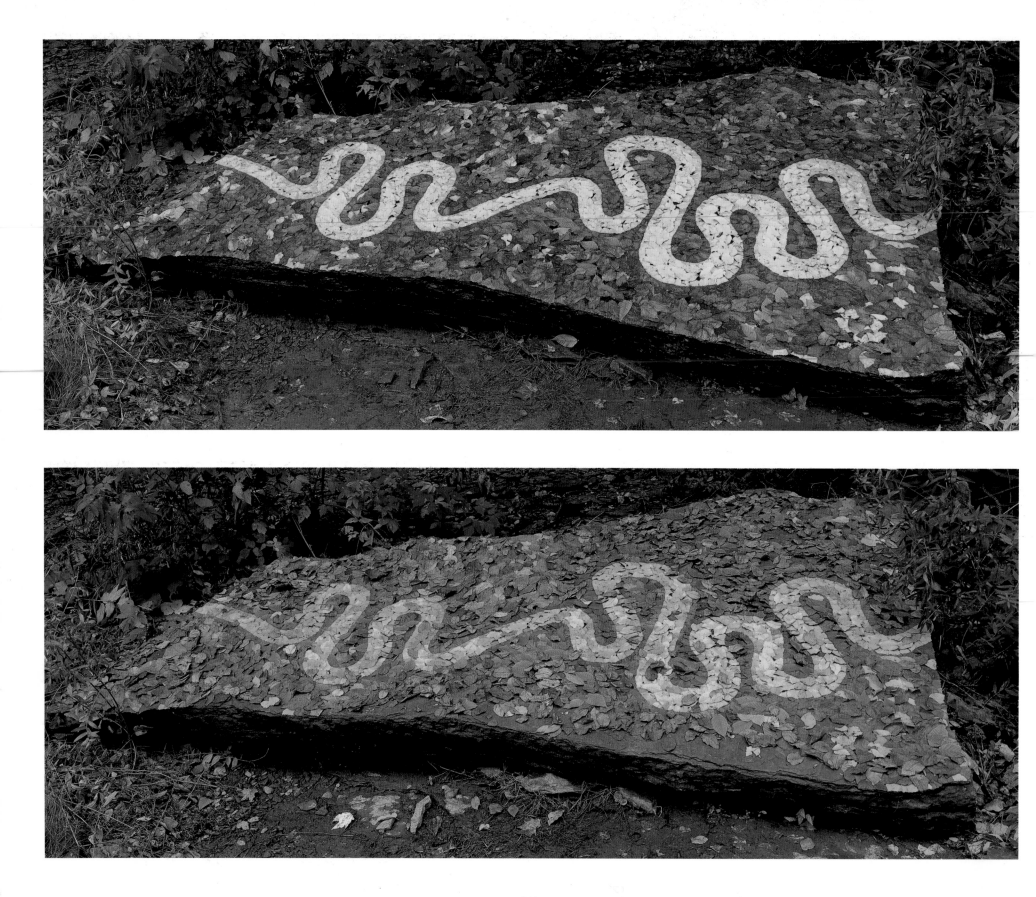

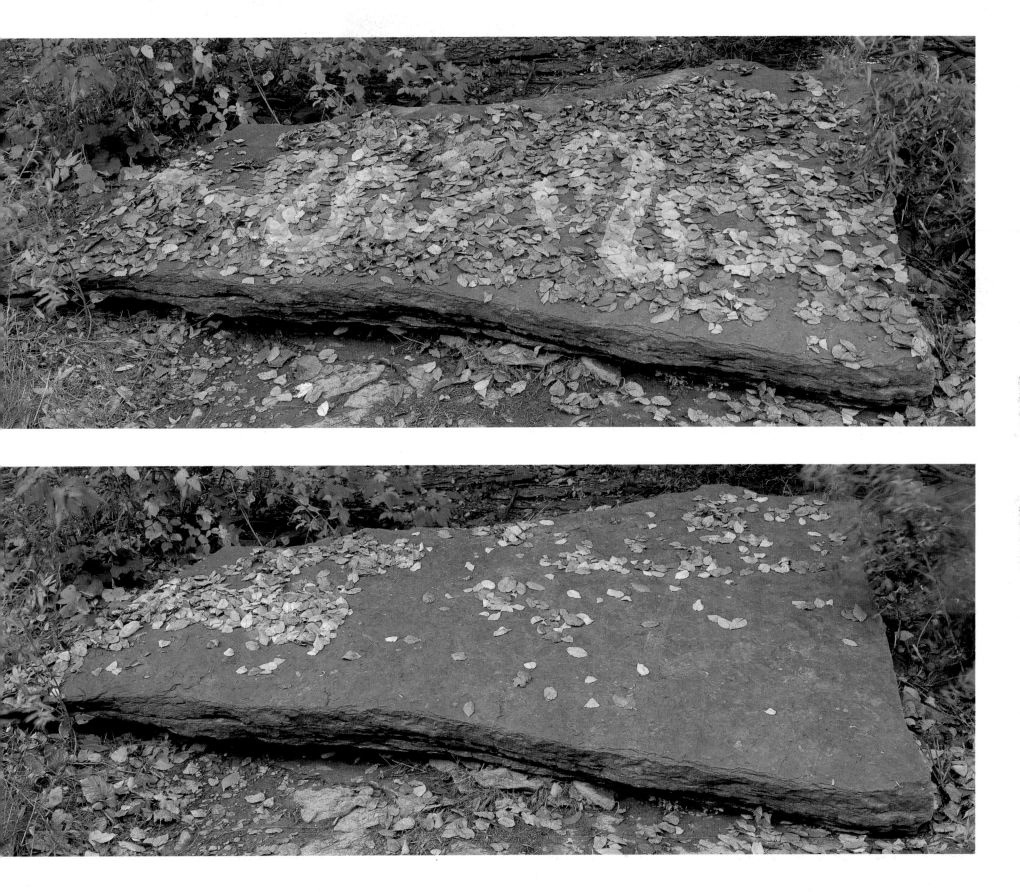

Andrew, and I began at 8.00am and finished just after 5.00pm. The pressure of finishing in one day became quite intense towards the end, especially when the light began to go. Just as I finished, the light returned and gave the yellow an incredible intensity. I will return tomorrow. I would very much like to have a series of photographs showing the leaves as they shrivel and blow away, revealing the rock they covered. A good day. The cold weather was hard on wet hands, which slowed down the work. Each leaf was dipped in water before being laid on the rock to which it then stuck. The rain stopped and I had to add a lot more water to keep the leaves fixed. There were occasional gusts of wind, which caused me some concern, but the work was never really threatened.

Tuesday, 5 October

A bit brighter this morning, but still a lot of cloud. Dry overnight. Went to the gorge. Yesterday's work almost unchanged, slightly drier.

Went to where one particular tree has been dropping red leaves and began to work with them. It started to rain and I lay on a rock in the middle of the river. Difficult to get to. Have to make a couple of precarious jumps on slippery rocks to reach it. The rain was fine and it took some time before the rock became damp enough to leave a shadow.

When I finished, it began to rain even more, so I returned to the rock and lay down again in the shadow, hoping to get a more defined imprint. It rained very heavily – a cold rain. The first cold shadow since last winter. It didn't appear to be stopping, so I had to get up and leave the shadow vulnerable to the continuing rain.

Returned to working with the red leaves. There are many flat rocks, with very defined, hard, angular surfaces. Began to cover one rock, but the red leaf is thick and does not lie flat, even when torn into small pieces. I became interested in two flat rocks and tried to make two red surfaces, but the problems with the red leaves forced me to change to yellow. The yellow leaves are very supple and lie flat, which allows the colour to be welded to the stone. The red leaves looked like a carpet. I liked the dialogue between the two stones, one on the bank and the other in water. The two surfaces appeared as if they were from the same cleft rock. Two is an interesting number – a partnership.

In the afternoon I returned to yesterday's piece. The yellow leaves are now becoming orange. I imagined that the changes in this work would be the leaves shrivelling, then blowing away. But if the weather remains calm, with the possibility of occasional rain, it could remain stuck to the rock for a very long time. The yellow would fade to brown and the serpentine form with it, which

Two flat stones
yellow leaves held with water

5 OCTOBER 1999

would be very beautiful and have strong links to a work made in Nova Scotia with snow and ice (*see* pages 120-121): white snow defining a form on dark ice, disappearing as the snow thawed.

Wednesday, 6 October

A strange day – cloudy, but with some breaks. As the morning progressed, it cleared and was quite bright. Collected yellow leaves, which were dipped into water, then laid on a rock edge that drops vertically to the river. Initially made it with a reflected line in the river below. It would have worked quite well, but where the current ran fast, the reflection was lost. Decided to concentrate the line into a long thin block of yellow. It looked promising, but needed diffused or direct sunlight.

As I finished, it became heavily overcast and began to rain. I lay down on a nearby rock to make a shadow. After a while, the rain stopped and I went back to the leaves. Throughout the day, I must have returned to make a shadow on this rock five or six times, but never succeeded, as it didn't rain hard enough.

Wind became a problem. Half of the leaves blew off into the water, and I scrambled to collect what I could as they drifted away. The leaves were laid like slates on a roof, overlapping each other, so that when the wind blew, one leaf would hold down and the protect the next. Many sculptures develop a grain as they are being made, just as a tree develops a grain as it grows.

Unfortunately, the wind changed direction, which made the work vulnerable. The leaves were laid for both the wind and the sun. I began first thing in the morning when the sun was to the east, and the leaves were laid so that one would not cast a shadow on the next – I wanted as even a yellow as possible. The sun's disappearance meant that I had missed the best light. It came out again very briefly around midday, but trees cast a shadow on the work and I had to wait for the sun to move round, by which time the sky was overcast once more.

With this and the rain shadow, it was becoming a very frustrating day.

I had noticed when walking along the riverbed that my assistant Andrew and I sometimes left footprints in the soft silt covering. I was able to make a pale drawing on the riverbed using my finger. Very little pressure was needed: a very delicate touch for the first part, then more forceful as the surface became rougher and harder, which made the line more direct.

It was another serpentine form. I have to stop making this form. It is becoming obsessive. But this work is a great partner to one made several days ago on a rock

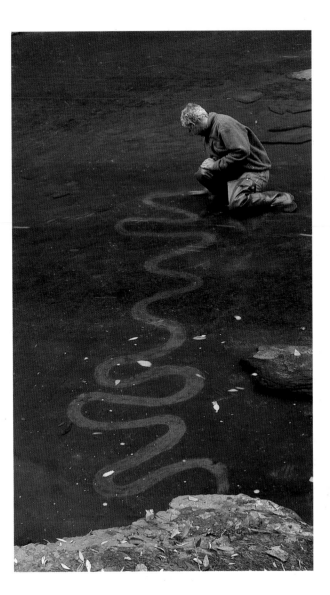

River bed
hand drawing

6 OCTOBER 1999

Overleaf
Leaves
dipped in water
laid on rock
difficult
strong wind
waiting for the sun

6 OCTOBER 1999

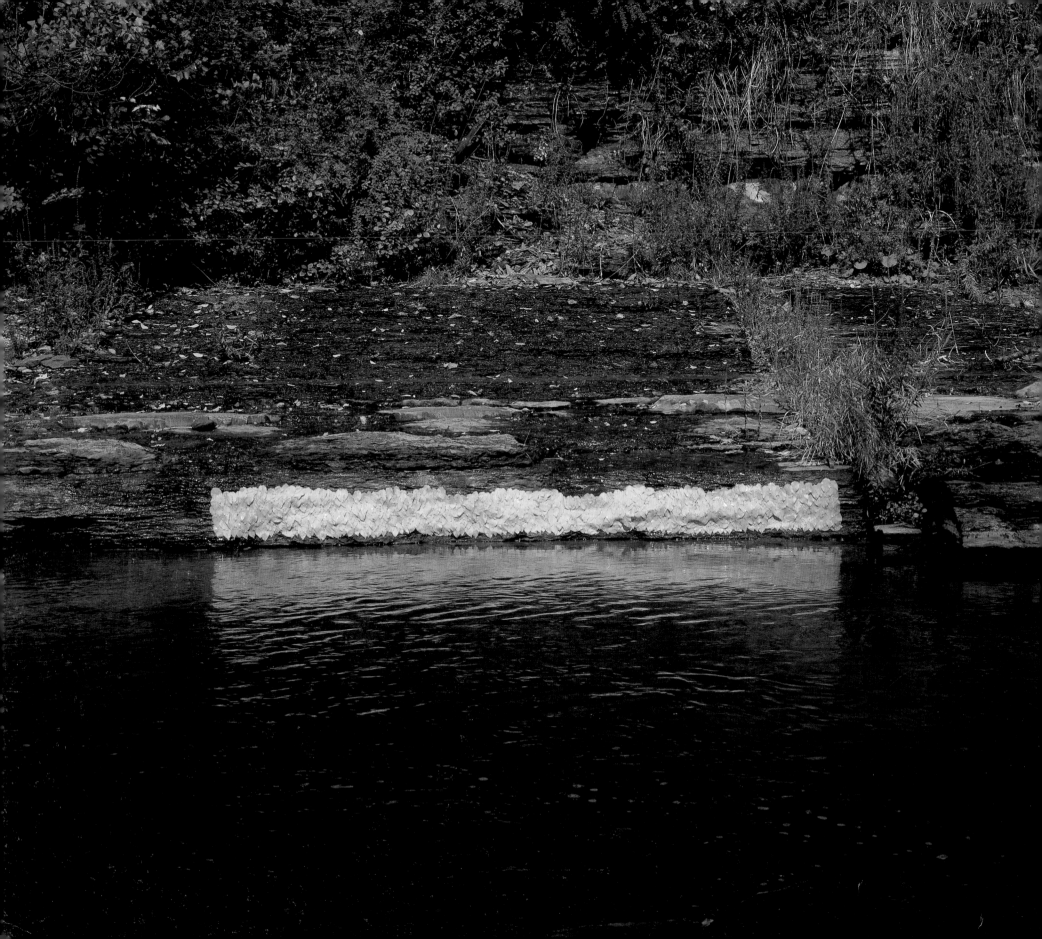

nearby, which, rather than gradually fading as I had hoped it might yesterday, is now shrivelling and blowing away.

At the end of the afternoon, the sun finally came out and I managed to see the yellow leaf patch, with the light shining not from the east, but from the west. The leaves were more textured than I might have wanted, but I was happy with the result. So, in the end, I think it was a good day.

People have found out that I am working on the campus, and I have had several visitors, which is interesting, but disruptive. To some people, I appear to be relaxing, lying down on a rock, and they think it is a good time to talk to me, but in fact I am lying still, concentrating on whether the rain will come or not.

I am enjoying the river and the gorge. This is an extraordinary place, very intense. The rock shedding the leaves opens the possibility of making more work on this stone. If too many people visit, then I will have to work elsewhere.

Thursday, 7 October

Sunny and cold. Returned to the same place. I feel bound to this place by the work I have already made here. It is so interesting to watch leaves dry up and blow off the slab of rock. It would be wrong to describe it simply as decay – the work is changing and becoming something else.

I still have not worked with the red tree that attracted me down into the gorge on the first day. Each time I have been distracted by the yellow. The stiff red leaves are difficult. I realised that I could work this leaf and colour more effectively in the form of a mound and, by combining slate with the leaves, have managed to achieve the necessary structure. The stone has enabled me to work the leaf in a different way from before. Building the stone, layer by layer and trapping the leaves by their stalks, I was able to form a pile of leaves.

Many years ago in Japan, I made a small pile of leaves that changed colour from red through orange to yellow, but it was very difficult and the more leaves I piled on, the more formless the shape became. I didn't have the necessary control over the material to make it as strong as I wanted.

The slate is more than an armature for the leaves. I have made stone works alongside leaf works and have described the process of layering stone as being close to the layering of leaves. To be finally making a piece combining the two and to use the stone as a leaf and the leaf as a stone is a very important discovery for me. Contained within the pile of leaves is the pile of stone – the trunk of a tree.

I chose a place that I knew the sun would reach at the end of the day. During the day, the sun was behind trees and only towards the afternoon did it finally come

Cairn of leaves

supported by cairn of stones

7 OCTOBER 1999

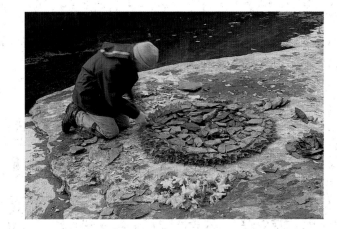

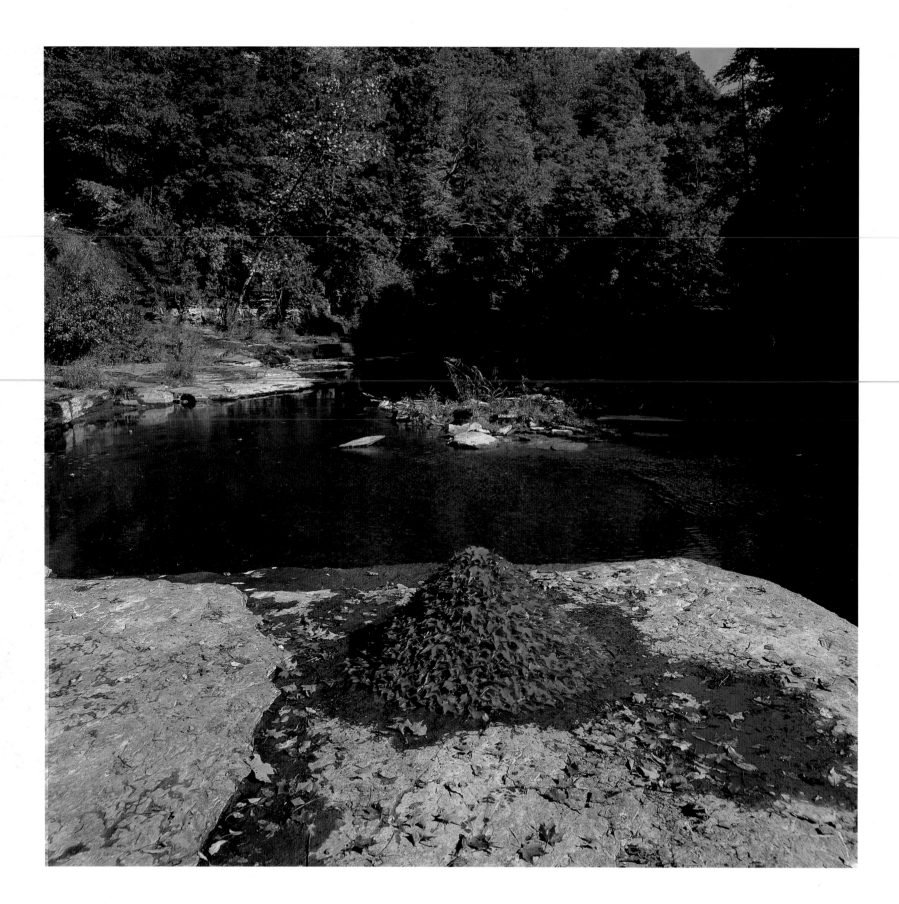

out – welcome warmth on what had been a cold day. It made the leaf cairn glow vibrantly. The leaves have come from the only red tree around, which is out of sight of the pile, and this gives the red additional intensity.

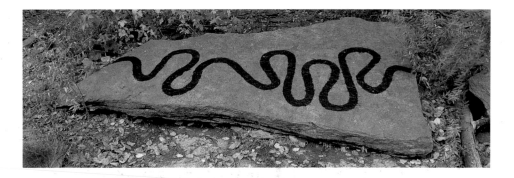

Friday, 8 October

It was windy last night, and when I arrived at the gorge, most of the leaves from the rock had been blown away. Even as I stood, the wind blew away the few that remained. It was quite beautiful to see the rock finally cleared of leaves again.

I reworked the first day's piece, making it more of a partner to the leaf work. I thought the wind would dry the wet line too quickly, but in fact the cold rock seemed to hold the moisture even better than several days ago when it was overcast, calm and damp, but quite warm. There is an enormous difference between making a controlled contrast with wet and dry stone and the effect of a casual splash.

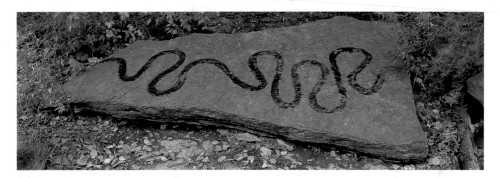

There is a great tension when trying to work the edge in this way. Too much water and the line runs; too little and it dries too quickly. The edge explores water, rock and time.

I reworked the form several times, redrawing it, trying to maintain concentration throughout the line. I make a mistake and have to wait for the mistake to dry out, along with the remaining work, before starting again. Although it is difficult, I enjoying working in this way. Eventually I achieved what I think was a very strong line, which I then photographed as it dried out.

The two versions I have made, one in leaves, the other in water, are related by a similar form, but also by the nature of water itself. It is the flow of water that has made the leaf. It was the use of the water that bound the leaf to another leaf and to the rock. I hope that the connections I make go much deeper than simply making the form once in leaves and once with water. I want to touch on the fluidity that runs through both leaf and stone.

Saturday, 9 October

Today I went to a different gorge. I have passed this gorge every day. It looked so far away, but clambering down made me realise how close it is. The place is more intimate and enclosed than where I have been working until now. The river is narrower with a large pool next to a waterfall. I walked a short distance downstream and came across one or two large, round boulders in striking contrast to the sedimentary, flat stones lying around.

River drawing on stone

soon evaporating

8 OCTOBER 1999

I covered one boulder with leaves, starting with dark green, which faded from pale green to yellow. I had intended to take it to orange and finish at red, but liked the dark green to yellow and decided to make it just with these colours. The colour faded from dark to light so that the leaves accentuated the effect of light on the stone, emphasising the boulder's form.

It was labour-intensive, and I could not have made this work or the others without the help of my assistant, Andrew. The collecting would have taken almost as long as the making, which itself lasted most of the day. A few small breezes caused me a bit of concern, but none of the leaves blew off.

I had collected quite a number of red leaves before changing my mind as to their use. It could be interesting to make the same piece again, but with red leaves, which would be hard as there are not so many of them around. Strangely, the red leaves are much stiffer than the green, even when from the same tree, and difficult to attach to the rock. It can be done, but they are more vulnerable to being blown off.

Sunday, 10 October

I had hoped to rework yesterday's piece using red instead of green. The weather was perfect. Collected red leaves from the same tree as the more supple green leaves, but just couldn't get them to stick. I presume this is because they come from the outer extremities of the tree, where the leaves grow thicker in response to there being more sun and are the first to change colour. When making leaf constructions I try to collect from trees out in the open. There is an enormous difference between the leaves that grow on the outside of the tree and those that grow near the trunk.

This work will have to be done another time. A difficult day, even though perfect for working: a light rain and calm, good for leaves on rocks. I walked up- and downstream, eventually making a pile of stones supported underneath by a piece of slate at water level. Between the slate and the cairn I made a sheet of leaves, which gave the pile a feeling of floating on top of the leaves. Just before I finished, the level of the river dropped for some reason. This was surprising, as it was actually raining at the time, and the water was becoming more discoloured. The dropping and rising of the water level has been very erratic in both gorges, and I suspect this is connected to dams further upstream, rather than the weather.

After making the cairn, I made a green line on a side pool of the river. This was quite interesting. I tried to make the line follow the contours of branches and stones in and around the pool. I don't think it was particularly successful, but

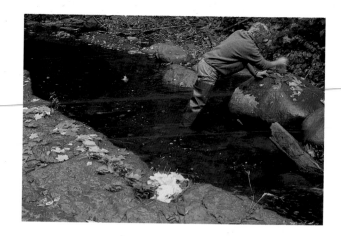

Leaves laid on a river boulder

held with water

green to yellow

dark to light

9 OCTOBER 1999

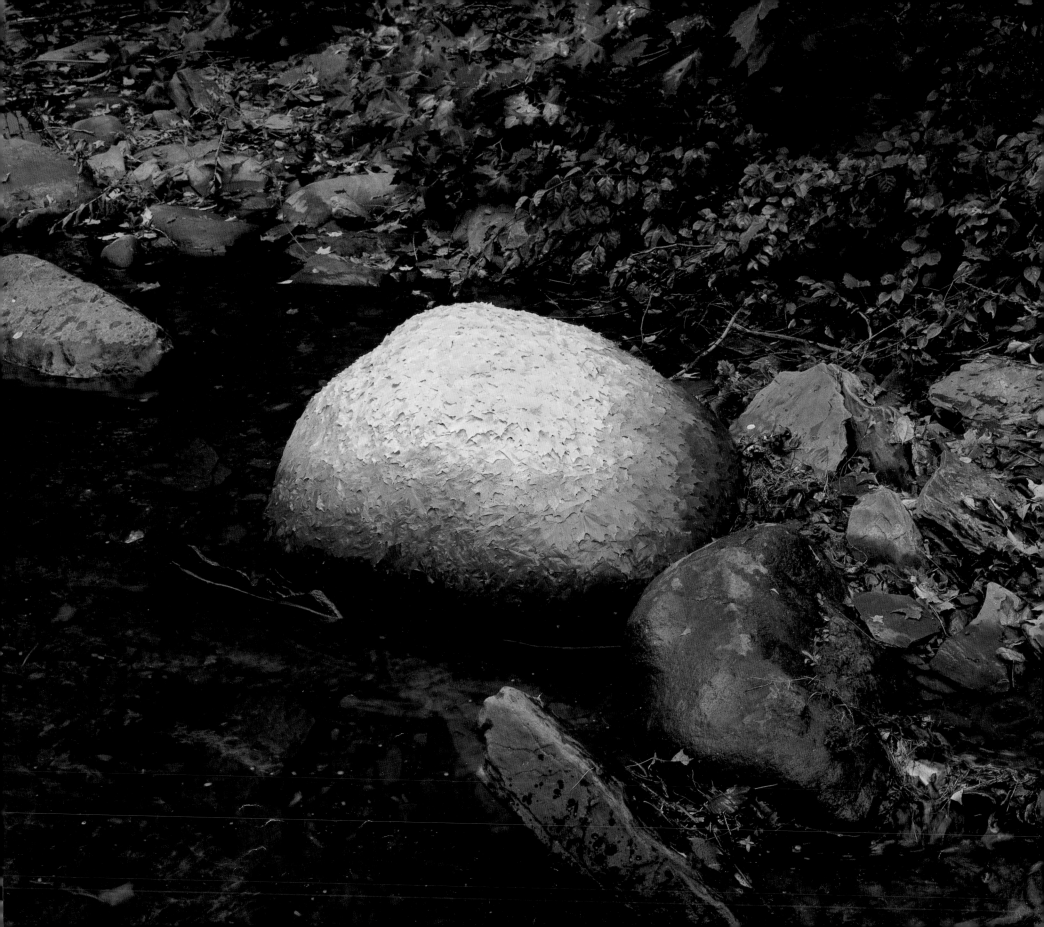

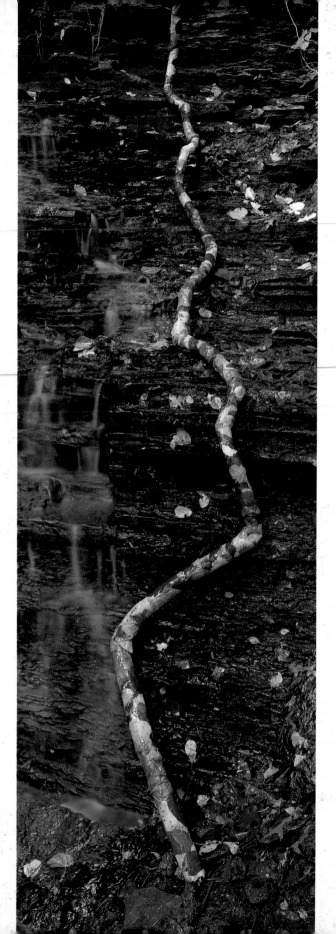

Several sticks

wrapped around with leaves

joined together

in a single line

beside a waterfall

12 OCTOBER 1999

who knows? I can't really see what I have made now. It is as if I have ground to a halt. This often happens. Bad days are important.

Looking back over the week, I feel I have made good works – more than usual. This place has so many materials and qualities that I am drawn to. It has slate, a stone that has recurred so much in my work, round stones, which look to be glacially deposited granite, waterfalls and a river, fall colours . . .

I also like the counterpoint between the university buildings above and the gorge below. The gorges are unnerving and somewhat threatening to look into. You can feel the strength, power and energy of the water that flows through them. It is a shock when you see them. They make the campus feel precarious.

Tuesday, 12 October

Returned to the first gorge and worked at a small waterfall, just hidden from the river, where it is difficult for people to see me. Struggled for a while, trying to do something. Eventually found branches, which were well curved. I laid them against the waterfall, then covered them with leaves. It was interesting to see how sinuous the line became.

The leaves stuck with water quite easily. It was more difficult getting the sticks to stay in place. The line collapsed four or five times, sometimes because I accidentally caught it as I climbed across the waterfall.

The sunlight was difficult for the work, but around three o'clock it became cloudy and the light was perfect. This work gives me a wonderful sensation of not knowing if I like it or not, which often means that I have pushed forward. It is a

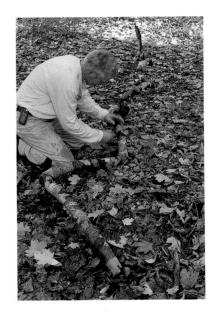

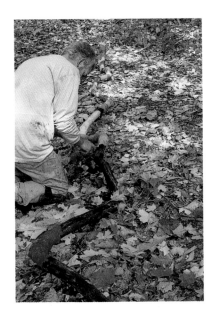

Line of sticks reworked twice
wrapped with leaves
held with water
the second time to follow
colour changes in leaves
becoming very windy
only a few leaves blow off

13 OCTOBER 1999

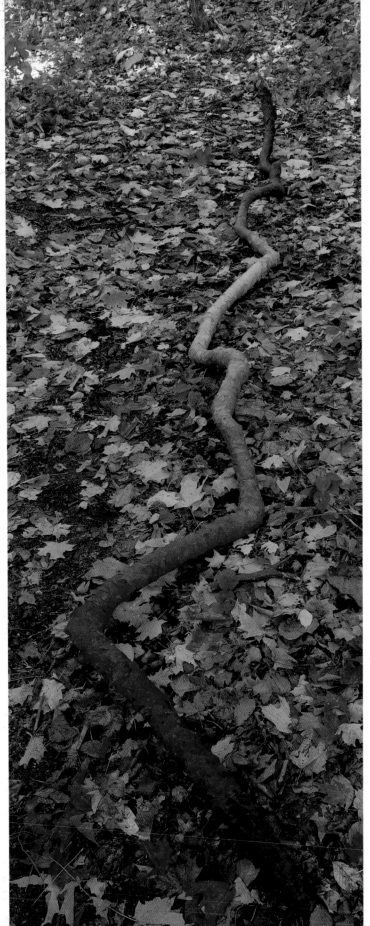

new piece and as yet I don't know if it is a good work or not. But I would like to take the line further and will rework it tomorrow with a colour gradation.

The occasional collapses were not without interest and the disjointed line reminded me of another line I have made that appeared to weave in and out of the trunk of a tree. I would like to make a stick line that looks as though it is going in and out of stone. Another idea is to lie the sticks on the ground and cover them with leaves so that the form is camouflaged. Or a line of sticks could be built into slate. Today's work has produced too many ideas for the time I have left.

Wednesday, 13 October

Had hoped for an overcast day, which had been forecast, but in fact it was sunny all day long. I wanted to rework the stick line and felt that an overcast light would be best. Removed the line from the waterfall and laid it in a bed of leaves. I began to cover the stick with leaves similar to those lying around, so that the line became camouflaged in one way, yet pure form in another. I like this work. Unfortunately, the sun didn't go in and although most of the line was in shadow, there was some dappled light. This added an additional layer of camouflaging that I neither wanted nor needed. It added too much.

After finishing, I decided to attempt another work on the same line, this time with leaves going from green through yellow to orange to red. I really did not think this would be possible, because of the difficult red leaves. Had I known that the wind was to become as strong as it did, I would not have even tried it. But once I'd started, I felt I should follow it through, even though the chances were slender. Amazingly, the leaves held on for most of the time. Even now, I don't know how. The wind was very strong and from time to time gusts blew leaves from trees and bent branches. It survived almost intact to the very end, when a few leaves were blown away, but I managed to replace them. I was extremely pleased with these two works that have extended the line further. I had intended to make the coloured line on the waterfall, but this way a much stronger dialogue has been created between today's two works. However, I might return to the waterfall tomorrow. I still like the idea of working the line into the falls.

Thursday, 14 October

Woke up with a headache, feeling ill, perhaps in anticipation of the talk that I have to give this evening. Consequently, I had a late start. Returned to where I worked the stick line yesterday.

What a different wood it is now. The trees are black and wet. The leaf colours are intense. Strangely, the small waterfall seems to have less water in it than before. I have not been able to understand what lies behind the flow of water in the rivers. Sometimes they flow fast when there is no rain, and when there is rain, they dry up.

I would have liked to have done something with the sticks again, but I really didn't have the energy. Instead, I worked below the waterfall, where I found two partner rocks, similar to the yellow ones that I worked on last week. This time, I laid green leaves on the top surfaces. The intensity of the green varied dramatically, depending on the light. Not such a bad work for a difficult day. I would have preferred in some ways to have worked with the sticks. Maybe I will have a chance tomorrow to make one final piece with them.

Friday, 15 October

Returned to the waterfall and gathered up the stick line. The steep banking at the sides of the waterfall was made of deep, rich, dark earth. I originally thought that I might make the line rest in a dug-out hollow, but decided to embed the sticks in the earth so that they were half-buried. I broke two or three of the bends so that the line lay flat on the ground.

I have never made a work like this before. I like the fossilised quality, as if it has been scraped out of the earth. I stained the sticks with the soil, so that one material appeared the same as the other. Burying and camouflaging works by covering them with leaves or soil appeals to me. Four lines made with the same branches are also interesting. Had I not been leaving today, I would have taken this line even further. Who knows, it may be something I can pick up again when I go home to Scotland or perhaps when I return here in March.

I have an idea for the installation next year in the museum here. The main exhibition room can be seen from above, and I like the similarity of perspectives between the views down into the gallery and those into the gorges. I have proposed to completely fill the gallery with stick domes and holes. I hope to introduce to the building a similar sense of energy to the one I feel when watching the river running through the gorge. The holes will become dark pools that generate flow and movement into the surrounding branches.

I just hope enough materials can be gathered from windfallen or pruned trees. It is an ambitious installation which will only be possible if there are enough materials to hand so that I can work quickly. This is important – not just so that the exhibition is ready in time, but so that the making has a fluid energy.

'Fall Creek' installation 2–9 March 2000

The weeks leading up to the exhibition have been difficult. My proposal came close to being rejected. The materials I wanted to use – timber from wind-felled trees – meant that there were all sorts of potential problems to do with infestation and the blocking of ventilation ducts in the gallery, but these were eventually overcome. It was also going to take a huge number of branches, and there was some doubt as to whether enough could be collected in time.

Initially there weren't enough white, bleached sticks, so my assistant Andrew and I went out to find more of these. It had begun to snow and they were difficult to spot, but in the end we found a sufficient quantity for me to finish the installation. The white sticks are important – they give intensity to the enclosed space, defining the darkness created by the other branches. The sense of blackness beneath the holes in the domes will not, I think, be possible to achieve. Because of the limited number of sticks, I've had to make the domes shallower than planned, and the floor beneath is quite shiny. But I am nonetheless looking forward to the end result.

The light is the most difficult aspect of the installation, and I have found it impossible to achieve exactly what I was after. Looking into the gallery from a balcony above is a bit like looking into a cave. The foyer behind can be very bright (with sunlight), which gives a piercing quality to the light illuminating the work from where the spectator is standing. We have installed lights on the walls of the gallery in an attempt to soften the effect. What I wanted to achieve was something similar to the quality of light I would find outside on an overcast day.

I wasn't quite sure how to join one enclosure to another. There are channels of thick branches defining and flowing between the domes that I quite like, a bit like deep water flowing around them. Four of the holes that were completed yesterday with the thin, bleached twigs and branches that Andrew and I collected from the lake shore have come apart slightly; the effect reminds me of works outside after a bird has landed on them. It must be due to those sticks (which were very wet when we picked them up) drying out and bending. Pine is very susceptible to this. An installation I did at San Jose with burnt sticks changed its form completely after all the branches curled up, which was interesting in itself. In this case, however, the edge around the hole is critical, and I was forced to clamber back over the sculpture, treading carefully for fear of causing a tremor resulting in more collapses. I then had to dig out the hole on the outer edge of the enclosure so that I could crawl in to make a repair. It worked, but I hope that when I come back to the gallery again, the branches will be as I left them. I would not like to do this very often.

Despite all the problems, I am pleased that I have managed to pull back this installation from the brink of its rejection. It is not as strong as I would have liked, but its realisation has taught me a great deal.

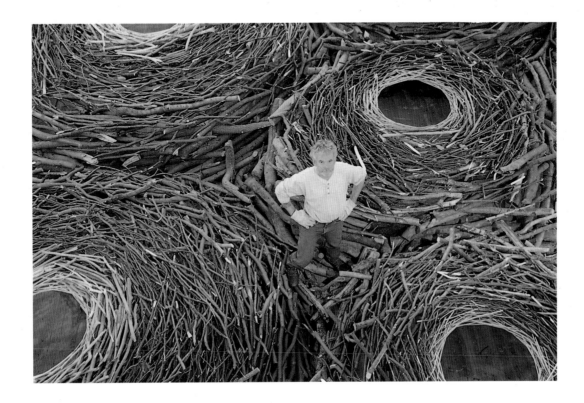

'Fall Creek' installation

HERBERT F. JOHNSON MUSEUM OF ART,
CORNELL UNIVERSITY, ITHACA, NEW YORK
9 MARCH 2000

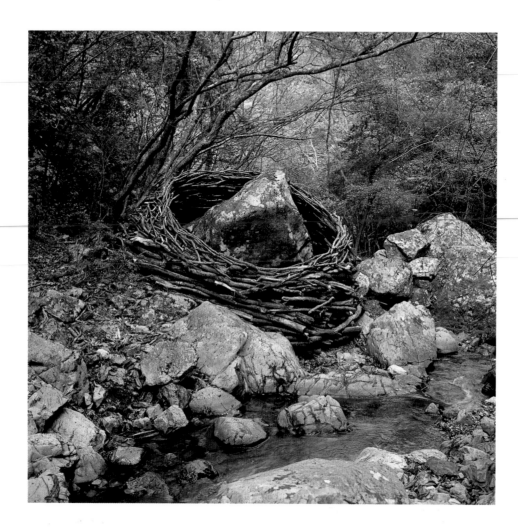

Stone house (day)

OUCHIYAMA-MURA, JAPAN

13-14 NOVEMBER 1991

CHRONOLOGY

Terry Friedman

In the winter of 1999 Andy Goldsworthy and Cameron Books invited me to contribute this Chronology to *Time*, which has been compiled in part as the result of lengthy discussions with the artist held at Penpont in January 2000. I had first seen Goldsworthy's work in 1981, thereafter avidly following its progress: in 1985, as Principal Keeper of Leeds City Art Gallery and The Henry Moore Centre for the Study of Sculpture, co-curating (with Tony Knipe) the first major exhibition and publication, *Rain sun snow hail mist calm Photoworks by Andy Goldsworthy*, which helped to bring his name and work to the notice of the wider public; in 1987 supporting the Stonewood Project; in 1988 contributing an essay ('Journeys') to *Mountain and Coast Autumn into Winter Japan 1987*; in 1989 interviewing him for BBC Radio; in 1990 co-organising the first retrospective, 'Hand to Earth', again held in Leeds, followed by a triumphant European tour, meanwhile instrumental in acquiring work for Leeds City Art Galleries; in 1992 another essay ('Essential Goldsworthy') for *Mid-Winter Muster*, accompanying an exhibition for the Adelaide Festival, Australia; in 1996 attending the noisy Paris premier of 'Végétal', a collaboration (as scenographer) with Ballet Atlantique-Régine Chopinot, then writing about it in *Wood*, published later that year.

By the millennium it became clear that a record of Goldsworthy's career was long overdue. While a significant part of his already vast output

of ephemeral work represented by photographs, as well as permanent installations and drawings, made on an almost daily basis over the last two-and-a-half decades, had become celebrated worldwide, the details of his life and accounts of the often complicated progress of his work and development of his sculptural ideas have been less readily available. During the compiling of the Chronology, the importance attached by Goldsworthy to repetition and renewal of sculptural forms, with variations in materials, place, weather, seasons over often long periods of time, has become plain. A sand work made in North Wales in 1983 and a variation in Holland in 1999 are by no means untypical. He has written: 'I work with some materials and places many times over. Each time is different . . . Each new sculpture is a result of knowledge accumulated through past experience', and most recently, 'Each work joins the next in a line that defines the passage of my life, the momentum of which gives me a strong sense of anticipation for the future'.

All statements in quotation marks in the Chronology are by the artist. Wherever possible, accounts of the artist's activities are accompanied by references to illustrations [in square brackets] in the following major publications:

Hand to Earth Andy Goldsworthy Sculpture 1976-1990, The Henry Moore Centre for the Study of Sculpture, 1990 (reprinted and published by W.S. Maney, Leeds, from 1991), with contributions by Andrew Causey, Sue Clifford, John Fowles, Terry Friedman, Angela King, Fumio Nanjo, Paul Nesbitt, Miranda Strickland-Constable, Hans Vogels and the artist, and a catalogue raisonné of photographs 1977-1989 and lists of publications, one-man and group shows 1980-1991, compiled by Clive Adams. (Abbreviated as *Hand*.)

Andy Goldsworthy, 1990, produced by Jill Hollis and Ian Cameron of Cameron Books; published by Viking Penguin, London; US edition titled *Andy Goldsworthy: A Collaboration with Nature*, Harry N. Abrams, New York; Éditions Anthèse, Arcueil, France; Zweitausendeins, Germany (1991); Terra, Holland (1997). (Abbreviated as *Goldsworthy*; the book is unpaginated.)

Stone, 1994, Cameron Books; Viking Penguin, London; Harry N. Abrams, New York; Éditions Anthèse, France; Zweitausendeins, Germany; Terra, Holland (1998).

Wood, 1996, with Introduction by Terry Friedman, produced by Cameron Books; published by Viking Penguin, London; Harry N. Abrams, New York; Éditions Anthèse, France; Zweitausendeins, Germany; Terra, Holland (1999).

Wall, 2000, with Introduction by Kenneth Baker, Cameron Books; Thames & Hudson, London; Harry N. Abrams, New York; Éditions Anthèse, France; Zweitausendeins, Germany.

Time, 2000, with Chronology by Terry Friedman, Cameron Books; Thames & Hudson, London; Harry N. Abrams, New York; Zweitausendeins, Germany; Editions Anthèse, France.

Readers wishing to explore further will also find references in the Chronology to useful but less readily accessible and in some cases out-of-print publications.

In compiling this Chronology, I am grateful for help from Andrew Causey, Allin and Muriel Goldsworthy, Judith Goldsworthy, Elinor Hall, Jill Hollis, Joanna Jones, Lis Lewis, Graeme Murray and Ella O'Halloran.

ANDY GOLDSWORTHY (Andrew Charles Goldsworthy) born 25 July 1956 at 10 Delamere Avenue, Sale Moor, Cheshire, the second of four children of Allin and Muriel Stanger Goldsworthy, both from Bacup, Lancashire, an engineering, textile and footwear manufacturing town near the head of the river Irwell valley, close to the Yorkshire border. Paternal great-grandfather, a Cornish tin miner who had moved north to work in the stone quarries; paternal grandfather, Frederick, a sole press operator in a local shoe factory, who often walked young Andy over the moors to the Britannia quarries near Bacup; paternal grandmother, Alice, a dressmaker; maternal grandmother, Maud Stanger, a long-time widow.

In 1961, Allin and Muriel Goldsworthy moved with their children to Bowden Vale, Altrincham, in Cheshire, then in 1963 to Alwoodley, Leeds, in Yorkshire, when Allin, the first person in his immediate family to have received a university education, was appointed Professor of Applied Mathematics at Leeds University.

'Alwoodley is only five miles from the centre of Leeds. On one side of the new housing estate where I was brought up were fields, on the other a built-up area. Early on I became aware of the difference, but also the connections, between countryside and city . . . As a child I got angry when I saw woods I had played in being bulldozed, but then I realised that the same thing had happened to clear the area where our house had been built. Difficult to be judgmental about a process you are part of. It made me more aware of what lies below the surface in towns and cities.'

1963-1974

Attends Wigton Moor County Primary, Wheatlands Secondary Modern and Harrogate High School (A-levels).

From the age of 13 begins working (evenings and weekends) for Mr and Mrs Carling at Grove House Farm, Alwoodley, near Leeds.

1974-1975

Rejected by Jacob Kramer College of Art, Leeds, Andy gains a place on the Bradford College of Art foundation course. For the first and only time he receives formal instruction on how to use a camera (a technician remarks that 'there are some people who can take pictures and others who just can't' and notes that Goldsworthy was one of those who could not.) Saves up for first camera – a Pentax SP1000 – which was to last until the end of his college days.

'There was a certain energy in the air at Bradford, and we were introduced to the work of performance artists and the American

Early work Bradford, 1975

environmental artists. My first outdoor pieces were done there, but they weren't to do with the land and looking back I can see that it was the works that I was shown that really exerted the greatest influence on me': Mark Boyle, Christo, Yves Klein, Gordon Matta-Clark, Ben Nicholson. Reads Grégoire Müller's the new avant garde Issues for the Art of the Seventies (1972), with boldly captioned illustrations of work by Joseph Beuys: 'MATERIALS THAT DETERIORATE, FAT THAT SLOWLY MELTS', Michael Heizer: ' "CIRCULAR PLANAR DISPLACEMENT DRAWING" ERASED BY THE FIRST RAIN', Richard Serra: 'THE EXPERIENCE OF THEIR SHEER WEIGHT AND POTENTIAL COLLAPSE', Robert Smythson's 'Spiral Jetty': 'THE PERCEPTION OF THIS PIECE IMPLIES THE UNDERSTANDING OF A DEVELOPMENT IN TIME'.

Parents move to Ilkley, Yorkshire in 1975. Goldsworthy stays at Alwoodley and moves into a caravan at Grove House Farm: 'This was to become a necessary alternative to art school, a place to go in term breaks both to work as an artist and to earn money – two days' labouring on the farm allowed me to do my own work for the rest of the week. The farm and farming were to be as significant to my development as art school, especially as far as response to the land and the working of materials were concerned. Many of the activities in farm work are sculptural: stacking hay bales, ploughing fields, feeding animals; also the marks left behind by the animals or made by farmworkers, tractors . . . the texture of the land. Working on a farm brought

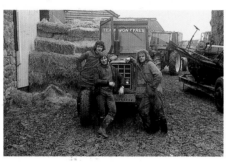

me up against the brutality of nature and the closeness of death – you can't avoid seeing it. Not at all the pastoral idyll that is some city dwellers' vision of the countryside. The energy and unpredictability of art outside the studio and gallery were important to me. Going outside art college felt so much more raw, and that's what interested me.' Shared caravan with elder brother, John, who was studying for a degree in applied biology, specialising in grassland ecology, at Liverpool University.

1975

Autumn. After being rejected by Leeds, Hull and Nottingham Polytechnics, Goldsworthy is the last but one candidate to be accepted for the B.A. Fine Arts Course at Preston Polytechnic, Lancaster Annexe, Lancashire. (Having more or less given up hope of a college place, he had resolved to pursue his art by continuing to live and work at the farm and would have done so without the intervention of his father, who inquired about places still available after the initial selection process and took him to an interview at Preston.) Lives at Morecambe during term time and returns to Alwoodley during holidays. Wary of art school after so many rejections, he deliberately adopts a way of working that is independent of college, and largely abandons classroom instruction for daily outdoor work on the nearby beach at Morecambe, with excursions to the Pennines. 'I remember the first day on the beach, it really didn't matter what I made – I was outside and I was beginning to learn. There was real purpose in having an art that was actually teaching me and that same purpose still sustains me now. The feel of a leaf, the crack of a stone, the flow of a river – these aren't just sounds and materials, they're life, and all the time there is a deepening relationship with the earth through making . . . My first works on the beach were made with a spade – straight lines, rectangles, etc., photographed as the tide came in.' The coast is

established as an important place to work (to which he will continue to return); 'the beach is a great teacher about time – the tides took away a day's work, imposed deadlines'. The dialogue between different environments, in this case the coast at Morecambe and the woods near Leeds, is to become a recurring theme ('Mountain and Coast', Gallery Takagi, Nagoya, Japan 1988; 'Sand Leaves', The Arts Club of Chicago, 1991) – 'I was amazed by the intensity of the smells associated with different environments: after working at the coast, the smell of the woods, then the smell of the coast again' – and forms the basis for a developing understanding of connections between materials: 'Stone made me sensitive to leaf and leaf to stone. One material gives energy to another.'

1976

Attracted to waste areas in towns and cities: 'I have always been able to work in urban situations, so long as some growth exists.' Many of his works at Morecambe Bay were made within sight of a nuclear power station: 'The power station at Heysham Head is something I have always worked alongside . . . and I think my work says how I feel about that. Morecambe Bay is one of the most polluted bays in Britain. [That] is for me a reason to work there. I feel these things very strongly, but this has to be expressed in my own way as an artist. I'm not an artist who can make a strong piece by contriving a point through the work. I'm trying to touch things that are much more substantial than that, the beach itself, the time that the beach has been there' ('Flow of Earth', 1992). 'When I began working outside, I had to establish instincts and feelings for Nature. I splashed in water, covered myself in mud, went barefoot and woke with the dawn'. [Hand 16] 'Sometimes I worked out on the mussel beds where there used to be fishing nets and I got to know the people there. Occasionally they caught seagulls which I asked if I could release. The moment of letting it go, of releasing the bird into the air, was very powerful. I see the throws as being like that – a release of energy into the space

Black sand
Morecambe Bay, Lancashire, 1977

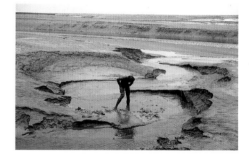

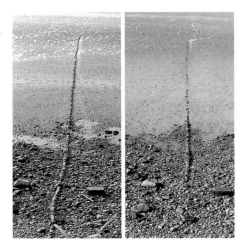

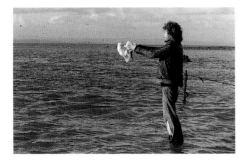

Stones sinking in sand
Morecambe Bay, Lancashire, May 1976

Releasing seagull
Morecambe Bay, Lancashire, 1976

First sand throw
Silverdale, Cumbria, 1976

predominantly in black and white using the Pentax SP 1000, though also records work in colour (with his father's Kodak camera): 'the photograph is a memory which evokes the experience of making and of being outside.' Restricted (by finances) to one 36-exposure film per week. At some point between 1976 and 1978, switches almost exclusively to colour film: 'Colour is what I see, so that's what I must work in.'

1977

Accelerates his working method by an intuitive use of diverse, random materials from day to day, making about 500 ephemeral works during 1977, many of which he considered failures, estimating at one point that out of one or two made each day, one good piece would emerge in a month. 'My sculpture can last for days or a few seconds – what is important to me is the experience of making. I leave all my work outside and often return to watch it decay.'

January-May. Heysham Head in Lancashire, Pen-y-Ghent in Yorkshire, Langdale, Scafell Pike and

Bow Fell, Cumbria, May 1977

with all its randomness and unpredictabilities.' Tries to find alternatives to geometric forms employed on beach. 'Instead of imposing forms upon nature I wanted to find forms that are already there.' Strips the bark off a split tree; lays a line of stones on the beach (which sink over time but are still there). [Hand 12-13] Makes first bracken, grass and dust throws, where touch is more important than what results, marking a new and constant arbitrariness in his art. Works

Scafell Pike, Cumbria, May 1977

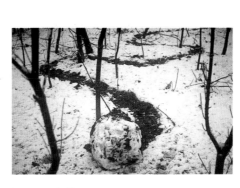

First snowball
Leeds, Yorkshire, January 1977

First red pool
Morecambe Bay, Lancashire, February 1977

Bow Fell in Cumbria (his first visits to mountains); makes first snowball in woods near Leeds and, at Morecambe, the first red pools using iron-rich stone found on the beach and rubbed to a powder (a technique that he will employ on a number of occasions in 1987, 1992-1995, 1997); explores the potential of rocks. 'I would start early in the day when there was often little or no wind. This encouraged me to make delicately balanced work that explored the surface tension of a calm

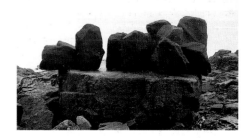

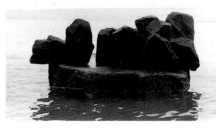

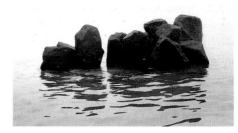

Heysham Head, Lancashire, March 1977

day'. [Hand 14-15, 17, 20, 22-23; Goldsworthy 39; Time 26-27, 49-51]

Summer-Autumn. In stark contrast, now concentrates on a small area making carefully

Ilkley, Yorkshire, June 1977

Langdale, Cumbria, June 1977

First hole
Southport,
Cheshire,
July 1977

White and
black
feathers
Morecambe
Bay,
Lancashire,
October
1977

Seagull
droppings
Morecambe
Bay,
Lancashire,
October
1977

arranged, almost painterly sculptures flat on the ground [Hand 100-101; Goldsworthy 106-107], resulting in a tension which forces a return to the broader landscape, with the photographs shifting from near to distant views.

July. Southport, Lancashire, the first hole, a momentous discovery. 'I was burrowing through a sand dune when it suddenly collapsed, except

for the outer crust which had a little irregular hole in it. When I looked into the space inside it was so black, it was really humming. Now when I look into a deep hole I am made aware of the potent energies within the earth. [Hand 26]

Winter. Concerned that a routine of making works flat on the ground is becoming fixed, begins making sculptures raised off the ground (an approach that matures and is more fully realised in later years).

1978

Winter-Spring. Continues exploring previous year's ideas in groups of works made in sequence over weeks and months. [Goldsworthy 22-23] Attends slide presentations at Polytechnic by Richard Long and David Nash, which is his first exposure to their work. Nash takes an interest in Goldsworthy, helps assuage teachers' anxieties about his maverick approach, and invites him to Grizedale Forest, Cumbria, where Nash is working through a one-year residency, including planting the 'Sweeping Larch Enclosure' (Fletched Over Ash, AIR Gallery, London, 1978). (Goldsworthy is impressed by Nash, his art and

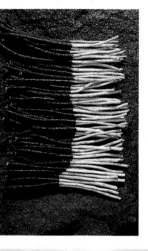

Partly
stripped
sycamore
twigs
Ilkley,
Yorkshire,
1978

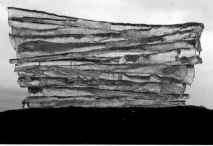

Stacked icicles
Morecambe Bay, Lancashire, February 1978

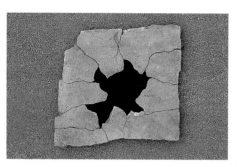

Broken stone reconstructed over hole
Morecambe Bay, Lancashire, May 1978

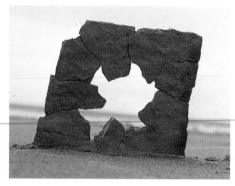

Broken, reconstructed stone, balanced
Morecambe Bay, Lancashire, May 1978

way of life, the only sculptor with whom he will have an ongoing friendship.)

Summer. Broken, balanced rocks placed to face the Lake District across Morecambe Bay. [Hand 10] Receives B.A. (Hons) degree in Fine Art. Returns to Leeds intending to continue making sculpture while living in a caravan and employed as a hand at Grove Farm, but with the death of Mr Carling's widow returns to Morecambe.

Summer–Autumn. Begins 'drawing' effortlessly fluid lines with a stick in the sand, aware of their impermanence. 'Drawing at its most essential is an exploring line alert to changes of rhythm and feelings of surface and space, playing from one to the other with the aesthetic rooted in movement.' Abersoch, North Wales, sticks damp seaweed line on a stone; Heysham Head, Lancashire, balances stones in 'early morning calm'. [Stone 104-105] Receives North West Arts award (£300) to print photographs for exhibition (in 1979), then and thereafter mainly printed by Charlie Meecham.

1979

February. Moves to a cottage in High Bentham, North Yorkshire: bare, rocky, sheep-farming country.

Balanced rocks
Morecambe Bay, Lancashire, May 1978

Seaweed
line
Abersoch,
North Wales,
August 1978

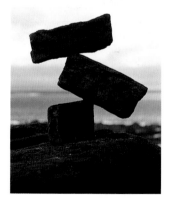

Forked
branch and
stick
Ilkley,
Yorkshire,
September
1978

Balanced
rocks
Heysham
Head,
November
1978

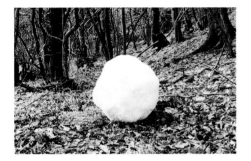
Snowball made from last patch of snow
Bentham, Yorkshire, 1979

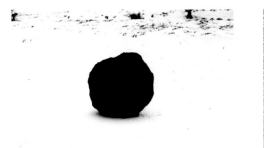
Mud-covered snowball
Bentham, Yorkshire, 1979

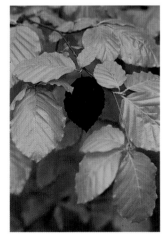
Beech leaf covered in black mud
Bentham, Yorkshire, June 1979

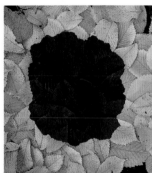
Elm leaves
Bentham, Yorkshire
November 1979

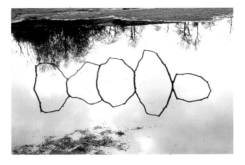
Forked sticks in water
Bentham, Yorkshire, March 1979

Mud-edged trench
Bentham, Yorkshire
April 1979

Rock covered with elm leaves held with water
Bentham, Yorkshire, September 1979

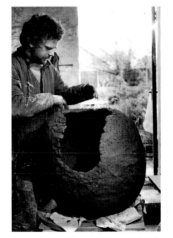
At Lunesdale Pottery Lancashire.

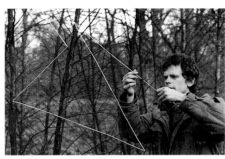
Making grass line
Bentham, Yorkshire, January 1980

Hole lined with peat
Ingleborough, Yorkshire, February 1980

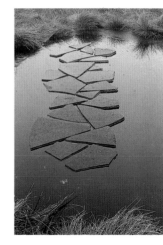
Ice on ice
Ilkley, Yorkshire, January 1980

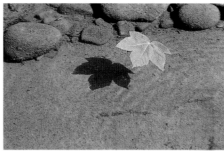
Sycamore leaf, floating
Bentham, Yorkshire, May 1980

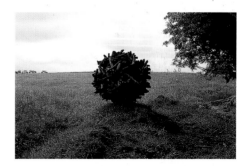
Stick stack
Bentham, Yorkshire, June 1980

June. Makes leaf work in which the middle leaf, covered in a thin layer of black mud, appears as a dense hole.

September. First rock covered with leaves (elm).

November. First leaf patch (elm).

Winter. While visiting parents at Ilkley, meets Judith Gregson, a student at Ilkley Teachers Training College. Her father, Barry Gregson, teacher at St Martin's College, Lancaster, ceramist and proprietor of the Lunesdale Pottery, has 'a very open-minded attitude towards the idea of my using his kiln, unlike the Polytechnic's ceramics department, which had strict rules forbidding the firing of foreign objects.' The two collaborate on various projects, including experiments in the firing of stone, which will culminate (in 1990) in the destruction of the kiln.

During 1979-1980 Andrew Causey, art historian, Chair of North West Arts, who first saw Goldsworthy's work on a visit to David Nash, purchases fifteen photographs (1977-1979) for The Arts Council of Great Britain Collection, the first sales.

1980

January. Continues making work off the ground: grass stalk lines; a snowball hung in trees. [*Goldsworthy* 41]

April-May. Bentham, Yorkshire, a green sycamore leaf floated on water, casting shadows on the river Wenning's sandy bed; a small rock covered in clay then left to dry and crack is unsuccessful as the weather is not dry for long enough (the idea was to come to fruition in 1992 in the far drier climate of California); both works firsts of their types.

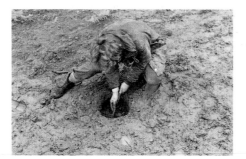

Grass stalks
in cobweb
Blaenau
Ffestiniog,
Wales,
May 1980

Slate throw
Blaenau Ffestiniog, Wales, June 1980

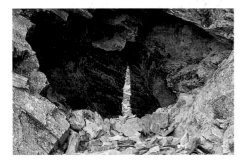

Stacked stone
Blaenau Ffestiniog, Wales, June 1980

May-June. Invited by David Nash to Blaenau Ffestiniog, North Wales, to look after Capel Rhiw, Nash's house and studio, in his absence. Goldsworthy makes 'Stacked stone' and 'Slate thorn', the first work in this material constructed at its source. [Goldsworthy 38, 40]

'Nature As Material An Exhibition of Sculpture and Photographs Purchased for the Arts Council Collection by Andrew Causey', The Atkinson Art Gallery, Southport, Lancashire, 5 July-8 August, the first exhibition. 'I want an intimate, physical involvement with the earth. I must touch. I take

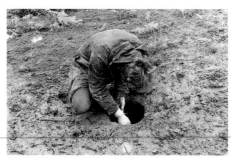

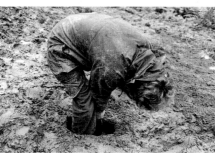

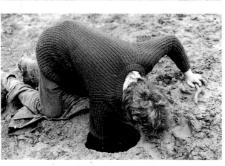

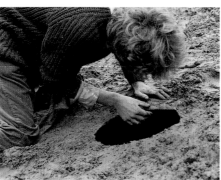

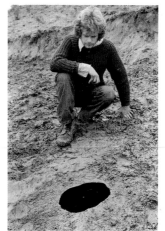

'How to
make a black
hole'
LYC Museum
and Art
Gallery,
Banks,
Cumbria,
July 1980

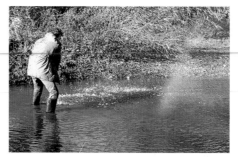

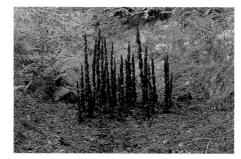

Rainbow making
Ilkley, Yorkshire, October 1980

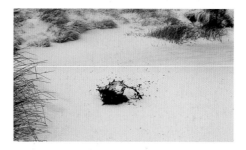

Mud-covered sticks
Ilkley, Yorkshire, October 1980

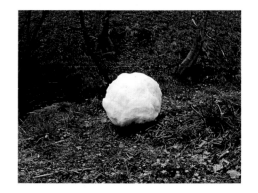

Peat splash
Ilkley, Yorkshire, December 1980

nothing out with me in the way of tools, glue or rope, preferring to explore the natural bonds and tensions that exist within the earth. The season and weather conditions determine to a large extent what I shall make. I enjoy relying on the seasons to provide new materials.'

July. First one-person show at LYC Museum and Art Gallery, Banks, Cumbria, on David Nash's recommendation. Works there for a month, establishing the idea of a visual diary recording each day's work, and makes step-by-step series of photographs about the construction of a black hole with explanatory diagrams, which are exhibited together with photographs of hazel stick throws and other works made nearby; black hole photo series and diagrams later shown in a group exhibition, 'New Sculpture', at The Midland Group, Nottingham. [Hand 21, 26, 44-45]

22 August. Begins recording date, location, weather conditions and appearance of ephemeral works (on completion) in pocket sketchbook diaries, a practice continued to the present day.

October. Moves with Judith Gregson to Ilkley, Yorkshire. First rainbow splash. Upright sticks covered in mud, the first spires.

Winter. Throws stone through snow into a peaty pool.

Receives Yorkshire Arts Award to print photographs for exhibition (1981).

1981

Ilkley and Middleton Woods, Yorkshire, working with sticks, leaves and leaf patches. [Goldsworthy 49, 51, 80-81] Carries large snowball, one of many made recently, down to low ground. Later the same day he sees it being kicked into a nearby stream, a shock that triggers an abrupt change of direction. Produces a series of complex,

Snowball brought from high ground
Ilkley, Yorkshire, May 1981

Crow and seagull feathers, wood floor debris
Yorkshire, 4 August 1981

Leaves, stalks, feathers, petals
Yorkshire, September 1981

layered, unstructured works combining several materials, subsequently evolving into more simplified ground structures. [*Goldsworthy* 52-53; *Hand* 103]

'Photographs of outdoor work in Yorkshire', St Paul's Gallery, Leeds, 24 March-11 April. First meeting with Terry Friedman, then Principal Keeper of Leeds City Art Gallery and the Henry Moore Centre for the Study of Sculpture.

Serpentine Summer Show 1, Serpentine Gallery, London, 4 July-2 August, selected by Miranda

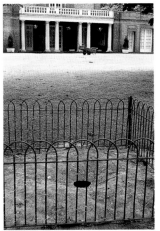

Hole
Serpentine Gallery, Hyde Park, London, July 1981

Line to follow colour change in rosebay willowherb leaves
Swindale Beck Wood, Cumbria, October 1981

Strickland-Constable, the first London exhibition. Digs a hole outside the gallery, the first public showing of an actual work. [*Hand* 25, 28, not 1982 as stated] Photograph of work widely misunderstood: effect of black hole thought to have been achieved by retouching.

September. Moves with Judith Gregson to a rented house at Brough, Cumbria: open, stony, high country, cold and snowy in winter. The first line to follow colours in leaves. [*Goldsworthy* 10]

1982

Winter. Brough, Cumbria, the first icicle reconstructed and frozen to rock on the steep-sided river bank where sun did not penetrate.

Ilkley. Snowball made for summer and stored in mother's deep freeze.

18 May. Blaenau Ffestiniog, North Wales, during a visit to David Nash overcomes technical problems and constructs the first slate arch. [*Goldsworthy* 34, not September as stated]

Trench edged with grass stalks
Swindale Beck Wood, Cumbria, November 1981

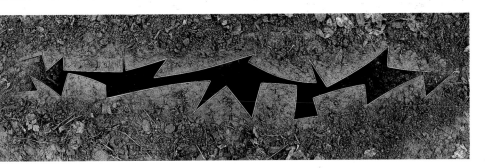

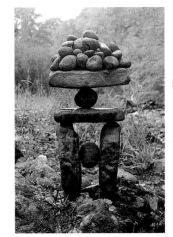

Snowball in summer
Tatton Park, Cheshire, Summer 1982

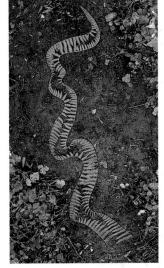

Bracken stripped down one side pinned to ground with slivers of bracken stalks
Brough, Cumbria, September 1982

17 July. Marries Judith Gregson at St Paul's Church, Brookhouse, near Caton, Lancashire. Judith, a practising sculptor, quickly becomes involved in Andy's work, proving indispensable, especially in photographing throws, rainbow splashes and, on occasion, ephemeral works being made or disintegrating.

Summer. 'Sculpture for a garden', Tatton Park, Cheshire (dates unrecorded), first outdoor snowball melt in group show with David Nash, Anthony Gormley, Paul Neagu and Ivor Abrahams, among others.

Balanced river stones
Cumbria, September 1982

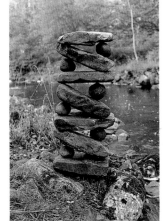

September-October. Brough and Swindale Beck Wood, Cumbria, the first serpentine form in bracken; balanced rocks, originally titled 'river stone thoughts' with Brancusi in mind. [*Goldsworthy* 36]

1-2 December. Brough, the first ice arch succeeds after several failures when arch collapsed as supports were removed. [*Goldsworthy* 33]

Ice arch
Brough, Cumbria, 1-2 December 1982

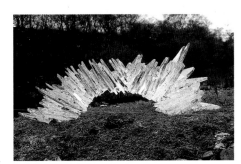

1983

Winter. Moves from Brough to the nearby Helbeck Estate, where the newly-weds are given the use of a house, a small wage and free logs and milk by Judge and Mrs. A.J. Blackett-Ord in exchange for part-time gardening. Begins constructing branch spires (leading to the Grizedale Forest commission in 1984). [*Goldsworthy* 54-55]

Spring. Begins making proposal drawings for large-scale permanent sculptures with Grizedale Forest specifically in mind. [*Hand* 156-157]

August. Abersoch, North Wales, the first serpentine form in sand, built on a sunny day to catch the light (developed at Haarlem in 1984, Arizona in 1989, The British Museum in 1994, Turin in 1995, and continues, *Time* 74-77, 123, 144-145, 149).

September. Yorkshire Sculpture Park, the first residency, during 'Sculpture in the Open Air' international symposium; grass stalk lines grow more elaborate; the first opportunity for the public to see ephemeral works on site. [*Hand* 27, 38; *Goldsworthy* 30]

Winter. Brough, Cumbria, stone spire; Grizedale Forest, serpentine branches, bracken stalk spires (foreshadowing the monumental Grizedale sculptures of 1984), establishing a pattern of familiarisation with sites for potential permanent

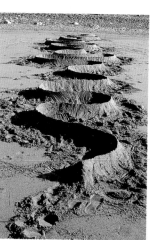

Sand edged to catch early light, viewed from south Abersoch, North Wales, August 1983

works by making ephemeral works there first.

Awarded a Northern Arts bursary (£4,000), which allows him to buy a Hasselblad square-format camera (not used extensively until 1988 due to the cost of film) and will cover the expenses of materials and subsistence while he works at Grizedale.

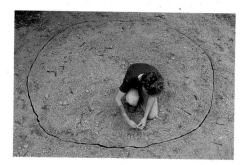

Circular crack (*above*) and tree hole (*below*)
Yorkshire Sculpture Park, September 1983

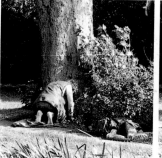

Stone spire
Brough, Cumbria, October 1983

Woven windfallen ash Grizedale Forest, Cumbria, November 1983

Bracken spires
Grizedale Forest, Cumbria, December 1983

Making 'Seven Spires'
Grizedale Forest, Cumbria, 1984

1984

After regular annual applications (since 1979) for the Northern Arts residency at Grizedale Forest (all rejected), he is invited to construct 'Seven Spires'– the first commission for a 'permanent' sculpture. 'I wanted to concentrate the feelings I get from within a pine wood of an almost desperate growth and energy driving upwards' (in Peter Davies and Tony Knipe, eds., *A Sense of Place: Sculpture in the Landscape*, 1984, p.151). [*Hand* 126-127] ('Seven Spires' begins to collapse in 1997, *Wall* 76-77.)

June. St Abbs, The Borders, the first rain shadow. 'Although among the most passive of my works, rain shadows are some of the most demanding and those that I have least control over. They are much more than an outline. I see all that I do as a shadow laid down in time as I lie on the ground. The trace that I leave will disappear from view, but is not lost – it becomes part of the place'. [*Goldsworthy* 77; *Time* 20-21, 151]

'I have become aware of how nature is in a state of change, and that change is the key to understanding. I want my art to be sensitive and alert to changes in material, season and weather' (in John Beardsley, *Earthworks and Beyond Contemporary Art in the Landscape*, 1984, p.134, which introduces Goldsworthy to an American audience).

5-13 August. Frans Hals Museum, Haarlem, Holland, residency at Haarlemmerhout Symposium, forced by the lack of stone to find three-dimensional structures in sand and leaves; the first leaf boxes. 'The sycamore has taught me most; within its leaf structure I realised my first leaf construction. By using its architecture I can make forms that grow from the leaf. The sycamore makes boxes, the chestnut makes spirals and horns.' [*Hand* 52, 55, 105; *Goldsworthy* 77] Installation in gallery: another hole in the ground, a relatively easy dig in sand after a few bricks have been removed from the

Leaf boxes (*right*) and carved sand (*below*) Haarlem, Holland, August 1984

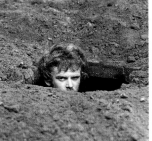

Frans Hals Museum, Haarlem, Holland, August 1984

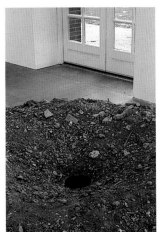

Serpentine Gallery, Hyde Park, London October 1984

floor. The first work made outside Britain, establishing the procedure for projects abroad: arrives on site with no preconceived ideas, makes ephemeral works with material at hand, photographs both successes and failures on a daily basis and exhibits the photographs as a single work accompanied by written notes and a location map.

'Salon d'Automne', Serpentine Gallery, London, 6-28 October, hole in floor. [*Hand* 29] In contrast to Haarlem, this time the floor, made of stone flags, is supported by a mixture of flints and

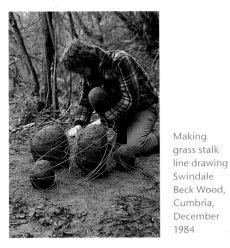

Making grass stalk line drawing Swindale Beck Wood, Cumbria, December 1984

concrete with, beneath it, hard, stony earth; the work requires permission from Crown Estates, demonstrating the difficulties which may be encountered in a gallery context (as at Venice, 1988, and The British Museum, 1994).

December. Swindale Beck Wood, Cumbria, grass stalk line 'drawings' take on a three-dimensional aspect: looping round rocks and secured by thorns and clay (a process which came to fruition in Dumfriesshire in 1990-91, *Stone* 84-85).

Work published in Richard Mabey, *Second Nature* (Jonathan Cape), pp.80-82, results in the first meeting with Susan Clifford and Angela King of Common Ground, a London-based organisation promoting art projects in the landscape, marking the beginning of a series of collaborations with Goldsworthy (in 1985, 1986, 1987, 1989).

1985

Spring. Grizedale Forest, Cumbria, constructs 'Sidewinder' (now decayed), a 60-foot-long 'serpent' of snow- and wind-damaged pine trees growing bent, pinned together with metal rods, which slithers and twists over rocks and between trees. [*Hand* 128; *Goldsworthy* 114-115]

'Evidence', Coracle Press, 3 May-7 June, organised by the director, Simon Cutts, the last exhibition held at 233 Camberwell New Road, London; makes a black hole by cutting through the linoleum and floorboards [*Hand* 31], melts the first debris-filled, deep-frozen snowball, made from late snow in Ilkley and stored in mother's deep freeze (anticipating work at Glasgow in 1989 and the Barbican, London in 2000). Through Cutts, Goldsworthy is introduced to Graeme Murray, with whom he is to pursue a number of collaborative projects after moving to Scotland, including those in 1987, 1989 and 1992.

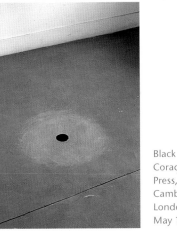

Black hole Coracle Press, Camberwell, London, May 1985

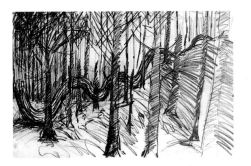

Proposal drawing for Sidewinder 1984

Snowball Coracle Press, Camberwell, London, June 1985

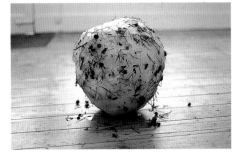

Galerie Löhrl, Mönchengladbach, Germany, November 1985

31 May-1 June. St Abbs, The Borders, line and cairn to follow colours in pebbles, commissioned by Simon Cutts (Coracle Press) and Scottish Arts Council, restating the theme of colour changes first explored in leaves in 1981, which came to fruition in 1998. [*Goldsworthy* 10-13]

July. Brough, Cumbria, limestone cones, evolving from Blaenau Ffestiniog stone ball (1980), and made in response to the 'Nine Standards', a group of stone monuments at nearby Helbeck (echoed later in nine cairns in nine pinfolds in the Sheepfolds Project, from 1996).

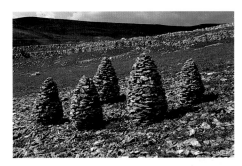

Limestone cones Brough, Cumbria, July 1985

September. Move to a flat at Langholm, Dumfriesshire, Scotland, when Judith is appointed to teach ceramics and sculpture, St Aidan's Comprehensive School, Carlisle, Cumbria (until September 1986).

Galerie Löhrl, Mönchengladbach, Germany, 3 November-13 December, the first rush line drawing using fresh rushes pinned to the wall with thorns, which, while initially looking good, dries and shrivels fast; by the next day the line has 'lost its energy'. (Subsequent reworkings of this idea entail collecting rushes which are allowed to dry in a variety of curves before installation, so that the line will retain its tautness: Aline Vidal, 1994, Michael Hue-Williams, 1996, Lelong, 2000).

11 December-29 January (1986). Residency with Artangel Trust and Common Ground working on Hampstead Heath and other London green spaces. [*Hand* 56, 59; *Goldsworthy* 17, 45, 50]

The Ecology Centre, London, 19 December-29 January (1986), exhibits Hampstead Heath photographs; installs a bracken frond serpentine pinned with thorns. [*Hand* 79]

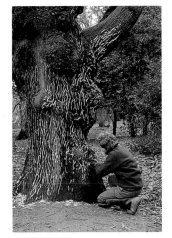

Hogweed stalks following channels in bark Hampstead Heath, London, December 1985

Bracken fronds pinned with thorns London Ecology Centre, December 1985-January 1986

1986

9 January. Interviewed by Christopher Bigsby, Kaleidoscope, BBC Radio 4. Appears on 'Blue Peter', BBC TV.

14-15 January. Fabian Carlsson and Clive Adams attend Goldsworthy's talk at London Ecology Centre, inviting him the following day to discuss representation by the Fabian Carlsson Gallery, Old Bond Street, his first London dealer. Beginning of a close working relationship with Adams, which will continue after closure of the gallery in 1991.

'Rain sun snow hail mist calm Photoworks by Andy Goldsworthy', Leeds City Art Gallery, 10 February-20 April, the first major exhibition and publication, touring to Northern Centre for Contemporary Art, Sunderland, County Durham and Apex Gallery, Portsmouth, Hampshire; attracts wide press coverage and public attention. 'Sometimes a work is at its best when most threatened by the weather. A balanced rock is given enormous tension and force by a wind that might cause its collapse'.

April. Hooke Park Wood near Beaminster, Dorset, makes a woven beech arch as a trial piece for the commission from Parnham Trust (John

Woven beech arch
Hooke Park Wood, Dorset, April 1986

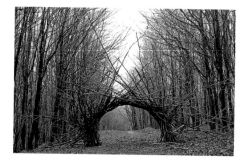

Knotweed stalks spiral
Holbeck Triangle, Leeds, Yorkshire, May 1986

Makepeace, furniture-maker) for Common Ground's New Milestones Project, reflected in a woven silver birch circle made in the same month at Langholm, Dumfriesshire. [*Goldsworthy* 57]

May. Leeds, makes knotweed stalks spiral and other ephemera on the Holbeck Triangle. [*Hand* 63]

July. Hooke Park Wood, erects 'Entrances', two circles of curved timber marking passage from a public road to a privately owned wood with public access. [*Hand* 60-61, 129-130]

August. With financial help from Fabian Carlsson purchases a house and adjoining studio, a nineteenth-century granary, at Penpont, Dumfriesshire, Scotland.

September. First work at Penpont, a continuous reed construction cradled in the outer branches of an oak tree, made on land belonging to the Duke of Buccleuch, the result of an introduction to the Earl of Dalkeith by Jenny Wilson of Dumfries and Galloway Arts Association. (The Earl will subsequently play a major role in enabling Goldsworthy to work in Scotland.)

September. St Louis, Missouri, residency at the St Louis Festival, the first visit to America. Meets paper-artist, Tom Lang, and begins collaborating on paper projects.

One of two branch circles flanking entrance
Hooke Park Wood, Dorset, July 1986

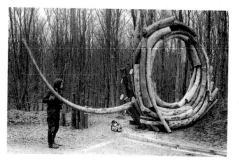

Sycamore leaf paper (with Tom Lang)
1986

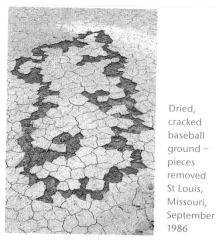

Dried, cracked baseball ground – pieces removed St Louis, Missouri, September 1986

31 October-1 November. Pollok Park, Glasgow, Scotland, the first leaf sheet. 'Glasgow brought to fruition a crack line and yellow streak through leaves that had been developing over the years – the idea finding the right time, place and material. I broke new ground – a hanging sheet of yellow leaves, one of the best pieces I have ever made. Amongst the rest, many starting points – markers for work to be discovered in the future.' [*Hand* 64-65; *Goldsworthy* 20-21, 102-103]

1987

First winter at Penpont. In sub-zero temperatures, some of the coldest weather yet worked by Goldsworthy, he makes the first major group of ice sculptures – column, fish, star, ball and icicle

Leaf sheet Pollok Park, Glasgow, 31 October 1986

Ice ball Penpont, Dumfriesshire, January 1987

points – on nearby Scaur Water. [*Hand* 144-145; *Goldsworthy* 82-89]

Penpont studio installations; proposals for five stone cones and a hilltop monument. [*Hand* 141, 155]

February. Yorkshire Sculpture Park, makes first horse-chestnut stalk screen held together with thorns: 'I tried to span what at the time seemed

Proposal for five stone cones in Dumfriesshire
1987

Proposal for hilltop monument in Dumfriesshire
1987

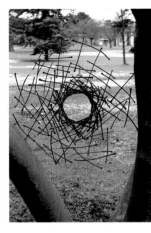

Horse-chestnut stalk screen Penpont, Dumfries-shire February 1987

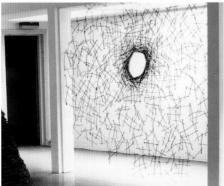

Horse-chestnut stalk screen
Fabian Carlsson Gallery, London, 1987

an impossible distance of at most eighteen inches between two tree trunks and, to my surprise, succeeded.'

'Andy Goldsworthy', first one-man show at Fabian Carlsson Gallery, London (dates unrecorded), including installations: a slate cone (purchased for the Government Art Collection, installed in the British Embassy garden, Copenhagen, Denmark); a slate hole (both slate

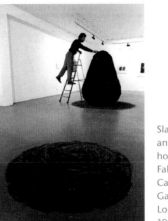

Slate cone and slate hole Fabian Carlsson Gallery, London, 1987

works made from material found in London skips); the first indoor horse-chestnut screen, made between two pillars away from potentially destructive wind and weather, which encouraged a larger scale, expanded further at Leeds and Gouda in 1990, San Francisco in 1992, Japan in 1993-1994 [Hand 30, 42, 84], and Santa Fe in 2000. [Time 158]

10-23 February. Yorkshire Sculpture Park, Winter residency.

25 April-7 May. Yorkshire Sculpture Park, Spring residency.

Sand drawing
Compton Bay, Isle of Wight, June 1987

June. Scaur Water, Penpont, Dumfriesshire, split hogweed pinned with thorns slowly floating downstream. [Hand covers]

June. Quay Art Centre, Newport, Isle of Wight, working with sand on Compton Bay. [Hand 66-67; Goldsworthy 26-27]

1 August-4 September. Yorkshire Sculpture Park, Summer residency.

'New Ground Sculpture by Andy Goldsworthy', Prescote Art and Design, 9-30 August (during the Edinburgh Festival), the first commercial gallery exhibition in Scotland organised by Ann Hartree, who was to become a close personal friend.

'Winter Harvest', Scottish Arts Council touring exhibition to public galleries and libraries in Scotland, August-December, curated by James Bustard, a unique, large, handmade table book produced with the writer, John Fowles, including a conversation: 'JF Much of your work is, like much of nature itself, very short-lived and transient by normal artistic standards. Does this worry you at all? AG Working with nature means working on nature's terms . . . Movement, change, light, growth and decay are the life-blood of nature, the energies that I try to tap through my work. I want to get under the surface' (reprinted in Hand 160-163).

Autumn. Begins working with the distinctive red sandstone of Dumfriesshire, initially using stone from a disused quarry nearby. 'It can be split along its grain into slices and is one of the few materials that I carve. I have cut holes into each slab, then reconstructed the stone with the holes aligning, becoming smaller as they deepen, looking into the centre, back in time.' (Later realised on a larger scale at the National Museum of Scotland in Edinburgh, 1998.)

October. Launches Stonewood Plot Fund, administered by Common Ground, to attract ten contributors of £500 each (in return for six

Carved red sandstone Penpont, Dumfries-shire, 1987

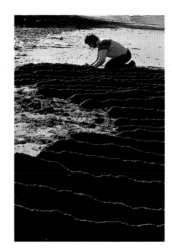

Sand brought to an edge for morning light Kiinagashima -cho, Japan, 7 December 1987

photographs and a drawing, one of which was distributed each year 1988-1994) to establish a long-term, outdoor working place on a 2.3 acre strip of scrubby woodland adjacent to a field used for sheep along Scaur Glen near Penpont, acquired on a 35-year lease from Buccleuch Estates; the project providing evidence of Goldsworthy functioning best in collaboration with curator, landowner, farmer and public as the expression of an awareness of the social structure of a place.

8 October. Son Jamie born.

21-28 October. Yorkshire Sculpture Park, Autumn residency, completing work over four seasons in one year (recorded in Parkland Andy Goldsworthy, Yorkshire Sculpture Park, 1988). [Hand 68-69; Goldsworthy 2, 4, 9, 14, 16, 18, 90-91, 110]

7 November-24 January (1988). Ouchiyama-mura, Kiinagashima-cho and Izumi-mura residencies, the first visit to Japan. 'I have become more aware of the significance of red and the intensity in the way it is revealed. I have experienced brilliant autumn colours in many places but never a red as deeply disturbing as the Japanese maple. The tree is often isolated against

Snow slabs, scraped line
Izumi-mura, Japan, 22 December 1987

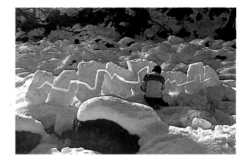

a green mountain, appearing like an open wound. It is this contrast which gives the red its energy and power'. [Hand 70-71; Goldsworthy endpapers, 15, 24, 37, 58-61, 77, 100-101]. In conversation with Fumio Nanjo, 9 December: 'FN It could be said that Art and Nature are at opposite poles, how would you react to that? AG I am part of Nature, I don't see myself as being in opposition . . . Our lives and what we do affect Nature so closely that we cannot be separate from it' (in Seiji Oshima and Terry Friedman, *Andy Goldsworthy Mountain and Coast Autumn into Winter Japan 1987*, 1988, reprinted in *Hand*, pp.163-165).

One of the participants in 'The Unpainted Landscape', Scottish Arts Council touring exhibition (book of same title, with essay by David Reason, published by Coracle Press, London, and Graeme Murray Gallery, Edinburgh).

1988

'Andy Goldsworthy Mountain and Coast Autumn into Winter Japan 1987', Gallery Takagi, Nagoya, 23 January-13 February; Fabian Carlsson Gallery, London, 24 February-19 March.

February-March. Selected by the Victoria and Albert Museum and the Department of the Environment to work in the Lake District National Park (Blencathra, Borrowdale and Derwent Water, Cumbria), returning to places worked as a student; makes slate throws; cuts slits into frozen snow; pieces reflected in water; the first slate and ice stacks (anticipating structures made at Stonewood in the Summer and at the National Museum of Scotland in 1998). 'Nature for me is the clearest path to discovery – uncluttered by

Ice stack
Lake District, Cumbria, March 1988

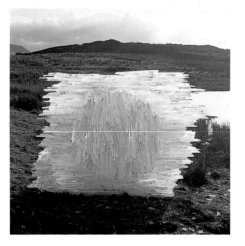

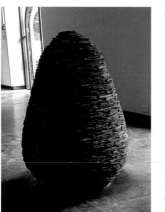

Slate cone
Grizedale,
Cumbria,
1988

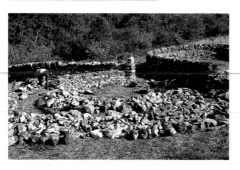

Working on 'The Wall'
Penpont, Dumfriesshire, Summer 1988

personalities or associations – it just is. A perfect lever. People like layers of leaves on a woodland floor – one generation after the other – each layer adding a new level to human understanding and character' (Sketchbook 19, February 1988). [Hand 46-47, 72-73; Goldsworthy 19, 62-69, 76-77, 92-97]

Summer. Begins making permanent work at Stonewood, Penpont: a slate hole; slate stack

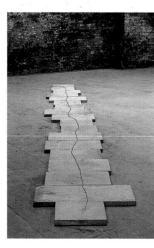

Broken paving stones version I Biennale, Venice, Italy, Summer 1988

standing sentinel to a blasted tree; 'The Wall' in the form of two linked sheepfolds separating the woods from farm land, one for sculpture, the other for grazing sheep (anticipating walls at Grizedale Forest in 1990 and Vassivière in 1992). Employs Joe Smith as dry-stone waller (intermittently until 1996). [Hand 138, 148-151; Goldsworthy 24, 118-119; Wood 5; Wall 42]

Invited artist at the Aperto (Open), Venice Biennale, Italy, 26 June-25 September. Proposal to dig black hole is refused; on arrival, walks outside gallery and finds discarded paving stones: makes broken paving stones versions I and II; sycamore leaf box is an 'Unofficial' entry. [Hand 40-41, 105]

July. First visit to Penpont by Jill Hollis and Ian Cameron of Cameron Books to discuss the possibility of publishing a book (*Andy Goldsworthy*, 1990).

Makes clay holes at Caton, Lancashire, with Barry Gregson, work which will be exhibited at Fabian Carlsson Gallery in 1989.

'Britannia. Trente Ans de Sculpture', Musée des Beaux-Arts André Malraux, Le Havre, France, 15 October-12 December, showing a slate hole and a slate crack made at Rouen. [Hand 30, 39]

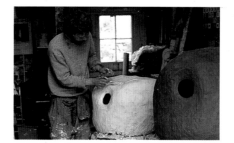

Making clay holes
Lunesdale Pottery, Lancashire, Summer 1988

Leaf hole Castres, France, October 1988 (Photograph by Julian Calder)

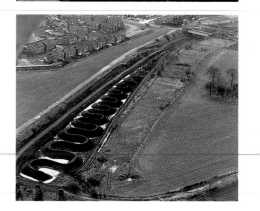

'Lambton Earthwork'
County Durham, 1988

17-26 October. Centre d'Art Contemporain, Castres, France, Autumn residency (recorded in *Garden Mountain Andy Goldsworthy*, 1989) [Hand 37, 77; Goldsworthy 24, 104-105]. Meets photographer Julian Calder, who is invited on the trip to the North Pole (April 1989), the first of a number of collaborations.

'Lambton Earthwork' near Chester-le-Street, County Durham, commissioned by Northern Arts and Sustrans, a quarter-mile-long earth serpentine form built on a section of abandoned railway line between Consett and Sunderland, like 'a river finding its route down a valley, the ridge of the mountain, the root of a tree . . . a river of earth'. [Hand 132-133; Goldsworthy 117] Makes leaf constructions during supervision of earth-moving, establishing a pattern of working simultaneously at different scales.

1989

January. Perthshire, Scotland, makes leaf throws on Tayside during three weeks of unusually mild winter weather while awaiting snowfall, then rolls and deep-freezes (in the then Christian Salvesen refrigeration depot at Blairgowrie) eighteen snowballs about a metre in diameter filled with natural materials, assisted by wife and father-in-law. [Hand 48-49, 114-115, 117]

Making snowball
Perthshire, January 1989

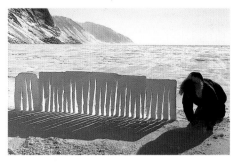

Grise Fiord, Ellesmere Island, Canadian Arctic
15 April 1989

March-April. 'Maze', Leadgate near Consett, County Durham, supplies drawing for a second, large-scale installation, concentric walls of earth on a triangular site along the same disused railway lines as the 'Lambton Earthwork' (1988); constructed while Goldsworthy is at Grise Fiord. He has misgivings about being absent while work is proceeding. [Hand 134-135; Goldsworthy 116]

Seal blood mixed with snow
March-April 1989

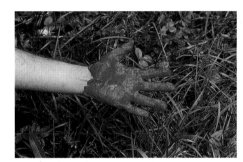

Poppy petals
Sidobre, France, June 1989

22 March-20 April. Grise Fiord, Ellesmere Island, Canadian Arctic, makes a powerful group of snow sculptures and the first snow-blood drawings. [Hand 94-95; Goldsworthy 70-73]

22-24 April. Trip to the North Pole funded by Fabian Carlsson. Constructs 'Touching North', four round arches of snow, each about ten feet high, oriented in four different directions but all facing south, photographed by Julian Calder. 'I have made a work that gives a sense of being at the centre of a place . . . the sun does not go down at all . . . and just circles round . . . Each arch catches the light at a different time . . . The ice is moving in the direction where the Pole is and there is a very good chance that this work will pass over it' (daily audio-taped diary in Touching North, Graeme Murray Gallery, 1989). [Hand 74-75; Goldsworthy 74-75]

31 May-7 June. Sidobre, France, part of the Castres project (1988), wraps red poppy petals around a granite boulder. [Hand 76; Goldsworthy 46-47]

Labège, France, proposal for a boulder enclosed by a dry-stone wall, unrealised. [Hand 139]

14 June. 'Touching North', The Late Show, BBC2 TV.

30 June. Interviewed by Terry Friedman, Third Ear, BBC Radio (transcript in Hand, pp.165-168).

'Black in Black'
Fabian Carlsson Gallery, London, June-July 1989

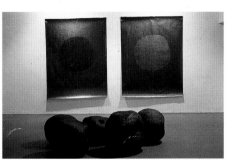

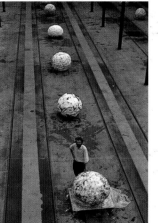

'Snowballs in Summer'
Old Museum of Transport, Glasgow
July 1989

'Touching North: Arctic Works', Anne Berthoud Gallery and 'Black in Black: New Sculptures and Drawings', Fabian Carlsson Gallery, London, 26 June-29 July, graphite drawings and installations: a slate stack; fired clay holes made at Barry Gregson's Lunesdale Pottery, Lancashire. [Hand 36, 89-93] L.A. Louvre Inc., Los Angeles, California, 1-29 July; Graeme Murray Gallery, Edinburgh, 1-30 September.

'Snowballs in Summer', Old Museum of Transport, Glasgow, 28 July-1 August, eighteen snowballs made in Perthshire in January and preserved in cold storage now installed and melted over five days, scattering their innards, 'drawing themselves on the floor'. [Hand 118-123]

Penpont studio, Dumfriesshire, 1989
(Photograph by Julian Calder)

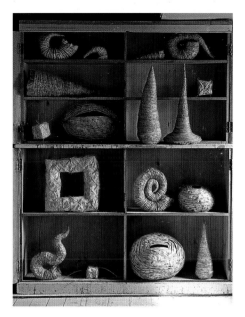

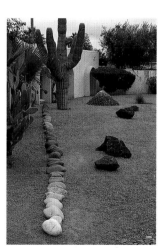

Line and cairn to follow the colour changes in stone
Phoenix, Arizona, November 1989

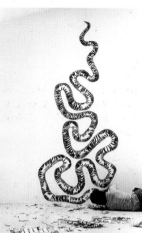

Stripped bracken fronds
Aline Vidal Gallery, Paris, France, 1989

August. Le Jardin Massey. Tarbes, France. [Goldsworthy 110]

'Leaves', Natural History Museum, London, 27 September-14 January (1990), organised by Common Ground, 32 leafworks made at Penpont and Lambton in 1988-1989, acquired by Leeds City Art Galleries in 1991 (recorded in Paul Nesbitt, Leaves, 1989). [Hand 98, 110-113]

Mossdale Farm, Yorkshire National Dales, proposal to build a curving wall down a hillside with a sycamore tree planted in each curve and guarded by the wall from weather, rejected (realised in another, more dynamic configuration at Grizedale in 1990 and Storm King in 1997-98).

November. Phoenix, Arizona, makes stone line and cairn to follow colour changes at the home of Daniel Moquay and Rotraut Klein, widow of the painter, Yves Klein; the first American private commission.

Invitation to visit and make proposals for permanent outdoor sculptures at two historic

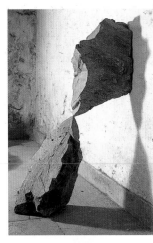

Whinstone
Penpont
studio,
Dumfries-
shire, 1990

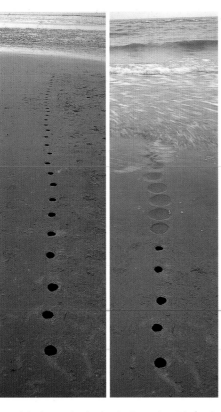

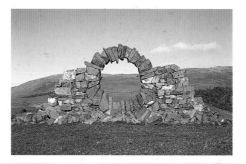

'Touchstone North'
Dumfriesshire, 1990

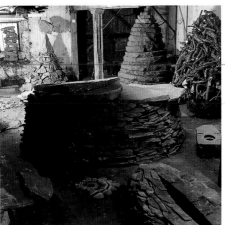

Penpont studio
Dumfriesshire, 1990

residences: Frank Lloyd Wright's Kentuck Knob, Dunbar, Pennsylvania [*Stone* 118] and Mies van der Rohe's Farnsworth House, Plano, Illinois, at the latter proposing a row of stones, one for each year of the house's existence, with sizes governed by the height of the annual floodwaters (realised in another form in 1992).

'Garden Mountain', Centre d'Art Contemporain, Castres, France, 13 December-14 February (1990), touring to St Fons, Tarbes and Galerie Aline Vidal, Paris; first one-man show in France. [*Hand* 80-82]

1990

During 1989 and 1990 makes work in the Penpont studio. [*Hand* 78, 83, 85, 87, 96, 106-107]

Spring. When uprooting dead bracken (last year's growth), discovers that the stalk below ground is black (which leads later to work using part-burned sticks 1997, 1998). [*Time* 34-35, 38]

Beach holes washed away by incoming tide
Morecambe Bay, Lancashire, January 1990

4 April. Daughter Holly born.

April. Dumfriesshire, 'Touchstone North', a large-scale, upright stone circle. 'Work made abroad should have purpose in the place that I live. I want my experience in the Arctic [in 1989] to find form in my home land. A work made north of Penpont – a touchstone between Penpont and Pole. A landmark that will orientate north.' [*Hand* 158-159]

Flevoland, Holland, a proposal for five conical, 20-metre-high hills, densely planted with trees, sequenced along a roadside, illuminated by the rising and setting sun, changing colours seasonally, unrealised. [*Hand* 124] (Subsequently reproposed at Laumeier, St Louis,

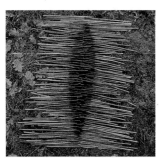

Bracken
stalks
Penpont,
Dumfries-
shire,
11 February
1990

Proposal for tree-planted hills for Flevoland
Holland, 1990

Missouri in 1991, and currently under consideration at the Cirque du Soleil, Montreal.)

'Torn Stones', Fabian Carlsson Gallery, London, 6 June-28 July, installation of 180 Borrowdale volcanic stones fired by Barry Gregson at the Lunesdale Pottery (destroying the kiln in the process). 'That stone can become liquid and liquid can become stone is a deeply unnerving but beautiful expression of change' [*Stone* 67-68]. (No more firing of stones allowed in Barry Gregson's kiln; it will be 1997 before Goldsworthy's own kiln is installed at Penpont.)

Ile de Vassivière, Limousin, France, ephemeral works; several proposals including Woodland

Wet and dry sand
Ile de Vassivière, France, 1990

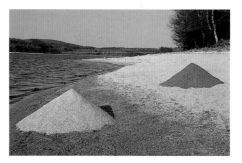

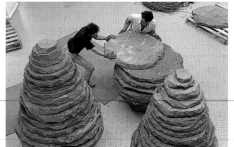

Installing 'Hand to Earth'
Leeds City Art Gallery, Yorkshire, June 1990

cones, unrealised [*Hand* 141], and one that was made. [*Stone*, 114-115]

'Hand to Earth Andy Goldsworthy Sculpture 1976-1990', Leeds City Art Gallery, 22 June-29 July, organised by The Henry Moore Centre for the Study of Sculpture; the first retrospective, touring to Edinburgh, Gouda in Holland, Toulouse in France 1990-1991 (*Hand to Earth*, 1990, 196pp, 194 illustrations with artist's statements and various essays).

June. Publication of *Andy Goldsworthy*, 120pp, 121 colour illustrations, with Introduction by the artist, the first large-format survey, beginning of a successful collaboration with Jill Hollis and Ian Cameron of Cameron Books, Moffat, Dumfriesshire.

Summer. 'Enclosure', a circular dry-stone enclosure containing a slate dome with hole, and trees planted outside the wall, commissioned by the Royal Botanic Garden, Inverleith House, Edinburgh. [*Hand* 139; *Stone* 112-113]

Summer. Gateshead, Tyneside, a proposal for a public park on the site of an old foundry, a set of giant cones constructed of two-inch thick, rusted, scrap steel plates laid on top of one another, monuments to a decayed industrial environment (only one cone realised, in 1991). [*Stone* 34-35]

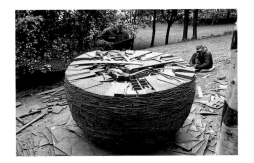

Making steel cone
Gateshead, Tyneside, Summer 1990

Proposal for 'Wall that went for a walk'
1990

'A difficult process: after each day's work, the top part had to be welded on to prevent materials being stolen. Even so, as the cairn neared completion, the top foot or so (representing several days' work) was prised off. Had the culprits not been apprehended by a passing plain-clothes policeman, still more of the sculpture would probably have vanished. When charged, the vandals claimed they couldn't tell the difference between scrap steel and a work of art.'

September. Grizedale Forest, Cumbria, commission for 'Wall that went for a walk, alert to the lie of the land, taking a route that incorporates a rock or tree into its length rather than flattening the ground or cutting the tree down' (completed 1991). [*Stone* 116-117; *Wall* 6, 8]

October. Isle of Skye, Scotland, stones covered in peat; balanced rocks (ideas developed in Japan in November). [*Stone* 78-79]

20 October. Bristol, Avon, 'Art in Nature', an illustrated talk for the 1990 Schumacher Lectures 'From Inspiration to Action: Business, Politics & The Arts in the Age of Ecology'.

29 October-7 November. Mochigase-gawa and Koshin-gawa, Ashio, Japan, work exhibited in 'British Art Now A Subjective View', Setagaya Bijutsukan, Tokyo, organised by Asahi Shimbun and The

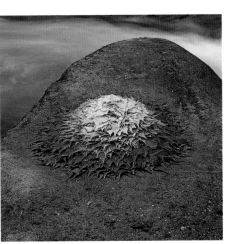

Maple leaves
Ashio, Japan, 1 November 1990

British Council [*Wood* 1; *Time* 25]. Meets Hiroi Sugimura, curator at Tochigi Prefectural Museum of Fine Arts (organiser of 'Two Autumns' in 1993).

Winter. Drumlanrig, Scotland, develops snowball drawings using earth, seeds and animal blood mixed with snow and melted on large sheets of paper (exhibited in 1992).

1991

Penpont. During 1991 makes a line of snowballs, anticipating change over time by revisiting and photographing them as they melt over several days, a leaf line floating on Scaur Water and other ephemeral work.

March. Visits Russia intending to work in Siberia but due to administrative difficulties is unable to travel there; makes snowball drawings with city-stained snow gathered from various public squares in Moscow.

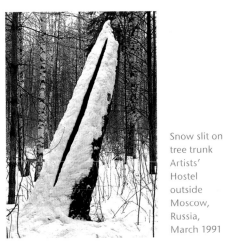

Snow slit on tree trunk
Artists' Hostel outside Moscow, Russia, March 1991

'Seven Holes'
Greenpeace UK Offices, London, April 1991

April. 'Seven Holes', Greenpeace UK Office, London; during the first three months as the clay dries out Goldsworthy repairs the cracks, until he realises they are the most interesting feature; the process has major implications for later installations (Los Angeles in 1997 and Edinburgh in 1998). [*Stone* 74-75]

5 June. Scaur Water, Penpont, hazel leaves stitched with grass stalks floating downstream, commissioned by the Association of Business Sponsorship of the Arts and published in their *Annual Report 1991*. [*Time* 52-55]

'Leaves', Atelier des Enfants, Centre Georges Pompidou, Paris, 5 June-2 November.

13 July-3 August. Artist-in-residence, Adelaide Botanical Garden, the first visit to Australia, working at Mount Victor sheep station and in the bush, making stone cairns, red sand throws and carvings; a mulga tree covered in red sand. 'I cannot describe the effect that red has on me. To understand that colour is to understand something of the spirit of this place.' [*Stone* 43, 52-57; *Wood* 18-19, 36, 56-57; *Time* 21]

22 August-3 September. Chicago, Illinois, working on the Michigan dunes and in the Illinois woods, the first works made for and photographed at night. 'I have never been in a place that has all the qualities of a coast – space, colour and light, but without an incoming tide to wash away the work. I became more aware of the powerful continuous effect of water on land.' Work shown in 'Sand Leaves', The Arts Club of Chicago, 16 September-4 November; first one-man show in America (*Sand Leaves*, The Arts Club of Chicago, 1991).

18-22 September. Laumeier Sculpture Park, St Louis, Missouri, proposal for two permanent sculptures, 'Frightened Mountains' and 'Red Hill' (similar to the proposal for Flevoland, 1990), both unrealised; covers a river rock with leaves and stones. [*Stone* 26-31]

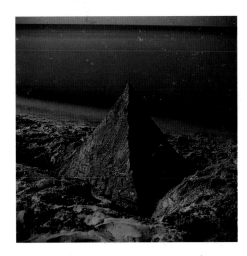

Moonlit sand
Lake Michigan, Michigan, August 1991

October-November. Scaur Water, Penpont, Dumfriesshire and Ouchiyama-mura, Japan, making partnered works assisted by Hiroya Sugimura. [*Stone* 16-17, 24-25; *Wood* 28] Filming on both locations for 'Two Autumns', The Arts Council of Great Britain/Channel 4 film (1992).

22-24 October. Scaur Glen, Dumfriesshire, two stone cones to mark night and day, one begun around midnight, finished at daybreak, and another begun mid-morning, finished at dusk. [*Stone* 36-37]

Winter. Lowther and Borrowdale, Scotland, snowball drawings (to be exhibited in 1992).

1992

February. Mount Victor Station and Kangaroo Island, South Australia, working with round pebbles and animal bones found on beach [*Stone* 10-11, 40-41]. Installs 'Mid-Winter Muster', Adelaide Festival, 26 February-28 March, tours to Dunedin and Auckland, New Zealand.

'Frightened Mountains' proposal for Laumeier Sculpture Park, St Louis, Missouri, September 1991

Carved sand
Mount
Victor,
South
Australia,
February
1992

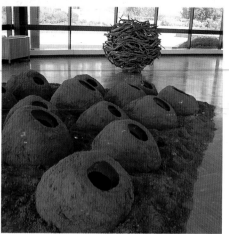

Compacted, carved sand and woven mulga sticks
Adelaide, South Australia, February-March 1992

Spring. Ile de Vassivière, France, 'Two folds', a circular dry-stone wall built on the line of an old wall, part in the forest, part in the lake; 'I liked the resonance of drawing old into new, exploring the boundary between wood and lake'. [Stone 114-115]

Spring. Atelier St Anne, Brussels, Belgium, installs 'Stone sky'. [Stone 86-87]

May. Oliver's Ranch (Napa Valley), Hope Ranch Beach at Santa Barbara and Lake Tahoe, California, boulders clad in bark and manzanita branches; sand stones; boulder covered in clay which successfully cracks in the consistently dry weather (realised after an unsuccessful attempt in 1980); the launch of the 'California Project' organised by Haines Gallery, San Francisco. [Stone 7-9, 50-51]

'California Project', Haines Gallery, San Francisco, California, 4 June-9 July; installs clay-covered rocks,

Icicle and earth drawing
Winter 1991-92

dried and cracked over several days, the beginning of Goldsworthy's association with the gallery and its director, Cheryl Haines. [Stone 69; Wood 81]

June. Laumeier Sculpture Park, St Louis, Missouri, returns to cover the rock worked in 1991 with dead sticks. [Stone 32-33]

'ICE and SNOW drawings and THROWS', Fruit Market Gallery (dates unrecorded), Edinburgh International Festival, organised by Graeme Murray, stained snow and icicles left to melt on paper which buckles to form landscapes of hills, ridges and valleys. 'There is a tension and excitement in this process in which I am the initiator but not the controller' (in Andy Goldsworthy, Paul Nesbitt and Richard Bright, ICE and SNOW drawings 1990-1992, 1992, p.8). [Stone 92-93]

Cracked,
clay-covered
boulder
California,
May 1992

Leaves pressed into bark
Dunbar, Pennsylvania, October 1992

1 September. Stonewood, Penpont, poppy-petal-wrapped branch in hazel tree. [Wood 50-51]

'Flow of Earth', produced by William Burdett-Coutts for the arts programme 'Celebration' (Boddington Festival), broadcast on Granada TV, 24 September.

28 September. London, premier of 'Two Autumns: The work of Andy Goldsworthy in Penpont Scotland and Ouchiyama Japan', a film by Peter Chapman, produced by Lightyears Films for The Arts Council of Great Britain in association with Border Television, Channel 4 and Tyne Tees Television.

'Hard Earth', Turske Hue-Williams Gallery, London, 8 October-27 November, 'white Dorset clay smoothed out with a plasterer's float, initially

'Hard Earth' Turske Hue-Williams Gallery
London, October-November 1991

looked the same as the walls and ceiling: the gallery appeared to be empty. Gradually the nature of clay revealed itself as it cracked, as if it was coming out of the building itself' [Stone 72-73]. First cracked clay work on floor (to be followed by floor and wall works in 1996, 1998, 1999). Beginning of working relationship with Michael Hue-Williams.

October-November. Kentuck Knob, Dunbar, Pennsylvania, 'Room', a circular dry-stone wall [Stone 119]; stone arch suspended between trees [Stone 99]; a line following colours in maple leaves pinned to a fallen tree. [Wood 72-75]

24 October-3 November. Runnymede, California, makes ephemeral work after a nine-year drought suddenly breaks with ferocious rain; the idea of nature growing through a structure becomes a major factor in subsequent sculptures: 'there is something deeply interesting about a bright green grass blade growing out of a black hole. I have never experienced such vigorous growth in such a short space of time, not out of barren-looking earth. I now realise the profound impact of rain.

Holes with
grass
Runnymede,
California,
October
1992

That the soil reacted so vigorously to it is evidence of the energy that the rain released and the change that it initiated.' [Wood 20-21, 48, 52-53]

November-December. Farnsworth House, Plano, Illinois, a proposal for a permanent outdoor installation (1989) realised in a variant form: a cairn of boulders piled to the height of the 1954 Fox River flood with future annual flood levels to be recorded in carved lines on the structure. [Stone 46-47]

Scarborough Bluffs, Toronto, Canada, two proposals for a cliff-top: a dry-stone enclosure intended to collapse a little each year as the cliff erodes [Stone 113] and a line of stones which would gradually fall over the edge of the cliff as the coastline receded, both unrealised.

Proposal for a cliff top
Scarborough Bluffs, Canada, 1992

1993

January-February. Dumfriesshire, makes a series of stone arches 'taking walks'; begins a series of red pools made by grinding iron-rich stones together in a river, realising in a stronger fashion a process first tried at Morecambe in the 1970s, where Goldsworthy still occasionally returns to work; [*Stone* 96-99] repeated in Japan in May.

5 February. Daughter Anna born.

Spring. Nice, France, 'Four Corner Cones', a private commission; Parc de la Courneuve, Saint-Denis, Paris, 'Blackwater stone'. [*Stone* 38-39, 64-65]

May. Scaur Water, Dumfriesshire, working dandelions on rock and riverside pool; red river rock pools. 'I imagine that most people's reaction to the colour is disbelief and that I have stained the pools with paint. In a way, two stones rubbed together is painting, but this is a colour from within the river. I like the way the work is so much part of the place. All I have done is to see it. These are

Red stone pool
Morecambe Bay, Lancashire, March 1993

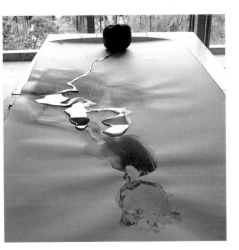

Mount Fuji and Ben Nevis snow drawing
Nashigahara, Japan, May 1993

the most difficult works to achieve.' [*Stone* 18-19, 21, 90-91] Scaur Glen, a slate arch 'moving gently in the wind' before collapsing. [*Stone* 94-95]

May. Nashigahara, Japan, working with dandelions, snow, ash, lava and red Gotemba quarry earth; 'A meeting of mountains': a snowball with earth from Mount Fuji is left to melt at one end of a 4.5 metre long sheet of paper; at the other is an existing drawing made by a snowball laden with earth from Ben Nevis, Scotland.

'Mid-Winter Muster Sculptures at Mount Victor Station', Harewood Terrace Gallery, Yorkshire, 24 May-4 July.

19 June. New York City, rain shadow [*Stone* 62]. Spends ten days making work in Central Park [*Wood* 2] in preparation for exhibition at Galerie Lelong, the beginning of Goldsworthy's relationship with the gallery, headed by Mary Sabbatino.

Sand installation, Storey Institute, Lancaster, Lancashire, 8 July-13 August.

Stacked sticks
Central Park, New York, 15 June 1993

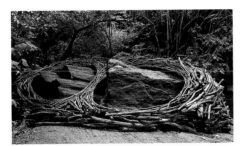

July. Elinor Hall joins the Penpont studio as assistant to Andy Goldsworthy.

9 July. Receives Honorary BA Degree, Bradford University.

23 July, Porth Ceiriad, Wales, balanced rocks brought down by the incoming tide. [*Stone* 101]

'Wood Land', first one-man exhibition at Galerie Lelong, New York City, 9 September-16 October, recent work made in New York, Illinois, Pennsylvania and Dumfriesshire. [*Wood* 78-79]

'Two Autumns', Tochigi Prefectural Museum of Fine Art, 17 October-28 November, curated by Hiroya Sugimura, the first large museum show in Japan. 'The emphasis on two seasons and places is an expression of connections in nature – that beyond each work lies another – a layer below waiting to be revealed – place beneath place, season beneath season'. [*Stone* 70-71; *Wood* 28-29, 80]

November. Buckhorn, Westchester County, New York, 'Wood through Wall', a private commission for Joel and Sherry Mallin, a dry-stone wall incorporating the trunk of a fallen tree. [*Wood* 54-55; *Wall* 10, 42] (Buckhorn becomes the Goldsworthys' home-away-from-home; the Mallins are subsequently involved in supporting activities at Storm King and Cornell University, 1999-2000.)

Winter. Barfil, Dumfriesshire, 'Rock fold', private commission, a dry-stone wall encircling bedrock revealed in a 'geological dig'. [*Stone* 108-111] (Bedrock later proves to be friable, returning to earth and quickly becoming overgrown, thus losing the stone landscape that had been uncovered and had helped form the work; beginning of the idea for the Sheepfolds Project, which will be realised from 1996.)

1994

'Two Autumns', Setagaya Art Museum, Tokyo, Japan, 19 February-27 March, makes a large snowball during the heaviest snowfall in 25 years. [*Wood* endpapers, 82-83]

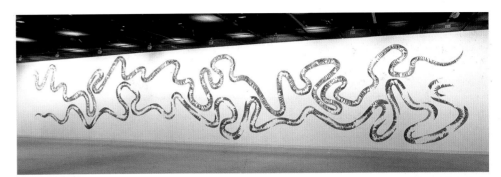

Bracken line (*above*) and leaf stones (*below*)
Tochigi Prefectural Museum, October 1993

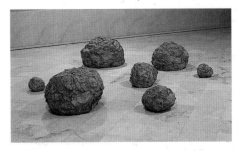

February-March. Penpont, Scaur Water, snowballs suspended in beech and oak trees; Capenoch Estate, five stone arches, the first of many works made on or near an ancient oak tree. 'The long branch that has grown horizontal to the ground has taught me that the tree is the land. The branch is like the landscape'. [*Wood* 26-27, 84, 98-99]

April. Publication of *Stone*, 120pp., 165 colour illustrations, with artist's statements.

'Stone', Michael Hue-Williams Gallery and Grob Gallery, London, 21 April-27 May, including 'Herd of Arches' made in Scotland and exhibited in the temporarily vacant building at 19 Bond Street (subsequently shown at the Hathill Sculpture Foundation, Goodwood, Sussex, then permanently sited in Cornwall, a movement of sculpture with important implications for future work). 'A local working quarry, Locharbriggs, generously offered me the run of rough stone from the quarry tip.' Meets Eric Sawden, quarry manager: beginning of working relationship which will be sustained in other sandstone projects (in 1998, 1999).

'Stone', Haines Gallery, San Francisco, 3 May-11 June, a rush-line wall drawing; two floor works including 'Drawing on slates'.

'Terre Rouge', Galerie Aline Vidal, Paris, 17 May-3 July, including a large wall stained with red, iron-rich stone.

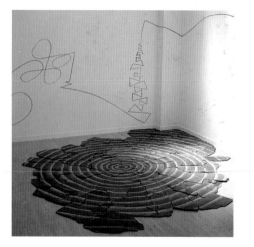

Scratched slate drawing and grass line Haines Gallery, San Francisco, California, May-June 1994

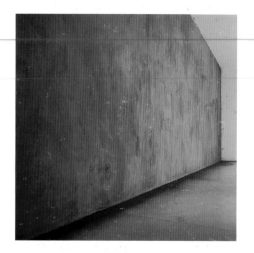

'Terre Rouge' Aline Vidal Gallery, Paris, France, May-July 1994

May. Continues working on Capenoch tree (dandelion line). [*Wood* 104-105; *Wall* 36]

'Laumeier Stone', Laumeier Sculpture Park, St Louis, Missouri, 4 June-7 August, exhibits photographs of 'River rock' worked in 1991, 1992 [*Stone* 26-33], with a marker cairn erected near the site; a hickory leaf spiral walled round in the river (anticipating work at The British Museum in October). [*Wood* 71]

6-18 June. Runnymede Sculpture Farm, California, dust throws. 'They had a quality of breath on a cold day and California is a place where you can feel the earth breathing – often violently' [*Wood* 17]; clay dug from ground, processed, worked and fired in purpose-built kiln, and the resulting pieces placed back in the location from which the clay was dug, assisted by Barry Gregson.

Stones in tree Fornaluix, Mallorca, July 1994

July. Fornaluix, Mallorca, Spain, balanced stones in olive trees and olive tree cairns. 'These trees are so old they feel like stone. The stones have given growth to the olive trees; they grow out of the earth because of the stone – within the wood is stone. The stone grows within the tree – the seed. The tree is stone expressed in wood'. [*Wood* 34-35, 46-47] (Leads to further tree- and stone-related works, notably the Wall at Storm King, 1997-99.)

July. Work on Capenoch tree (oak leaf lines). [*Wood* 108-109]

July. Royal Botanic Garden, Edinburgh; while remaking the slate cone (1990), visited by Régine Chopinot, one of France's foremost contemporary dance choreographers, discusses collaborating on a new ballet, 'Végétal', with her company Ballet Atlantique (premiered in 1995).

October. Work on Capenoch tree (beech leaves line). [*Wood* 112-113]

22-25 October. The British Museum, London, places spiral of sweet chestnut leaves in a black basalt libation bowl; installs 'Sandwork', 30 tons of sand temporarily snaking through the Egyptian

Purpose-built kiln
Runnymede, California, June 1994

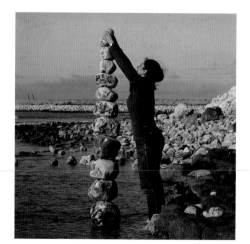

Régine Chopinot on the beach
La Rochelle, France, November 1994

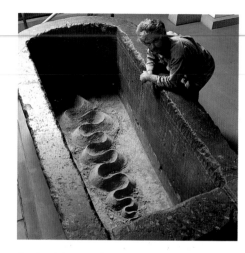

Sandwork in sarcophagus British Museum, London, December 1994 (Photograph Julian Calder)

Sculpture Gallery. 'Sand is somewhere between stone and earth. It can be compressed hard and yet it can become fluid. It has a sense of strength, fragility and movement. The work would flow through the room – touching the sculptures and incorporating them into its flow.' Proposal originally rejected as too disruptive and needing an excessive amount of space, but, supported by the curator James Putnam, Goldsworthy agrees to make the work overnight for one day only; it stayed for three. [*Wood* 44, 70]

November. One of many visits to La Rochelle, France, to pursue discussions with Régine Chopinot about 'Végétal'.

November-December. Work on Capenoch tree (cone, ball and column of stacked sticks). [*Wood* 114-115]

'time machine Ancient Egypt and Contemporary Art', The British Museum, London, Department of Egyptian Antiquities, 1 December-26 February (1995), a group show curated by James Putnam; 'Stonework' set in a schist sarcophagus; 'Sandwork' in a breccia sarcophagus; 'Leafworks' in a grano-diorite sarcophagus and a black basalt libation bowl; the first leaf constructions made for existing containers. 'The sarcophagi are not just containers of death, they are containers of life, in that out of death comes life' (artist's statement, *time machine*, Trustees of The British Museum and Institute of International Visual Arts, 1994, p.46).

15 December. Son, Thomas, born.

December-January (1995). Scaur Glen, Dumfriesshire, stones covered in peat.

1995

4-5 January. Work on Capenoch tree (seven snowballs). [*Wood* 116-117]

'Breath of Earth', San Jose Museum of Art, San Jose, California, 2 February-23 April, installations. [*Wood* 39, 42-43]

25 February. Work on Capenoch tree (rosebay willowherb stalks). [*Wood* 96-97]

7 March. Work on Capenoch tree (hollow snowballs). [*Wood* 100-101]

'Four Stones', Galerij S65, Aalst, Belgium, 11 March-15 April, the beginning of a working relationship with August Hoviele.

14 March. Issue of 'Springtime', Royal Mail stamps (19p, 25p, 30p, 35p, 41p) and postcards featuring five ephemeral works.

Clay-covered branch on slate
San Jose, California, February-April 1995

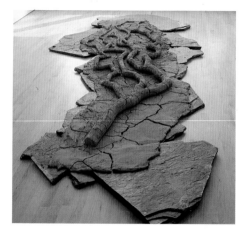

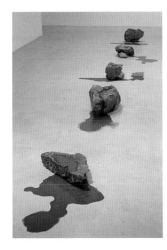

'Black Stones
Red Pools'
Galerie
Lelong,
New York,
March-April
1995

March. Mount Kisco, New York, 'Stone house' [*Wood* 31]. First visit to Storm King Art Center, Mountainville, New York.

'Black Stones Red Pools', Galerie Lelong, New York City, 23 March-22 April, work made in Dumfriesshire, Winter 1994-1995, stone installation. 'I feel there is connection between the black and the red, the red flowing around the earth as a vein. It has made me aware of the flow of nature'; 'I had made similar work on the Isle of Skye [in 1990]. Reworking qualities that I had initially achieved by chance has given a deeper understanding of weather, season and stone' (in *Black Stone, Red Pools*, ProArte, 1995).

April. Buccleuch Estates agrees to sell a farmhouse, near Penpont, to be remodelled as a permanent residence, offices and studios.

April. Work on Capenoch tree (lines of well-rotted oak strips). [*Wood* 102-103]

April. Discussions with Steve Chettle, Public Art Officer, Cumbria County Council, for a major, county-wide sculpture initiative to be launched by the Heritage Services Department for UK Year of the Visual Arts (1996), managed and developed by Cumbria Public Art over five years (until 2000; now extended to 2002-2003); Goldsworthy proposes building 100 dry-stone sheepfolds, their potential locations identified by sites on the Ordnance Survey and historical maps (launched January 1996).

Encouraged by Katherine Febros, British Council art adviser in Paris, to attend the opening of 'Earth Memory', Musée départemental, Digne-les-Bains, Haute-Provence, 19 May, Goldsworthy discovers the extraordinary geological context of this remote part of the Basses-Alpes. Meets Nadine Gomez-Passamar, the museum's director, and Guy Martini, the beginning of one of his most sustained and significant relationships to a place

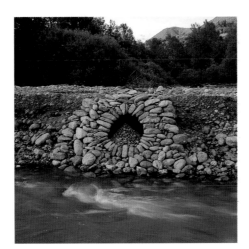

Cairn
Digne-les-Bains, France, July 1995

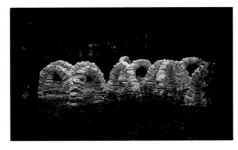

'A Clearing of Arches'
Goodwood, Sussex, June 1995

and people outside Scotland (works there in July, 1997, 1998, 1999, 2000).

June. 'A Clearing of Arches', a proposal for the Hathill Sculpture Foundation, Goodwood, Sussex, to make a chalk sculpture to be seen at night; later installed in the dimly lit ground floor of a barn in Penpont, Goldsworthy's first studio there.

June. Work on Capenoch tree (leaf dome with hole). [*Wood* 106-107]

14-26 July. River Bès, Digne, France, makes a solitary cairn successively layered with differently coloured stones, stalks with burnt ends, sand, and bleached branches as an expression of the geological strata of the nearby mountain range. [*Wood* 7-13]

July. La Rochelle, France, constructs bracken and fern fronds backdrop for 'Végétal'. [*Wood* 41]

August. Penpont, Ballet Atlantique-Régine Chopinot company visit. Makes stick and dust throws together with dancers. [*Wood* 16, 59]

August. Work on Capenoch tree ('Stone houses'). [*Wood* 110-111]

August. Begins working with wool gathered from fields, 'a material which has complex associations that I need to meet head-on' – one aspect of a much broader project concerning sheep farming and the landscape (which has its focus in the Sheepfolds project).

August. Thomas Riedelsheimer, German film maker, contacts Goldsworthy about a proposed collaboration (filming will begin in 1998).

September. Work on Capenoch tree (earth hole). [*Wood* 106-107]

October. Storm King, New York, invited to make a proposal. 'I spent several days walking, looking and occasionally making ephemeral works – getting to know the place'; including red leaves laid in a water-filled hollow in a rock. [*Wall* 40]

17 October. Carrick Bay, Dumfriesshire, eleven arches made between tides. [*Time* 30-31]

'Végétal' (Earth, Seed, Root, Branch, Leaf), choreography by Régine Chopinot, scenography by Goldsworthy, premiered by Ballet Atlantique

Wool line
Penpont, Dumfriesshire, August 1995

Stone spire
in stick cairn
La Rochelle,
France,
November
1995

at La Coursive, Scène Nationale, La Rochelle, France, 6-7 November, to a mixed reception; a stick cairn installed in the courtyard outside the theatre is physically attacked by a dance critic. Subsequently tours France to many venues over several years. [*Wood* 14, 32-33, 58]

25 November-9 December. Alaska, invited by Anchorage Museum of History and Art and Alaska Design Forum to work at Turnagain Arm with wood, rocks, water and ice. [*Wood* 60-65] (Exhibition in 1996.)

14 December. Awarded an Honorary Fellowship by the University of Central Lancashire 'in recognition of his work as an artist and sculptor of international repute which reflects his strong ties with the Northwest of England'.

'time machine Antico Egitto e Arte Contemporanea, Museo Egizio, Turin, Italy, 14 December-31 March (1996), including

Frozen stick ring, dripped icicle
Alaska, November 1995

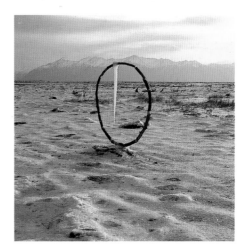

Constructing 'Sandwork'
Museo Egizio, Turin, Italy
December 1995-March 1996

installations of 'Sandwork' (a version of the British Museum work) and 'Leafwork', bracken line on ceiling echoing the sand work (Italian edition of 1994 catalogue). [*Wood* 45]

28 December. Glen Marlin Falls, Dumfriesshire. 'The coldest I have ever known in Britain. I was able to break and freeze icicles faster than ever before. The icicle is an expression of something of the core of the tree, its spine, and the works are

Proposal drawing and construction of sheepfold Mungrisdale, Cumbria, January 1996

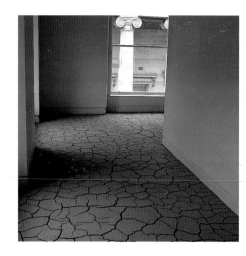

Cracked clay floor Museum of Modern Art, Glasgow, Scotland, March 1996

as if for a moment that spine has shifted and stepped outside the tree, almost as an apparition.' [*Wood* 66-67; Malcom Andrews, *Landscape and Western Art*, 1999, cover]

1996

8-12 January. Redmire Farm, Cumbria, erects Mungrisdale Sheepfold, the first of the proposed 100 sheepfolds; built with Steven Allen, champion waller, who will head the team of wallers working on all future dry-stone wall projects (Steven Chettle, Paul Nesbitt and Andrew Humphries, *Andy Goldsworthy Sheepfolds*, Michael Hue-Williams Fine Art, 1996, with proposal drawings). [*Wall* 18]

16 January. Work on Capenoch tree (branches stacked to form an opening). [*Wood* 86-87]

2-10 February. Work at Capenoch tree (snow line; ice arch; snow hole; mud-smeared snow hole, reworked as serpentine; snow cairn capped with mud, covered with mud and snow): 'Works like this are what I live for'. [*Wood* 88-95, 118-119]

20-21 February. 'Végétal' performed at the Théâtre de la Ville, Paris (recorded in *Végétal*, Ballet Atlantique–Régine Chopinot, 1996).

March. Permanent installation of cracked clay floor at Glasgow Museum of Modern Art.

'Alaska Works', Anchorage Museum of Art, 17 March-29 September; tours to Alaska State Museum, Juneau (5 December 1996-15 February 1997) and University of Alaska Museum, Fairbanks (1 April 1997-2 June 1997).

April. Cahors, France, dandelion line following

Dandelion line
Cahors, France, April 1996

house contours; exhibited, with a rosebay willowherb screen installed in an old church, in 'Printemps de Cahors', 14-19 June. [*Wall* 36]

May. Visits The Getty Research Institute for the History of Art and the Humanities, Los Angeles,

Proposal drawings for The Getty Institute
Los Angeles, California, May 1996

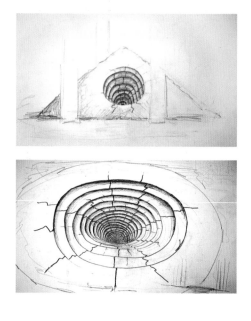

California; makes proposal (realised 1998).
29 June-2 July. Penpont, Régine Chopinot visits to discuss making a film about 'Végétal'.

26 July. Announcement of National Lottery grant (£340,000) to finance the Sheepfolds Project.

'Sheepfolds 1996-2000', Tullie House, City Museum and Art Gallery, Carlisle, Cumbria, 27 July-1 September, proposal drawings.

August. Buys a Fuji panoramic GX 617 camera, allowing the kind of works which had previously been shot in two, three or even four frames to be photographed in one.

1-21 September. Mount Kisco, New York, private commission, rebuilds an old dry-stone wall flanking a road to incorporate three boulders. [*Wall* endpapers, 16, 17] Site visit to Storm King to initiate Wall project (realised 1997-2000).

9 September. First visit to Montreal, Canada, to discuss a permanent outdoor sculpture commissioned by Cirque du Soleil for its new headquarters; Goldsworthy proposes 'Montreal Arch', approximately four metres high, weighing 80 tons, constructed in Dumfriesshire of local, rough-hewn, red sandstone (a traditional building material once transported to Montreal as ships' ballast). The arch will have one foot on the lawn, the other in an adjacent cornfield – a bridge rather than an entrance, as an expression of the intercontinental movement of the stone, paralleling the journey of Scottish emigrants to Canada (to be installed in 1998). Guy Laliberté, co-founder and Director of Cirque du Soleil, commissions a sandstone arch stepping from land into water for his Montreal residence (which will be installed in 1999). [*Time* 60-69]

Horse-chestnut stalk screen
Cork Street, London, October-November 1996

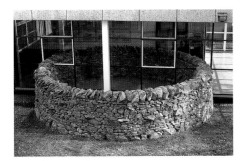

'Jack's Fold' University of Hertfordshire, St Albans, October-December 1996

10 October. Publication of *Wood*, 120pp, 145 colour illustrations, with Introduction by Terry Friedman and artist's statements.

'Wood', Michael Hue-Williams Fine Art, London, 11 October-22 November, including installations: a woven oak ball, a rush line drawing and a horse-chestnut stalk screen.

'Jack's Fold', University of Hertfordshire, Margaret Harvey Gallery, St Albans, 8 October-7 December, a circular dry-stone wall bisected by the glass wall of the gallery (described in Steve Chettle, Steven Adams, and Matthew Shaul in conversation with the artist, *jack's fold*, University of Hertfordshire, 1996), as part of Goldsworthy's one-year post at the university as Research Fellow in the Faculty of Art and Design; the fold was subsequently returned to its Cumbrian origins.

Begins (in Scotland) a major group of leafworks to be installed in a purpose-built wooden wall in a newly built California residence – private commission resulting from the 1989 display of an earlier collection of leafworks in a Penpont studio cupboard illustrated in Andrew Causey, *Sculpture Since 1945*, 1998, pl.94. (Completed November 1997; installed January 1998.)

'Wood', Galerie Lelong, New York, 8 November-4 January (1997), including burnt sticks installation brought from Buckhorn, New York State, where it was made (since returned there and left to decay).

'Wood', Haines Gallery, San Francisco, 16 November-18 January (1997), including series of stick, slate and moss holes; the first California clay wall – 'a huge discovery'. [*Time* 9]

December. Penpont, constructs three columns and three lines of stone (remodelled as a single column and serpentine of stone in January 1997).

25 December. Scaur Glen, Dumfriesshire, an ice-encased stone cairn erected over two successive nights. [*Time* 46-47]

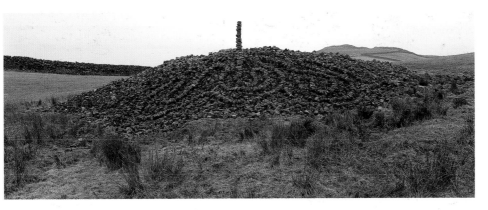

1997

Penpont, installations incorporated into the new residential fabric of the Goldsworthy family home: stone cairns and slate wall, the first permanent outdoor works around the house. [*Time* 24]

February. Penpont, the first visit by Thomas Riedelsheimer, film maker.

National Museums of Scotland, Edinburgh, commission for permanent sculptures in the new Chambers Street extension: a proposal for a group of fired boulders to be placed on the roof terrace as a homage to the Edinburgh geologist, James Hutton, who wrote about heat as the engine in the cycle of change and fluidity in stone (*A Theory of the Earth*, 1785). In preparation, installs in the Penpont studio a purpose-built, industrial-sized electric kiln, manufactured at Stoke-on-Trent, but due to technical difficulties the boulder project is abandoned.

April. Begins Spring section of series of ephemeral works, 'Coleridge's Walk', tracing a walk undertaken and documented by the poet in the Lake District.

Clay wall, not yet cracked Haines Gallery, San Francisco, California, November 1996

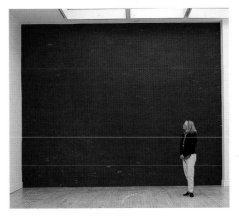

Stone column and serpentine
Penpont, Dumfriesshire, January 1997

May. The Getty Research Institute for the History of Art and the Humanities, Los Angeles, California, aware of the irony of making a work for an organisation devoted to art conservation, installs an internal, skylit spiralling clay hole which will crack unpredictably over the following months and is positioned so that the sun will shine directly

Clay hole, The Getty Research Institute, Los Angeles, California. Made May 1997.

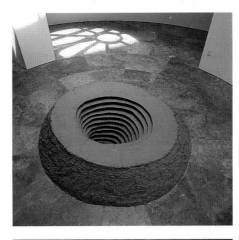

on it once a year at midsummer (destroyed when a water pipe burst, 1999).

7-18 June. Cumbria, 'Walking Arch', part of the Sheepfolds project. 'I will make an arch in Scotland from Locharbriggs red sandstone erected in a sheepfold on the Lowther Hills near to where I live, after which it will follow a drove route from Scotland through Cumbria and into Lancashire or Yorkshire. The arch will stay overnight at folds along or close by the drove route. It will be erected and photographed at each site before being dismantled and taken to the next' (in Andy Goldsworthy and David Craig, *Arch*, Thames & Hudson/Harry N. Abrams, 1999, p.5).

15 August. 'Végétal' (1995) performed by Ballet Atlantique-Régine Chopinot at the Edinburgh International Festival.

25 August-11 September. Herring Island Environmental Sculpture Park, Melbourne, Australia, erects Castlemaine slate 'Cairn' and Dunkeld sandstone 'Stone house'.

September. Westchester County, New York, private commission, eleven creek arches. [*Wall* 88-89]

September-October. Storm King, New York. 'I found [a derelict dry-stone wall] of which very little remained, but its lie could be picked out by the straight line of trees growing along its length . . . The new wall now follows a line in sympathy with the trees, working around each one in a protective enclosing gesture. I walked in and out of the trees many times to find the right direction, flow and feel', a pattern similar to the Grizedale 'Wall that went for a walk' (1990); assisted by Steve Allen, Max Nowell and Gordon and Jason Wilton. Works with leaves and river rocks. [*Wall* 24-27, 30-31, 38-39, 66-69]

'Stone house'
Melbourne, Australia, August-September 1997

Leaf works
California Made 1996-1997, installed January 1998

'Cairns', Musée départemental de Digne, Digne-les-Bains, France, 24 October-8 January 1998, an installation to commemorate the tenth anniversary of the Réserve Géologique de Haute Provence (Nadine Gomez-Passamar, Guy Martini, Anne Bineau, Pierre Coste, *Andy Goldsworthy Cairns*, in French, 1997, with extracts from the artist's Digne journal, 14-26 July 1995, and other statements).

November. Begins to assemble stones for Montreal Arch at Locharbriggs Quarry, Dumfriesshire.

1998
Penpont. Begins series of 'sheep paintings' formed by footprints of sheep on large white canvases stretched out on grazing land with sheep or cattle food in centrally placed containers.

Preparing sheep painting
Penpont, Dumfriesshire, January 1998

Cairn Museum of Contemporary Art, Chicago, Illinois, February 1998

February. Visits Chicago, notorious for its cold winters, to freeze a stone cairn to an outside wall of the Museum of Contemporary Art; unusually mild conditions make this impossible. 'I left a cairn on the ground next to the wall as a monument to the failure.' Discusses proposal for future project to make snowballs in winter, deep-freeze them and release them in summer. (A similar project will be realised in City of London, 2000.)

March. Glenluce, Dumfriesshire, private commission, a balanced column of graduated beach stones embedded in a slate wall filling an abandoned door in an old stone barn.

March. British Airways headquarters, West Drayton, London, a two-part work: an indoor slate cairn and a nearby outdoor slate chamber.

Indoor slate cairn and outdoor slate chamber
West Drayton, Middlesex, March 1998

April-May. National Museum of Scotland, Edinburgh, builds 'Clay Wall' and four quadrant-shaped 'Slate Walls' in the Early People exhibition gallery; four Locharbriggs red sandstone holes placed at cardinal points on the roof terrace, an alternative to the abandoned fired boulders proposal (1997). [*Time* 10]

'Arche', Musée d'Art Contemporain de Montréal, Canada, 8 April-7 June, works made in Dumfriesshire and Alaska (in 1993, 1995, 1997), 'Drove Arch' in Cumbria (1997); installs arch stepping through a wall and a circle arch (Réal Lussier, *Andy Goldsworthy Arche*, Musée d'Art Contemporain de Montréal, 1998).

'Goldsworthy', Galerie Lelong, Paris, 4 June-18 July, installs a horse-chestnut stalk screen with a hole framing a balanced column of stone (which was originally made for 'Végétal', 1995).

Stone column
Glenluce, Dumfriesshire, March 1998

Horse-chestnut stalk screen and stone spire
Galerie Lelong, Paris, France, June-July 1998

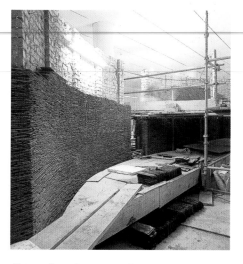

Slate walls under construction
Museum of Scotland, Edinburgh. April-May 1999

'Être Nature', Fondation Cartier, Paris, 17 June-20 September, including a woven stick ball.

Stick ball
Fondation
Cartier,
Paris, France,
June 1998

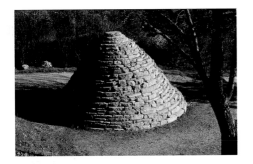

Water cairn
Digne-les-Bains, France, July 1998

27-28 June. Penpont, meeting with Régine Chopinot and Thomas Riedelsheimer to discuss making a film for the forthcoming ballet collaboration 'La Danse du temps'; Goldsworthy's idea of filming a cracked clay wall incorporating a serpentine form as an expression of movement, like water, is met with enthusiasm.

July. Digne-les-Bains, France, five water cairns (built by three English dry-stone wallers) at intervals along path from car park to the Réserve Géologique – water diverted from a nearby stream falls into the sound chamber of each cairn before flowing on to the next and finally emerging from the fifth cairn; works with stone and leaves in River Bès; discussions with Nadine Gomez-Passamar and Guy Martini lead to the decision to make a cracked clay wall as a permanent installation at the Musée départemental and to ask Thomas Riedelsheimer to film it for 'La Danse du temps'. Having noticed the large number of derelict agricultural stone buildings in the surrounding landscape, Goldsworthy proposes rebuilding some of them

Rush line drawing Springer & Winckler Galerie, Berlin, Germany, September 1998

Second section of 'Wall'
Storm King Art Center, New York, Autumn 1998

and incorporating works into their fabric in the process.

August. Penpont, working with earth and moss directly on a tree as if the work is growing inside the trunk. [*Time* 36, made April 1999, 37, 40]

'Installation und Photographie', first exhibition at Springer & Winckler Galerie, Berlin, Germany, 26 September-30 October; makes a rush line drawing using the internal angles and curves provided by the architecture of the building.

September-October. Storm King, New York, overseeing construction of the second section of 'Wall', which 'built up such a momentum that it willed itself into the lake, up the other side and over the hill'. Makes ephemeral work in the nearby river and environs: 'There was an important link between the river of water and the river of stone

Burnt waste timber salvaged from skip Ingleby Gallery, Edinburgh, November-December 1998

that the wall was becoming.' [*Wall* 23, 37, 53-55, 64-65] Begins filming there with Thomas Riedelsheimer.

'Andy Goldsworthy', Ingleby Gallery, Edinburgh, 11 November-19 December, work related to the Museum of Scotland installations. [*Time* 11]

1 December. Opening of the National Museums of Scotland Chambers Street extension.

1999

Goldsworthy embarks on a number of millennium projects which will be left unfinished to be completed in the next century.

January. Dunesslin, Dumfriesshire, private commission, erects a large stone cairn with a hole in which is planted a hawthorn tree sapling that will come to maturity in 25 years. (Two other tree cairns are planned for completion by 2001 to mark a circular walk.) [*Time* 23]

January-March. Uncertain about the availability of snow in Scotland, makes seven of a total of fourteen, six-foot diameter snowballs, each containing materials 'as memories of the twentieth century', which are refrigerated (to be released on Midsummer's Day 2000).

29 January -13 February. Foxpoint, Nova Scotia, Canada, making ephemeral work along the Atlantic seaboard for filming by Thomas Riedelsheimer. [*Time* 96-121]

March-April. Ellon, Aberdeenshire, Scotland, private commission, erects half of 'Logie Cairn', the other half awaiting completion in 2000, with a

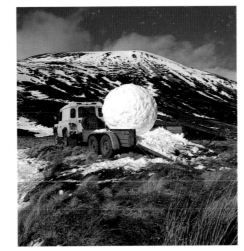

Loading snowball to be transported to cold store Glenshee, Perthshire, early 1999

thin gap between signifying the passage of time, visible from a particular angle; from other viewpoints, the structure will be perceived as whole and solid (a version is proposed for San Francisco, California). [*Time* 12]

15-25 March. Schoorl and Baarn, Noord-Holland, invited by the Staatsbosbeheer (Dutch Forestry Service) to work on the beach and in woods as part of its 100th anniversary celebrations. 'I work directly with the land because it nourishes me. It is full of energy and change and growth and I feed on that. I need that. I see myself as the next layer on the many layers that have made the landscape so rich. It would be a layer that will be covered up after I have gone. I find that a very beautiful idea' (in Martin Kuipers and Tanja Karreman, *Andy Goldsworthy*, Provincie Noord-Holland aan Staatsbosbeheer, 1999). [*Time* 122-137]

Spring. Penpont, filming with Thomas Riedelsheimer.

Spring. Storm King, New York, final version of Wall's descent, modified to align with the western section across the lake; makes ephemeral work. [*Wall* 52, 85]

June. Digne, France, erects the first of three sentinel cairns which will be sited in each of the three valleys in the Réserve Géologique, marking a ten-day walk; previous proposal (1998) to renovate stone buildings develops into idea of providing refuges for those undertaking the walk: at appropriate intervals along the route, around fifteen derelict stone buildings will be made weatherproof and Goldsworthy will incorporate a work into each structure, allowing people 'not only to see the works, but to spend the night with them.' 'The two projects can be combined and will strengthen each other.' Makes the clay wall for 'La Danse du temps'; Régine Chopinot and company watch the wall crack and work with Goldsworthy in the river Bès. [*Time* 83-94]

July. Montreal. Carries out private commission for arch proposed in 1996.

July. Near Storm King, New York, 'Folded Wall', private commission, a dry-stone wall enclosing a tree and a stone (in the manner of Stonewood in 1989). [*Wall* 12]

12-29 July. Santa Fe, New Mexico, makes work for 'Two Rivers' exhibition to be held at SITE Santa Fe (2000). [*Time* 138-157]

August. Two-year appointment as Senior Lecturer/Practitioner-Fine Art in the Department of Art and Art Therapies, Faculty of Art and Design at the University of Hertfordshire.

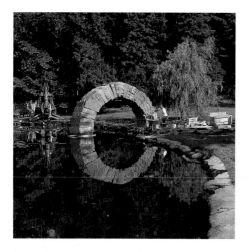

Locharbriggs sandstone arch
Montreal, July 1999

Summer and Autumn. Penpont, filming with Thomas Riedelsheimer.

August. Storm King, New York, ephemeral work. [*Wall* 33]

September. Rainscombe Park, Oare, Wiltshire, private commission, erects half of 'Wiltshire Arch', made of Locharbriggs sandstone which remains scaffolded, awaiting completion in 2000, bridging the two centuries and stepping through time. [*Time* 14-15]

3-15 October. Cornell University, Ithaca, New York, makes ephemeral work on campus for 'Fall Creek' project to be exhibited in 2000. [*Time* 162-177]

'La Danse du temps', choreographed by Régine Chopinot, scenographic film by Goldsworthy and Riedelsheimer, premiered by Ballet Atlantique at La Coursive, Scène Nationale, La Rochelle, France, 8-9 November. [*Time* 95]

November. Hollister, California, private commission, erects half of 'Holister Cairn', the other half awaiting completion in 2000; a clear joint will mark the division between the two halves. [*Time* 12-13]

November-December. Clougha Pike, Lancashire, private commission, a dry-stone wall enclosing an oval hollow 'overlooking an area where I had lived and worked some 20 years ago'. [*Time* 18]

'New Photographic Work', Michael Hue-Williams Fine Art, London, 23 November-14 January (2000), Dutch work made in March.

December. Makes all but one of the remaining snowballs to be placed in various locations in the City of London on Midsummer's Day 2000.

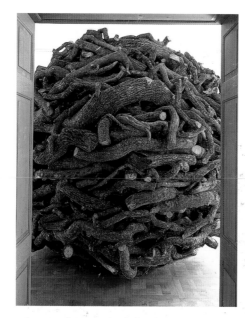

Oak stack Storm King Art Center, Mountainville, New York, May 2000
(Photograph by Jerry L. Thompson)

'Fell Run', Dumfriesshire, a project under discussion with the Earl of Dalkeith and Jenny Wilson (Dumfries and Galloway Arts Association) involving a series of arches.

2000

January-February. 'Penpont Cairn' made on the invitation of the villagers on a small hill next to the main road entering the village. 'I intend it to act as a marker to time and place, but also as a guardian and sentinel, an acknowledgement

'Penpont Cairn'
Dumfriesshire, January 2000

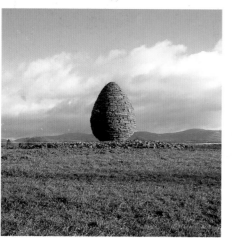

Snowball
Smithfield, London, 21 June 2000
(Photograph by Ian Cameron)

not only of the strong influence of the Dumfriesshire landscape on my art, but of the people who live here'. Assisted by Andrew McKinna.

January. Overcomes technical difficulties with kiln and begins firing stones in anticipation of 'Rock Pools' installation at the Barbican, London, later in the year.

'Digne works', Hôtel Scribe, Paris, 10 January-12 February, photographs of work made in preparation for 'La Danse du temps'.

11-15 January. 'La Danse du temps', Ballet Atlantique-Régine Chopinot, Théâtre de la Ville, Paris.

March. Des Moines Art Centre, Iowa, proposal for a permanent, three-part outdoor sculpture, the other two sited on the east and west coasts of the United States, connecting the mid-western plains to the oceans.

'Fall Creek', Herbert F. Johnson Museum of Art, Cornell University, Ithaca, New York, 10 March-4 June. Installation and ephemeral work made in October 1999. [*Time* 177]

'Two Rivers', SITE Santa Fe, New Mexico, 1 April-28 May. [*Time* 157-161]

April. Digne, France. Makes second of three cairns. 'Three Valley Walk' proposal discussed in June 1999 is accepted.

'A Line and a Wall', Galerie Lelong, New York, 4 May-28 June; installations are a grass stalk line and cracked clay wall.

'Andy Goldsworthy', Storm King Art Center, Mountainville, New York, 22 May-15 November; opening (on 20 May) of 2,278 foot long 'Wall' and indoor installation and launch of *Wall*, 96pp, 104 colour illustrations and six quadratones, with Introduction by Kenneth Baker (who had written about Goldsworthy in *The San Francisco Chronicle* in 1994 and *The Smithsonian Magazine* in February 1997), artist's statements and poems by Norman Nicholson.

1 June. Appointed Visiting Professor at the University of Glasgow's Crichton Campus in Dumfries, south-west Scotland.

June. Awarded OBE (Officer of the Order of the British Empire) in The Queen's Birthday Honours List.

'Snowballs in Summer', City of London, 21 June. Thirteen snowballs containing various materials, among them Scots pine cones, chalk and barbed wire, placed in a variety of public locations near Barbican Gallery early in the morning of 21 June and allowed to melt over the following days.

1 July. Appointed Andrew D. White Professor-at-Large at Cornell University, a post that will run until 2006.

July. Construction of second of Dunesslin cairns, a private commission begun in January 1999.

'Time', The Curve, Barbican Centre, London, 30 August-29 October, including a snowball containing ground red stone melting in the gallery, 'Rock Pools' – an installation of fired sea boulders, video installations of fired stones in kiln and of 'Snowballs in Summer', and, possibly, the largest clay wall to date (still to be confirmed as this publication went to press).

'La Danse du temps', Ballet Atlantique-Régine Chopinot, Barbican Theatre, Barbican Centre, London, 6-9 September.

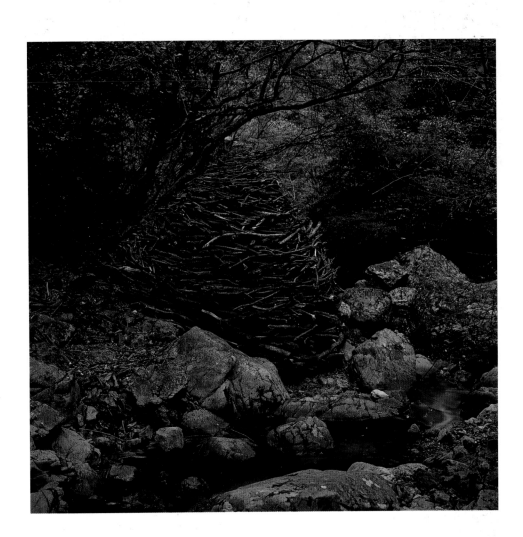

Stone house (night)

OUCHIYAMA-MURA, JAPAN

13-14 NOVEMBER 1991